THE ROAD TO BYZANTIUM

THE ROAD TO BYZANTIUM
Luxury Arts of Antiquity

HERMITAGE ROOMS
ГОСУДАРСТВЕННЫЙ
ЭРМИТАЖ
at SOMERSET HOUSE

COURTAULD INSTITUTE OF ART

Published by Fontanka

This book has been published to coincide with *The Road to Byzantium: Luxury Arts of Antiquity*, an exhibition held in the Hermitage Rooms at Somerset House, London, from 30 March to 6 September 2006, and jointly organised by the State Hermitage Museum and the Courtauld Institute of Art.

Editors
Frank Althaus and Mark Sutcliffe

Consultant editors
Peter Stewart and Antony Eastmond

Editorial assistance
Anna Petrakova and Anastasia Miklyaeva

Design
John Morgan studio, London

Photography
Yury Molodkovets and Svetlana Suetova

Translation
Christine Barnard, Margaret Bradley and Andrew Bromfield

Index
Hilary Bird

ISBN 0-9543095-5-3 (hardback)
ISBN 0-9543095-6-1 (paperback)

Reproduction by Mondadori, Italy
Printed by Artes Graficas Toledo, Spain

First published in 2006 by
Fontanka
11 Coldbath Square
London EC1R 5HL
info@fontanka.co.uk

Front cover: *Plate with a Silenus and a Maenad* (detail)
Constantinople, AD 613–629/30 (cat. 85)

Frontispiece: *Vessel with Scythian Hunting Scenes* (detail)
Northern Black Sea region, Lower Dniepr, 400–375 BC (cat. 10)

The exhibition organisers would like to thank the Trustees of the British Museum for the loan of the Dish with Scene Derived from the Triumph of Dionysos (cat. 92) and the Trustees of the Victoria & Albert Museum for the loan of the Veroli Casket (cat. 103)

Illustration acknowledgements
Copyright in all photographs in this catalogue belongs to the State Hermitage Museum with the exception of the following:

Statue of Augustus from Prima Porta, Vatican Museums and Galleries / Bridgeman Art Library (p. 40)

The Doryphoros, Museo Archeologico Nazionale / Bridgeman Art Library (p. 41)

Portrait of Hadrian, Museo Archeologico Nazionale / Bridgeman Art Library (p. 44)

Fig. 1.1 and 1.2 (p. 63), after B.I. Lescenko in V.P. Darkevich, *Khudozhestvennyi Metall Vostoka VIII–XIII vv.*, Moscow, 1976, figs. 23, 28 (annotated by M. Mango)

The Arch of Constantine, Rome (detail) © Alinari 17325 (p. 76)

Statues from the Esquiline Hill, Rome © P. Stewart (p. 77)

Glass Bowl, reproduced with kind permission from D. Buckton (ed.), *The Treasury of San Marco in Venice*, London, 1984 (p. 80)

Dish with Scene Derived from the Triumph of Dionysos © The Trustees of the British Museum (cat. 92; pp. 111, 161)

The Veroli Casket © V&A Images / Victoria and Albert Museum (cat. 103; pp. 65, 81, 165)

F

CONTENTS

THE ROAD TO BYZANTIUM

EXHIBITION ACKNOWLEDGEMENTS

We would like to extend special thanks to Lord Rothschild for his particular contribution to the Hermitage Rooms as well as others who have offered their invaluable assistance for this exhibition. In particular we would like to thank His Excellency the Ambassador of Russia, Yuri Fedotov, His Excellency the Ambassador of Greece, Anastase Scopelitis, Sir Patrick Fairweather, Mrs Jane Ferguson, Mr Dimitri Goulandris, Professor Judith Herrin, the Viscount Norwich, Mrs Zelfa Olivier, Dr Victoria Solomonidis, Sir Christopher White and Mr Emmanuel Zuridis.

EXHIBITION PATRONS

The Road to Byzantium: Luxury Arts of Antiquity is a major collaboration with the State Hermitage Museum, displaying more than 160 ancient treasures which have never before been shown together. We would like to extend our grateful thanks to the following donors. Their vision and significant support has enabled us to bring *The Road to Byzantium* to a wide audience.

Alpha Bank London
Mr Len Blavatnik
The J.F. Costopoulos Foundation
Cycladic Capital LLP
The Sir Joseph Hotung Charitable Settlement
The A.G. Leventis Foundation
SETE S.A.

SUPPORTERS OF THE HERMITAGE ROOMS

We acknowledge with grateful thanks ongoing support for the Hermitage Rooms at Somerset House by the Edmond J. Safra Philanthropic Foundation, The Deborah Loeb Brice Foundation and the Founding Members of the Walpole Circle.

Hermitage Development Trust Advisory Board
Professor Mikhail Piotrovsky, President
Mr Nicholas Ferguson, Chairman

Mr Theo Bremmer
The Marquess of Cholmondeley
The Marchioness of Douro
Dame Vivien Duffield DBE
Lord Hindlip
Mrs Marie Josée Kravis
Lord Moser KCB, GBE, FBA
Mrs Geraldine Norman
Lord Rothschild OM, GBE, FBA
Mrs Charles Wrightsman

Dr Deborah Swallow, Executive Director

The Walpole Circle
Mr Len Blavatnik, Access Industries
Mrs Abigail Bowers
William Browder, Hermitage Capital Management
The Marquess of Cholmondeley
His Grace The Duke of Devonshire
Dame Vivien Duffield DBE
Nicholas and Jane Ferguson
Rocco Forte Hotels
Mr Georges C Karlweis
Professor and Mrs Nasser D Khalili
Ms N Parker
Mr Simon Robertson
Mr and Mrs S N Roditi
Lord Rothschild OM, GBE, FBA
William and Olga Shawcross
Mr Peter Simon
Mr John Studzinski
Mrs Charles Wrightsman

and others who wish to remain anonymous

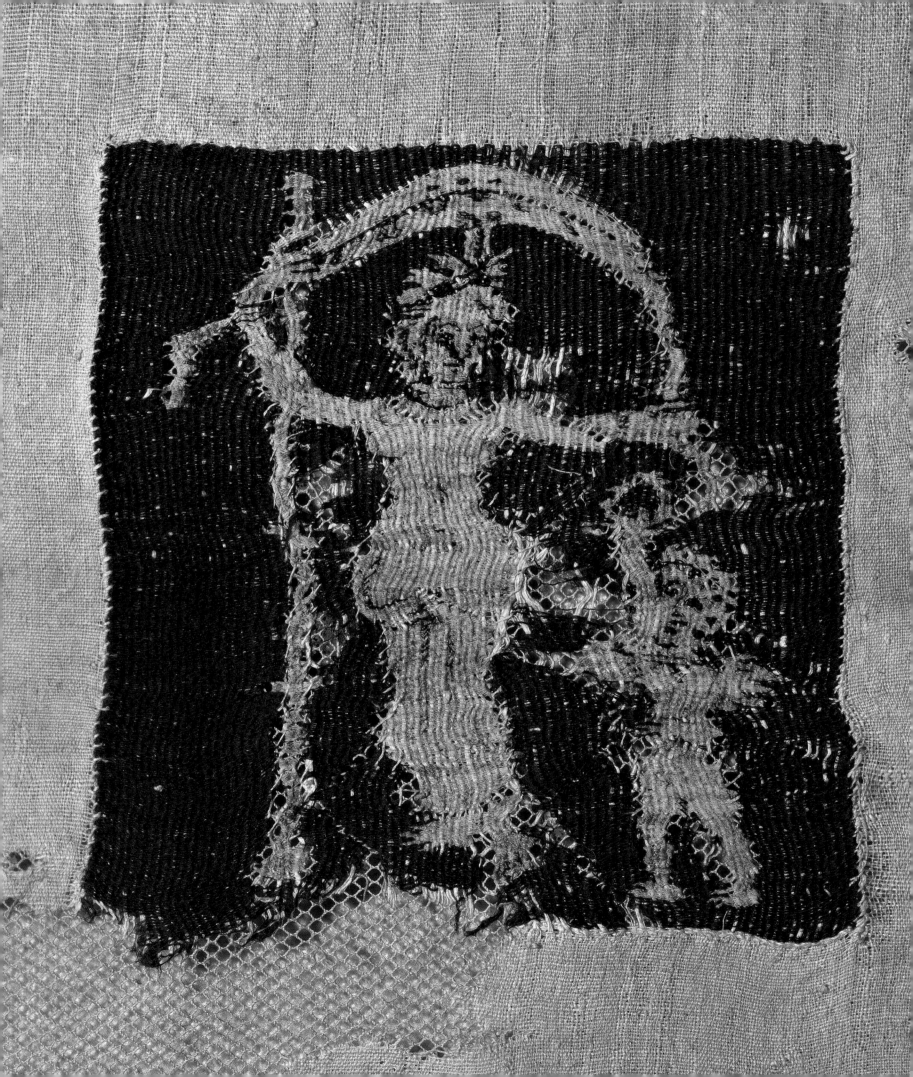

DIRECTORS' FOREWORDS

STATE HERMITAGE MUSEUM

This exhibition is the fruit of wonderful cooperation between the Hermitage Museum and the Courtauld Institute of Art. We have combined our considerable experience in academic research with materials from the collections of a universal museum, as the Hermitage undoubtedly is.

The results have enabled us to show aspects of the Greco-Roman cultural inheritance which are often overlooked, not only by the public but by academics, too. The sheer variety of the Hermitage material reveals the true extent of the influence of Greek culture – its creative echoes and its geographical borders. The artistic language of antiquity was easily translated into that of the Scythians, the Persians, the Turks and Egyptians; and while the original material lost something in translation, there was also much that it gained. Thus the Greek world broadened its reach, while its roots sank deeper and its achievements attained new heights.

The thread of Greek inheritance was never broken. Works in this exhibition show the continual cross-pollination of artistic traditions and their manifestation in the art of Byzantium. The much-cited break between antiquity and the Middle Ages, overcome only by the Renaissance, was in fact no such thing. The road to Byzantium was quite even; simply it did not always run where people sought it.

There are no icons on display here; instead, the exhibition is built around the luxury arts, a medium which has its own laws governing the way traditions spread and are handed down. For it is in the decorative, in symbols of wealth and social standing, that cultural influences and artistic languages are often best preserved, as they are reworked and reinterpreted in ever more interesting forms. So too the picture of the world that produced them becomes broader and richer.

The exhibition contains numerous wonderful and rare objects, among them many of symbolic significance. The gold dancers from Bolshaya Bliznitsa combine two dances, and their mystery and beauty bring together two worlds: the calm of Greece and the whirl of the East. The silver Byzantine dish showing Alexander the Great's flight to the heavens amidst engraved symbols of antiquity and the Middle Ages might itself serve as a symbol for the whole exhibition. The road to Byzantium does indeed lead to great heights!

It has been a great pleasure for us to work on this exhibition with our British colleagues. I believe we have created a new and successful formula for cooperation between museum and university scholars: much work and many more exhibitions lie before us.

Professor Mikhail Piotrovsky
Director, State Hermitage Museum

COURTAULD INSTITUTE OF ART

This is the fourth exhibition organised jointly by the Courtauld Institute of Art and the State Hermitage Museum. The partnership between our two institutions provides a unique opportunity to share collections and intellectual resources, and to bring to London works of art which might not otherwise be readily available to students, scholars and the public. The current exhibition, of luxury arts of antiquity, fulfils these aspirations, adding purposefully to its predecessors: *Peter Paul Rubens: A Touch of Brilliance*; *Heaven on Earth: Art from Islamic Lands*; and *Circling the Square: Avant-Garde Porcelain from Revolutionary Russia*.

The Hermitage has a truly remarkable collection of late antique and early Byzantine silver, showing the extraordinary longevity of classical Greek styles and imagery, as established by Leonid Matsulevich in his pioneering study of 1929. At the Courtauld, too, there is a strong tradition of scholarly research on the arts of Byzantium and late Antiquity, led by Emeritus Professor Robin Cormack and his students, and continued by current faculty. Research arising from both institutions allows *The Road to Byzantium* to present the argument for classicism's survival and transformation over more than a millennium, as ideas first developed in the fifth century BC were admired, copied, challenged and reinterpreted by peoples of different cultures and religions.

This exhibition relies on the energy and expertise of a great many people at both the Hermitage and the Courtauld. We are grateful for their contributions to this project. Our thanks are also due to the Trustees of the British Museum and of the Victoria & Albert Museum for generously lending key objects.

We are immensely grateful for the support of the Edmond J. Safra Philanthropic Foundation which has enabled this creative partnership truly to flourish and develop, and to The Deborah Loeb Brice Foundation, the Founding Members of the Walpole Circle, and to Mr Len Blavatnik, Chairman of Access Industries, for their continued commitment to supporting world-class exhibitions in the Hermitage Rooms at Somerset House.

Finally I would like to pay a special tribute to the Patrons of *The Road to Byzantium*: Alpha Bank London, Mr Len Blavatnik, The J.F. Costopoulos Foundation, Cycladic Capital LLP, The Sir Joseph Hotung Charitable Settlement, The A.G. Leventis Foundation, and SETE S.A. It is their extraordinary generosity that has made this exhibition possible.

Dr Deborah Swallow
Märit Rausing Director, Courtauld Institute of Art

LEFT (DETAIL)
*Upper Part of a Tunic
with Aphrodite and Eros*
Egypt, 4th century AD
cat. 70

Original Inscriptions
Where appropriate, inscriptions have been given
in the original Greek and Latin. Inscriptions
are generally given using capital letters, with
explanations or interpretations in upper and
lower case script as sense requires.

Greek and Latin Spellings
In general Greek, rather than Latinized, forms of
Greek names have been employed, except where the
Latin form is particularly familiar (e.g. Pantikapaion,
not Panticapaeum; but Achilles, not Akhilleus).
However, conventional transliterations have been
used even at the cost of consistency (thus Dionysos,
not Dionusos).

Russian Transliteration in General Text
The transliteration system used for Russian words
and names in the main text is a version of the British
Standards Institute (BSI) system, modified to improve
readability. Thus the Russian 'e' is given as 'e' except
at the beginning of a word or after another 'e', when
it becomes 'ye' (e.g. Yelizavetgrad, Alekseyev); 'ë' is
given as 'yo'; the common adjectival endings 'ий' and
'ый' are both given as 'y' (e.g. Artyukhovsky); soft and
hard signs are omitted.

Russian Transliteration in the Bibliography
The Library of Congress (LC) system is used for
Russian publications in the bibliography (both at
the end of each catalogue entry and in the general
bibliography) to facilitate access to works in the
original Russian.

In the catalogue bibliographies, a shortened form
is given for each publication (usually author or
exhibition title, date of publication, page or picture
reference), while the full entry can be found in
the main bibliography – in the case of Russian
publications, first transliterated, then translated.

For publications in Russian, the names of Russian
authors are transliterated according to the LC system.
Foreign-language publications may use a different
spelling for the same author; these differences are
reflected in the bibliography. Thus, for example,
Zalesskaia (corresponding to the LC system) is
used for publications in Russian, while Zalesskaya
is used if that spelling has appeared in a foreign-
language publication (similarly e.g. Marshak/
Marschak; Gaidukevich/Gajdukevič).

Map 1 locates Greek, Roman, Byzantine, and
Central Asian peoples and places in the modern
geography of the Mediterranean and Black Sea.

Map 2 indicates the location of Greek and
Scythian sites, including barrows (indicated by
the sign ✳), in the northern Black Sea region.

Map 1: The Classical and Byzantine World

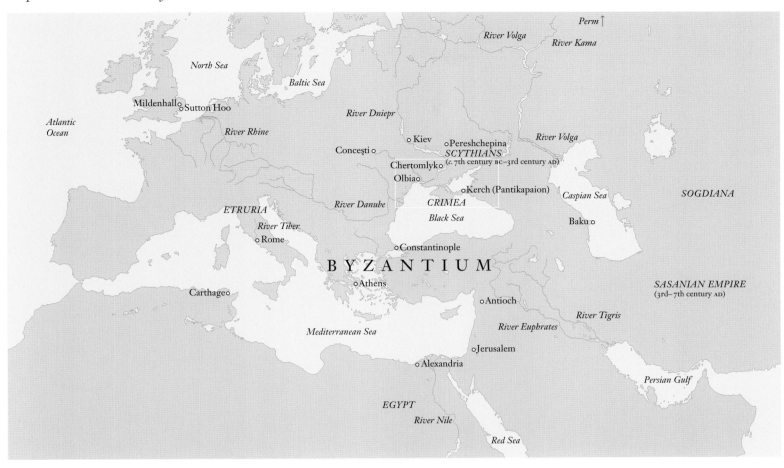

Map 2: Greek and Scythian Sites in the Northern Black Sea Region

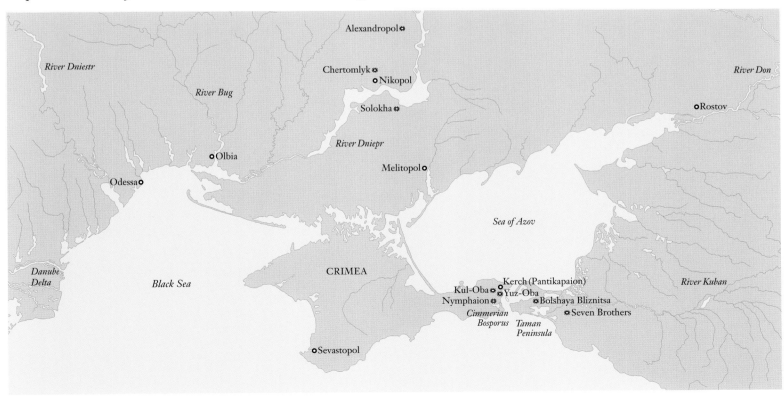

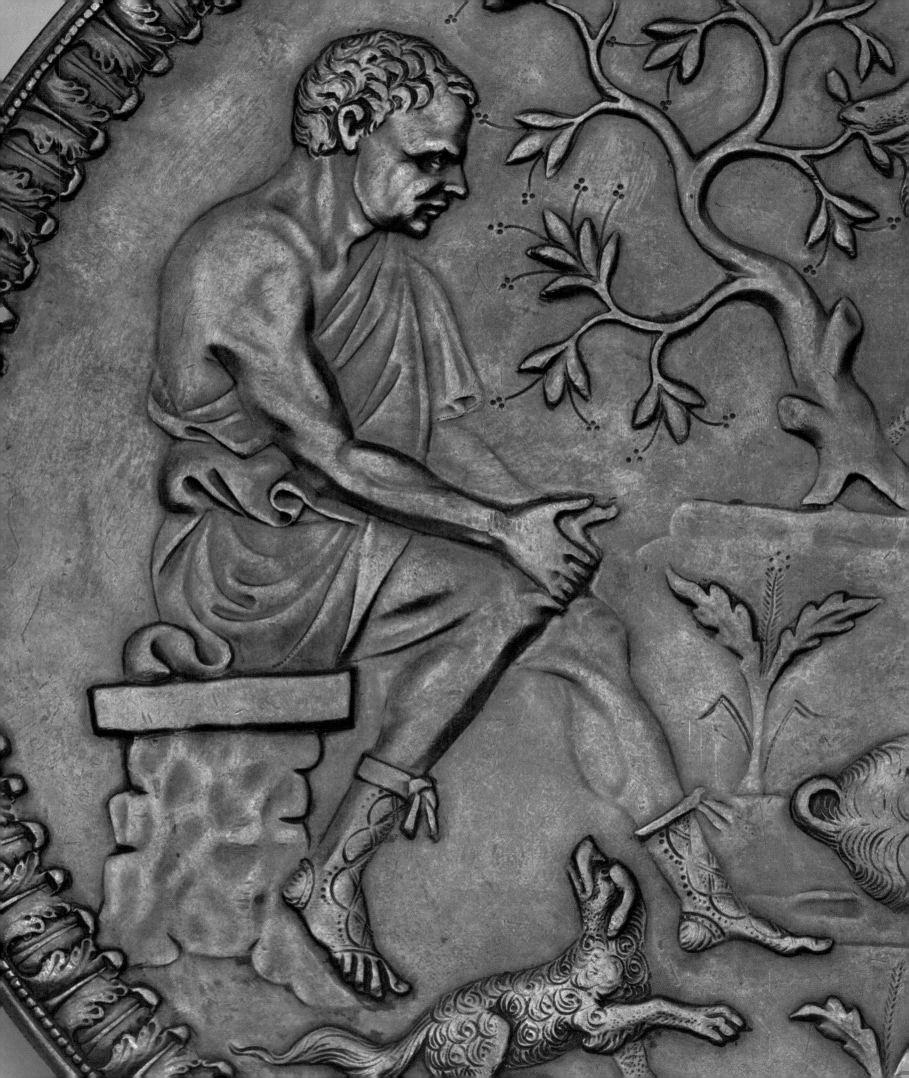

Robin Cormack

THE ROAD TO BYZANTIUM

Classicism, in the sense of an approach to art that centres on the naturalistic depiction of the human body, has been at the heart of European and Mediterranean cultures for 2,500 years. _The Road to Byzantium_ examines the birth of classical art in ancient Greece, its enduring influence in the ancient world and, finally, its survival in the Christian culture of the East Roman, or Byzantine, Empire. Constantine the Great inaugurated the empire's new capital at Constantinople in 330 AD, and it remained the residence of the emperor and his court until 1453.

But such an exhibition, with its careful selection of objects, immediately raises questions about the modern view of this classical heritage. Whose concept of classicism is this? Whose vision of antiquity? Whose road to Byzantium? Such questions are the consequence of changing conceptions of the classical world in Britain and elsewhere. The traditional 'canon' of classical literature is no longer the only determinant of what is being read today, and classical studies themselves are no longer a central part of the educational curriculum in the way they once were. These questions also reflect critical readings of Ernst Gombrich's highly influential chapter on classical art, 'Reflections on the Greek Revolution', in his 1960 book _Art and Illusion_. It is this discussion which has since guided (or taunted) many art historical conceptions of the nature of classicism and its supposed dissolution in the Middle Ages. Classicism has increasingly become a problematic concept. By bracketing in one exhibition objects which throw light on visual thinking over a broad span of time from the fifth century BC to the twelfth century AD, the challenge is to unravel some explanations for the persistence of classicism over this period, and the significance of the changes that occurred in the production of art in the Greek world as it experienced the religious shift from polytheism to monotheism. How did the Christian culture of Byzantium handle paganism?

For Gombrich the stimulus for the development of classicism in the period of Greek democracy – his 'Greek Revolution' – was the way in which artists approached the representation of narrative scenes through their dramatic evocation of mythical episodes.[1] The question that he was seeking to answer was how and why did Greek art develop so rapidly towards 'naturalism' during the sixth and fifth centuries BC.[2]

LEFT
Plate with a Herdsman (detail)
Constantinople, AD 530s (?)
cat. 84

1. Gombrich, 1960, p. 133.
2. Beard, 1985, p. 207.

Red-figure Amphora with Athena
Attica, Providence Painter, 470–465 BC
cat. 4

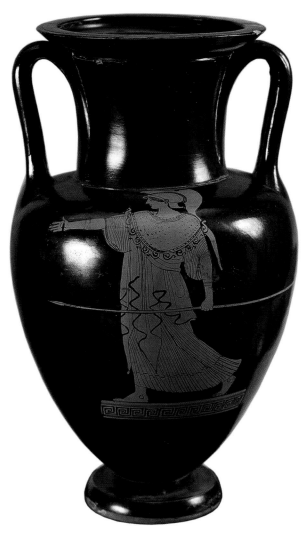

Intaglio with Isis and Horus
Alexandria, *c.* 50 BC
cat. 48

3. Gombrich, 1960, p. 144.
4. Gombrich, 1960, p. 145.

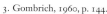

He saw this progressive development of Greek naturalism as the consequence of the artist's desire to represent the exact moment of the narrative story – unlike Egyptian art which offered only stereotypes as it sought to portray events timelessly. For Gombrich the Greco-Roman world demonstrated the powers of its new ways of thinking visually through its continued production of lifelike and illusionistic images. Only with the rise of Christianity and the absolute power of the late Roman Empire did illusionism cease to be the aim of art; instead it reverted to the hieratic and totemic form out of which it had been liberated. He hesitated to call Byzantine art a 'decline' ('it is hard to use such a word when one stands in San Vitale in Ravenna'),³ but he does see it as a reversion to pre-Greek conceptions, though 'Medieval art never eliminated the discoveries of Greek art'. In other words Gombrich's explanation for the development of classical naturalism is set out in terms of the functions of narrative imagery: classical mythology was seen as a free fiction, whereas the life of Christ needed an art form which conveyed it as a timeless re-enactment of Biblical events. Hence his pessimistic (and surely unacceptable) conclusion that Byzantine art 'led to a concentration on distinctive features and came to restrict the free play of the imagination in artist and viewer alike'.⁴

This exhibition offers its special perspective on this artistic process, and the opportunity to assess the persistence of classical forms and subjects, particularly from mythology, and how they contributed to the character of Byzantine art. It also raises questions about the tensions between religious and secular art (to use two loaded terms), and how the ideas

of Greek classicism fed into the imagination of later artists, patrons and viewers. And it focuses on the intimate forms of art that were produced for use on special occasions, for everyday life and in tombs. The recurrent subjects throughout the exhibition include representations of classical gods and goddesses and their progeny, particularly Dionysos, and a number of figures known from the epics of Homer and other popular texts. There are also representations of hippocamps ridden by nereids – these fish-tailed horses of the sea were the favourite form of transport of the ocean gods – and representations of the superhuman hero Herakles. All these images had a part to play in the development of the types and forms that are found in the Classical and Hellenistic periods, and they show varying levels of naturalism. The paradox is that these images cannot properly be described as 'life-like imitations' of these figures, but are the contribution of artists to the visualisation of an unseen world. They therefore have a religious function as well as a practical function. These practical functions are equally ambivalent. The gold *gorytos* cover with scenes of Achilles' life evokes ceremonial display rather than military action or an actual hunt (pp. 74, 106–7; cat. 9). It comes from the Scythian tomb of Chertomlyk, no doubt that of a chieftain in this society which both imported and copied Greek luxury arts. The vessel from the Solokha barrow shows Scythians hunting lions, the sport of kings (*below*, pp. 2, 108; cat. 10). Some of the Athenian ceramics may have been made for use in symposia, but their imagery transcends mere drinking vessels and their display during the festivities must have enhanced the dining experience. Yet their ultimate function may have been as exports and for use in distant burial tombs.

What is special about the holdings of the Hermitage Museum is that they are able to offer a different perspective from the collections of the UK, which include a high percentage of works from the western Mediterranean area. Although part of the Hermitage collection comprises pieces from private collections, purchases and donations, yet substantial materials come from archaeological excavation. These objects, which were found in the Crimea and further east, open up a broader range of questions. Who produced them? What were their functions? How did they reach places so far from the Mediterranean world?

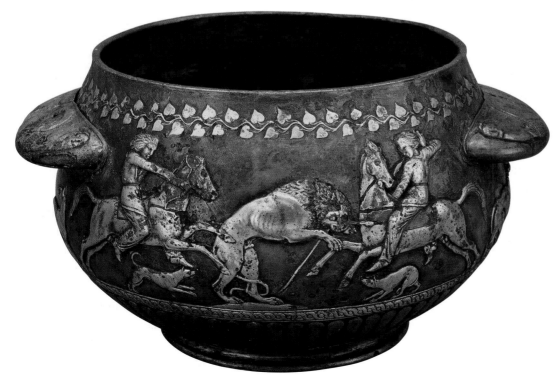

Vessel with Scythian Hunting Scenes
Northern Black Sea region, 400–375 BC
cat. 10

The objects discovered in the northern Black Sea area, for example, offer some precise information in answer to such questions. Significant finds come from the Kul-Oba Barrow near Kerch, which was explored in 1830; subsequently other excavations, such as the Bolshaya Bliznitsa mound in Taman, provided a good range of grave goods, including women's jewellery (*below*; cat. 20–25). Other burial mounds add quantity and quality to our picture of luxury in the region. One is reminded that the majority of Athenian ceramics in western collections come from the excavation of Etruscan tombs in Italy. These tombs from the Bosporan Kingdom provide comparative evidence from the other end of the Greek world. Some works are imported from Greece, some are made locally. They show the actual process of assimilation of classical ideas into the broader world of antiquity, both in terms of common styles and techniques, and also with the acceptance of common subjects and mythologies. This is evidence not simply of the movement of Greek colonies and merchants into the northern Black Sea region, but of the interaction of peoples at a cultural level. It is this kind of cultural exchange which is to be seen at later dates in the interaction of Sasanian and Sogdian cultures with the Mediterranean world.

What helped politically to broaden the spread of classicism after the fifth century BC were the conquests of Alexander the Great in the east and emulation of Greek cultural values among his successors in the Hellenistic period, and subsequently the incorporation of the Greek east into the Roman Empire. Both Augustus and Hadrian are notable Roman emperors, whose visual world and its stylistic vocabulary appear to represent a wholesale commitment to, and manipulation of, the forms of classicism. Not only did new versions of

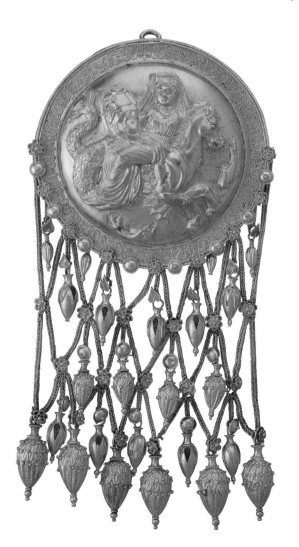

Disk Pendant with a Nereid on a Hippocamp
4th century BC
cat. 20

classical figures and compositions decorate the public places of the cities and ornament the houses of the empire, but the public images of these emperors and their courts evoked classical ideals – not least the many statues of Antinous, or look-a-like Antinous statues (p. 94; cat. 34). The use of the most expensive materials – gold, sardonyx and cornelian among others – documents the investment of money, time and artistic taste into classicism by the elite and artists of the Roman Empire. This steady continuation – or regular revivals – of classicism met their challenge in the fourth century AD with Constantine's declaration that it was no longer illegal to be Christian, and the subsequent acceptance of Christianity by Theodosius I as the true religion of the Roman Empire. Thereafter the people of Constantinople identified themselves as members of the empire into which Christ had chosen to be born, and as Romans. We call them (somewhat anachronistically) Byzantines, because they were citizens of a place which has a history going back to its foundation as Byzantium, a Greek colony on the Bosporus between the Black Sea and the Sea of Marmara in the seventh century BC (the mythical history is that it was founded by Byzas of Megara in 658 BC). It was only under Constantine's new foundation that the city was massively developed to be perhaps the largest urban centre of the Middle Ages.

One of the repercussions of the religious upheaval of Christianity was the status of pagan knowledge and culture, and its absorption into the Greco-Roman imagery that remained at the core of early Byzantine art. This absorption is made very obvious by the figures and designs of Coptic textiles from the tombs of Egypt which revel in pagan figures like Dionysos and a wealth of mythological allusions (*below*; cat. 66–80). But these textiles

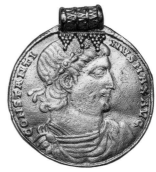

Medallion with Constantine I (the Great)
Roman Empire, Thessalonica, AD 324
cat. 59

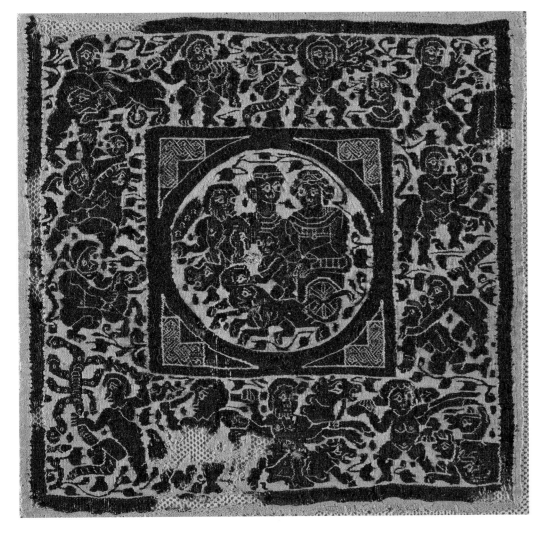

Textile with Dionysos and Ariadne and the Twelve Labours of Herakles
Egypt, 5th century AD
cat. 69

probably represent a secular use and not necessarily an elite patronage. The luxury objects in the exhibition pose the question directly of how the early Byzantine elite handled the past. Such patrons continued to receive a traditional education, reading Homer and other classical texts, as well as writing and reading a continuing Greek literature (and up to the sixth century AD using Latin as well). The situation is eloquently addressed by a number of famous minds of the period, and among the fourth-century AD Christian Church Fathers both Gregory of Nazianzus and Basil encouraged the judicious study of the classics of ancient literature. In the fifth century AD Nonnos of Panopolis in Egypt could count on an audience for both a long epic poem based on the mythology of Dionysos and a versification of the Gospel of St John. This world which accepted both pagan knowledge and Christian revelation is amply illustrated in the early Byzantine pieces in the exhibition, but they still pose many problems for the art-historical overview of the period.

Byzantine silverware provides some of the most striking examples of the survival of classical traditions into the Middle Ages, clearly dated in several cases by their control stamps. While the fourth-century AD Conceşti amphora might be argued to reflect still surviving pagan aristocratic tastes, the plates with a herdsman, with a silenus and maenad, and with Meleager and Atalanta, all from the predominantly Christian world of the sixth and seventh centuries AD, are clearly more complicated objects (cat. 84, 85, 87). To appreciate their references requires something more than a superficial familiarity with mythology, and in the case of the plate with Athena judging the quarrel of Ajax and Odysseus, knowledge beyond Homer alone is called for (p. 66; cat. 86). These are works of art fit for learned discussion and contemplation. Just as the set of silver plates with the life of David (now divided between Nicosia and New York) show a similar classical style and many overtones of meaning, these silver plates lead us into the complex world of Byzantine art before the outbreak of iconoclasm around 730, when figurative Christian art was banned from the churches of Constantinople. At the same time that these luxury works were being made by the silversmiths of Byzantium, artists were producing religious icons, some with highly naturalistic representations of Christ and the saints (best represented by the icon collection of the monastery of St Catherine at Sinai), others with far more stereotyped images, like the mosaics of the church of St Demetrios at Thessaloniki. In other words, we have good evidence of the range and variety of artistic expertise in Byzantium, and of the reception and development of classicism as one strand of Byzantine art.

But the materials from the Hermitage offer one extra dilemma. Just as it is difficult to say what the various functions were of Attic ceramics which turn up in distant places, so some of the silver plates of Byzantium also have ambivalent histories. One of the obvious cases of an afterlife of the objects created in the Byzantine world is the silver plate of the dispute between Ajax and Odysseus over Achilles' armour. This was purchased by Alexander Stroganov in 1780 from a family who had found it (with other silver objects, both Sasanian and Byzantine) in a sandy bank of the Kama river on his Perm estate, 800 miles east of Moscow. In the period from the sixth to the fourteenth century this region was the home of traders who sold furs to merchants in exchange for silver vessels and steel swords. The plates were then used for sacrificial meat and even as faces for their pagan idols.[5]

Was the plate made for export or did it have a long phase of appreciation in Constantinople? The production of classical- or Byzantine-inspired silver and bronze vessels in the Sasanian and Sogdian orbit – and even further east – shows that other societies were ready to accept Greek mythology and style as a sign of luxury in art. Equally important is the character of the grave goods from the Pereshchepina burial, found in 1912 in the sand dunes of the Vorskla river beside the Ukrainian village of Malaya Pereshchepina, near the town of Poltava. It consisted of a wooden coffin containing over 800 pieces, mostly of gold and silver.

5. Marshak, 2000, pp. 101–2.

The decipherment of a gold ring as the cruciform monogram of Kuvrat (or Kubrat) in a Byzantine format and the dating of the other materials (which come from a period of around 200 years) makes this burial most likely to be that of the Christian Khan Kuvrat of Great Bulgaria, who died in 651 (*right*; cat. 107–32). This chieftain of a large nomadic group was buried with his treasured possessions, including art in the classical tradition which shows his contacts with the Byzantine empire. The Hermitage material from this and other archaeological sites is important evidence of the continuation and spread of classicism across a wide geographical area.

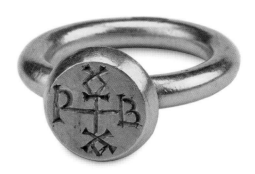

Ring with the Monogram of Kuvrat
Constantinople, early 7th century AD
cat. 108

A treatment of the materials in this exhibition chronologically must prompt the question of the significance of Byzantine iconoclasm between 730 and 843. Should one regard iconoclasm as a turning point and the ending of antiquity? Can the materials up to the eighth century AD be regarded as the continuation of classicism, followed by an insurmountable gap? The materials in this exhibition show that such a conclusion would be too great a simplification. It does not account for the extraordinary variety of Byzantine artistic production, both before and after iconoclasm. For Gombrich, as we have seen, the sixth-century AD mosaics of Byzantine Ravenna were an indication already of the rejection of classical values and aims. But the objection to this suggestion is that it does not sufficiently account for the special functions of these decorations. The sanctuary mosaics of San Vitale are designed to provide a monumental presentation of the sacred ceremonials and doctrines of the church in order to enhance the mystery of the solemn Eucharist. The traditions and devices of classicism are not in fact abandoned here, but are handled in new ways to create a sacred space for the celebration of the liturgy and worship of God by the Christian faithful, who are protected on earth by the Roman Empire headed by the emperor Justinian and his wife in Constantinople. Both are shown as symbolically present in the procession which begins the service as the congregation enters the church from the courtyard. It is a highly emotive and many-layered decoration. As monumental art it aims to serve a different function from the objects in the exhibition. They can give a more rounded view of the totality of the Byzantine experience. But many of these objects, like the works destroyed by the iconoclasts, disappeared from view in Constantinople – they were buried in tombs or as hoards or they were traded. This means that after iconoclasm, when the production of church art began again in substantial quantities, experimentation in new forms and new media (like glass enamelling) was a feature of Byzantium. But this did not mean that classical forms and subjects were abandoned. The inclusion in the exhibition of the ivory Veroli casket from the Victoria and Albert Museum is a pointer to the continuing attractions of classicism (pp. 65, 81; cat. 103). Its scenes are a highly sophisticated set of variations on classical themes in a classical style – the rounded forms of the figures are a daring and virtuoso example of undercutting the ivory. Whether or not the imagery is meant to illustrate the *Dionysiaca* of Nonnos of Panopolis or simply to tease the erudite viewer, in either case the appreciation of the casket depends on an appeal to a love of classical mythology. Such a familarity with pagan stories and their possibly subversive and satirical messages may have been a minority interest in tenth-century Byzantium. But then this was also the case, it seems, in the Italian Renaissance, where mythological art 'now existed within a wider culture whose assumptions were alien to it'.[6]

The conclusion that emerges for Byzantium is that, whereas over time a deep classical knowledge was increasingly accessible only to a small literate elite, yet the veneer of classicism was visible to all in many works of art.

6. Bull, 2005, p. 379.

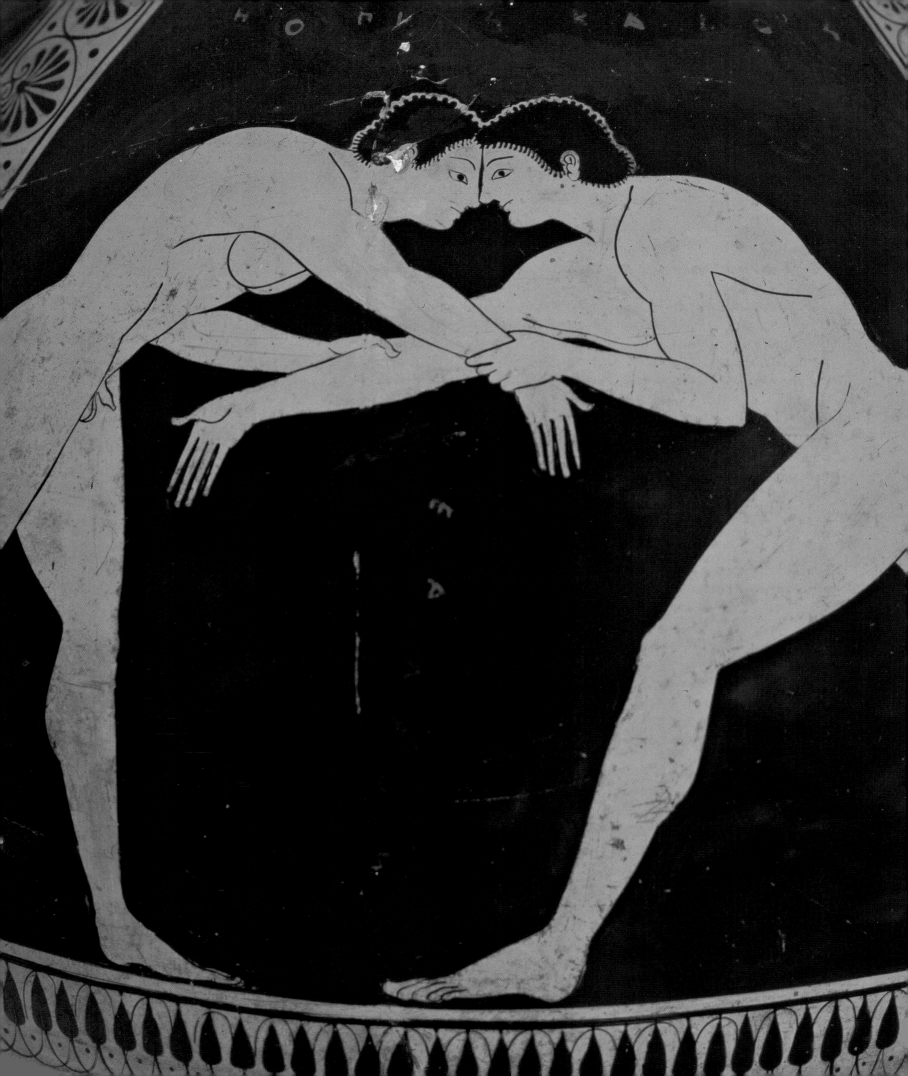

Anna Petrakova

THE BEAUTY OF THE HUMAN BODY IN ANCIENT GREEK VASE-PAINTING

The art of Greece is clearly linked to that of Byzantium: they share many of the same subjects and characters, especially those derived from mythology. But Byzantine art, while retaining the outward form of earlier artistic manifestations, reinterpreted these subjects within a Christian context. The art of these two cultures – pagan and Christian – also displays similarities in certain formal means of representation. Although sculpture in the round – the main medium of expression for the Greeks in the plastic arts – was not common in Byzantine Christian art, comparison of two-dimensional works of art (painting and drawing) of the two periods is highly instructive. The main similarity concerns the canons governing the representation of a person's external features: his or her body, clothes, movements and gestures as they correspond (or fail to correspond) to conceptions of the beautiful and the ugly, of what is admissible or inadmissible in representing the physical being.

A favourite theme in discussions of Greek art is its striving, from the Homeric period onwards, for 'realism', which can be said to have reached its culmination in the Classical period of the fifth and fourth centuries BC. Some scholars have described this tendency as evolution,[1] others as 'decline'.[2] The Greeks' aspiration to realistic representation, and their admiration for it, is revealed in epigrams and prose descriptions of works of art, which often refer to a statue (or picture) as being alive, indistinguishable from a real person or animal, capable of deceiving anyone. There were many epigrams about masterpieces by the sculptor Myron, in which, for example, 'he once searched for his "Heifer" among a living herd and could only recognise it by driving away the other heifers'. This was typical of how statues by famous sculptors of the Classical period, and especially of the late Classical period (now known through Roman copies), were characterised. (It is interesting to note that Byzantine *ekphraseis* often employ a similar motif, for example in the novels of the Palaiologan era: 'You could say of this sculpture that it is animated, alive'.)[3] However, when we turn from literary theory to the works of art themselves, it is only those of the Hellenistic period which seem to fit these textual descriptions. What, then, were the Greeks' ideas of the ideal and the real in sculpture of the High Classical period, if what we regard as idealised seemed to them the perfect incarnation of the Aristotelian idea of mimesis, or imitation?

LEFT
Red-figure Pelike with Wrestlers (detail)
Attica, Pioneer Group, *c.* 510 BC
cat. 1

1. *See* e.g. Vipper, 1972.
2. Gombrich, 1960.
3. *Livistro and Rodamna*.

The idea of the man-made image being true to life was perpetuated in the ancient world not just through descriptions of works of art, but also in mythological stories. These tell of people being transformed into stone statues (Niobe, the enemies of Perseus), or statues becoming living people (Pandora, Galatea). The notion of the Greeks being able to create images that can compete with nature's own creations has long been accepted (from the time of ancient Greece itself) as one of the traditional characteristics of ancient Greek art – to the extent that to this day many scholars still oppose the 'living' art of the Greeks of the fifth and fourth centuries BC to the conventional, strictly regulated art of other ancient peoples, particularly those of the Middle East. The art historian Ernst Gombrich repeatedly addresses the idea of the Greeks' journey from idealism to naturalism,[4] characterising it as 'a journey from which there was no return'.[5] This Greek realism, however, is by no means the same as modern European realism. Although the Greeks turned to portraiture and the representation of contemporary events in the Classical period, for a long time their methods of representing the human body in these works remained entirely dependent on the traditions of preceding ages. For all the abundant variety of scenes that appear in Attic vase-painting from the end of the sixth century BC onwards, showing people in realistically unattractive guises – during battles, drunken orgies and so on – the bodies of the characters demonstrating these indecorous forms of behaviour correspond perfectly to the Greek ideal of physical beauty.[6] But what, exactly, is this ideal?

Red-figure Krater with Poseidon and Amymone
Attica, Achilles Painter, *c.* 460 BC
cat. 6

4. Gombrich, 1960; Gombrich, 1995, etc.
5. Gombrich, 1995, p. 78.
6. Cohen, 2000.

'The Greeks had no doubt that the god Apollo was like a perfectly beautiful man.' This is how Kenneth Clark begins the second chapter of his famous book *The Nude: A Study of Ideal Art*.[7] But who is the most beautiful man supposed to be like? In works of ancient literature (from ancient Greek epic to the late epigrams) there are frequent, often highly specific, descriptions of the human body: 'You have Hera's eyes, O Melita, and Athena's hands, the legs of Thetis and the breasts of Aphrodite herself'.[8] Ancient authors often made this kind of direct comparison to the physical features of the Greek gods when describing the human form. A god is like a beautiful man, a beautiful man is like a god: the circle is closed. But when we turn to descriptions of the bodies of the gods themselves (in order to discover just what 'Athena's hands' are like), the information proves even less specific. Apart from the radiance that is spread around them, and their height, which exceeds that of mere mortals, the characteristics of the gods' bodies are extremely imprecise. The authors of antiquity tend to dwell on the gods' grace of movement and sonority of voice, as well as their moral disposition and positive inner qualities: in other words, characteristics that are hard to convey in painting or sculpture. Furthermore, they constantly emphasise that physical beauty is the outer manifestation of inner beauty, of spiritual qualities (again, a motif typical of Byzantine literature as well). A person beautiful on the inside cannot be ugly on the outside, and vice versa; physical beauty, therefore, is a sign of the beauty of the soul.

The eighteenth-century scholar J. J. Winckelmann devoted an entire chapter of his seminal work on classical art to the ways in which various parts of the body are depicted in Greek art; he described and explained their dimensions and proportions in the greatest detail, providing theoretical justifications for his opinions and examples from ancient sculpture. However, even he admitted that 'it is easier to establish what beauty is not than what it is'.[9] Ancient Greek literature cannot provide all the necessary information for a discussion of physical beauty in art, and so works of decorative art, in particular painted vases, become an important resource.

'Decorating clay vases seldom called for high art, though some of the artists so occupied were consummate draughtsmen', writes John Boardman.[10] Yet it is precisely this art-form that so vividly illustrates the Greek idea of 'beauty'. Such well-known scholars as Winckelmann, Gombrich, Panofsky and Clark have repeatedly discussed questions of physical beauty in Greek art, using famous works of Greek sculpture to exemplify their argument – works that no longer survive and which are mostly known only from Roman copies or from descriptions in ancient texts. But vase-painting allows us not only to study original masterpieces, but also a cross-section of mass-produced works of art, in which the canon of 'high' art was used as a sort of fixed template, with the result that the rank and file craftsmen did not have to concern themselves with its meaning and origin. It is also significant that red-figure vase-painting (which marks the beginning of the Classical period in Attic vase-painting) did not make the same strides towards the naturalism that is typical, for example, of late Greek sculpture. A variety of reasons can be found for this: the system of vase-painting workshops with traditions that were handed down from generation to generation; the nature of the work, requiring that the draughtsman's hand be trained to the level of automatism; the specific conventions of vase-painting with its limited selection of representational means (two basic colours, a two-dimensional surface, adherence to the given form of the vessel which the drawing must decorate). Sculpture, therefore, became the art-form in which the Greeks tried to express their artistic powers and their aspiration towards mimesis – after all, the three-dimensional nature of sculpture already offered a closer approximation to reality than the conventional art of vase-painting. And so while sculpture moved rapidly towards naturalism, the vase-painters continued to duplicate the traditional standards of physical beauty established by their predecessors.

7. Clark, 1956, p. 26.
8. *Greek Anthology*, v, 94.
9. Winckelmann, 2000, p. 108.
10. Boardman, 1996, p. 100.

The beautiful human body was one of the most important themes in ancient Greek art, and artists and theoreticians of the time attempted to develop concepts, as well as systems of numerical relationships, to express this ideal (their treatises, alas, are known only from indirect testimony). That this should have been so is hardly surprising: in the culture of the Mediterranean city-states physical beauty was accorded special attention. 'The women of Lesbos gather here // Vying as to who is most beautiful of all ...' was how a sixth-century BC poet described the ritual beauty contests that were part of the cult of Hera.[11] The numerous sporting competitions and beauty contests contributed to the development of this ideal of a healthy, young, physically developed body. Vitruvius's description of architecture as being beautiful according to its 'use' and 'strength', qualities from which 'beauty' flows, seems equally applicable to the Greeks' idea of the body beautiful. But, of course, by no means everyone actually possessed a beautiful body. A respectably married Athenian woman could hardly have had the same opportunities to work on her physique as an Athenian man or Spartan woman. And yet the goddess Hera (whose image was modelled on that of a respectable married woman) is shown in ancient Greek decorative art as having physical attributes that are almost as perfect as those of Athena. The Greeks can hardly have failed to notice the imperfections of their contemporaries' bodies: their ability to observe physical beauty, to pay attention to particular parts of the body and describe them, is amply demonstrated in ancient Greek literature, in particular by the epigrams. During the Hellenistic period this close observation of the human form found its expression in decorative art, and especially in sculpture, with a whole series of ugly old men and women, delightful plump children, boxers with broken bones that had knitted wrongly, and so forth.

However, the idea of imitating nature had existed in ancient Greek written sources long before it was realised in practice. 'Although ancient Greek thought did adhere to the concept of mimesis, it was no stranger to the thought that the artist should oppose nature ... as her independent rival, correcting her inevitable imperfections with his free creative power'.[12] In this respect a story told by Pliny about the painter Zeuxis is significant. When painting Helen the Beautiful, Zeuxis 'selected five girls in order to convey in his picture what was most beautiful in each'.[13] Here, then, is both 'realism', in the painstaking attention to the faithful representation of separate parts of the models' bodies, and 'idealism', in the act of combining them into a single image. 'It is not possible for the people Zeuxis depicted to exist in reality; but it is better to show them that way. Because the model must stand above reality. And as for what they call improbable it should be said ... that sometimes it is not so improbable. For "it is probable that the improbable also happens".'[14] The idea of 'correcting' natural imperfections is also typical of Byzantine theory and practice, in which the artist is described as 'a greater wonder-worker than nature herself, since first he nurtures his conception in his thoughts and only afterwards embodies it in art'.[15] And the Empress Maria (also called Martha) is described thus: 'Neither Apelles, nor Pheidias, nor any other sculptor ever created such statues. No one has ever seen such commensurate proportions of the limbs and parts of the body, such a correspondence of the whole to its parts and the parts to the whole in a person'.[16] Despite this apparent 'realism' and its assiduous promotion in verbal form, the depiction of the human body in Greek art was actually governed by the strict observance of a defined set of rules. This can be traced back to long before the classical age, continuing until the end of the Classical period (traditionally dated from the second quarter of the fifth century BC to the final third of the fourth century BC).

The characteristic features of the ideally beautiful individual (god or human) were evidently established in oral tradition, and subsequently described – almost unchanged – in the most ancient works of Greek epic, and then in Archaic lyric works and Classical dramas, and finally in the late epigrams and novels. These features include general characteristics,

11. Alkaios 41 (130).
12. Panofsky, 1960, p. 12.
13. Pliny, *Natural History* xxxv. 64.
14. Aristotle, *Poetics* xxv.
15. Eustathios Makrembolites, *Hysmine and Hysminias.*
16. Anna Komnene, *The Alexiad.*

Red-figure Amphora with a Running Girl (detail)
Attica, Providence Painter, 470–465 BC
cat. 4

such as exceptional height, radiance and fragrance; strength and power (for men); and gentleness and grace (for women). But certain aspects of physical appearance were particularly noticed by the Greeks (while other features they ignored entirely). Thus attention is focused on the hair, characterised by fair ('golden'), luxuriant and thick curls; the eyes, which are large and dewy ('owl-eyed', 'ox-eyed'); a clear ('silvery') complexion; the whiteness or radiance of the skin; strong, slim legs for women, or at least what was visible beneath their clothes ('slim-ankled', 'beautifully-ankled'); a long, strong neck; and aspects of the elbows and fingers ('pink-elbowed', 'pink-fingered'). It is these physical features which are accorded special attention in the images on Greek vases. In the description and depiction of men prominence is also given to powerful arms and broad shoulders and chest; in the depiction of *hetairai* (courtesans), to breasts and hips.[17] Other important aspects of this representation of beauty are fine clothing and a well-tended body (anointed and clean) – and, of course, youth, expressed through a well-developed and healthy physique that is beautiful in itself (only a very few late epigrams speak of the charms of old age,[18] or of love without physical beauty).[19] The gods are distinguished from mortals by their exceptional

17. Cf. *Greek Anthology*, v, 15; v, 36; v, 56.
18. *Greek Anthology*, v, 227; v, 258.
19. *Greek Anthology*, v, 227; v, 258.

height – a difference in scale that is sometimes found in Greek vase-painting, and also in certain works of Christian art. Furthermore, while it is impossible to express certain of the attributes mentioned above in vase paintings (radiance, fragrance and so forth), it is possible to convey other important components of the physical ideal through an established 'set' of viewpoints and poses, gestures and movements (which for the gods should be measured and smooth, as opposed to satyrs, for example, who are shown in complex foreshortenings, their movements frenzied and haphazard). Similar representational devices can also be seen in the art of Byzantium. Vase-painting provides far greater opportunity to study the interaction and movement of groups of figures than sculpture does, since the majority of sculptures that survive are free-standing statues. And thanks to the large number of surviving vases, the physical appearance of various categories of characters can be compared, and the beauty of the human figure seen not in isolation, but in context.

In an article devoted to classical Greece, A. Borbein provides an apt definition of this artistic phenomenon as a *Rezeptionsphänomen* ('phenomenon of perception').[20] This definition is appropriate both in terms of how classicism was understood by the numerous later 'classicisms', and also for understanding the ideas of beauty and artistic aims of the classical artists themselves. One of the ancient Greek 'phenomena of perception' is the ability to perceive many things in reality, while not wishing to perceive the same things in visual art (akin to G.E. Lessing's differentiation between the capacities of painting and poetry). Greek culture of the classical age continues to draw a distinction between what can be described and what can be represented – in drawing, sculpture, or even on the stage. In the famous tragedies of the fifth century BC the murder scenes were not played out in front of the audience, but described in words spoken by the chorus (in contrast with the Roman theatre, which showed everything openly on stage). Similarly, in Greek representations of human bodies, while epigrams describe a great variety of human forms (people with crooked legs, short in height and so forth), red-figure vases delineate only a single body-type of a standardised beauty in which the emphasis is placed on precisely those characteristics of the individual which were celebrated in 'high' literature. Even in the depiction of drunken brawls (*below*), the ideal body-type is still used. Departures from the norm can only

Red-figure Kylix with a Brawl
Attica, Panaitios Painter, *c.* 480 BC
Hermitage Museum, inv. no. Б.2110

20. Borbein, 2002, p. 9.

be expressed when parts of the body are positioned in exceptional ways (with complex and unusual foreshortenings) or when they are of non-standard size, for instance the immense sexual organs of the satyrs as opposed to the 'boyish' attributes of the numerous handsome men.[21] Appropriate scale is important in the representation of the body: the renowned Zeuxis 'is sometimes reproached for depicting heads and parts of the limbs of the body as too large'.[22] Distortions of the body type are permitted in vase paintings only when actors are shown performing, or various 'others' (Cohen's terminology) are depicted: members of other races, such as Scythians or Ethiopians, for example.

These rules continued to be observed in vase-painting, while in sculpture the High Classical period, which represented 'the world under control', was replaced by the Hellenistic age and 'the world of the individual'.[23] This difference in development between vase-painting and sculpture is one of the oppositions that lies at the heart of Wölflin's theories about the cyclical change in art-forms of similar periods, which have different artistic interests and norms. Thus the Classical period, with its emphasis on the typical and supra-individual and its reduction of all the imperfections of the real world to a common denominator, is opposed to the Hellenistic, with its interest in what is dissimilar, whimsical and non-standard. Even in the late love epigrams, which advocate broad tastes (blonde and brunette, tall and short, and so forth, are all equally good),[24] we still constantly encounter the assertion that extremes, either of the soul or the body, are not good and that it is better to settle for something between the extremes: the Aristotelian mean.[25] The ideal (and therefore best) is still the average, typical version securely established by history. The justification for this is beauty, defined in accordance with the teaching of Socrates as expounded by Plato, beauty understood as biological appropriateness: the greatest possible correspondence of one or another part of the body to its purpose and the functions that it fulfils. In the art of the Classical period this principle of appropriateness is expressed in the composition and in the gestures and poses of the figures (a fact that links it with the art of Egypt and the Near East, which also offers the clearest angles of view to show a person engaged in some specific action or occupation, rather than a chance, transient pose).

As Boardman has pointed out, the word 'Classical' can mean various things.[26] Sometimes it refers to the period from the end of Archaic art (*c.* 480 BC) to the end of the fourth century BC. Sometimes it refers more specifically to the period of the Parthenon in the second half of the fifth century BC. However, the idea of beauty and the appropriateness of the typical is already present in Greek vase-painting in the Archaic age, and even earlier – in geometrical vases.

This was encouraged by the very nature of the process by which Greek vases were produced – as a form of mass art which reproduced specific compositions and iconographic models in great numbers, but which was made by hand. The trained hand of a draughtsman created a certain physical type, which was then reproduced in multiple versions by the master craftsman and his pupils (making it possible for us to divide the master craftsmen into groups) and all, naturally, according to the set standards for reproducing the body of that time. In addition, each character of Greek mythology possessed his or her own set of attributes including specific objects, dress, hairstyle and so on, as well as his or her own body type and facial features, while the genre characters possessed attributes appropriate to their social status (for instance, a *hetaira* was shown naked, while a 'respectable' woman was shown clothed). It was their correspondence to the canon that determined these characters' degree of beauty. Apart from 'biological appropriateness', beauty was the sign of both exceptional spiritual qualities and high social status: 'Our lady was a beauty, but beside Callirhoe she could have been taken for a servant', says one of the women in a novel of the first to second century BC, describing the life of the fifth century BC.[27]

21. Kon, 1998, p. 127.
22. Pliny, *Natural History* XXXV. 64.
23. Pollitt, 1972.
24. *Greek Anthology*, XII, 5.
25. Cf. *Greek Anthology*, V, 37.
26. Boardman, 2000, p. 7.
27. Chariton, *The Loves of Chaereas and Callirhoe*, Book 2.

Ernst Gombrich attributed Greek art's conversion to realism and naturalism over the course of the sixth and fifth centuries BC to its aspiration to narrative content, which developed in parallel with the aspiration to narrative content in Greek literature.[28] However, this narrative content, particularly in the case of vase-painting, consists in details indicating the time and place of the action and special compositional techniques, in place of the timeless and placeless character of earlier compositions.[29] The bodies of the characters continued to be shown in an idealised way for a long time. Greek vase-painting is characterised to a greater degree and for far longer than sculpture by the aspiration to represent, not a concrete individual with individual peculiarities, but a 'sign' of a certain social/gender/mythological type possessing a specific set of characteristics. In this sense the signs in the decoration of red-figure vases are scarcely different from the signs of geometrical vases – the difference consists in the image's degree of significance in the context of the overall decoration of the vase. In the geometrical style the signs are subordinate to covering the vase's surface with ornament; they occupy a small area, and are arranged to follow each other at set intervals, which lends them the quality of ornament constructed according to specific rhythmical laws. A figure taken out of context, whether human or animal, appears crude, almost grotesque, since the craftsman has schematised it to an extreme extent.[30] In the Archaic era the emphasis gradually shifts from the system of interrelations between ornamental elements to the separate image, which nonetheless still remains a sign. In geometrical vase paintings only the most essential features of the characters are singled out: the men have large, strong legs, broad shoulders and a torso in the form of a triangle with its apex pointing downwards; the female characters are represented by a triangle with its apex pointing upwards, and they have narrow shoulders, wide hips and skirts. The black-figure vase-painting of Attica continued these traditions, although it paid greater attention to conveying details in the images of individual figures, which acquire a sense of volume and a greater variety of poses than the geometricised figures of early Greek vase-painting.

The appearance of red-figure vase-painting in about 530 BC is usually hailed by scholars as the long-awaited invention of a technique that allowed the craftsman to achieve greater freedom in the depiction of reality, at a time when the more conventionally restricted black-figure technique had exhausted itself. However, this depiction of reality is only apparent, as is well illustrated by the famous Hermitage psykter with an image of *hetairai* at play. It shows four different women, each with her name actually written beside her. But when we compare the images we cannot see the difference between them. In the same way that geishas are depicted in Japanese prints, the beauty of the *hetairai* is not rendered by showing the individual characteristics inherent to each of them, but through the closest possible approximation of personal features to an ideal conceptual pattern (in which the idea of bodily beauty as a whole is combined with the idea of what is proper or not proper for the representation of a character of a particular sex and social status). This is no longer simply an abstract token with a minimal likeness: it is the subtle reduction of nature to an ideal concept of what she ought to be like. It is a Greek version of that exalted realism in which the admiration of nature is so great and the attitude to her is so respectful that the wish arises to correct any unfortunate accident in her. A difference in age does not have any effect on body type: on the pelike with a swallow (cat. 1) the three ages of man – boy, youth and adult – are shown within a single pictorial space. All three characters have identical faces and bodies, and the difference in age is represented by size (as in Egyptian art), while the eldest, in addition, has a beard. Such vases were made by early exponents of the red-figure technique, and the same traditions were maintained during the Classical period.

Similar phenomena can be seen in the decoration of the stamnos with a procession of girls by the early classical Villa Giulia Painter (*left*), and the decoration of the stamnos

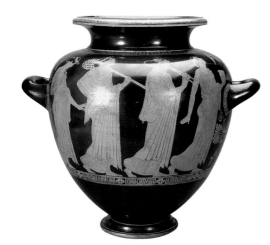

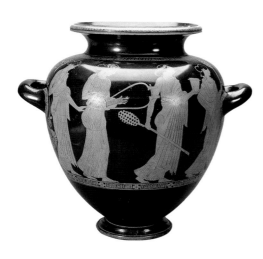

Red-figure Stamnos with a Procession of Girls
Attica, Villa Giulia Painter, *c.* 460 BC
Hermitage Museum, inv. no. Б 2110

28. Gombrich, 1960.
29. Webster, 1939; Arnheim, 1982;
 Stansbury-O'Donnell, 1999.
30. Swindler, 1929.

with a procession of youths and men by the Kleophon Painter – a brilliant representative of the art of the High Classical period (*below right*). These images repeat a single body type with only insignificant changes: the girls are identical to each other and the boys and men are also identical (a beard is the only specific attribute of those who are older; the difference in age is not expressed in the drawing of either the face or the body). In the decoration of the inner surface and two sides of a drinking-cup by the Painter of the Hermitage Komos, the same type of body and face are repeated in the images of youths and girls (the gender difference is only expressed through elements of clothing and hairstyle and through the indication of sexual characteristics). A fine example of the classical approach to depicting the corporeal canon is the painting showing a warrior's farewell on another stamnos by the Kleophon Painter. The faces and bodies of the warrior, the woman and the old man are strikingly similar: their arms and legs are identical in size, fullness and form, and the faces are also very much alike. The difference, apart from sexual characteristics, lies in the types of clothing and the hairstyles. This applies particularly to the image of the old man, since the only indications of the age of his young-looking body are a stick and grey hair. In early red-figure vases the interaction between characters is expressed in poses and gestures, while in later vases (as in the case of the stamnos with the warrior's farewell), facial expressions also appear, but they do not disrupt the ideal body type. As happens in Christian art, Greek vase-painting provides the viewer with an initial stimulus in the form of a symbol or sign, while the viewer, knowing the content of what is represented in advance (whether it is a myth or an ordinary, everyday scene), 'recalls' this content when he looks at the image, and in this way becomes a co-creator with the artist, reading more into the work than can be seen by the eye.

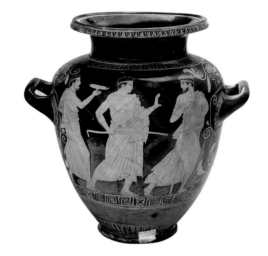

The close study of the model and the attempt to reproduce his or her body in all its detail, as was the case with the depiction of the old men and women of Hellenistic art, had a similar effect on the viewer as that produced on Jonathan Swift's Lilliputians when contemplating the face of Gulliver: they recoiled in horror from a face magnified so many times over. But when Gulliver looked at himself in the mirror he saw something quite normal, a more generalised image akin to those created by the Greeks of the Classical period or the artists of the numerous 'classicisms' who took their lead from the Greeks, removing all that was transient, such as the effects on the body of ageing or the privations of life. Over-zealous attempts to convey a person's external appearance 'truthfully' lead to a naturalism which can turn even the most beautiful model or subject into an ugly image. Perhaps this is one of the reasons that caused the Romans of the ages of Augustus and Hadrian and also, later, the creators of early Christian art, and after them the artists of Europe, to turn back again and again to the ideals of the classical age.

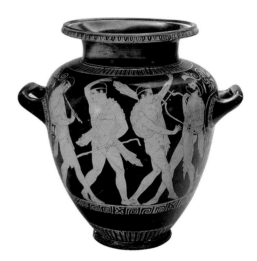

Red-figure Stamnos with a Komos
Attica, Kleophon Painter, 440–435 BC
cat. 7

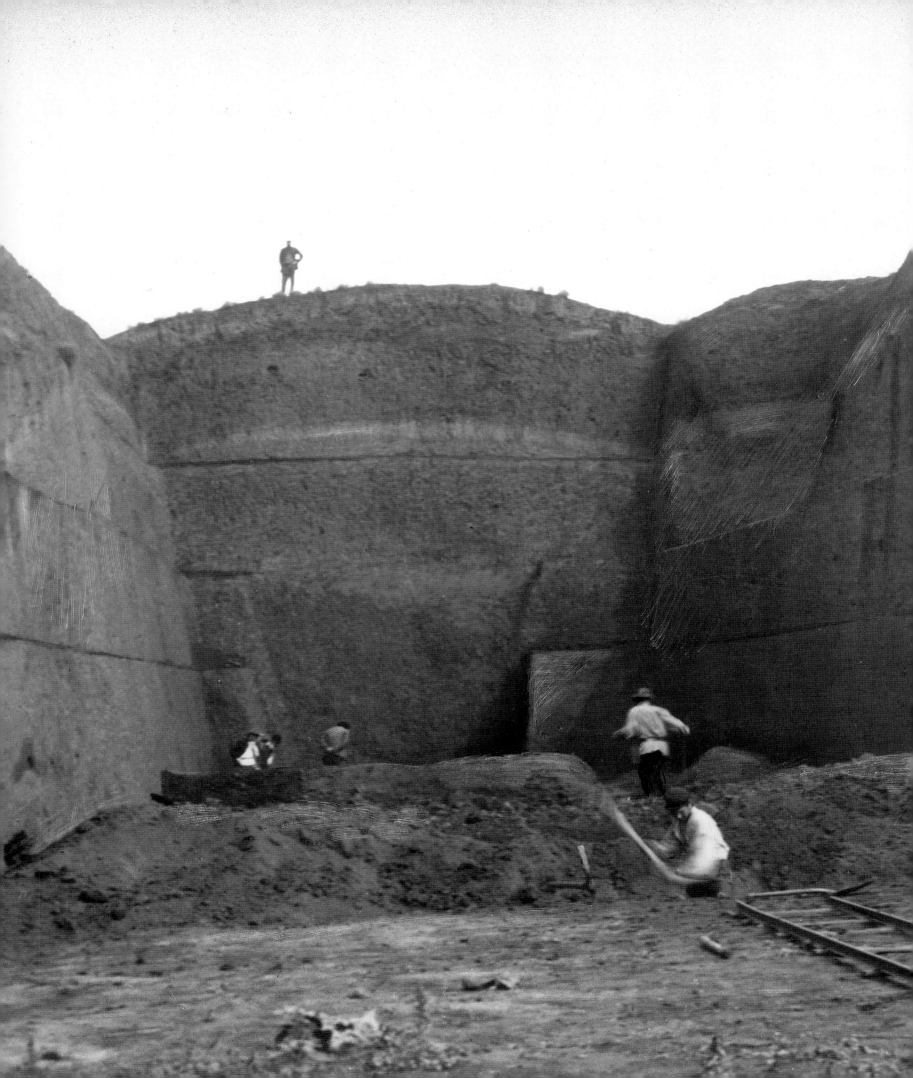

Andrei Alekseyev

GRECO-SCYTHIAN ANTIQUITIES: A HISTORY OF EXCAVATION IN SOUTHERN RUSSIA

Among the most exceptional exhibits in the Hermitage are the works of art in gold and silver that were made for the Scythian inhabitants of the northern Black Sea region, and which were excavated from aristocratic burial mounds. These works were often the product of Greek craftsmen, and they help to illustrate the classical tradition in the luxury arts. The discovery and study of such artefacts also testifies to the development of Russian archaeology since the eighteenth century.

The first known historical work on the Scythians in Russian is the book *Scythian History* by Andrei Lyzlov (according to various sources, Lyzlov was either a steward from Moscow or a priest from Smolensk). Written in 1692 but first published only in 1776, this work was also the first attempt to provide a systematic account of the known sources relating to this most ancient period of Russia's history. During the reign of Peter the Great in the early eighteenth century, there was intense interest in the early history of the Slavs in general and the Russian people in particular, and aspects of Scythian history were examined at the tsar's request by the German philosopher, mathematician and linguist Gottfried Wilhelm Leibniz. This growing interest in Scythian history was put on a more formal footing after the founding of the Academy of Sciences in St Petersburg in 1725. It was here that Theophilus Siegfried Bayer carried out his research into ancient history, writing several works devoted to Scythia and the Scythian peoples, while Gerhard Friedrich Miller, a well-known specialist on Siberia, took a lively interest in ethnographical relics and archaeological monuments, including those from the south of Russia. Vasily Tatishchev included chapters on the Scythians and Sarmatians in his celebrated *History of Russia from the Most Ancient Times* (1768), while Mikhail Lomonosov and Vasily Tredyakovsky also devoted considerable attention to the period. It should be noted, however, that the paucity of sources at the time allowed great scope to the imagination, resulting in scholarly hypotheses that were not particularly well-grounded, and sometimes simply naïve. At various times, for instance, scholars have referred to the Scythians and Sarmatians as the ancestors of the Slavs, the Finns or the Turks.

LEFT
Excavations at the Solokha Barrow, northern Black Sea region, 1912

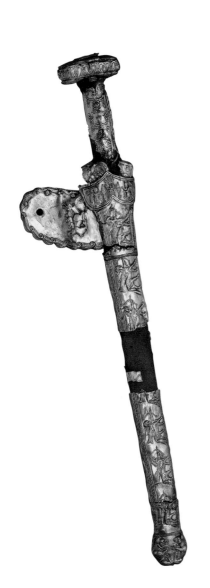

Sword from the Melgunov Barrow
7th century BC
Hermitage Museum, inv. no. Дн 1763.1/19

In the early eighteenth century the state authorities in Russia also began to show an interest in archaeological antiquities. Peter the Great wrote the first memoranda and decrees prescribing that various antiquities, especially those 'that are very old and exceptional' or which bore inscriptions, for instance, should be sought out and recorded. It is significant that Peter was interested not only in the objects themselves, but also in the conditions under which they were discovered, and he therefore ordered that 'everyone must make drawings of how things were found'. At this time, when comprehensive scientific study of the eastern territories of the Russian Empire was just beginning, it was antiquities from Siberia, and above all gold artefacts depicting animals and people of the Scythian period, which aroused the greatest interest. This booty, plundered from ancient burial mounds by robbers known in Siberia as *bugrovshchiki* ('mound-men'), was conveyed to the capital and delivered to Peter the Great in person. Following the emperor's death, his personal collection was transferred to the Kunstkamera, or Cabinet of Curiosities, which he had founded in Petersburg in 1714, to become the first museum collection in Russia. In the mid-nineteenth century this collection was transferred to the Hermitage, where it became known as the Siberian Collection of Peter I.

During the second half of the eighteenth century, in the reign of Catherine the Great, Russia expanded to include the extensive territories of the northern Black Sea steppe, the Lower Dniepr region, the Crimea and the Trans-Kuban region. These conquests, which were of such political and economic importance to Russia, also laid the foundation for archaeology as a discipline. At first the state's attitude to the newly acquired southern territories was defined primarily in geo-political terms: according to the so-called 'Greek project', Russia was supposed to inherit the mantle of the Byzantine Empire, drive the Turks out of Europe, and create a 'Constantinopolitan Empire' on the annexed territory. And the throne of this empire was destined for Catherine's youngest grandson, Constantine Pavlovich, who was groomed for the role from childhood (*right*).

A lingering echo of this fantastic political project, which was never realised, can still be heard in the names of such Black Sea coastal cities as Sebastopol, Simferopol, Melitopol, Theodosia, Eupatoria, Odessa and others. In 1787 the empress herself made a trip to the *Novorossiisky krai* ('New-Russian Territory') and the Crimea, and it was at this time that the scientific description and study of Russia's new regions, including archaeological investigations, truly began. The journeys made to the southern territories by such men as Vasily Zuev, Pyotr Simon Pallas, Gmelin-Mladshy and Pavel Sumarokov focused attention on the ancient burial mounds of the steppe, and in particular on Scythian sites such as the magnificent Chertomlyk Barrow on the right bank of the Lower Dniepr, and other ancient settlements. These inquisitive and well-educated travellers correctly identified the ancient Greek cities of Olbia on the Lower Bug, and Pantikapaion on the site of modern Kerch, amongst others.

However, the first excavations of Scythian remains in the south of Russia had been carried out even earlier, in 1763, by the governor of the New-Russian Territory, General Alexei Melgunov. He ordered the excavation of the so-called Litoi ('Cast'), or Melgunov, Barrow, which proved to be the tomb of a Scythian 'king' from the seventh century BC; the finds from this barrow, now in the Hermitage, clearly testified to the Scythians' contacts with the ancient states of the east (*left*).

The excavations of the Melgunov Barrow marked the beginning of Scythian archaeology, and it is significant that around the same time, in 1763–4, Andrei Nartov made the first translation into Russian (from German rather than from the Greek) of Herodotus's *History*.

At the very end of the eighteenth century the General of Engineers Van der Weide excavated the first burial mound in the vicinity of the Bosporan city of Phanagoria on the Taman peninsula; a few years later, around the beginning of the nineteenth century, General Pyotr Sukhtelen carried out the first excavations in Olbia on the Lower Bug; and in 1811 General Semyon Gangeblov began to excavate in Kerch. This period, known as the 'archaeology of the generals', effectively marked the beginning of systematic exploration of the territory of the ancient Kingdom of the Bosporus.

Simultaneously with the excavations in the south of Russia the first local museums were established, located close to the sites of ancient settlements: a museum of antiquities was opened in the town of Nikolaev, 35 kilometres from Olbia, in 1805; in Theodosia, on the site of an ancient settlement, in 1811; in Odessa in 1825; and in Kerch in 1826. Other specific measures were taken to preserve ancient remains from being destroyed and plundered. For instance, in 1804 Academician G.K. Keller, librarian of the Hermitage and chief curator of its collection of gems and medals, was sent south on an official mission, and the following year a government decree was issued, based on the findings of his report.

At the beginning of the nineteenth century, almost at the same time as the 'archaeo-logy of the generals', a new group of researchers in the field emerged. They were educated amateurs from the middle strata of society: lowly civil servants, officers, state officials and merchants. These enthusiasts included Paul Dubrux, a French émigré and head of the customs service in Kerch, who created his own private museum, and Ivan Stempkovsky, the governor of Kerch and Yenikal; both men were involved in excavations carried out in 1830 at one of the most famous Scythian tombs from the fourth century BC – the 'royal' barrow at Kul-Oba. The finds from this outstanding site were immediately transferred to the Hermitage, where they became the pride of its collection of antiquities. The tomb was found to have been undisturbed by grave-robbers – an extremely rare occurrence in the archaeology of the northern Black Sea region – and its discovery was like coming upon an entire museum of Greco-Scythian toreutics.

The way in which this ancient site at Kul-Oba was excavated provides an insight into how archaeological research was conducted at that time. The excavators began by removing the stony surface of the tumulus. Dubrux, who suspected that the tumulus was an artificial mound, soon noticed the corner of a structure beneath made of dressed stone. Within three days they had cleared the entrance to a tomb, constructed of immense, care-fully dressed blocks of stone and covering an area of about 20 square metres. Three people had been buried in the tomb. Lying on a wooden bed was a 'king' wearing a massive gold *grivna* (pendant) round his neck, with gold bracelets and decorative gold plates sewn onto his clothing. Alongside him lay a sword in a scabbard decorated with a gold cover, a *gorytos* (quiver cover), a whetstone in a gold cover, and a beautiful gold phiale. Next to this burial was that of a woman who had been buried in luxurious attire, with gold ornaments sewn onto her clothes, a gold diadem, *grivna*, necklace, and beautiful temporal pendants with medallions bearing images of the head of Athena Parthenos (based on the head of Pheidias's famous statue made for the Parthenon between 450 and 440 BC). Lying at the feet of this 'queen' was the famous gold vessel, now in the Hermitage, decorated with four scenes showing heroes from the mythological story of the origins of the Scythians (according to the interpretation proposed by D.S. Raevsky). The same vault also revealed the burial of a groom, with the bones of a horse, weapons, numerous ceremonial silver vessels, bronze cauldrons and clay amphorae.

When the investigation of the tomb had been completed, it was entered by robbers who discovered a secret chamber – in fact another, earlier, burial under the stone flags. Here they found one of the most famous items from the burial mound – a gold plaque in the form

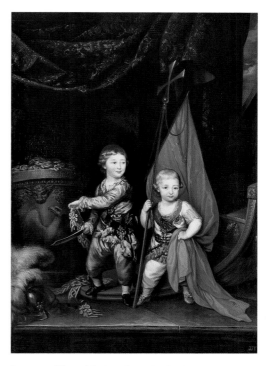

Portrait of Grand Dukes Alexander Pavlovich and Constantine Pavlovich
Richard Brompton, 1781
Hermitage Museum

of a recumbent deer, which was subsequently returned by one of the robbers for a reward. Tsar Nicholas I, who was familiar with the treasures of Kul-Oba, was extremely pleased with these discoveries, but while ordering further investigation of 'tomb antiquities similar to those from Kul-Oba', he was also obliged to reaffirm the prohibition on excavation work without specific authorisation.

However, it was only some thirty years later, in 1859, that the Imperial Archaeological Commission was established under the Ministry of the Imperial Court to carry out and oversee all archaeological investigations throughout the country. All archaeological finds were now supposed to be handed over to the Archaeological Commission, which, from 1889, was also given the exclusive right to grant permission for excavations. The Commission had close organisational links with the Hermitage, and passed the most interesting and important finds on to the museum. The remaining antiquities were distributed to other museums that were also under the Commission's supervision.

With the establishment of the Archaeological Commission, investigations of burial mounds in the steppe began on a large scale. However, the first 'royal' Scythian burial mound from the fourth century BC had been investigated a few years before, in the early 1850s, close to Yelisavetgrad (now Dnepropetrovsk) in the Lower Dniepr region. This was the Alexandropol Barrow (or Meadow Tomb), which reached a height of 20 metres (*below*).

It is worth noting that this was not only the first, but also the only, large burial mound to be effectively fully excavated in the nineteenth century. However, the ultimate fate of the collection from this burial mound was a sad one. In 1932 the Hermitage handed it over in its entirety to Kharkov in Ukraine, and during the evacuation of Kharkov's museums in 1941 the special train carrying their collections was destroyed by German bombs. Only a small number of finds from the Alexandropol Barrow survive, in the Hermitage and in Kharkov.

For some time following the establishment of the Imperial Archaeological Commission, a leading role in the development of Scythian archaeology was played by the well-known Russian historian Ivan Yegorovich Zabelin, who excavated several Scythian burial mounds in the Trans-Dniepr region between 1859 and 1863, including the famous Chertomlyk Barrow, and the Bolshaya Bliznitsa burial mound on the Taman peninsula. He also conducted excavations at Olbia. Zabelin's main academic interest was the history of

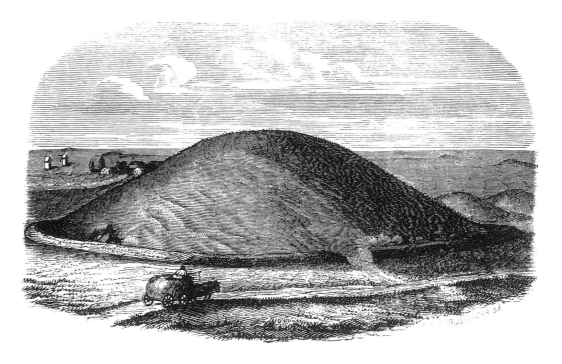

Alexandropol Barrow
Engraving, 1850s

Russia and Moscow, but he applied the precision and thoroughness of the historian to the work of archaeological excavation, and therefore the results of his investigations produced some extremely interesting discoveries. The huge dimensions of the Chertomlyk Barrow (approximately 20 metres high and 115–120 metres across) and the presence of a mighty stone *krepida* (wall) around the foundations of the tumulus, coupled with a lack of financial resources, prevented Zabelin from excavating the burial mound in its entirety, and he was only able to investigate the central section. Under the surface of the mound he discovered a complex underground sepulchre, with four chambers leading off like petals from the base of an entrance shaft approximately 11 metres deep. One of the chambers had been used for the interment of a noblewoman and her female servant; it also contained a set of silver vessels for religious use – an amphora and a dish with a ladle – and Greek clay amphorae. In another chamber two warriors in rich costumes had been buried with their weapons. The other two chambers had been used as store-rooms, filled with ceremonial costumes and headdresses, Greek clay amphorae, a bronze cauldron and bows and arrows. Unfortunately, the main burial chamber, where a 'king' had been interred and which adjoined the chamber of the 'queen' on the west, had been almost completely ransacked in an ancient robbery. However, the robbers had failed to discover several small niches in the walls, and these yielded many remarkable discoveries, including the gold cover for a *gorytos* (pp. 74, 106–7; cat. 9), swords, including a unique Achaemenid specimen, scabbards with gold covers and gold plaques for sewing on to clothing. Next to the central burial were three burials laid out for funeral horses in gold and silver regalia, and two burials of grooms.

Further, more recent, investigations of the burial mound were carried out over a period of several years (in 1979, 1981 and 1983–6). This work, conducted jointly by Ukrainian and German archaeologists under Boris Mozolevsky, Vyacheslav Murzin and Renate Rolle, identified the distinctive structural, engineering and architectural features of the tumulus and its several burial chambers. Additional burials were also discovered, including the large northern side burial, which had also, unfortunately, been robbed in ancient times. From information gleaned from various objects (stamps on the Greek amphorae, a Greek black slip vessel, the style of certain artefacts, including the plaques for sewing on to clothes), it is possible to surmise that the main burial chamber of the Chertomlyk Barrow dates to around 340–320 BC, and the northern, or entrance, burial to the very end of the fourth century BC. One possible hypothesis is that Chertomlyk was the burial site of one of the unnamed Scythian kings referred to in ancient sources, in particular in Arrian,[1] which would allow the date of the main burial site to be narrowed down to around 329 or 328 BC.

Investigations were not confined to the steppe of the northern Black Sea region. In 1864 Zabelin and A.E. Lyutsenko, director of the Kerch Museum, initiated excavation work at the Bolshaya Bliznitsa Barrow on the Taman Peninsula – in the Asian part of the Bosporan Kingdom. This site from the second half of the fourth century BC is of exceptional interest because, according to L. Stephani's interpretation, its tumulus concealed several stone tombs belonging to members of a single family. These include three women who may have been priestesses of the local deity, the Great Goddess, whose cult had merged with the Eleusinian Mysteries and become close to various aspects of the cults of such Greek goddesses as Demeter, Persephone, Artemis, Athena and Aphrodite.

Later, in 1875–6 and again in 1878, Baron Tiesenhausen, a member of the Archaeological Commission, excavated the Seven Brothers Barrows on the Taman Peninsula, dating from the fifth and early fourth centuries BC, the largest of which was 15 metres in height. The tombs beneath the tumuli contained members of the Sindian nobility, perhaps even members of the royal family. In any case, modern scholars believe it possible that one of the latest burial mounds (no. 3, dating to the first quarter of the fourth

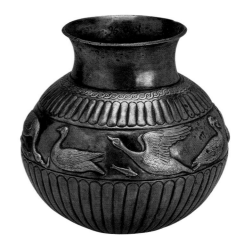

Vessel with Ducks and Fish
Bosporan Kingdom, 4th century BC
From Kul-Oba Barrow
cat. 29

1. Arrian. *Anabasis Alexandri*. IV. 15

century BC) belonged to the famous Sindian king Hekataios. Numerous gold ornaments, weapons and ceramic vessels of both Greek and local origin were discovered in these tombs, as well as bronze Etruscan and Greek works of art, gold and silver vessels, including a beautiful Achaemenid rhyton, various kinds of fabric, and bronze details from horses' bridles, decorated in the Scythian animal style. The finds from the Seven Brothers Barrows show that the local population had extensive contacts with the Scythian world, not purely in terms of material culture but also in the sphere of political and even dynastic relations.

At around the same time, Lyutsenko, N.P. Kondakov and S. Verebryusov excavated the so-called Nymphaion Barrows, which formed part of the necropolis of the Greek city of Nymphaion. They were constructed before the city was annexed by the Bosporan kingdom in the late fifth century BC, and contained the burial chambers of members of the nobility of a separate Scythian tribe who had apparently established a protectorate over the city state at that time. The material from these burial chambers, while preserving certain barbarian features, reveals a strong Hellenic influence in this particular group of Scythians. And the similarity between many of the artefacts from the Nymphaion and Seven Brothers burial mounds accords well with Herodotus's testimony that in winter the Scythians crossed the ice of the Cimmerian Bosporus (the Strait of Kerch) to the land of the Sinds.[2]

The best known and most successful archaeologist researching the northern Black Sea burial mounds in the late nineteenth and early twentieth centuries was Nikolai Veselovsky, a professor at St Petersburg University (*right*). He was responsible for excavating such world-famous sites as the fourth-millennium BC Maikop Barrow in the Northern Caucasus, sites in the Trans-Kuban region (excavations of 1897), the Scythian barrows at Ul (1908–10), the Kelermes Barrows (1904 and 1908) and many others. And it was Veselovsky who excavated two of the greatest royal Scythian barrows of the late fifth and early fourth centuries BC in the northern Black Sea steppe. In 1891–4 Veselovsky made a partial exploration of the Oguz Barrow, and in 1912–13 of the Solokha Barrow (p. 30), where outstanding works of Greco-Scythian art were discovered in the tombs: the famous gold comb surmounted by a miniature statuary group engaged in a battle scene (*left*); a gold phiale with images in the Scythian animal style; a silver cover for a *gorytos* with a scene from a Scythian epic or myth; and a silver vessel with Scythian hunting scenes (pp. 15, 108; cat. 10). Despite his considerable archaeological experience, the manner in which Veselovsky carried out his investigations and documented the historical sites he had excavated was by no means always satisfactory. To gain an overall picture it is necessary to compare information from various researchers (in particular, A.A. Bobrinsky, A.A. Spitsyn, B.V. Farmakovsky and S.A. Polovtsova) who visited Solokha during the excavations or made use of documents which have now been lost.

Beneath the tumulus, which rose to a height of 18 metres and extended for about 110 metres, two burials were discovered: a central burial site and a secondary one to the side. The central burial had been robbed in ancient times, but nonetheless in two of its chambers (one intended for human burials, the other a storeroom), several funerary artefacts had survived: a silver kylix with the inscription ΛΥΚΟ, gold plaques from ceremonial garments, a gold needle, Greek amphorae, bronze arrowheads, and so forth. Another burial in which two horses had been buried in regalia with gold ornaments had survived entirely intact. Judging from all this information, it would seem that a man and a woman were buried in the tomb.

The entrance burial to the side proved to have been untouched by the robbers; it contained the burial of a 'king' accompanied by three other men, and a burial with five horses. The main burial had taken place in a separate niche of the underground tomb. The remains of the 'king' were accompanied by an extremely lavish set of funerary accessories.

Gold Comb with a Scythian Battle Scene
Late 5th–early 4th century BC
Hermitage Museum, inv. no. Дн 1913.1/1

2. Herodotus. IV. 28

There were gold plaques sewn on to his clothing, a gold *grivna* around his neck, a decorative gold *setka* (latticed pendant) on his chest and five gold bracelets on his arms. Lying to the left of the buried man were two swords, one of which had a hilt decorated with gold and a gold scabbard, and a silver *gorytos* with arrows, on top of which was a gold phiale. To the right of the buried man was the magnificent gold comb mentioned above, a *shestoper* (mace), a Greek bronze helmet of the Corinthian type (reworked by a Scythian craftsman, as was often done with ancient helmets in a barbarian cultural environment), numerous silver vessels of different forms (some bearing images), a Greek clay kylix, and bronze *knemides* (greaves). Some Greek clay amphorae, a rhyton and cast bronze cauldrons had been placed further away.

On the basis of various data (the dates of the Greek kylix, amphorae and elements of horse regalia, as well as modern radioactive carbon dating), it appears that the primary burial in the Solokha Barrow was constructed in the late fifth century BC, and the entrance burial in the early fourth century BC.

The outbreak of the First World War in 1914 did not bring a complete halt to archaeological exploration in the northern Black Sea region. The final report of the Archaeological Commission was only published in Petrograd in 1918, in other words after the Russian Revolution, and it contained information about excavations in the period 1912–15. The final echo of the large-scale excavations in the south of Russia was perhaps Veselovsky's exploration in 1917 of one of the Yelizavetinsky Barrows in the Kuban region, the results of which attracted the attention of scholars owing to the grandeur of the burial structures and the sumptuous richness of the funerary accessories. After that there was a long pause in the archaeological investigation of ancient burial mounds in southern Russia; it was only renewed, on an even larger scale, some thirty to forty years later under the Soviet government.

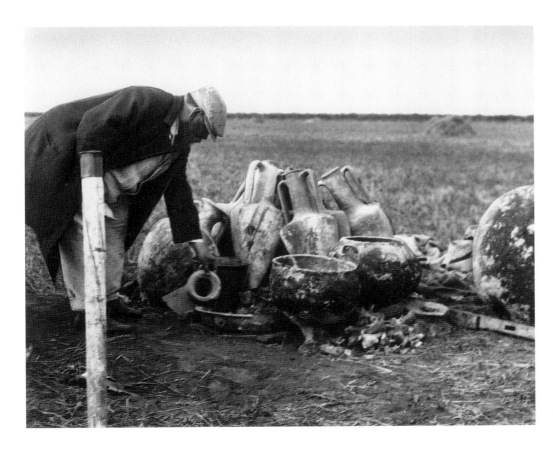

Nikolai Veselovsky with Finds from the Solokha Barrow
1913

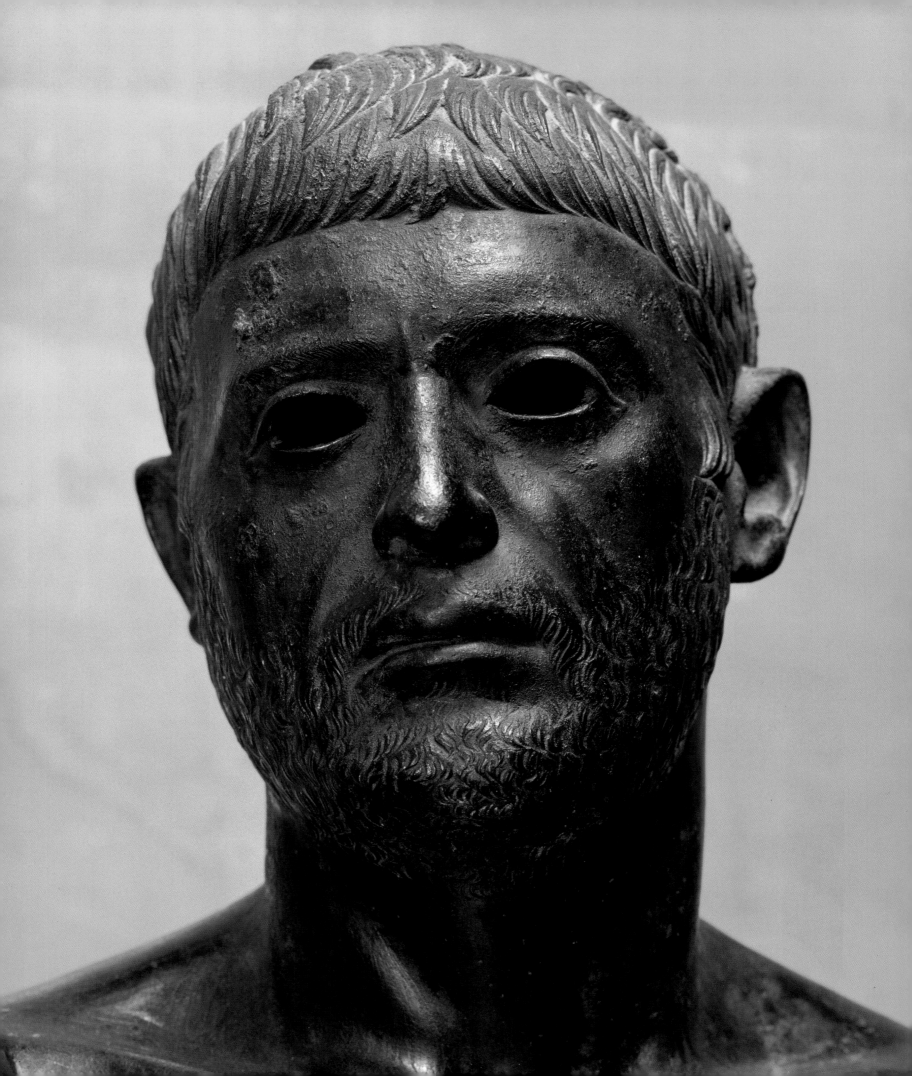

Anna Trofimova

CLASSICISM IN THE ROMAN PORTRAIT: THE AGES OF AUGUSTUS AND HADRIAN

The two major epochs of classical portrait sculpture in the art of ancient Rome were the reigns of Augustus (27 BC – AD 14) and Hadrian (AD 117–138). Classicism was, of course, fundamental to various periods of ancient art – for example the Hellenistic period, the late Republic, and the reign of Gallienus – but it was only under Augustus and Hadrian that the imitation of classical Greece became universal, embracing all forms of art and the majority of its schools and genres. The classicizing style was appropriated by the imperial court and used as an instrument of state, dictating the basic forms of artistic styles throughout the Roman Empire; it was rooted in the world-view and ideology of these periods.

A similar phenomenon is seen in the art of Byzantium which, at various stages of its history, drew on the classical tradition – for two principal reasons. First, tradition and stereotype were powerful forces in Byzantine culture and so a significant part of the heritage of classical antiquity was preserved. Secondly, Byzantium accepted in its entirety the political and state doctrine of Rome, which centred on the personal cult of the emperor and the philosophical and political conception of the unlimited power of the monarch. It was this imperial cult that provided the impetus for the development of court culture in the capital, and for the convergence of secular and church ideologies. It was formalised in terms of officially accepted artistic expression, employing a clear and simple artistic language.

This paradigm has continued into the modern era, with classical revivals often accompanying a reinforcement of centralised personal power: witness the absolute monarchies of the eighteenth century, the empires of the nineteenth, and the totalitarian regimes of the twentieth. However, while employing the same classical 'template', each period has introduced its own historical content and contemporary ideas. The degree to which these can differ is demonstrated by one of the most 'classicized' cities in the world, St. Petersburg, with its neo-classical architecture from the period of Catherine the Great and Alexander I, the neo-classicism of the Russian revolution, and the Stalinist neo-empire style.

Despite differences in historical circumstances, classical art of whatever period undoubtedly shares certain fundamental features – not just the antique robes and images from ancient mythology, but general principles that stem directly from the art of classical antiquity: clarity, harmony, consistency, strict formal rules and the aspiration to an ideal. Does this mean that statues of the Roman emperor Octavian Augustus and monuments to Soviet leaders are classical images of equal value? Surely not, since Roman classicism belongs entirely to the ancient world, whereas examples of more recent revivals of

LEFT
Portrait of a Roman
Rome, 50–40 BC
cat. 31

classicism are essentially based on abstractions, images that are entirely conventional and metaphysical, representing a pure projection of civic ideas. This modern form of classicism, the product of a bureaucratic state, gradually turns into an instrument of suppression, a means of inculcating socio-political ideas into the minds of the masses.

Roman art certainly differs from this kind of classicism, but it should not be confused with its inspiration – the art of ancient Greece. The glory of classical art lies in the fact that 'it does not simply interpret life, but is itself a part of life'.[1] To the Greek, who made no distinction between 'nature' and 'harmony', the beauty of the human body (i.e. form) *was* the fundamental content of sculpture. To the Roman, form was not important in itself: it served to define a different – spiritual – content; for instance, ideal beauty expressed the nobility and valour of the ruler.

There is much to be gained by comparing specific works of portrait sculpture – the leading genre of Roman art – and analysing the distinctive features of these early Roman manifestations of classicism; we begin to understand the ways in which they are alike and how they differ, and also how Greek forms are transformed in order to express Roman ideas. The Hermitage collection of Roman portrait sculptures, one of the finest in existence, presents the opportunity to look at many of the most important figures represented in court art – the rulers of the Roman Empire, as well as their heirs and members of their families.

A return to Periclean Athens had been discussed even before the time of Augustus; during the reign of Gaius Julius Caesar (100–44 BC) the rhetorical forms of classical Greece came to be regarded as ethical norms. The influence of Greek sculpture can be traced in portrait sculpture of the late Republic, in which scholars have identified a classicizing tendency.[2] Among the first to be depicted in this manner was Cicero (106–43 BC), the great Roman orator, lawyer and politician. Cicero's portraits, like his writings, are usually associated with the concept of 'classical Latinism'.[3] His works are devoted entirely to the Republic – not so much to specific historical situations as to the image of an ideal Roman state. In his treatises, letters and speeches, Cicero extols the Roman nation's historical values, founded on conservatism and tradition. And in Cicero's opinion, the defence of the 'Roman idea' was no longer conceivable without Greek culture: 'I have always to my own benefit combined what is Greek with what is Latin'.[4]

Other Roman aristocrats of the old school gradually began to accommodate themselves to Hellenic ideals – men such as Marcus Porcius Cato, an uncompromising republican and one of the most stubborn and zealous proponents of 'the customs of our ancestors', who took up the study of the Greek language and culture when already an old man. A surviving bronze bust of Cato in this classicizing style is close in manner to the bronze portrait sculpture of a Roman in the Hermitage collection (p. 38; cat. 31).[5] The latter's most striking quality is a sense of stoicism, expressed in a powerful emotional impulse: the Roman's face is dramatically expressive, a combination of patient endurance and sorrow. The bust's powerful sculptural rendition of forms, typical of the work of Hellenistic sculptors, is combined with the expressive force and precision of detail characteristic of works by Roman artists. Scholars link this style to a particular genre of portraits depicting outstanding individuals, brilliant politicians and military leaders.

From the end of the second century BC the influence of Greek culture was increasingly felt within the highest social strata of Roman society. The Greek language became fashionable, along with Greek scholarship, rhetoric, philosophy and, in particular, Greek art. Following the conquest of Greece, a large number of works of art were brought to Rome, as were their creators – and these Greek artists and sculptors began to play a significant role in the artistic life of Rome from the end of the second century BC. They created numerous works of art for Roman patrons: portraits, statues for religious cults, historical

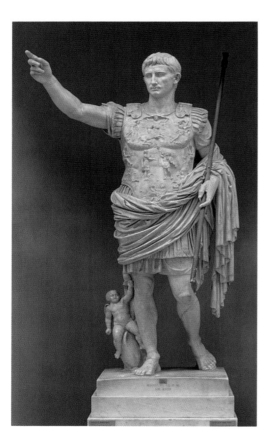

Statue of Augustus from Prima Porta
Rome, 19–17 BC
Vatican Museums and Galleries, Vatican City

1. Kaschnitz von Weinberg, 1961, p. 19.
2. Schweitzer, 1948, pp. 1120–7.
3. Schindler, 1985; Kaiser Augustus, 1988, p. 303, no. 139.
4. Cicero, *On Obligations*, 1, 4, 7.
5. Simon, 1986, p. 59, no. 65.

reliefs and marble copies of Greek originals. This copying of Greek originals was performed on an almost industrial scale, and copies of famous Greek statues began to fill Roman villas and gardens, enriching the leisure hours of rich Romans. Copies of works from the fifth and fourth centuries BC were, of course, particularly prized.

With the beginning of the age of Augustus (27 BC – AD 14) classical ideals acquired universal value for the first time, as Greek idealism became assimilated into the state's world-view. In portrait sculpture, the artistic style of Athenian democracy was the model for representing the supreme personality cult of the emperor. In official portraits that paraphrase works by the Greek sculptor Polykleitos (c. 450 BC), Augustus is presented as *primus inter pares*. The statue of the emperor from Prima Porta (*left*), for example, is a programmatic work of Augustan classicism, expressing in allegorical form the essence of Augustus's political doctrine of a new era that will bring peace to the Romans. Works of art and literature from the early period of his reign are permeated by this idea of the onset of a 'Golden Age' of Augustus, a mood of renewal and hope.

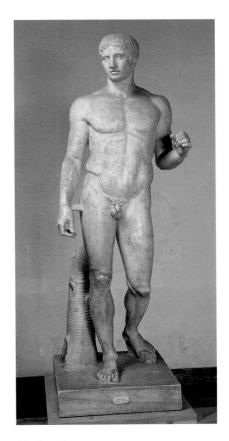

The Doryphoros
Copy after an original by Polykleitos
Pompeii, *c.* 440 BC
Museo Archeologico Nazionale, Naples

> Now once again begins the majestic order,
> Virgo rising to greet us again, and Saturn's kingdom.
> Again from the tall heavens a new tribe is sent,
> Look favourably on the newborn with whom, replacing
> The iron generation, the golden generation shall inhabit the earth…
>
> He shall be granted the life of the gods, shall see the heroes and the gods
> Together, and they shall see him numbered among them.
> The world shall submit to him, quieted by the valour of his eyes.
> (Virgil, *Eclogue IV*, 5, 15)

The statue of Augustus from Prima Porta is reminiscent of Polykleitos's most famous work – the *Doryphoros*, or Spear-Bearer (*right*), which possibly represented Achilles. The emperor is holding a spear – an attribute of Achilles and a symbol of dominion in Rome from the very earliest times. The statue's composition and iconography are based on works by Greek sculptors; like the statues of Polykleitos, Augustus is shown with his weight on his right leg, his left placed casually behind him. His arm, however, which is extended in front of him in the gesture of a general facing his army, disrupts the self-enclosed rhythm of a typical classical composition. Rather than the calm of an athletic body at rest, this is a gesture of dignified command, embodying the idea of Augustus's future mission to the state of Rome.[6]

Historical literature, poetry and official art of the time frequently evoke the sense of harmony and order of classical Greece. 'Know, artist, that simplicity and unity are needed in all things!' writes Horace, poet of the 'golden mean'.[7] The harmony and order expressed in Polykleitan forms are the sculptural embodiment of these concepts. Cicero referred to this type of cultural and spiritual continuum when he wrote: 'A considerable part of nature's strength and her reason is displayed in the fact that only one living being (man) understands what order is, what decorum is, and what is due measure in word and deed. Therefore no other being feels the charm and harmony of those things that are perceived by the viewer. In extending this visual perception to the speculative realm, natural reason requires that care be taken for the preservation of beauty and consistency.'[8]

6. Kaschnitz von Weinberg, 1961, pp. 14–15; Zanker, 1977, p. 43; Kaiser Augustus, 1988, pp. 298, 386, no. 215; Simon, 1986, pp. 53–7.
7. Horace, *Ars Poetica*, 250.
8. Cicero, *On Obligations*, 1, 4, 14.

The general principles of classical art can be traced in the Hermitage portraits of Augustus (*below*). In representing the ruler of Rome, the sculptor has borrowed certain formal techniques from the art of early Greek classicism: an ideal geometric use of proportion and a generalised treatment of forms. Like Polykleitos's subjects, Augustus never ages: he is always shown young and beautiful. But even so, he is quite easily distinguishable from those idealised figures. In addition to recognisable family traits of hairstyle and face, the sculptor endows him with the qualities expected of his position: majesty (*maiestas*), authority (*auctoritas*), dignity (*gravitas*) and mercy (*clementia*). These qualities were also evident in the portrait of the *princeps* on coins, which became a form of imperial propaganda.

In a statue of Augustus from Cumae, now in the Hermitage, the emperor is shown in the deified form of Jupiter seated on his throne. The statue's composition is based on Pheidias's famous sculpture of Zeus at Olympia, from the High Classical period (*c.* 430s BC). In his right hand Augustus holds a sphere with a figure of the goddess Nike, in his left a staff of regal authority. The Hermitage work can be dated to a period after the death of Augustus, when the custom of deification was legitimised and became quite customary.

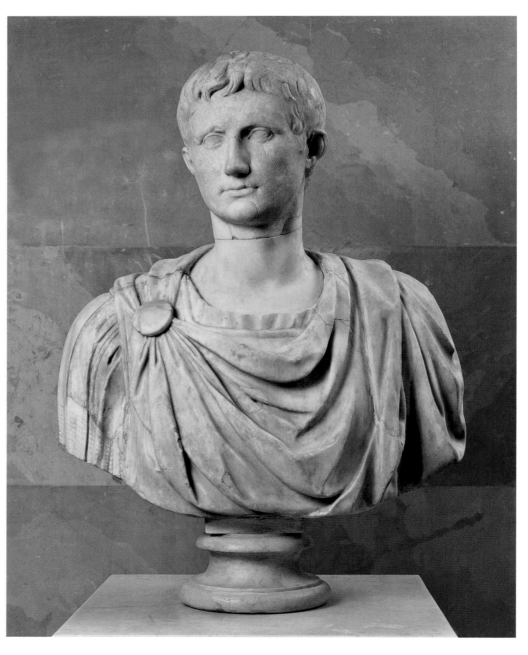

Portrait of Augustus
Rome, first half of 1st century AD
Hermitage Museum, inv. no. A.284

Statues of this type were often erected in provincial cities, symbolising the unshakeable stability of the regime, the majesty and might of Rome. In contrast with earlier portraits of Augustus, the statue from Cumae was influenced not only by fifth-century BC works but also those from the fourth century BC. It combines abstract, simplified modelling redolent of the Classical period with the theatrical solemnity of Hellenistic art. This statue of Augustus from Cumae is interesting because it was reconstructed in the eighteenth century by the talented Italian sculptor Gnaccherini (1804–75). The only genuinely ancient parts are the head and several fragments; the composition is based on images of a well-known statue of Augustus preserved on coins. Gnaccherini succeeded in creating a convincingly integrated image – in effect an elegant classicizing remix.

Portraits depicting members of the ruling family play an important part in the classicism of the age of Augustus. The main purpose of these images is to reinforce the dynastic cult, to affirm the legitimacy of hereditary power. For this reason the sculptors maintained an abstract and solemn style, while accentuating certain distinctive external family features. In one portrait of Livia (*below*; cat. 32), the emperor's wife is shown as the high priestess of

Portrait of Livia, Wife of Augustus
Rome, second quarter of 1st century AD
cat. 32

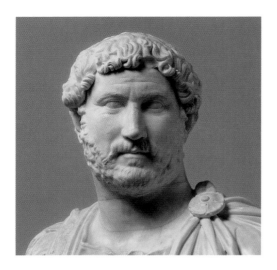

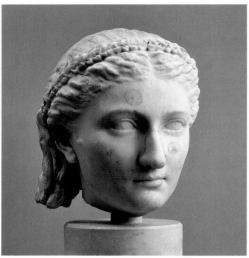

TOP
Portrait of Hadrian
Rome, second quarter of 2nd century AD
Museo Archeologico Nazionale, Naples

ABOVE
Portrait of Sabina, Wife of Hadrian
Rome, first half of 2nd century AD
Hermitage Museum, inv. no. A.400a

9. Historia Augusta, *The Life of Hadrian*, XVIII, 8.
10. Kahler, 1950, pp. 143–59; Clairmont, 1966, p. 34;
Evers, 1994.
11. Dio 69. 11.
12. Historia Augusta, *The Life of Hadrian*, XIV, 7.

Ceres and of Divus Augustus – that is, a priestess of the cult of her deified husband. This sculptural image of Livia derives from ideal statues of the Greek goddesses. In comparison with Augustus her face is rendered far more like a portrait, with emphasis on the qualities of imperiousness and haughtiness.

Within Augustan art a significant position was occupied by children's portraits, which represented the heirs and successors to power. The children of Augustus's family are always easily recognisable from their distinctive features – the feline cut of their eyes and their stylised hairstyles. A superb portrait from the Hermitage depicts Augustus's favourite grandson Gaius Caesar, the son of his daughter Julia and the general Agrippa. The sculptors who created these portraits are clearly following the images of children created by Praxiteles in the fourth century BC, but unlike the Greek master they depict their subjects with a greater degree of sentimentality, emphasising in particular the plumpness of the child's cheeks and lips and the softness of the infant's hair.

The features of classicism seen in portrait sculpture during the reign of Augustus continued under his successors, rulers of the Julio-Claudian dynasty, which ended with Nero's suicide in AD 68; subsequently, under the Flavian dynasty (AD 69–96), they gradually disappeared. The clarity, purity and unostentatious dignity of the sculptural images of Augustus are replaced by an unnatural bravura style and surfeit of sculptural mass. The influence of Greek sculpture is reduced even further under Trajan (AD 98–117), when art and ideology turn to the ideals of the old republic for inspiration.

The second wave of classicism starts during the rule of the emperor Hadrian (AD 117–138). The widespread enthusiasm for Greek culture at this time is usually linked with the personality of the ruler himself. He was called 'Graeculus' because from a young age he was immersed in the study of the Greek language, philosophy and art. The emperor travelled a great deal and spent ten of the 21 years of his reign abroad. 'He was passionately fond of travelling: he wished to see with his own eyes everything that he had read concerning various places in the entire range of lands.'[9] Hadrian is known to have been elected *archon* (chief magistrate) of Athens and was initiated into the Eleusinian Mysteries. The ruler's fondness for Greek culture is clearly expressed in his official portraits. Hadrian is shown bearded (*above left*), and his image is reminiscent of Pericles (*c.* 500–429 BC), the embodiment of the ideal of democratic Athens. This significant change in the ruler's image is also expressed in the preference for civilian clothing over armour. The prototypes of these portraits were statues of Greek intellectuals of the fifth and fourth centuries BC.

From traditional textual sources we know that Hadrian was a worldly, highly educated and artistically gifted individual with a certain inclination to mysticism. The emperor distinguished himself as an architect, and at his famous villa in Tivoli he collected together numerous famous Greek statues and built copies of Greek and Egyptian architectural monuments. But the most important of the sculptural images at the villa were those of Antinous, a Bithynian youth who was Hadrian's favourite.[10]

The Hermitage collection contains three portraits of Antinous that were reportedly found in the villa at Tivoli (*right*, p. 94; cat. 34). The authors of antiquity tell us that Hadrian and the beautiful Greek youth were inseparable, and Antinous accompanied the ruler everywhere. Tradition has it that during a trip to Egypt Antinous committed suicide by throwing himself into the Nile. In the opinion of his contemporaries, this sacrifice forestalled the prophesied death of the emperor.[11] The inconsolable Hadrian began worshipping Antinous as a deity, founded a cult in his honour and erected statues and temples to him throughout the Roman Empire. 'At Hadrian's behest, the Greeks deified Antinous and asserted that prophecies were transmitted through him.'[12]

The emperor's passion for Antinous was an expression of the period's ardent enthusiasm for Greek culture, as well as Hadrian's aspiration to Greece's unattainable ideal of beauty. Antinous is usually depicted in the form of an ideally beautiful, naked youth with the attribute of one of the deities. The external appearance of the subject is idealised to an extent that makes it hard to call these statues and busts portraits: a classical 'Greek' profile, straight brows, a rounded face framed with thick, curly hair. The image of the youth, like the sculptural forms, is directly borrowed from the High Classical art of Greece in the fifth century BC, but there are certain new features that appear in the artistic image of Antinous, features introduced by the age of Hadrian: a mood of melancholy and languorous sadness, a passive submission to fate. These portraits are devoid of the radiant harmony and strength that are intrinsic to works of Classical Greek sculpture. The best of Antinous's 'portraits' possess a dreamy, sentimental sensuality, and a faint shadow of doom; gradually, however, as the statues are repeatedly reproduced, these qualities are transformed into an artistic cliché.

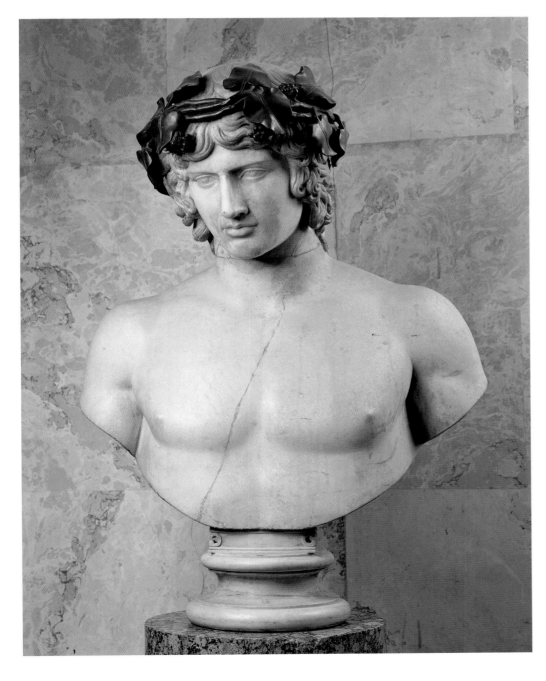

Portrait of Antinous
Rome, *c.* mid-2nd century AD
Hermitage Museum, inv. no. A.431

The pessimistic and doleful moods that permeate the art of this period are expressed in a poem supposedly written by Hadrian himself shortly before his death:

My soul, you wanderer,
My body's guest and companion,
Now you depart to your rest,
To a bare, gloomy region,
Having forgot your former jollity.
(Historia Augusta, *The Life of Hadrian*, xiv, 7)

The image of Antinous and other subjects from Hadrian's time are much further removed from the classical sources than the harmonious works of Augustan classicism. The heavy, overbearing forms of Hadrianic sculpture lack the structural clarity of the Augustan statues. The inherent emotional tension of these works is achieved by means of techniques that are not characteristic of classical art: an open composition with sharp contrasts of form, proportions and textures.

A comparison of portraits of the two rulers, Augustus and Hadrian, shows a difference in the understanding of the image of the emperor, the formation of which depended to such a great extent on the classicizing style. The portraits of Augustus are impersonal: they employ parallels with the art of Greek classicism to embody the abstract concepts that made up his programme of government and political plans. The image of Augustus corresponds to the hopes and aspirations of civil society, with the person of the ruler completely concealed behind the institution of power.

The portraits of Hadrian, in contrast, do not represent collective (i.e. social) ideals, but the figure of an ideal ruler who is the bearer of Roman virtues and higher Greek culture. This combination of opposites (the depiction of an individual's personal qualities and the universal principles of rule) gradually reduces the genre of the portrait to absurdity. Hadrian is shown in so many guises that sometimes his appearance is changed beyond recognition, especially in portraits produced in the eastern provinces, which differ sharply from those that come from the capital.

A sculptural portrait from Jerusalem which shows a stern, gloomy old man (*right*; cat. 33) provides evidence of a further move away from the Augustan image of the emperor. This work was made under the influence of traditions that were still current at the time in portraits from Syria and Palmyra. It shows an eastern image of a formidable, implacable ruler. The composition is dominated by frontality and symmetry, the style of execution by a gloomy solemnity. This portrait demonstrates the convergence of classical models with the vision of the East, which was to dominate during the period of late antiquity and was embraced by the art of Byzantium.

RIGHT
Portrait of a Man Wearing a Laurel Wreath
Western Syria, mid-3rd century AD (?)
cat. 33

Vera Zalesskaya

THE CLASSICAL HERITAGE IN BYZANTINE ART

Byzantium was inundated with images of pagan gods and heroes. The subjects drawn from ancient mythology were numerous; so too were the routes by which they arrived. With the victory of Christianity the gods of Olympus ceased to exist in the world of religion; as subsequent cultural developments demonstrate, however, they acquired true immortality in the world of art.

A fourth-century AD source, *The Apostolic Constitutions*, offers the following recommendation: 'Shun all pagan books. What do you want with speech or laws that are foreign to you, or false prophets, the reading of whom turns empty-headed people away from the true faith? Turn away entirely from all that is foreign and invented by the devil.' And so it would seem that the images of antiquity were 'foreign ideas invented by the devil'. However, the inspiration that they brought people remained a vital part of Christian Byzantium throughout its thousand years' existence. This was truly a new lease of life for ancient culture. With its 'real' life over, pagan mythology continued to exist semiotically in the political emblems of the Byzantine state and the religious emblems of the church.

It is a commonplace that the whole of early Christian art is permeated with symbolism. Both material artefacts and written sources testify to this fact. On the one hand, there is the direct testimony of Eusebius concerning Orpheus as a symbol of Christ, and on the other there are various mythological characters – Orpheus again, Bellerophon, Herakles and Odysseus – who all act as bearers of the idea of salvation, of the victory of good over evil, of prosperity and wellbeing.[1] And to this we should add the numerous images of real and fantastic animals and birds, various plants (mandrake root, willow, etc.) and objects with a hidden meaning (for instance, an anchor or boat).[2] All of these were perfectly compatible with the religious symbolism and cult artefacts of Christianity. The temple itself was a symbol of the universe, while the images on icons were protoplasts: the selection of colour combinations symbolised the plant and animal world, while the use of perspective also had symbolic significance. The doctrine of Euhemeros, according to which the ancient gods had originally been people, became widespread, especially in the western part of the Roman Empire, encouraging the practice of seeing the gods of antiquity as patrons of the various crafts: Minerva was the first woman to teach people to work with wool, Kheiron was the inventor of medicine, Hermes Trismegistos, the Thrice-Great, was the first astronomer, Mercury was the first musician and so on.[3] The interpretation of the heroes of the Trojan cycle contained in the twelfth-century AD *Gesta Romanorum* ('Deeds of the Romans') is altogether indicative of this aspect of medieval culture in Western Europe: Paris is the devil,

1. Brandenburg, 1968, pp. 49–85; Torp, 1969, pp. 101–12; Huskinson, 1974, pp. 76–91; Age of Spirituality, 1979, pp. 127–9; Hanfmann, 1980, pp. 75–99.
2. Daniélou, 1961.
3. Seznec, 1940, pp.15–25.

Helen is the soul, or the whole of mankind, abducted by the devil, Troy is hell, Odysseus is Christ, Achilles is the Holy Spirit.[4] It is also worth noting that images on the antique cameos found in the West during the Middle Ages were interpreted by contemporaries as expressions of specific good wishes or moral values: Mercury signified wisdom, Artemis a happy marriage, Herakles success in military matters. It is ideas of this kind, which transformed mythological icons into amulets, that explain the profusion of carved stones with ancient subjects on Romanesque reliquaries and crosses.

The symbolic interpretation of ancient images is also constantly present in Byzantine literature. As an example it is enough to mention such works by early Byzantine authors as Horappollon's *On Hieroglyphs*, and *Dionysiaca* ('The Deeds of Dionysos') by Nonnos of Panopolis. Horappollon's treatise, which contains an interpretation of the Egyptian script, was based on didactic symbolism and expressed the enthusiasm for the ideogram that was typical of early Byzantine culture.[5] In *Dionysiaca* what interested the author was not the myth of the god of wine and merriment, but the story of how Dionysos underwent three incarnations – as Zagreus, Dionysos and Iakkhos. It is interesting to ponder what concept an inhabitant of Byzantium in the eighth century AD must have had of Dionysos when he transformed the god's hollow sculptural portrait into a vessel for holy water and ordered an appeal to God to be engraved on it (*below*, p. 86; cat. 139). Another clear illustration of the way in which the symbolism of ancient images existed within Byzantine literature is provided by the exposition of the myth of Oedipus in the twelfth-century AD *Tale of Hysmine and Hysminias* by Eustathios Makrembolites: young people strolling in a garden admire the art of a painter who has displayed his works there, and try to uncover their hidden meaning – for the artist is the Sphinx, setting riddles in his works for Oedipus, i.e. the viewer. 'I have guessed your riddle, artist, I have understood your story, I have immersed myself in your very thoughts: if you are the Sphinx, I am Oedipus, if you prophesy in dark words as if from the Pythian altar and tripod, I am your servant and the expounder of your riddles.'

Statuette of Dionysos with Text of Psalm 28:3 (detail)
Rome, 2nd–3rd century AD (statuette)
Byzantium, 8th–9th century AD (inscription)
cat. 139

4. Hamann-MacLean, 1949/1950, p. 165.
5. Averintsev, 2004, p. 153.

There is an entire series of well-known examples of fourth- and fifth-century AD toreutics, of which a silver dish from Mildenhall in the British Museum is perhaps the best example. On artefacts of this kind, as well as on copies of them in cheaper materials, such as the clay fragment in the Hermitage (cat. 95), the head in the central medallion is a personification of the Earthly Ocean, the cosmos, and according to the interpretation of the Neoplatonist Porphyrios of Tyre (232–304), this is not only the mortal universe of the senses, but also a concentration of earthly powers. The nymphs, meanwhile, the daughters of Okeanos, are souls descending into the world and are identified with profound cosmic powers: they signify eternal becoming, communion with life and death. In his exegesis on Book XIII of *The Odyssey* the same author wrote: 'It should not be thought that such interpretations are forced and that their cogency is the result of fabrications. One must acknowledge how rational is ancient wisdom and the wisdom of Homer, and not deny its precise understanding of every human virtue, since in his mythological invention Homer *hinted enigmatically at the representation of matters divine*. Homer would not have achieved his goal and realised his entire conception if he had not started from certain true notions, extending them into the realm of imagination.'[6]

The image of Herakles among the bacchants can also be full of hidden meaning: his labours, his search for a moral path (a theme dealt with by the sophist Prodikos, but valued especially highly by the cynics and stoics) and his martyr's death – all of these transformed the hero of antiquity into a saviour of mankind, endowing him with messianic features. In his 60th speech the cynic Dio Chrysostom provides an allegorical interpretation of the myth of Herakles, the first mythological character in the gallery of the cynics' ideal heroes.[7] Herakles' way of life was valued especially highly: he grew up in the forest and was close to nature; he wandered the earth wearing the skin of a lion, armed only with a club, wanting for nothing. Devotees of the teachings of the cynics saw him as a great example, and his labours were regarded as the victory of a free spirit over the vices. This Herakles was perfectly acceptable to medieval art and he became one of the popular heroes of 'Byzantine antiquity'.[8] There is a work by the fifth-century AD epigrammatist Palladas entitled 'On a Downcast Statue of Herakles':

I saw the bronze son of Zeus in the dust of the crossroads:
They used to pray to him, now they have cast him down in the dirt.
And astounded, I said: 'O God of three moons, protector from evils.
Invincible hitherto, tell me, by whom are you overthrown?'
Appearing before me in the night, the god spoke to me with a smile:
'A god am I, but even so have learned the power of time over me'.

Palladas, however, was mistaken: time proved powerless over this famous mythological image and it was destined to have a very long life indeed.

Just as in Roman times, the images on early Byzantine sarcophagi showing competitions between athletes, and the victors holding laurel wreaths and palm branches, had a symbolic meaning that was in keeping with the funereal theme.[9] The comparison of human life with the sport of athletes was quite a common notion in ancient philosophy. Having first appeared with Plato, this idea was later developed in the teaching of the stoics, who identified the athlete with a wise man possessing true knowledge. The athlete's victory in competition was therefore regarded as the victory of good over evil, as the triumph of life. The standard attributes of the victor – the laurel wreath and palm branch – also possessed a definite eschatological meaning: as evergreen plants, they were symbols of immortality.

6. Porphyrios, chap. 12.
7. Nakhov, 1976, pp. 61–4.
8. Weitzmann, 1973, pp. 1–37.
9. Cumont, 1942/2, p. 473.

Fragment of a Dish with a Circus Hunting Scene
Eastern Mediterranean, 4th–5th century AD
cat. 97

Depictions of hunting scenes possessed a similar symbolism, and the hunters could simply be characters with the attributes of a hunter or well-known heroes from ancient myth – Hippolytos, Adonis, Meleager, Bellerophon, Herakles. Hunting was regarded as an act of valour, and the hero's victory in the hunt was a victory over death, over sins and temptation.[10] As a form of spiritual death, sin and temptation were even more terrible than physical death. If Bellerophon was riding a horse among the hunters, that signified the ascension of the soul, if it was Adonis then it signified rebirth in nature, and if it was Herakles – the suppression of evil powers. This kind of interpretation of heroic hunting scenes had to be in keeping with Christian ideas, and their appearance on Byzantine artefacts was entirely legitimate. Hunting scenes on Byzantine artefacts could thus be interpreted by contemporaries in various ways: as one of the most widespread of traditional images, as allegories filled with philosophical meaning, or as a form of magical protection against harmful powers. In fact we are dealing here with the phenomenon that was discovered by Cyril Mango in his analysis of mid-Byzantine hagiography: for intellectuals these images were a kind of literary *ekphrasis*, while for the uneducated they were filled with magical ideas.[11]

The tradition of the symbolic and allegorical interpretation of ancient authors, begun by the Neoplatonists, was continued by Christian apologists and the fathers of the church, above all by the Great Cappadocians. The allegories of Gregory of Nyssa are in many ways similar to the philosophical constructs of Porphyrios of Tyre: they share not only certain ideas, but also the explanations provided for specific images. The symbolism of the 'cave of nymphs', with its numerous mythological characters, figures in both Porphyrios and Gregory of Nyssa, and Gregory's commentaries on the Old Testament, with their rich allegorical subtext, are reminiscent in their images and their formal literary devices of the interpretations of mythological images in Homer by the stoics.

The presence of a symbolic subtext in scenes of ancient mythology was also allowed by St Gregory Nazianzus. In Gregory's homilies the wandering Odysseus is associated with the ship of life crossing a stormy sea on its course to heaven, while Odysseus escaping the sirens is seen as the triumph over death. In St Gregory Nazianzus even the ordinary

10. La chasse, 1980.
11. Mango, 1963, pp. 55–64.

characters of Hellenistic bucolic literature are transformed: he makes them ponder on the vanity of earthly life. The following quatrain by him may serve as a typical example of such Christian bucolics:

> Tormented by profound grief, yesterday I sat sadly
> Alone in a shady grove, withdrawn from all human company.
> It pleases me to heal my weariness of spirit in this way,
> Making quiet conversation with my weeping heart.[12]

The dish with a herdsman among his flock (*below*, p. 12; cat. 84) serves as an excellent illustration of these poetic lines.

In *Ad adolescentes, de legendis libris Gentilium*, the 22nd homily of St Basil the Great advising youths on how to read pagan books, we find the genuine rehabilitation of pagan classicism and a justification for the legitimacy and even necessity of its use by Christian authors. The pivotal point of this sermon in imitation of Plutarch's work *De Legendis Poetis* ('On Reading Poets') did not lie in the recommendations concerning the transformation of images from ancient mythology into symbols of the Christian religion, but in the claim of the undoubted and, above all, practical usefulness of such images in helping the reader to grasp the deeper levels of the Christian religion. Basil the Great teaches that in reading the pagan authors one should not follow them 'wherever they may lead but, while borrowing from them everything that is useful, one must know how to discard other things'.

Plate with a Herdsman
Constantinople, AD 530s (?)
cat. 84

12. From a translation by Averintsev, 1976, p. 37.

According to Basil the Great, the ancient heritage can and should be used at three levels. First, it serves for 'the exercising of the spiritual eye', since it is only by means of comparison with works of antiquity that one can grasp the profundity of Holy Scripture. Secondly, a truth or great idea must be presented in a form that is beautiful and appropriate to it, just as a ripe fruit on the tree appears even sweeter if it is elegantly framed by foliage. Thirdly, a correct selection of material from the works of pagan authors assists the moral improvement of the Christian. The use of pagan classical art to affirm Christian doctrine was also allowed by Theodoret of Cyrrhus. The title of his work – *The Cure for Hellenic Maladies, or the Attainment of Evangelical Truth from Greek Philosophy* – conveys the essence of the arguments that it contains.[13]

In apocryphical Coptic texts Dionysos and the Maenad were interpreted as representations of Adam and Eve; Aphrodite being born from her seashell was regarded as a Christian soul appearing in the waters of baptism; and Leda and the swan as a representation of the immaculate conception.[14]

For classically educated Christians, mythological scenes on silver vessels, in addition to their purely traditional interpretation as illustrations of myths, might also have signified certain 'higher truths'. The written evidence does not provide a clear picture of how images from antiquity were understood by Byzantines and how widespread such interpretations of them were beyond intellectual circles. On the one hand, by the sixth century AD the pagan iconography had basically been forgotten (for instance, John of Ephesus informs us that the Tyche of Constantinople on a *solidus* of Justin II's time was regarded as a representation of Venus), but on the other hand, in a period of bitter dogmatic disputes an inclination for abstract thinking was typical not only of highly educated people, but also of simple citizens. Gregory of Nyssa wrote with a certain irony that even street traders and bathhouse attendants neglected their own business to indulge in disputes about the 'created' and the 'uncreated'. People who might have seemed very far from the subtleties of ancient philosophy, but who had the desire and inclination to discuss *homoiousios* (Christ's being of similar substance to God) and *homoousios* (Christ's being of identical substance to God, or consubstantial) must have understood, at least in part, the conventional means for the expression of abstract truths; in other words they must have known, as Porphyrios of Tyre had called upon them to do, the meaning of 'signs and portents'.

The images of ancient mythology were so popular in Byzantium for several reasons, one of which was the dominance of tradition. Traditionalism was a consequence of both the conscious conservatism of Byzantine society and the inertia of its craft tradition, and in certain specific instances it was also a reflection of high politics. The rulers of Byzantium saw the following of ancient traditions as a guarantee of political stability and the preservation of Roman emblems as a demonstration of the grandeur of the New Rome. The diplomatic gifts which the rulers of Constantinople regarded as particularly important in contacts with the countries and peoples surrounding the empire are indicative. Precious gifts to barbarian nobles were not an invention of the Byzantines: this was an ancient tradition. In imperial Rome, on festive occasions such as the emperor's coronation or birthday, soldiers' salaries, usually paid in money, were supplemented or replaced with a valuable gift. The items used for such rewards included weapons, crowns, cups and ornaments.

The instructions given by Constantine VII Porphyrogennetos (913–59) to his son Romanos are quite typical: a far-sighted ruler must know which people might be useful to the Romans and in precisely what way, which people hostile and in precisely what way, and also how and with the help of which other people the enemy can be crushed and conquered; it is also necessary to know what gifts they would like to receive.[15] We know that every year the leaders of the barbarian forces whose help Byzantium was interested in receiving were

13. Lemerle, 1971, pp. 45–46.
14. Kakovkin, 1981, p. 123.
15. Constantine VII Porphyrogennetos, ch. 1–9.

sent a large quantity of ceremonial weapons, expensive clothing, items of jewellery, special issues of coins and medals, and cups made of precious metals. The vessels presented were not strictly cups: they were dishes or bowls richly decorated with shields like those with portraits of Constantius II (337–61) from the crypts at Kerch. They did not have a round base, but were spherical in form and equipped with loops for hanging from the belt. Such vessels would be filled with gold coins, and the two of them together made a valuable gift. Research into the items that make up the Pereshchepina complex (cat. 104–32) has identified among them gifts from the emperor Heraclius (610–41) to the Bulgarian khans Organa and Kuvrat. These gifts included a silver hand-washing set (cat. 105–6), presumed to have been given in 619 during a visit to Constantinople by a Bulgarian mission led by Organa, a patrician belt with a massive gold buckle (*below*), and personalised rings with Greek monograms that incorporate the title of *patrikios* (p. 19; cat. 107, 109). Such a gift possessed a triple symbolism: the belt and the ring transformed Kuvrat into an honorary Byzantine *patrikios*, the same belt together with the coins made him an honorary consul, while the sword, bracelets and gold coins, subsequently made into a necklace, were a reward to an ally of the Byzantines who had helped to crush the Avars during the third decade of the seventh century AD.

The items that served as gifts to Byzantium's allies were manufactured in Constantinople but decorated in the barbarian manner. The jewellers of the capital bore in mind their customers' tastes when they created decorative items for the rulers of the northern Black Sea region, where the artistic traditions of the 'age of the Huns' were still alive, and employed the techniques of masters of the polychrome style. For instance, the belt buckles and plates from Pereshchepina resembled Byzantine models in form and structure, but were decorated with coloured glass and paste stones, as mementoes of the age of the migration of peoples.

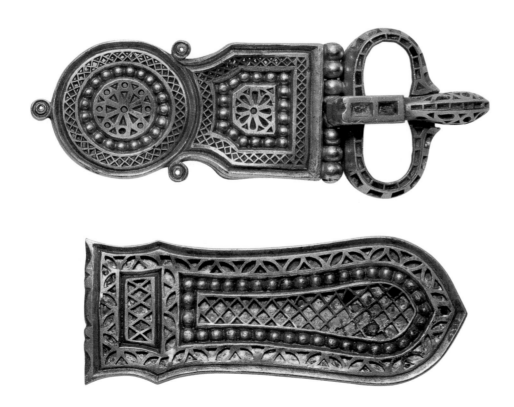

Belt-buckle and Belt-end
Byzantium, mid-7th century AD
cat. 110–111

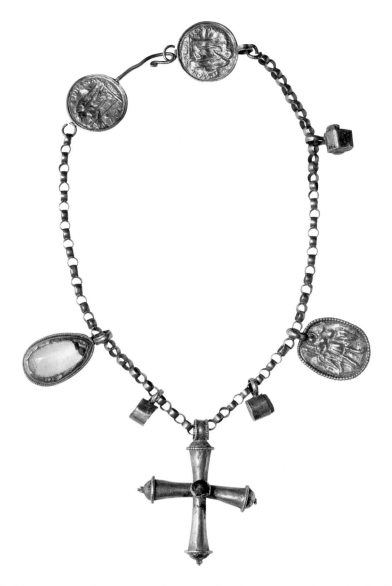

Necklaces were also among the rewards given to warriors who had distinguished themselves, as well as to foreign leaders. In *The Wars* of Procopius of Caesarea we find an interesting statement: Belisarius, renowned general of the emperor Justinian, rewarded those who had distinguished themselves most with money, gold bracelets and necklaces.

The Byzantines wore two kinds of decoration round their necks: one was based on Roman models with twisted hoops of gold, while the other, which had a chain as its main structural element, included *phalerae* (decorative disks). In Byzantine times the leather cord was replaced by a twisted metal one and various plaques and medallions start to be used as *phalerae*. Decorations of this kind became popular with the barbarians, since the items that the Byzantines gave them combined very well with the ornaments worn on the chest that were fashionable in these tribes before they began to associate with the Byzantines. Thus, when the historian Menander wrote about 'cords decorated with gold' that were sent to the Avars as a gift in the sixth century AD, he was thinking of necklaces made up of coins, medallions of various shapes and stones set in metal. A necklace with a cross and pendants from Mersina (ancient Zephyrion) near Tarsus is of exactly this type (*above*; cat. 98). As is made clear by descriptions of ceremonies at the Byzantine court of Constantine VII Porphyrogennetos, a cross on a chain was associated with a specific court title and served as its badge of honour. It could equally well be received by a barbarian leader who had accepted Christianity or a pagan ally.

The influence of the advocates of heretical teachings – above all the followers of dualistic conceptions and the magi, who engaged in occult practices and worshipped the eastern deities Cybele and Anahita, the Horseman of Thrace and Sabazios – contributed to the preservation of certain pagan images (compare the votive hand of Sabazios, cat. 39 (*below left*), and the votive hand with a cross, cat. 141 (*below right*); the intaglio with Isis feeding Horus, cat. 48 (p. 14), and icons of the Virgin feeding the Infant Jesus). Artefacts of this kind can justifiably be called 'sub-antique'[16] and can be regarded as examples of a sub-culture.[17] Sub-antique art, what Grabar also called 'the third world of antiquity', was essentially a marginal phenomenon.[18]

Byzantine symbolism, based on Neoplatonic philosophy (as opposed to the symbolism of medieval western Europe based on the teaching of Euhemeros) was of two kinds: 'intellectual' and 'popular'. While the latter merged into superstitions and magic, the former was one of the means through which the heritage of antiquity was Christianised.[19]

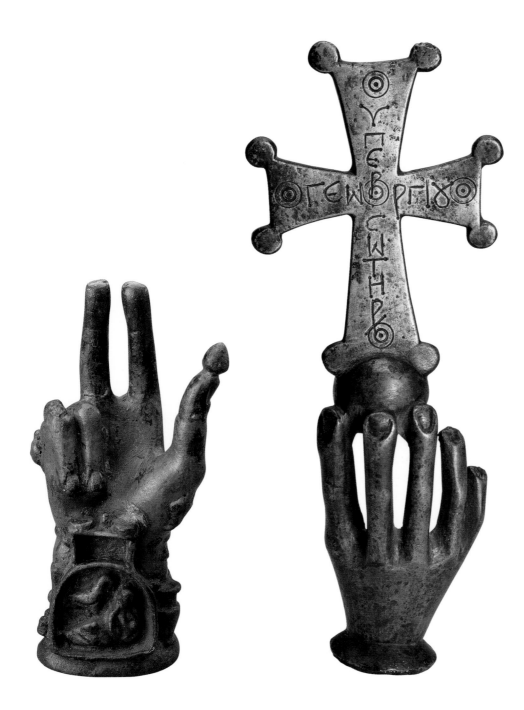

FAR LEFT
Votive Hand (Hand of Sabazios)
3rd–4th century AD
cat. 39

NEAR LEFT
Votive Hand with a Cross
Syria, 6th century AD
cat. 141

16. Trilling, 1987, pp. 469–476.
17. Brown, 1991, pp. 20–21.
18. Grabar, 1972, pp. 1–59.
19. Cooke, 1927, pp. 396–410.

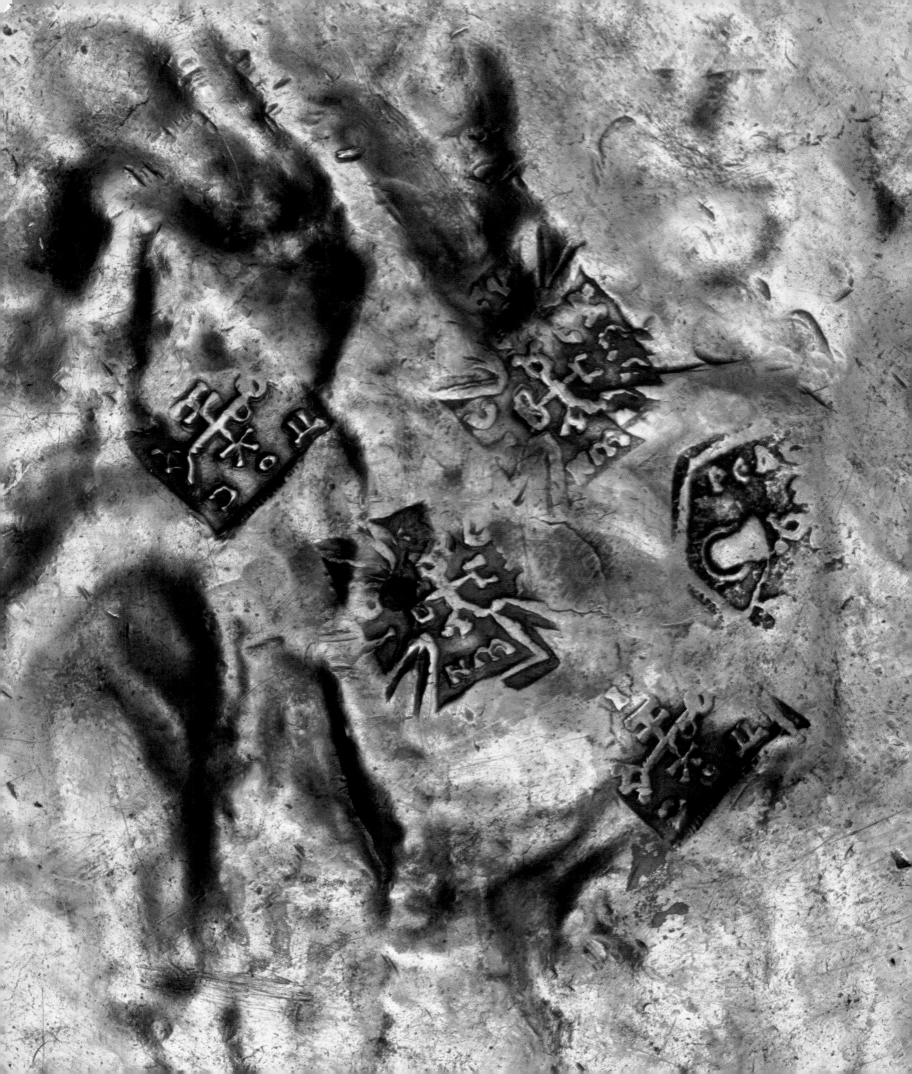

Marlia Mundell Mango

SILVER IN CHANGING CONTEXTS

The late Roman and Byzantine domestic silver objects exhibited in the Hermitage Rooms at Somerset House offer insights into the culture that produced them; at the same time, nearly all were found outside the Empire and have, therefore, something to say about the other cultures that preserved them. The largest collections of late Roman/early Byzantine domestic silver plate belong to the Hermitage and the British Museum. While the latter silver consists largely of treasures found in Rome, Mildenhall in Britain, Carthage, Lampsacus in Asia Minor, and near Kyrenia in Cyprus,[1] the Hermitage silver on display here was recovered in the Crimea, the Caucasus, at Conceşti in Romania, at Malaya Pereshchepina in the Ukraine, and at several sites in the Ural Mountains. The composition of the various groups in which the silver was found is itself of great interest, for while some formed functional domestic groups, others did not.

About 1500 pieces of late Roman and early Byzantine silver plate survive;[2] they were made for either ecclesiastical or domestic use. The abundant production of silver plate in this period has been explained by the general cessation of silver coin in the Eastern Empire between 400 and 615. Nearly all this silver when analysed has been shown to be of 92–98 percent purity,[3] and recent scientific work has established that at least some of the metal was mined along the south shore of the Black Sea or in the Taurus Mountains. About 200 of the preserved silver objects bear state control stamps of the sixth and seventh centuries AD which were applied during manufacture, and thus can be accurately dated. However, the earliest known stamps occur on series of small dishes manufactured by the state for distribution on imperial anniversaries and ceremonial occasions to the military and others; these include the bowls bearing the name of Licinius, dated to the 320s, one of which is in the British Museum. In decorative character these bowls relate to the bowl with Constantius II of 343 (p. 97; cat. 61). While there is no state stamp on the object, a pointillé inscription on the reverse starts with ANT, thought to indicate that it was made in a state workshop at Antioch. Other single or paired stamps were occasionally used on certain types of objects (such as bowls) until the end of the fifth century AD, when the emperor Anastasius

1. *See* Dalton, 1901; Kent and Painter, 1977; Buckton, 1994.
2. Boyd and Mundell Mango, 1992, XXIII and note 15.
3. P. Meyers, in Boyd and Mundell Mango, 1992, pp. 169–89; Mundell Mango and Bennett, 1994, p. 22.

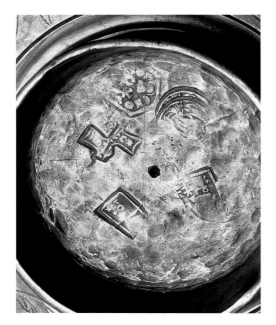

Plate with a Herdsman, Control Stamps (detail)
Constantinople, AD 530s (?)
cat. 84

introduced a complex system, further refined under Justinian. This comprised five stamps of different shapes containing combinations of imperial monograms and busts as well as the full names and monograms of various officials, including the *comes sacrarum largitionum*, the person in charge of precious metal production by and for the state. Most scholars agree that the stamps were applied in Constantinople, although stamps naming the cities of Carthage, Antioch and Tarsus are known. Of the objects displayed here the plate with a herdsman (pp. 12, 53; cat. 84) has stamps of Justinian (527–65) (*left*); those on the washing set (*right*; cat. 105–6) are of Maurice (582–602), the plates with a silenus and a maenad (p. 71; cat. 85) and with Meleager and Atalanta (p. 73; cat. 87) date to the reign of Heraclius (613–30), while the flask with nereids (pp. 70, 105; cat. 82) and the wash basin with fishing scenes (p. 68; cat. 88) are among the latest in date (641–51), having stamps of Constans II. Leonid Matsulevich's *Byzantinische Antike*, published in 1929,[4] used the control stamps to establish a chronology of silver objects decorated with mythological subjects extending as late as 651, far later than one would normally have guessed from the subject matter and style of the decoration. Like coins, these stamped silver objects offer precise integral dating, and thus provide a chronological reference point for other archaeologically associated material.

The types of surviving domestic silver include display and serving plates, bowls, spoons, amphorae, ewers, situlae, handled wash basins, mirrors, a polycandelon, lamps, and lampstands. Silver sheets were also used to revet collapsible stools and tables. The names and standard functions of domestic objects may be learned from inventories, laws, cookery sources, inscriptions on objects, and contemporary illustrations of eating, drinking and bath scenes, some of them on the objects themselves. During this period plates and spoons became increasingly larger and heavier. Some of the largest silver plates, of about 70 cm in diameter, may have been used as table tops. Sidonius Apollonaris, speaking of wealthy households, refers to 'masses of … silver plate' and 'silver set by panting attendants on sagging tables', stressing the weight and scale of the metal.

The types of object exhibited here include the display plate, the amphora, the washing set and the pyxis (p. 62; cat. 40), while the full range of domestic silver available is best shown by the Esquiline (Rome), Mildenhall, Carthage, Lampsacus and Cyprus treasures in the British Museum.[5]

The plates in this exhibition have figural decoration and fall into the category of display or 'picture' plates, which may have been used as part of a dinner service. Such plates are found or recorded singly, in pairs, or in extended sets. The larger plates are called *missoria*. Notable among the treasures of the British Museum are sets of matching plates and bowls of various sizes, often of simpler adornment such as a monogram or cross in the centre, which formed part of a dinner service. These sets of plates and bowls were complemented by sets of spoons, usually numbering 12 each; they could be decorated with figures, amusing inscriptions or the owner's monogram.

Amphorae were used as part of a drinking service. While that from Malaya Pereshchepina (p. 69; cat. 104) has a traditional shape, the Conceşti amphora (pp. 69, 88–9; cat. 81), decorated with Amazonomachy, is more avant-garde in appearance. Its tall, narrow (once stoppered) neck kept liquids warm, and in shape it resembles contemporary copper-alloy samovars. While not operating as a samovar itself, it may have been used to carry warm water to the table for mixing with wine, and its thick handles may have served to reduce the heat while being carried.

Because much food was taken from serving platters and eaten by hand, washing was a necessary part of the meal, and washing sets composed of basin and ewer were used at table. Silver sets used for washing before meals are mentioned in Justinian's Digest (34.2.19, 21) and in inventories. The washing set on display is called a *cherniboxeston* (wash basin and ewer) in an

4. Matzulewitsch,1929. *See now* Dodd, 1961.
5. On silver services for dining and drinking *see* Mundell Mango (forthcoming).

inscription on the basin handle. Three types of silver wash basins are known from late antiquity. The first (called conventionally a *patera*) has a flat and broad bowl with a horizontal handle (*below*; cat. 105); the second, represented here by the basin with fishing scenes, has a deep saucepan shape and a horizontal handle, and is called conventionally a *trulla* (p. 68; cat. 88); the third, the *pelvis*, is a wide basin often with a pair of drop handles. As with the basin with fishing scenes, all three types often have aquatic decoration (fish, shellfish, water birds, fishermen, mythological marine characters).

Who, within the empire, owned this type of silver? The following cases illustrate that in addition to wealthy individuals, people of several levels of society owned some personal silver plate. John Rusafaya, a decurion of Edessa, possessed dinner and drinking services which in 621 so impressed the king of Persia that the latter seized them. Many women at Antioch, it was said in 514, dined from heavy silver plates and were carried on silver litters to the public baths, taking heavy silver articles with them. Chrysaorios, a student coming from Tralles in Asia Minor, brought his own silver service with him to the law school at Beirut in about 500. After the Riot of the Statues in 387, the sophist Libanius describes panic-stricken officials fleeing Antioch, each with several mule-drawn carts of personal silverware. Jordanes commissioned a series of silver *missoria* while serving as Master of Soldiers in the East (*magister militum per Orientem*) in 466–9. Even churchmen owned silver. At Jerusalem in about 400, the bishop John had 1500 pounds of silver in his personal possession, possibly

Wash Basin
Constantinople, AD 582–602
cat. 105

Ewer
Constantinople, AD 582–602
cat. 106

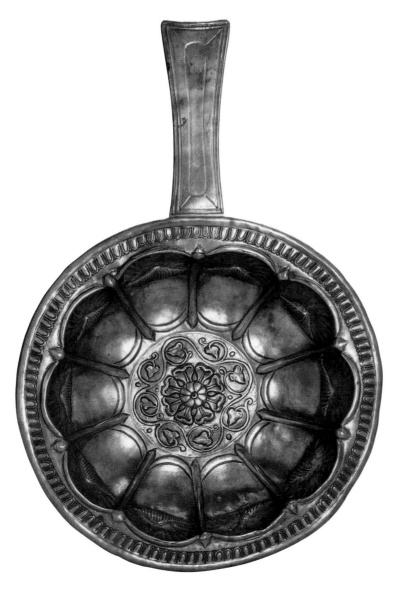

in the form of a service, and a deacon had 100 pounds of silver. Troilus, another bishop, intended to buy himself at Alexandria a service of elaborate silver with relief decoration, paying 30 pounds of gold, which could have bought up to 540 pounds of silver. Further down the social scale, a prostitute owned a silver situla (later accidentally recycled as a chalice!) and an illiterate sailor and his wife in Egypt owned some silver in addition to houses, objects of gold, copper, brass, and clothing, as stated in their will dated 583/4. The social status that silver plate conferred or reflected was often seen in terms of wealth or power; while to resist its allure signified virtue. Hence, St Anthony in the desert was tempted by a silver plate (*diskos*). Family silver donated to be recycled into liturgical silver or given to the poor became a literary cliché: the conversion of the metal symbolizing the spiritual conversion of the donor from a worldly to a religious life.

Two of the late Roman silver objects in the exhibition – the two imperial plates (pp. 78, 97; cat. 61, 62) – were excavated within the Empire in the Crimea, while the plate with a nereid (p. 104; cat. 37) was found in 1895 in Azerbaijan, formerly a Romanized border area. Four of the other objects in the exhibition were found in two other areas in Eastern Europe, where the contexts of the deposits suggest the use of the silver within other, foreign cultures.[6] The first of these was the hoard of objects found at Conceşti in Romania, represented here by the amphora with Amazonomachy (pp. 69, 88–9; cat. 81); the second was at Malaya Pereshchepina in the Ukraine (cat. 104–6). Both hoards contain barbarian ornaments, Byzantine silver and other material placed in burials or other ritual deposits; at Conceşti in a fifth-century AD context, at Malaya Pereshchepina in a sixth- or seventh-century AD context. In composition these hoards are comparable to other European deposits at Bolshoi Kamenets and Apahida (fifth century AD), and at Tepe, Martynovka,

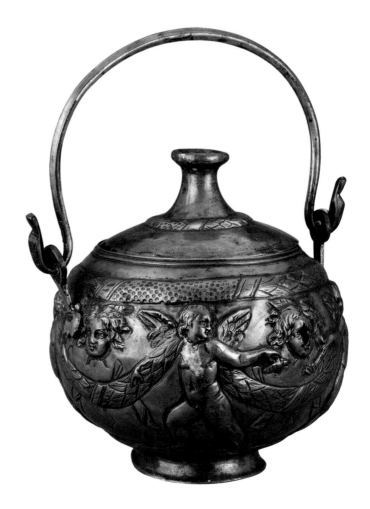

Pyxis with Erotes and a Garland
Eastern Mediterranean, 3rd century AD
cat. 40

6. Mundell Mango, 1998.

Sutton Hoo, Kuczurmare, Vrap and Erseke (sixth or seventh centuries AD). Barbarian imitations in gold and silver of Roman/Byzantine silver have been found in some of these places and elsewhere. The silver in these European deposits form functional sets, even if, as with the Malaya Pereshchepina hoard, the origin of the silver is heterogeneous (e.g. Byzantine, Sasanian and Avar). These sets mirror those in use within the empire and almost always include eating vessels such as a large plate (diameter 55–72 cm), and/or drinking vessels such as ewers, amphorae, goblets, cups or bowls, and/or washing vessels such as basins, ewers or situlae. But the function of a given type of object may have changed with its migration outside the empire: for example, the Malaya Pereshchepina church paten may have served as an eating or serving plate, while the goblet at Martynovka may be an adapted Byzantine church chalice.[7]

In addition to the amphora with Amazonomachy and a plate, situla, ewer and collapsible stool, the Conceşti burial included the personal armour of a military man who owned a silver helmet. The Malaya Pereshchepina hoard (with its paten/plate, three ewers, basin, 11 goblets, and mug) has been associated with Kuvrat, khan of Great Bulgaria.[8] It is possible that this group of silver may have been imperial largesse or diplomatic exports from the Empire. The Byzantine silver is unlikely to have been booty: whereas churches were regularly looted by invading barbarians, only one piece of identifiable church silver – the Malaya Pershchepina paten – has been found outside the Empire.

The other six objects in this exhibition (cat. 82, 84–8) belong to a group of two dozen pieces of Byzantine silver found in at least 12 locations in north-east Europe in the Kama and Vyatka Valleys above the Volga River. After an initial find in 1780–1 of the plate with Ajax and Odysseus (p. 66; cat. 86) and two other Byzantine objects at Sludka, similar finds occurred at other sites. These included the plate with a herdsman and the plate with a silenus and a maenad, discovered at Klimova and Kalganovka. Five objects, including the plate with Meleager and Atalanta, the flask with nereids and the basin with fishing scenes, came from unidentified sites in the Kama Valley. Altogether 170 Byzantine, Sasanian, post-Sasanian and central Asian silver objects dating from the sixth to thirteenth century AD have been found together in mixed hoards at 32 sites in the Kama Valley. Although part of the Byzantine silver formed the basis of Matsulevich's study of 1929, the Byzantine material as a whole was never published prior to the summary of finds in A. Effenberger's Berlin exhibition catalogue of 1978.[9]

Fig. 1.1, 1.2. Examples of shamans and other ritualistic figures scratched onto Byzantine plates from the Kama silver.

With the exception of three washing vessels (including the flask with nereids and the basin with fishing scenes here), all the Byzantine objects from the Kama Valley are plates. With regard to the decoration of the silver, 11 objects are covered in mythological, pastoral or other classical subjects, while another 11 plates (not in the exhibition) have a central ornament, either a cross, rosette or other motif.

Although indistinguishable typologically and decoratively from the Roman/Byzantine silver finds in eastern Europe, the Kama silver formed no functional sets when found. These objects had passed into an alien culture where they were put to a very different use, as shown by recent studies by V. J. Lescenko and V. P. Darkevich. Figures of shamans and other ritualistic drawings had been scratched onto a total of 18 silver objects, including three Byzantine plates (fig. 1.1, 1.2), which were pierced for attachment and upright display. According to Lescenko these drawings were added in the ninth to tenth century AD by members of the Lomovatov, Rodanov and Sylven Cultures who inhabited the remote Kama Valley to the north of the territory of the Volga Bulgars. The silver objects, together with swords, were traded to the northern peoples by the Volga Bulgars in exchange for sable pelts in the ninth to tenth century AD, rather than in the sixth to seventh century AD, the period when the earliest Kama silver was manufactured.[10]

7. Mundell Mango, 1995, p. 80. Lacking an inscribed dedication, the goblet/chalice may never have belonged to a church.
8. The extended Vrap treasure (with two plates, four goblets, two cups, situla and ewer) has been associated with Kuvrat's son Kuber. See Werner, 1984.
9. Effenberger et al., 1978.
10. Darkevich, 1976; Lescenko, 1976; Ballint, 1977; Effenberger et al., 1978, pp. 35–42.

Dish with a Silenus and a Maenad,
Control Stamps (detail)
Constantinople, AD 613–629/30
cat. 85

Where did the Volga Bulgars acquire the silver during the ninth and tenth centuries AD? This was the period when large numbers of Abbasid silver coin (*dirhems*) appeared on eastern trade routes which ran to the south-west of the Kama Valley. T.S. Noonan demonstrated that the *dirhems* originated in Transoxiana in Saminid Central Asia and travelled west into Europe by way of the Caspian and Caucasus, just to the south of the Volga Bulgar territory.[11] The Volga Bulgars may have acquired likewise in Transoxiana the silver traded north into the Kama Valley, moving it westward on a parallel course to the north of the *dirhem* route.

The Byzantine silver provides some evidence that it came to the Kama Valley from Central Asia, crossroads of east-west trade.[12] Two Byzantine objects, one being a plate decorated with Achilles, bear Central Asian inscriptions (one Sogdian, one Choresmian), probably added in Central Asia. Two others have the names of Byzantine owners scratched in Greek: Andrew on the plate with a silenus and a maenad (*left*) and Theodore on a plate with a cross. This indicates that the objects were not diplomatic gifts to a barbarian power, but, for a while at least, the personal possessions of particular individuals, such as merchants. The mythological subjects of decoration, such as Dionysiac scenes, accord well with what is known of central Asian tastes in silver, as demonstrated by what K. Weitzmann called the Euripides bowls.[13] The other type of exported Byzantine silver, the plates with crosses mentioned above, may well have appealed to Nestorian merchants who were active all along the silk route.[14] Seeing that legislation of the emperor Valens in 374/5 banned the export of gold, but not silver, from the empire, it is possible that Byzantine silver plate formed a convenient export currency for the silk trade and that at least some stamped plate was intended for this purpose.

Two objects in the exhibition, the dish with the flight of Alexander (p. 114; cat. 133) and the bowl with an empress's banquet (*below*; cat. 134), extend the story of Byzantine domestic silver into the Middle Ages. The fact that in the seventh century AD more stamped domestic silver was made than church silver – 56 objects as against seven – should indicate an increasing production lasting into the medieval period rather than a tapering off. Medieval written sources refer to a carved (relief-worked) silver service, heavy gold gem-encrusted plates, and hand-washing sets in use in the imperial palace. Imperial gold and silver plate was also taken on military campaign. Among the aristocracy and other elites, more general references to

Bowl with an Empress's Banquet
Byzantium, 12th century AD
cat. 134

11. Noonan, 1980.
12. Mundell Mango, 1998, pp. 222–6.
13. Weitzmann, 1943; Denwood, 1973. Bactrian work, now redated to the fourth to sixth century AD by Marschak, 1986.
14. Atiya, 1968, pp. 237–302; Hambye, 1957; Moule, 1940.

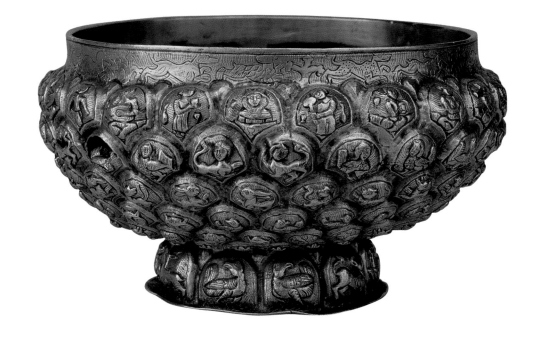

precious metal vessels may include silver table services. However, very little domestic silver survives from after the year 700. The dish with Alexander and the bowl with an empress's banquet, both found in Siberia but attributed to workshops in Byzantium, provide precious evidence from the domestic sphere. The exterior of the bowl, attributed to the twelfth century AD, is covered with a multitude of figures including musical and other performers and animals, many of exotic nature; the mounted military saint on the floor of the bowl is identified by Greek inscription as St George. The dish with the flight of Alexander in the centre is attributed to the period of Frankish occupation of Constantinople in the early thirteenth century AD; it displays a decorative layout and a series of figures that follow a more classical scheme than does the bowl. Both bowl and dish belong to a group of silver objects, found in Russia in various locations, which represent a type of decoration that contrasts with the classical subject matter and style displayed on the ivory Veroli casket of the tenth century AD (*below*, p. 81; cat. 103). However, the motifs and styles, particularly of the bowl, recall the orientalizing art of much sgraffito-ware pottery. Yet both bowl and dish have late Roman predecessors. The bowl's grid, enclosing small figures, recalls the similar decorative layout of the Animal ewer in the Sevso treasure. The vine scrolls, incised and relief figures, cusped edge and tall foot of the dish with Alexander find several late antique comparanda. The bowl and dish from the Hermitage relate stylistically and iconographically to a previously unknown set of ten silver plates, nine of which were recently put on display in Athens.[15] The tenth plate names the medieval owner, Constantine the Alan, *proedros*. A Constantine the Alan, *magistros*, took part in the battle of Dvin in 1047 and could well have subsequently acquired the more elevated title of *proedros*, first introduced in 963. The lettering of the plate's Greek inscription compares well with others dated 1042–50, 1062 (the Brescia astrolabe), and 1078–81.[16] If made in the eleventh century AD, these new plates would be slightly earlier than the two Hermitage objects, and represent a stage of Byzantine production situated between that well attested for church silver in the tenth century AD, and the Russian finds, most of which are normally placed in the twelfth. In form and decoration the Hermitage bowl and dish represent a medieval version of the domestic silver bowls and plates produced in the late Roman and early Byzantine periods. Further study of the new silver now in Athens should increase our knowledge of the domestic sphere of medieval Byzantium, now heavily focused on the ecclesiastical.

Lid of the Veroli Casket
Byzantium (probably Constantinople)
mid-10th century AD
cat. 103
Victoria & Albert Museum

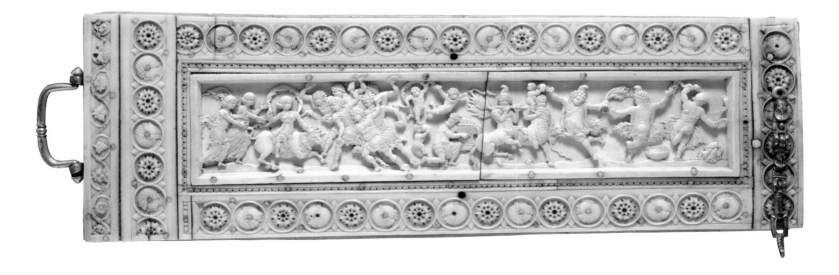

15. Ballian and Drandaki, 2003.
16. Mundell Mango (forthcoming).

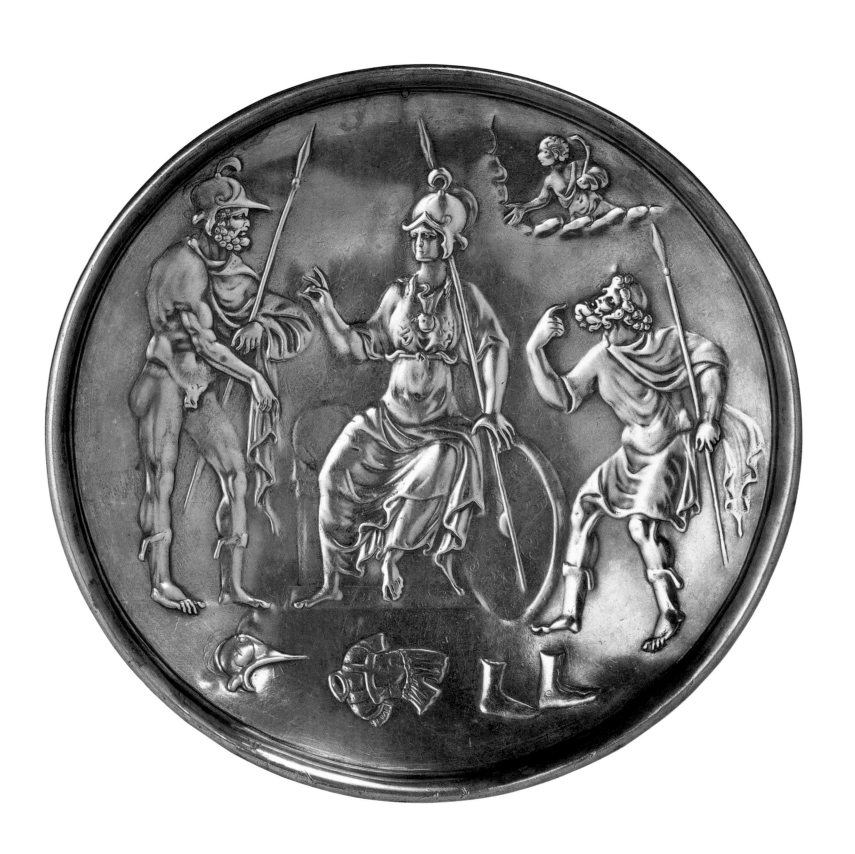

Ruth E. Leader-Newby

CLASSICISM AND PAIDEIA IN EARLY BYZANTINE SILVER FROM THE HERMITAGE

The Hermitage's collection of late antique and early Byzantine silver is truly remarkable. Among its many examples of domestic silverware from this period are some of the best examples of classicism to have survived from the late Roman world. Why is the classicism of this material so significant? A comparison with another type of late antique silverware is instructive. If we look at the silver *largitio* plates produced in the fourth century AD as a form of imperial commemoration, these were at the forefront of late antique artistic innovation. The Hermitage's bowl from Kerch showing a mounted emperor is a prime example: its flat frontal figure of Constantius II, whose bodyguard carries a shield emblazoned with the Christian chi-rho symbol, employs both the stylistic abstraction which is a distinguishing feature of late antique art, as well as the new iconography of Christianity which had begun to be incorporated into the representation of the Roman emperor (p. 78; cat. 62). Domestic silver, by contrast, is a conservative medium, which looks back to longstanding Greco-Roman artistic traditions, both stylistic and iconographic. Such conservatism, however, served a specific late antique cultural function.

The examples of silver in this exhibition were probably made in or around Constantinople, to adorn the tables of the early Byzantine elite, and combine a classical style with subjects taken from the traditional mythological repertoire of Greco-Roman art. Thus, we see Meleager setting off to hunt with Atalanta (p. 73; cat. 87), Athena adjudicating the quarrel between Ajax and Odysseus over the weapons of the dead Achilles (*left*; cat. 86), nereids riding sea monsters (pp. 70, 104–5; cat. 82), a maenad and a silenus dancing in a

Wash Basin with Fishing Scenes
Constantinople, AD 641–651
cat. 88

Dionysiac frenzy (p. 71; cat. 85). Elsewhere there are Neptune and fishermen with tridents (*above*; cat. 88), a thoughtful herdsman with his goats (pp. 12, 53; cat. 84): timeless characters from the world of Greek pastoral. What is so remarkable about the presence of such decoration on items which can be dated to the very end of the period defined by scholars as 'late antiquity'? The answer lies in the historians' traditional view of art and society in Byzantium in the sixth and early seventh centuries AD, which suggests that a Christian outlook and Christian images increasingly came to dominate all areas of life, both public and private. In the literary sphere, mythological poetry, which had flourished into the fifth century AD, was no longer being written, and mythological allusions disappeared from other types of writing. But while written evidence gives the impression that secular culture was in decline, the artistic evidence – including this silverware – paints a picture of tenacious survival.

Why should this be so? To understand this late flowering of classical themes on silver, we have to look more broadly at the functions served by late antique silverware in a domestic context, and how this influenced its decoration. Most of the items of silverware in this exhibition are plates or dishes whose surfaces are covered with repoussé relief decoration. The 'all-over' nature of this decoration suggests that their primary function was as display

pieces, rather than vessels for serving food, which would have obscured their elaborate designs. Other pieces, such as the fourth-century AD amphora from Conceşti decorated with a battle of Amazons and Greeks (*below left*, pp. 88–9; cat. 81), and the seventh-century AD flask with a nereid (p. 105; cat. 82), could have been used to serve liquids without obscuring their superb decoration. By contrast, the amphora (*below right*; cat. 104), ewer and wash basin from the Pereshchepina hoard are much simpler, with minimal decoration (p. 61; cat. 105–6). The ewer and basin would have been used for washing dinner guests' hands before the meal, while the amphora could have held wine or water at table. Yet to see these as purely 'utilitarian' would be misguided, since the very material from which they were made (gilded silver) advertised their owner's wealth and status, especially in the case of the amphora which stands at nearly half a metre tall. Where complete, or near-complete, table-services have been found (such as the Mildenhall hoard in Britain, or the Kaiseraugst hoard in Switzerland) we see a range of different levels of decoration reflecting the fact that while some of the pieces would have been used to serve food, others would have been intended to adorn the dining room and provide a talking point for dinner guests. It is this latter function we must bear in mind when we look at the classical style and subject matter of so many of the Hermitage pieces.

In the fourth and early fifth centuries AD mythological imagery flourished in the domestic sphere. It appeared on silverware, floor-mosaics, wall-painting, ivory boxes and plaques and textiles (both for furnishing and for wear). This was not a new phenomenon, of course: such imagery had been favoured for domestic decoration in the Roman world since

BELOW LEFT
Amphora with Amazonomachy
Byzantium, 4th century AD
cat. 81

BELOW RIGHT
Amphora
Constantinople, 6th century AD
cat. 104

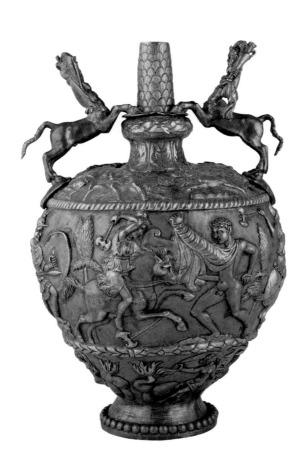

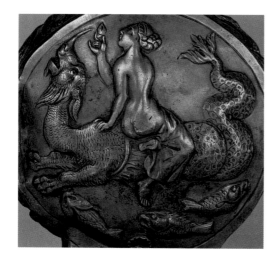

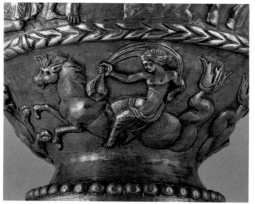

the late Republic. But this traditional iconography remained significant for viewers in late antiquity, even though the context in which it had existed for centuries was being transformed by the establishment of Christianity, which called into question the validity of the mythological tradition. Paradoxically, what we might call cultural traditionalism helped to disguise such changes by maintaining continuity with the past. One such source of continuity lay in the traditional education of the elite in the Greco-Roman world, a process commonly referred to as *paideia*. As an educational programme, *paideia* was highly standardized, based on a narrow range of great authors of the Classical period and fixed modes of interpreting them. Students would study under a grammarian to learn the rules of language and literary composition through reading the poets, above all Homer and Euripides in the Greek-speaking world, and Virgil and Ovid in the Latin-speaking west. This would be followed by training in oratory under a rhetor or sophist, where again students were encouraged to take great orators of the past such as Demosthenes and Cicero as models for rhetorical composition and technique. The components of *paideia* had remained more or less the same since the second century BC; yet despite the changes in the Greco-Roman world between the Hellenistic and late Roman periods, the late antique elite continued to value *paideia* as an important part of their self-definition. This was because *paideia* was as much a training in a particular mode of social interaction, as it was the teaching of specific knowledge. Its strength lay in its uniformity, allowing it to serve as a common bond between members of the elite who might otherwise be separated geographically, or by their relative positions in the severely hierarchical world of late antique power politics.

But *paideia* worked with visual, as well as literary, culture. In their original contexts (before the vicissitudes that led to their burial outside the frontiers of the Roman Empire), the lavishly decorated silver plates and other vessels that we see in this exhibition would have formed part of large silver dining services owned by members of the early Byzantine elite. They would have been prominently displayed in their owners' houses, where their mythological themes would have complemented those of the floors and walls (in the form of mosaics, wall-hangings or paintings, and statues). A dining room decorated in this way was the setting where members of the elite would entertain each other, and where political issues were discussed and alliances formed. A display of silverware reinforced the host's status in terms of wealth and culture; the former through the precious material of which it was made, the latter through the vessels' mythological subject matter. Owning such items marked him out as a man of *paideia*, and at the same time gave his guests the opportunity to display their *paideia*, by recognizing the scenes depicted, commenting on them, making connections between different myths.[1] Such displays of *paideia* enforced the social cohesion of the elite in a period when it was threatened by changing social and power structures, and in this way the traditional mythological imagery of classical art could be an important tool in communicating its values.

The remarkable continuity of classicizing decoration on domestic silver from the fourth to the seventh centuries AD suggests that the culture of *paideia* continued to influence the decoration of silverware throughout the early Byzantine period. Subjects that occur on fourth-century pieces reappear in the seventh: the Conceşti amphora, beneath the Amazonomachy which decorates its main body, features a frieze of nereids riding on composite sea monsters, half-animal, half-fish (*above left*). The same motif (albeit a single nereid on each side, rather than a frieze) features on a flask whose control stamps date it to between 641 and 651, making it one of the latest datable pieces of early Byzantine silverware (*top left*). From the perspective of *paideia*, it is not hard to see the lasting appeal of the 'sea thiasos' as an iconographic theme. No major pagan deities are featured. Its lack of any real narrative means that it is free of dubious – from a Christian perspective – moral overtones. This use of

sea-thiasos iconography can be observed as early as the end of the fourth century AD, on the Projecta casket from Rome (now in the British Museum). A wedding present whose inscription urges the happy couple, Secundus and Projecta, to 'live in Christ', it combines scenes from an aristocratic woman's toilet and procession to the baths, with the toilet of a marine Venus, accompanied by the same type of nereids riding sea-creatures that we see on the contemporaneous Conceşti amphora, and the flask of three centuries on. The nereid on one side of the flask, who holds her hair in one hand and admires her reflection in a mirror held in the other, is remarkably similar in these gestures to the figure of Venus on the Projecta casket. The nereids and Venus on the Projecta casket provide an elevated mythological parallel to the aristocrat's toilet shown beneath them. Their meaning lies firmly in the secular sphere, as mythological types of beautiful women. On the Conceşti amphora, therefore, the nereids contrast with the warlike Amazons shown above them (two different types of mythological female), while on the flask (which could possibly have been a woman's toilet vessel for use in the bath, rather than part of a dinner service) they represent an educated allusion to female beauty. The classical pedigree of the motif allows it to stand as a symbol of *paideia*.

A similar continuity of theme over several centuries can be seen in silver decorated with scenes of the followers of Dionysos, such as the Hermitage's seventh-century AD plate showing the dancing figures of a silenus and a maenad (*below right*; cat. 85). Two fourth-century AD dishes with dancing maenads and satyrs from the Mildenhall treasure feature the same basic composition of a pair of dancing male and female followers of Dionysos. Dionysiac imagery is a good example of the way that *paideia* allowed the iconography associated with a pagan god to be 'secularized' for consumption in a Christian society. On one level, the context in which silver with this type of decoration was used (i.e. for dining) would have made imagery associated with the god of wine appropriate. But not all late antique images of Dionysos can be fixed in a sympotic context, an example being the impressive collection of textile fragments (mostly appliqué clothing decorations) with Dionysiac imagery in the exhibition (*below*; cat. 69, 71, 74, 77). This suggests there is a further dimension to the popularity of Dionysiac imagery in late antique art. In both Greek and Latin literature up to

BELOW LEFT
Textile with Dionysos and a Maenad
Egypt, 4th century AD
cat. 71

BELOW RIGHT
Plate with a Silenus and a Maenad
Constantinople, AD 613–629/30
cat. 85

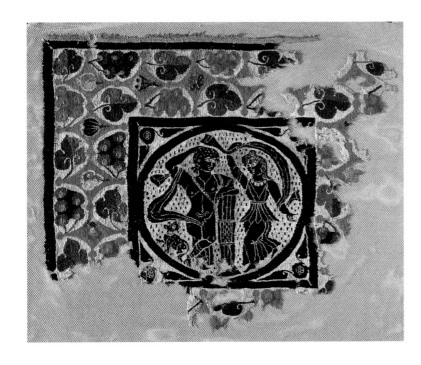

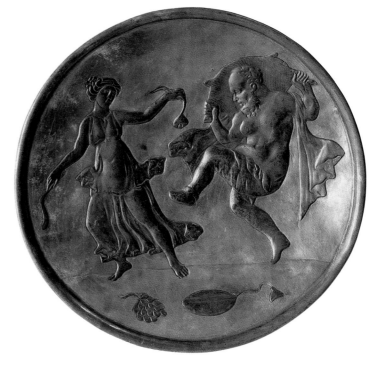

the fifth century AD, Dionysos continued to fascinate poets, most notably Nonnos of Panopolis, who wrote a lengthy neo-Homeric epic about him, the *Dionysiaca*. But Nonnos was not a pagan devotee of the god – far from it. He was a Christian whose earlier work included a verse paraphrase of St John's gospel. The *Dionysiaca* is a showpiece of its author's erudition and *paideia*, and it is in this light that we should understand his choice of subject: Nonnos showed his poetic credentials through both his poetic style (i.e. Homeric epic) and his choice of subject (the mythology of Dionysos). Through both, he is placing himself within a respected cultural tradition. Although the writing (but not necessarily the reading) of poetry like that of Nonnos ceased over a century before the plate with a silenus and a maenad was made, its decoration, and the ubiquity of Dionysiac imagery in late antique art, can be more fully understood if we see Dionysos and his followers as generic representatives of Hellenic literary culture.

Not all the items on display evoke *paideia* on such a basic level, however. The sixth-century AD plate depicting Athena deciding whether Odysseus or Ajax should be awarded the armour of the deceased Achilles appeals to the viewer's knowledge of the Homeric epics (p. 66; cat. 86). This particular episode is not taken directly from Homer's narrative (although the quarrel between Ajax and Odysseus, and its consequences, are alluded to in Book XI of *The Odyssey*), and so arguably presents a greater challenge to the viewer's *paideia*. At any rate it is certainly possible to imagine the potential this scene would offer for individuals to display their knowledge of the characters and events inside and outside Homer's poetry. This subject is unique among surviving silverware, unlike that of the hero Meleager, who is depicted on an early seventh-century AD plate, as he prepares to go hunting with Atalanta (*right*; cat. 87). Other examples of him include the Meleager plate in the Sevso Treasure (fourth/fifth century AD), where he features with his companions in the Calydonian boar hunt in the plate's central medallion, and in a vignette on the plate's rim with Atalanta; as well as a sixth- or seventh-century AD plate in Munich where he is shown alone with the Calydonian boar. In each case, he is portrayed in a different composition, suggesting not a design passed between workshops, but the enduring popularity of a hero admired in the Roman world as an example of manly *virtus*, or bravery. The Hermitage plate focuses attention on the relationship between Meleager and Atalanta, the two central figures of the composition. Viewers might therefore have been encouraged to recall the traditional use of hunting as a metaphor for amorous pursuit in literature; equally they might anticipate the tragic outcome of this love in the Calydonian boar hunt.[2]

The early Byzantine silver from the Hermitage shows that *paideia* survived as an important cultural influence on the visual arts in the sixth and seventh centuries AD. At the same time, we must remember that classicizing silver with traditional iconography was not the only type produced in this period. A large number of plain silver plates survive from the sixth and seventh centuries AD, decorated only with a cross or cross-monogram surrounded by a wreath or scroll. These too were intended for domestic use, and hint at the increasing encroachment of Christianity on secular and private life. At the opposite end of the spectrum in terms of quality, the seventh century AD saw the production of the David plates, a set of nine plates of varying sizes depicting the early life of the biblical King David. They combine biblical subject matter with a classical style to equal that of the Hermitage plates. Indeed, there are close resemblances between the depiction of armour in the David plates and the plate with the quarrel between Odysseus and Ajax. But the David plates can be seen as being in direct competition with the Homeric subject of the Hermitage plate, in as much as the particular choice of narrative (which focuses on his victory over Goliath and the events leading up to it) seems designed to present a Christian alternative to the heroes of classical mythology. Byzantium of the sixth and seventh centuries AD was a society in

2. Meleager gave the boar's head to Atalanta, thereby offending his uncles; in the ensuing quarrel he killed them. When Meleager was born, his mother had been told he would live until a log of wood on the fire burnt through. She took the log from the fire and kept it, until, distraught by her brothers' deaths at Meleager's hands, she threw it back on the fire. Shortly afterwards Meleager expired.

transition. The diversity of the silver surviving from this period gives us vital insights into that period of transition, insights that cannot be obtained from surviving written sources. When we look forward to the art of ninth- and tenth-century AD Byzantium, we should not be surprised that its occasional revivals of classical iconography are concentrated in the luxury arts, since it was in the luxury art of silverware that both classical styles and iconographies survived the longest in the art of late antiquity.

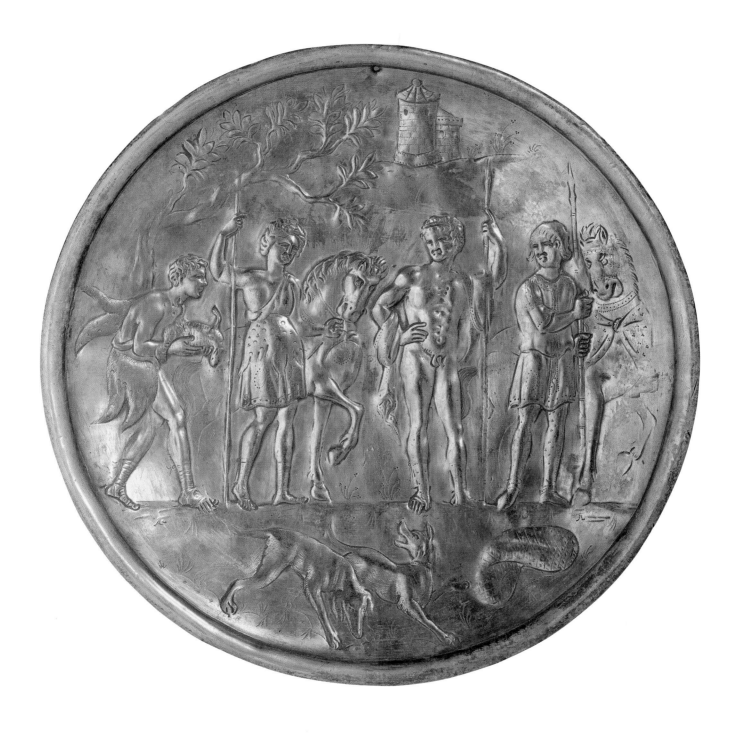

Plate with Meleager and Atalanta
Constantinople, AD 613–629
cat. 87

Antony Eastmond and Peter Stewart

ANCIENT CLASSICISM
IN RETROSPECT

The Road to Byzantium is an exhibition about continuity. It demonstrates the extraordinary longevity and geographical diffusion of classical Greek styles and imagery over the course of a millennium and more. But to tell the story of their enduring appeal requires a rather unconventional selection of objects. Alongside typically classical works of art such as Attic red-figure vases and Roman portrait busts are objects which seldom appear in surveys of classical art (from miniature gold plaques to Coptic textiles) and those whose classical traits disguise complex, sometimes surprising histories (a statuette of Dionysos inscribed with the words of a psalm; classical imagery on Sasanian vessels from beyond the territories of the Roman and Byzantine Empires). The *gorytos* cover from Chertomlyk introduces the history of classical gold working in strikingly paradoxical fashion: it is a beautiful example of classical style and iconography, undoubtedly the work of a Greek craftsman, depicting Greek mythological scenes, yet associated with that most 'un-Greek' of weapons, the bow and arrow, and recovered from the burial of a Scythian aristocrat far to the north of the Black Sea (*left*, pp. 106–7; cat. 9).

Above all, as the *gorytos* cover reminds us, to tell a story of classical continuity on this scale requires close consideration of luxury works of art which are such an important part of the Hermitage collections, but which survive relatively rarely elsewhere. For it is particularly in luxury media that the traditions of Greek classicism were preserved through antiquity and into the Middle Ages.

A different selection of objects would tell a different story. Just as traditional accounts of the development of Byzantine art have tended to concentrate on religious art, especially icons, the history of classical Greek and Roman art often focuses on sculpture in stone, which survives in relative abundance from those periods. But any conventional narrative of the development of classical art that puts such an emphasis on sculpture will inevitably describe a disintegration of classical forms, the disappearance of classical techniques, which seems to characterize late Roman art of the third and fourth centuries AD.

LEFT
Cover Plate for a Gorytos with Scenes from the Life of Achilles (detail)
Northern Black Sea region, 350–325 BC
cat. 9

Roundels (2nd century AD) and Frieze (4th century AD)
The Arch of Constantine, Rome (detail)

Since the days of Vasari, the early fourth-century AD Arch of Constantine in Rome has been used to illustrate this apparent 'decline' of the classical tradition, for it notoriously combines reused, highly classical, naturalistic and illusionistic relief sculptures of the second century AD with contemporary, Constantinian friezes (*above*). The latter, with their squat, two-dimensional, repetitive figures and their symbolic rendering of space, have always seemed to encapsulate the ascendancy of non-classical forms in late antique art.

In reality the comparison is somewhat specious. It is certainly not a comparison of like with like, for the various sculptures of the Arch performed rather different roles, and in any case its fourth-century AD reliefs can hardly be seen as straightforwardly typical of all sculpture of the period. On the other hand, the Arch of Constantine does point to a genuine phenomenon of transformation in late Roman sculpture, even if it is now rare for scholars to talk of 'decline', and the gradual disappearance of classical style in public monuments is increasingly related to the expressive needs and expectations of late antique patrons and viewers, rather than the ineptitude of the artists.[1]

On a much longer timescale the disintegration of classicism in Roman sculpture can be observed from the history of portraiture. Very high-quality, often highly classical, naturalistic and sensitive portraits in stone and bronze do survive from the fourth century AD and later, notably from eastern provinces of the Empire. Yet there is a manifest tendency towards abstract and schematic features, particularly in portraits of emperors. The qualities of the earlier Roman portraits in the exhibition are almost entirely absent from the portraiture of the late Empire. In fact, earlier portraits were frequently reused and recut in late antiquity. And the numbers of works produced evidently plummeted. There is, for example, a pronounced drop in the number of public portrait statues, extant or attested through inscriptions and other sources, from the later third century AD on. By the seventh century AD the portrait statue, an art-form that had commanded the utmost esteem for a thousand years of Greco-Roman history, had virtually vanished, to be fully revived only many centuries later.[2]

1. For traditional and more positive interpretations of the Arch *see* e.g. Elsner, 2000.
2. On the transformation and disappearance of portrait statuary *see* e.g. Stichel, 1982; Smith, 1985, pp. 209–21; Smith, 1999.

This story of transformation in sculpture seems to offer a foil for *The Road to Byzantium*; for the exhibition presents works of art spanning exactly the same period, but which show how certain classical traits remained in use, virtually unchanged. Certainly this is an alternative art-historical route. That does not mean, however, that *our* history is more true, or even that old notions of artistic decline are altogether *untrue*. It means merely that the extraordinary and precious works preserved in the Hermitage – chance survivals from the fringes of the classical and Byzantine worlds – present the classical tradition from a different perspective.

The fact that such fundamentally different accounts of ancient classicism can exist says something about the danger of any generalising narrative. What we are dealing with is the very partial survival of classical art, in certain media, for the representation of particular traditional subjects, in certain social contexts. The essays in this catalogue and the objects themselves give an indication of how and why this may have occurred. What is important is that this 'continuity' coincides exactly with the traditional story of decline and transformation.

It is perhaps easy to see why luxury art in particular – works that were treasured, discussed, exchanged within a highly educated late Roman aristocracy wedded to traditional values – should have lent themselves to the use of ancient classical styles and mythological imagery where sculpture did not. Yet increasingly it appears that a contrast emerged within the tradition of sculpture itself. A number of late antique sculptures intended to furnish rich houses and villas – representations of pagan deities and mythological subjects – display a classicism of style and iconography which (like that of the Byzantine silver) misleadingly implies a much earlier date. Such is the case, for example, with a group of large-scale statues of Poseidon, Helios, Zeus (?), Herakles and a satyr, from the Esquiline Hill in Rome (*below*). Most scholars now accept an argument based on the sculptors' signatures that these works were made in at least the middle of the fourth century AD, where previously their style had led to suggestions of the late second or early third century AD. Similarly, the villa at Chiragan in France contained an extraordinary series of large-scale, naturalistic relief sculptures of the labours of Herakles which appear to be fourth-century AD creations, though stylistically and technically they could scarcely be more different from the late antique reliefs of the Arch of Constantine.[3]

A taste for classicism in certain domestic sculptures corresponds to the traditional artistic interests that continue to manifest themselves in late antique literature. Here we still find the art-critical commonplaces that are so prominent in the work of earlier authors: references to the proverbially great masters of classical Greek art – the likes of Praxiteles and Apelles – and an admiration for the lifelike qualities of naturalistic sculpture.[4]

The classicizing sculptures that survive from late antiquity do not quite suggest classical continuity to the extent that the luxury arts do, but they do imply that even across very

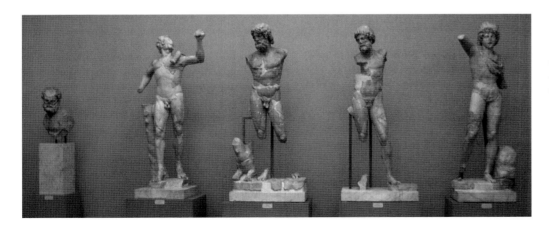

Marble Statues of Herakles, a Satyr, Poseidon, Zeus (?) and Helios
4th century AD
from the Esquiline Hill, Rome

3. On these examples of classicism in late antique sculpture *see* Kiilerich, 1993, pp. 230–3; Hannestad, 1994, pp. 105–60; Bergmann, 1999. For the debate over the Esquiline group *see* Roueché and Erim, 1982; Moltesen, 2000.
4. *See* Elsner, 1998, pp. 243–9 (especially on the writings of Callistratus).

different media classical principles continued to be deemed suitable and desirable to represent the literary and mythological themes that dominated the leisure of the cultivated Roman nobility. Conversely, it should be stressed, we might point to a whole range of late antique works, in both luxury media and sculpture, for which classical idioms were less obviously appropriate: works pertaining to the sphere of government, imperial power, and political self-representation, in which the symbolic representation of space, frontality of figures, hierarchy of scale, and diminished naturalism – the spectrum of 'typical' late antique traits – were all perfectly suited. Examples include the famous Missorium of Theodosius, a huge late-fourth-century AD commemorative dish, which depicts the emperor and his sons as the focus of court ceremonial. The figures' stark frontality and the hierarchical distortion of scale contrast with a classicizing personification of the Earth beneath their feet. In this exhibition, the silver bowl representing (probably) Constantius II on horseback falls into the same category (*below*; cat. 62), for like the Missorium of Theodosius it preserves aspects of classical style, but they are consciously subordinated to the need to communicate the emperor's authority as boldly and lucidly as possible.[5]

These various contradictions complicate any attempt to explain the survival of classical imagery into the Byzantine period. But in fact they are an essential aspect of the tradition of classical art, even at a much earlier stage. For, in their plundering of the heritage of Greek art, artists of the Roman Republic and early Empire had already shown themselves to be adept at picking and choosing from the repertoire of classical forms.

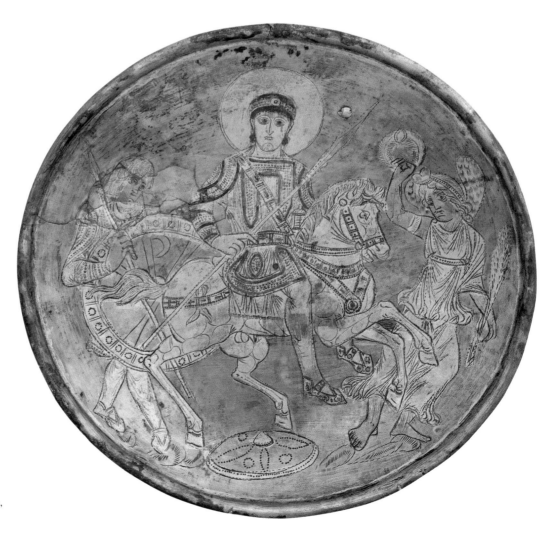

Bowl with the Triumph of Constantius II
Antioch, mid-4th century AD
cat. 62

5. On such scenes and their purpose *see* Leader-Newby, 2004, pp. 11–59.

Roman artists have often been disdained in the past for their dependence on earlier Greek models. (A whole class of Roman sculpture – 'ideal sculpture' – has been written out of most histories of Roman art because it has been viewed as merely derivative neo-classicism or, at best, copying.) Attitudes have, however, been changing over the last few decades. It is now appreciated that, from the whole spectrum of classical Greek art, Roman artists and their patrons selected their models, almost intuitively perhaps, according to how differing styles and images fit their purposes. Their choices were governed by a sense of aesthetic *decorum* by which the varieties of classicism were suited to different subjects and genres, different art-forms, different media and settings.[6]

It seems likely that this sort of sensibility about how the heritage of Greek classicism should be used survived into late antiquity. The persistence of classicism through the Roman and Byzantine periods was a complex phenomenon, to be characterised by plural-ism and selectivity. It is not a simple story of survival.

CONTINUITY AND RENAISSANCE

Further questions about continuity are raised in different ways by the youngest objects in this exhibition – notably the tenth-century AD Veroli casket (pp. 65, 81; cat. 103) and the early-thirteenth-century AD dish with the flight of Alexander (p. 114; cat. 133). How did the classical stories, motifs and styles survive this long into the Middle Ages, and what did they now mean to those who commissioned and used such objects? These medieval works are virtuoso displays of the technical skills of ivory carving and metal working; they adopt a naturalistic style and depict historical and mythological figures from the classical world, all in ways that match anything that precedes them in this exhibition. They fit seamlessly into the long narrative of classicism, and bring the story down to the thirteenth century AD and beyond. But does this apparent continuity hide more than it reveals? Consider how far removed both objects are in time from those of late antiquity, let alone the classical Greek world. Constantinople by the tenth century AD was a very different city from that in the age of Constantine the Great (306–37) or Justinian (526–75). The landscape of the eastern Mediterranean had been transformed by the rise of Islam in the seventh century AD. An Islamic Caliph now ruled what had once been Rome's and Byzantium's eastern and south-ern provinces in Syria, Egypt and North Africa. Islamic armies had hammered at the gates of Constantinople in the seventh and eighth centuries AD, but without success. In the west, Byzantium's monopoly on the inheritance of Rome was challenged by the rulers of the Holy Roman Empire in Germany and Italy. Its religious identity was now resolutely Christian, and its view of the past now revolved as much around the spiritual legacy of Jerusalem as around the political legacy of Rome. The century of iconoclasm (*c.* 726–87 and 815–43) had forced theologians to produce an elaborate justification for religious art, which now had a spiritual power as a window into Heaven, allowing direct communication between man and God.

The long gap between the final objects of late antiquity and those of the tenth century AD, and the political, social and religious changes that accompanied it, has often been seen as the Byzantine Dark Ages. The scant artistic survivals from this period make it difficult to reconstruct an unbroken path from the Pereshchepina burial silver or the seventh-century AD flask with nereids (pp. 70, 105; cat. 82) to the tenth-century AD Veroli casket. This has led to the suggestion that what these later pieces represent is a 'Renaissance' – a rediscovery and rebirth of classicism in the Middle Ages, up to four hundred years before the Italian Renaissance. But it is doubtful whether anyone connected with these works would have recognised the idea of a rebirth of the classical past. On the contrary, they thought that they

Floor of a Bowl with a Representation of St George (detail)
Byzantium, 12th century AD
cat. 134

6. *See* Hölscher, 2004; Perry, 2005.

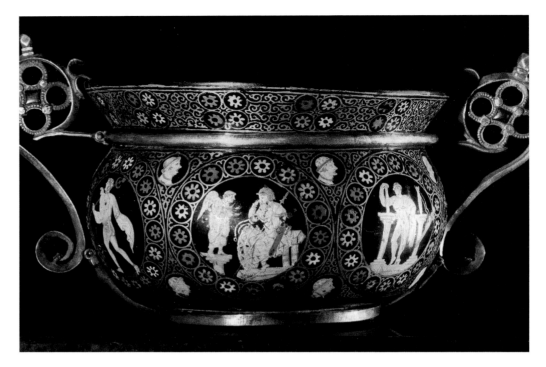

Glass Bowl with Classical Imagery
10th century AD
Treasury of San Marco, Rome

were its living embodiment. Walking through the streets and fora of Constantinople, visitors and inhabitants would have been surrounded by memories and objects from the classical past. Writing in exile in Nicaea in about 1207 the imperial secretary Niketas Choniates was able to recall the hundreds of classical statues that had stood in the city until the calamity of the fall of the city to the forces of the Fourth Crusade only a couple of years earlier.[7] More than 300 such statues, including works by Pheidias, Praxiteles and others, had been brought to the city in its early years, and even though some had been lost over the centuries, many remained as part of the day-to-day visual environment.[8]

The inhabitants of the Byzantine world regarded themselves as Romans and their emperors as the direct successors of Caesar and Augustus, and this was proclaimed in the titles that were used down to the fall of Constantinople in 1453: 'Faithful in Christ God, Emperor and Autocrat of the Romans'.

The concept of a rebirth does not fit a culture that itself saw no break with the classical past, and treasured itself as the maintainer of those very traditions. The appearance of classical motifs in the last centuries of Byzantium was not so much a revival of a lost past, but a period of renewed, accentuated interest in something that was always there, a core element in the identity of the empire, woven into the very fabric of its political institutions, its physical monuments and its educational system.

However, it is one thing to promote yourself as the living embodiment of continuity, and another to understand that tradition in the same way. The variety of ways in which the imagery on the Veroli casket has been described – eclectic, whimsical, confused or satirical – indicates the problems in understanding how such ancient stories were perceived in the Middle Ages (*right*). And similar problems have arisen with the interpretation of the apparently random array of mythological scenes on a glass bowl made at about the same time as the Veroli casket, and now in the Treasury of San Marco in Venice (*above*).[9]

Has the classical world only survived by the skin of its teeth, with its visual language – its stylistic and iconographic vocabularies – preserved, but its meaning at best incompletely understood? Or are we witnesses to the teasing games of the educated rich, conflating and juxtaposing myths to confound their friends? Both these interpretations see such objects in very different ways, but equally both rely on a very different relationship between the myths

7. Cutler, 1968; Niketas Choniates, 1984.
8. Now usefully catalogued by Bassett, 2004.
9. Kalavrezou-Maxeiner, 1985.

and their viewers: the classical past now lives on in a different way, as an archive to explore, rather than a tradition to live.

If Byzantium, and especially Constantinople itself, carried the torch of classicism into the Middle Ages, then the flame passed to Venice in the thirteenth century AD. At the same time as they oversaw the dismemberment of the Byzantine Empire in 1204 when they diverted the Fourth Crusade away from the Holy Land to Constantinople, the Venetians claimed its mantle for themselves.[10]

As possessor of 'one quarter and one half of one quarter' of the empire after 1204, Venice self-consciously adopted the role of political and cultural successor of Rome in the thirteenth century. This was most visibly displayed on the façade of the dogal church of San Marco in the centre of the city. The exterior was largely decorated with spoils from Constantinople, including the four bronze horses presumably taken from the entrance gates of the hippodrome. Although this preserved these rare classical bronzes for posterity, and declared Venice's role as inheritor of the classical past, it also transformed that past, now presenting the horses not as a chariot-racer's quadriga, but as the chariot of Christ.[11]

Similarly, beneath the horses a series of six relief marble plaques above the entrances to the church combined images of saints with those of Herakles. A late antique carving of the hero was paired with a medieval copy, demonstrating not only the continuity of the classical, but also its transformation, as now the pagan hero was presented as a prototype for the struggle and triumph of Christianity itself.[12]

The road to Byzantium ensured the survival of classicism for more than a millennium. However, it is a story in which transformation is as important as continuity. The objects displayed here from the Hermitage show the ways in which those ideas, first developed at the time of the 'Greek Revolution' in the fifth century BC, were admired, copied, challenged and reinterpreted by peoples of different cultures and religions in ways their first creators could never have imagined.

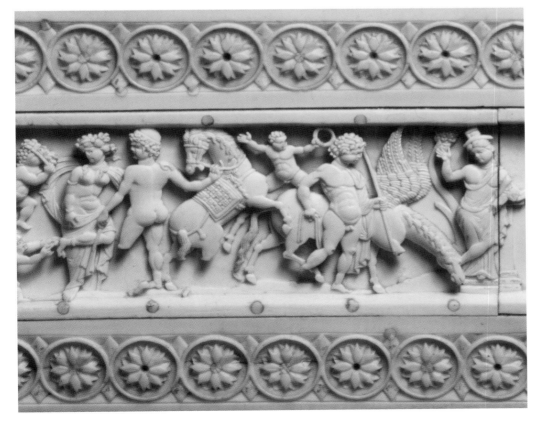

The Veroli Casket (detail)
Byzantium (probably Constantinople)
mid-10th century AD
cat. 103
Victoria & Albert Museum, London

10. Brown, 1996.
11. Jacoff, 1993.
12. Demus, 1955; Demus, 1995.

Red-figure Krater with a Girl and an Old Man (detail)
Attica, Achilles Painter, *c.* 460 BC
cat. 6

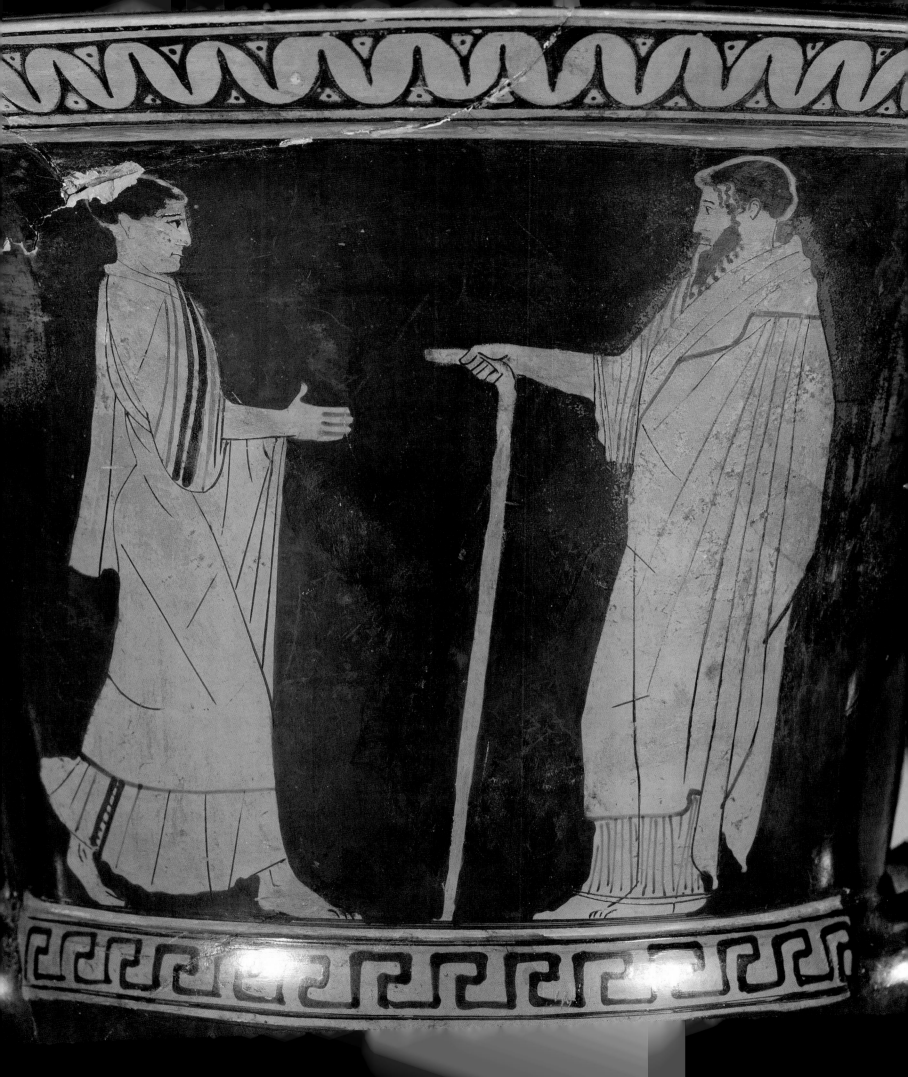

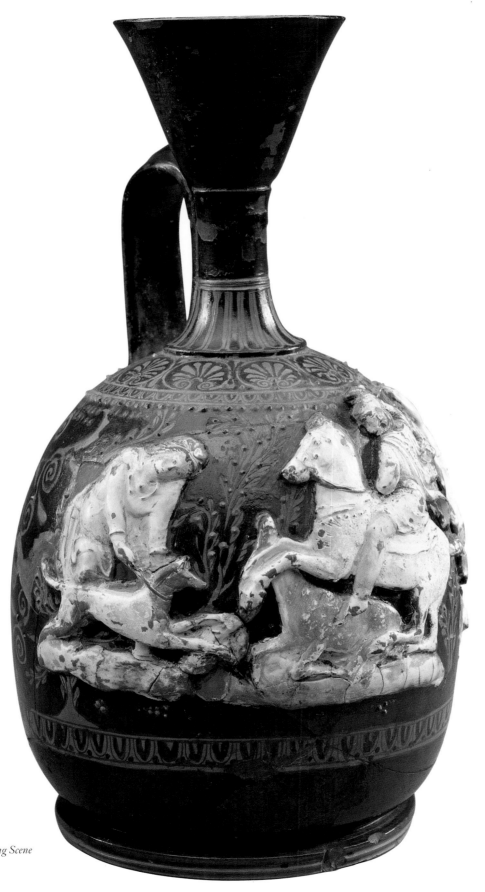

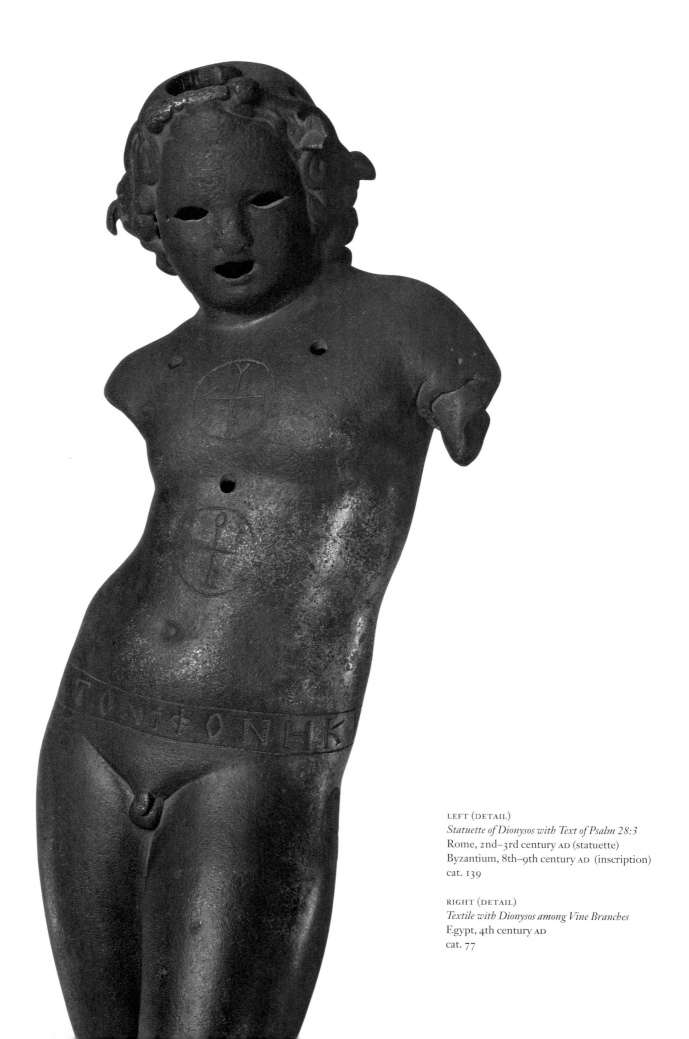

LEFT (DETAIL)
Statuette of Dionysos with Text of Psalm 28:3
Rome, 2nd–3rd century AD (statuette)
Byzantium, 8th–9th century AD (inscription)
cat. 139

RIGHT (DETAIL)
Textile with Dionysos among Vine Branches
Egypt, 4th century AD
cat. 77

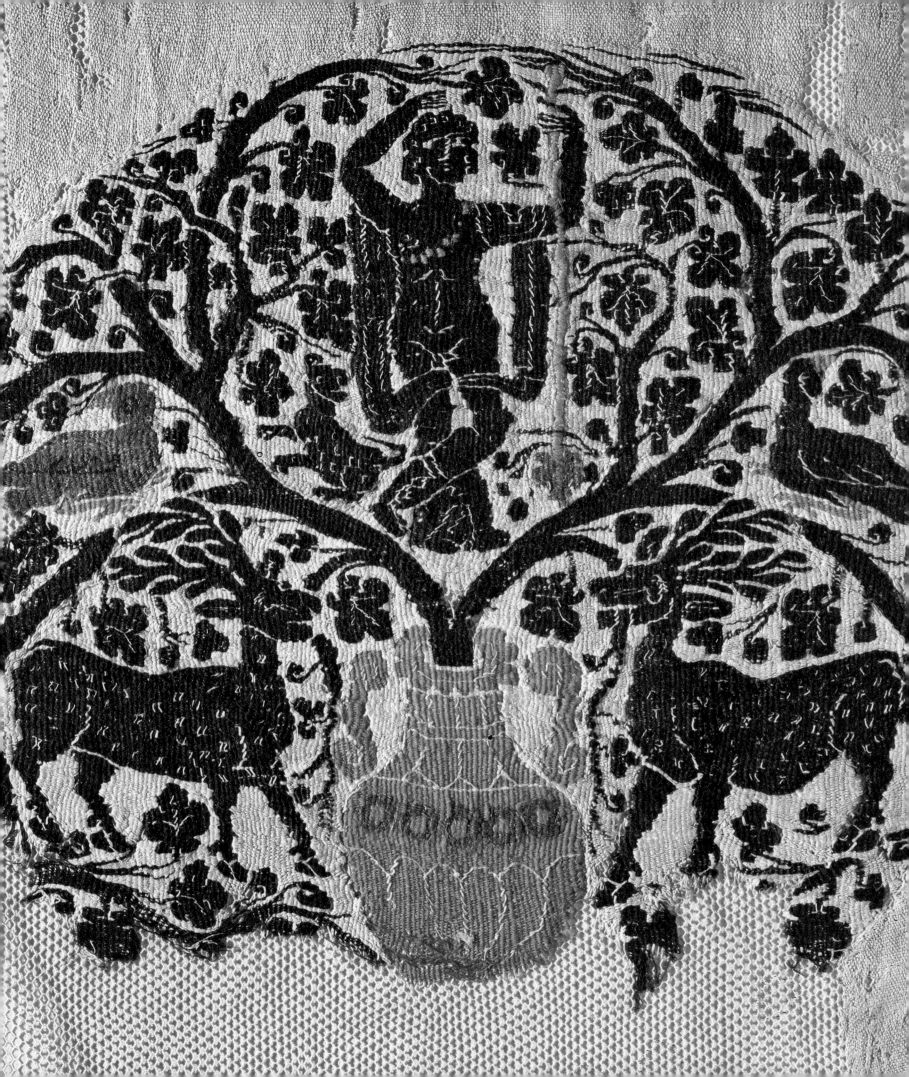

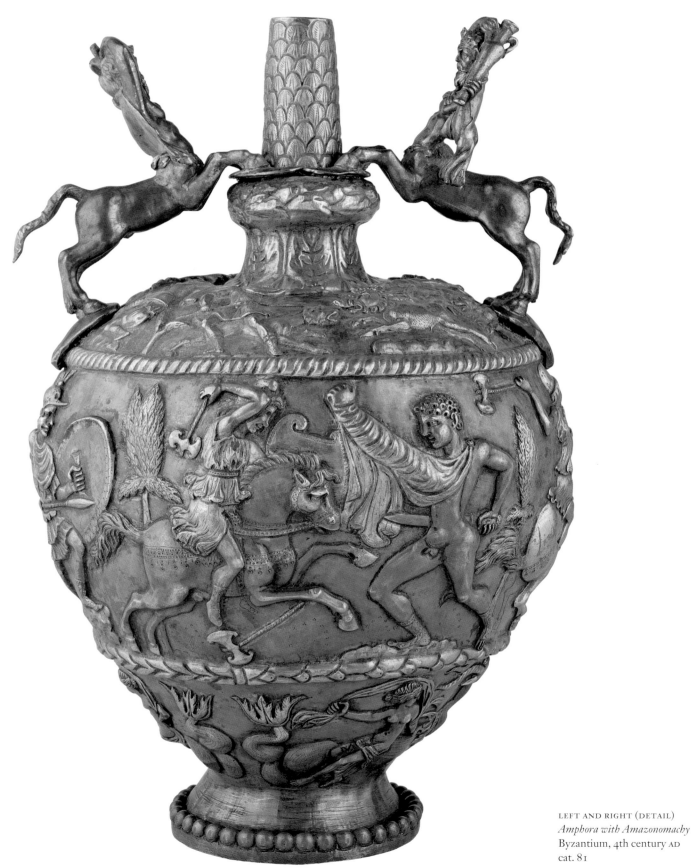

LEFT AND RIGHT (DETAIL)
Amphora with Amazonomachy
Byzantium, 4th century AD
cat. 81

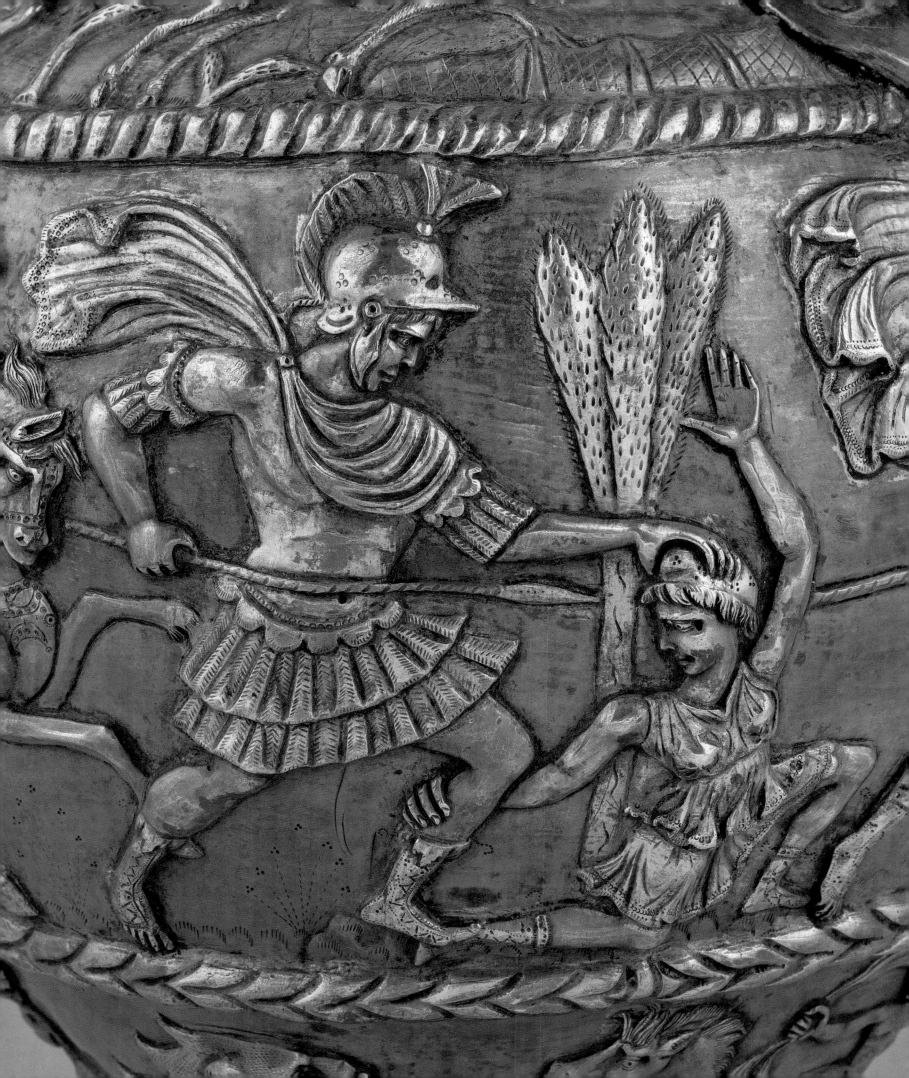

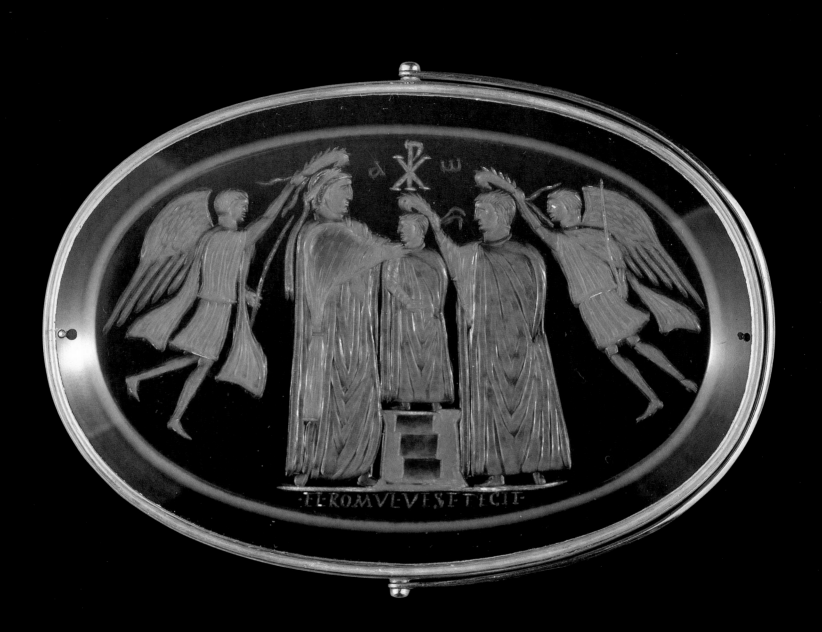

LEFT
*Intaglio with the Investiture
of Valentinian III*
Rome or Ravenna, *c.* AD 423
cat. 65

RIGHT
*Cameo with Constantine the Great
and the Tyche of Constantinople*
Rome, 4th century AD
cat. 60

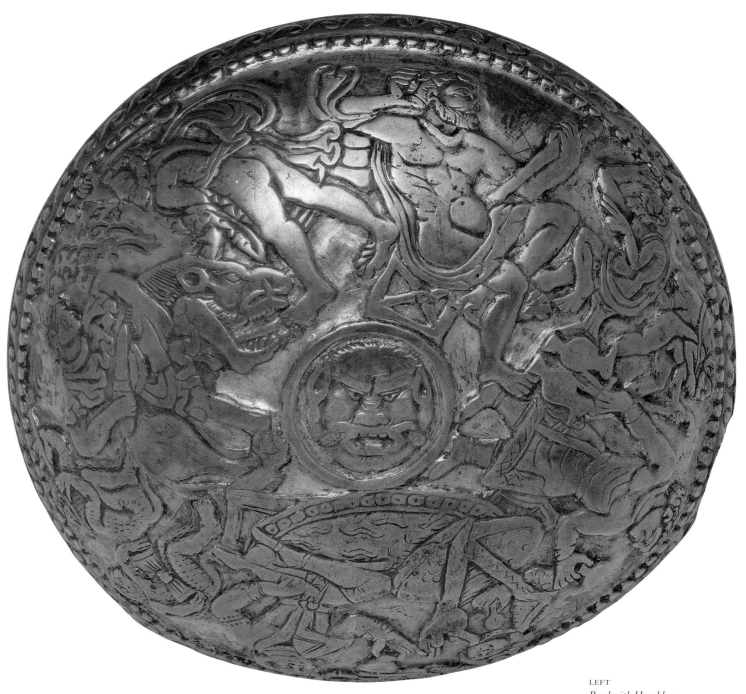

LEFT
Bowl with Herakles
Northern Tokharistan (Central Asia)
6th–7th century AD
cat. 90

RIGHT
*Textile with Dionysos and Ariadne
and the Twelve Labours of Herakles*
Egypt, 5th century AD
cat. 69

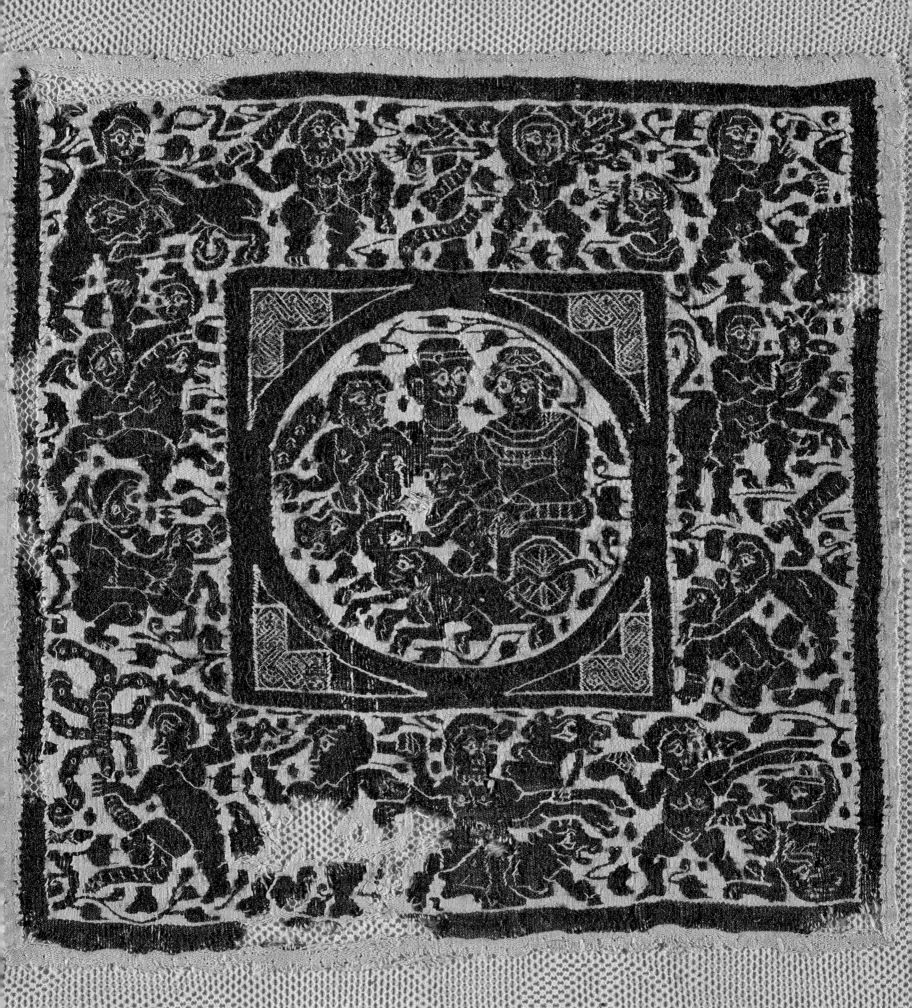

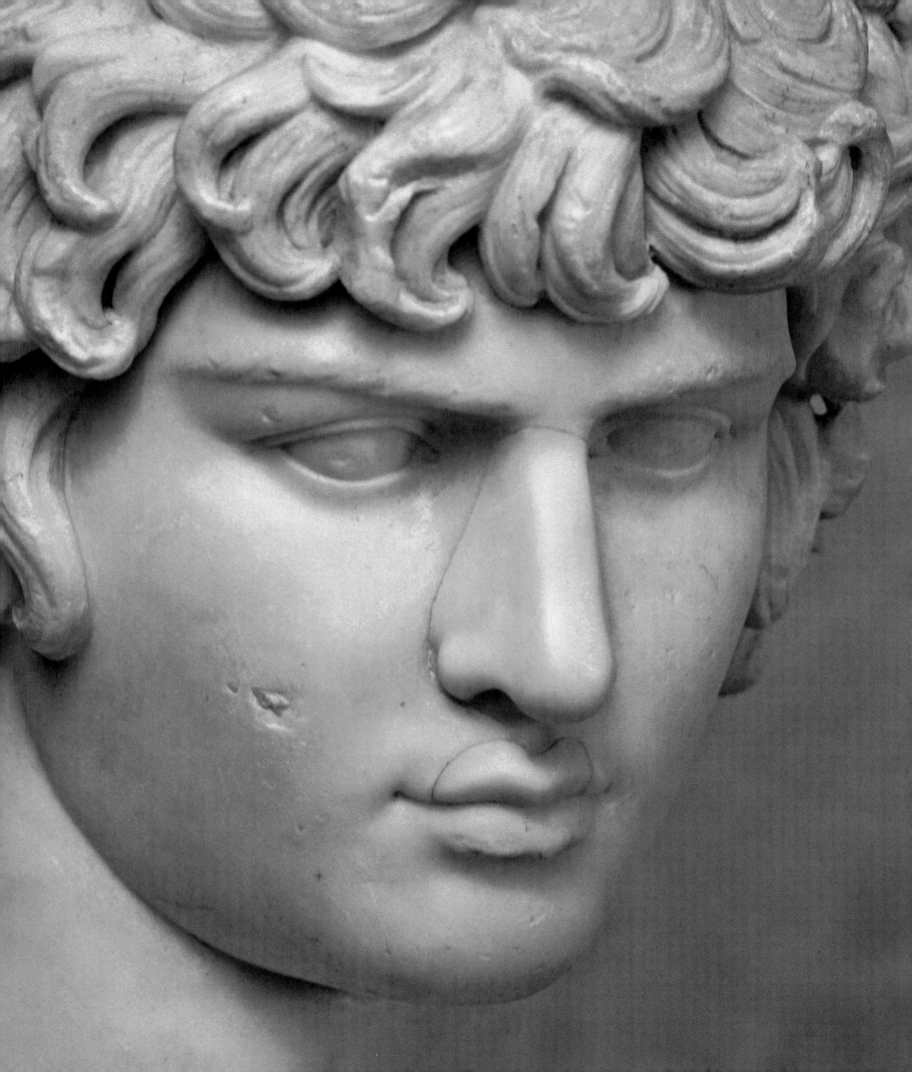

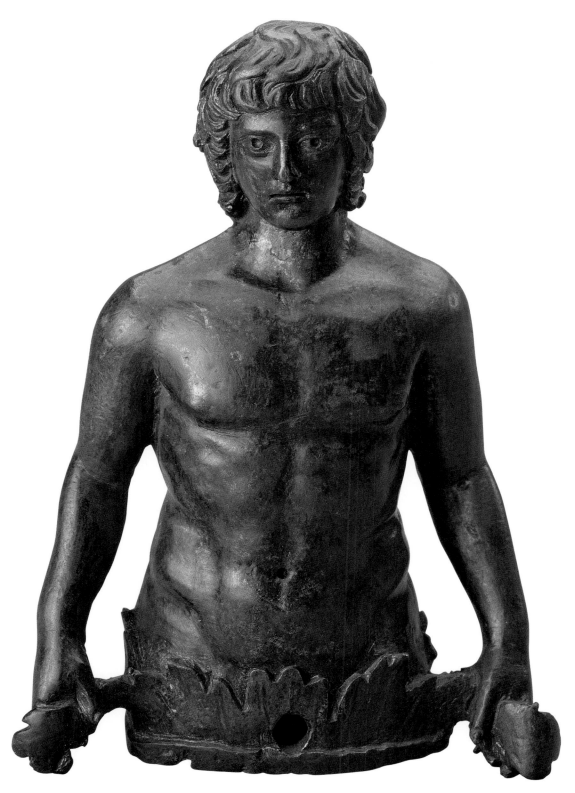

LEFT (DETAIL)
Portrait of Antinous as Dionysos
Rome, second quarter of 2nd century AD
cat. 34

RIGHT
*Chariot Decoration in the form
of a Half-figure of Triton*
Thrace, late 2nd–early 3rd century AD
cat. 41

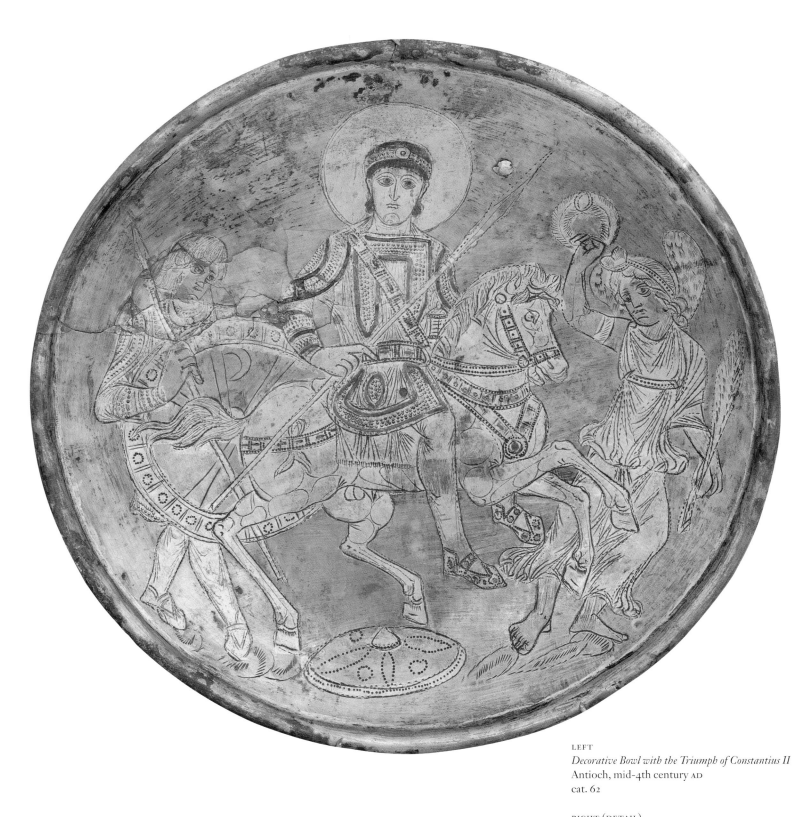

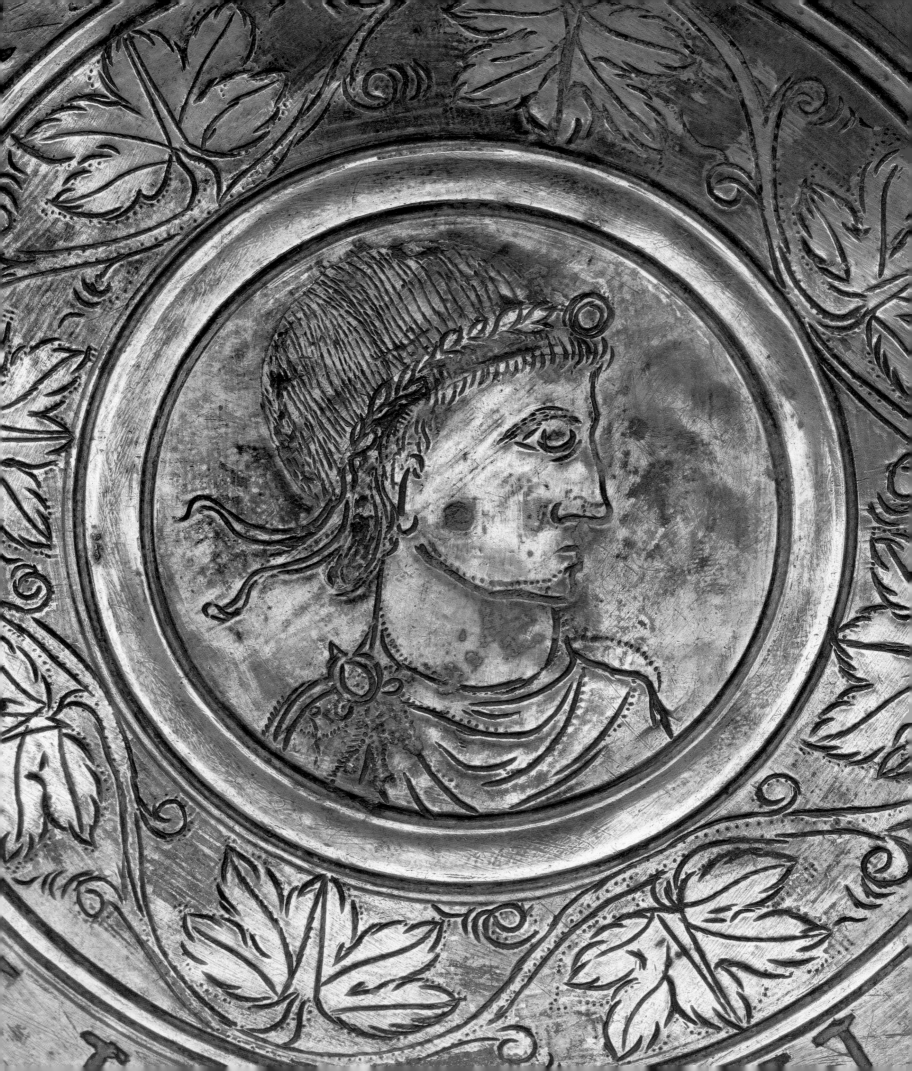

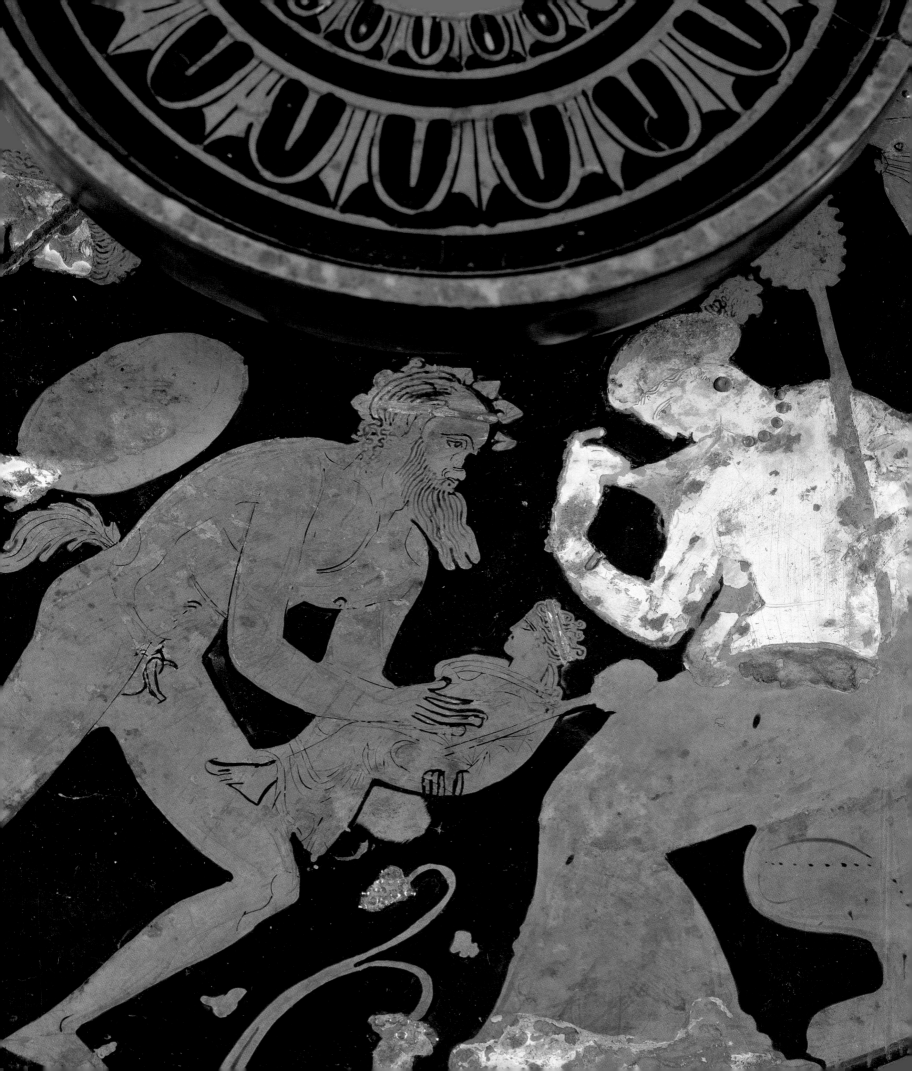

LEFT (DETAIL)
Red-figure Lekanis with the Infant Dionysos
Attica, 370–360 BC
cat. 16

ABOVE
Plaque with a Dancing Girl
4th century BC
cat. 24

RIGHT
Plaque with a Dancing Girl in a Kalathos
4th century BC
cat. 25

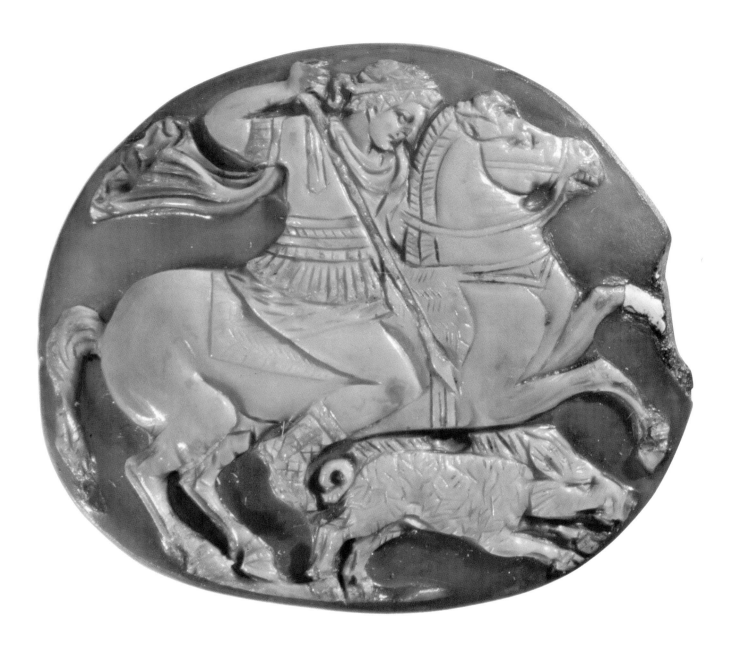

LEFT
Cameo with Alexander the Great Hunting a Boar
Rome, 1st century AD
cat. 43

RIGHT (DETAIL)
Kylix with Bellerophon Killing the Chimaera
Attica, 470–460 BC
cat. 5

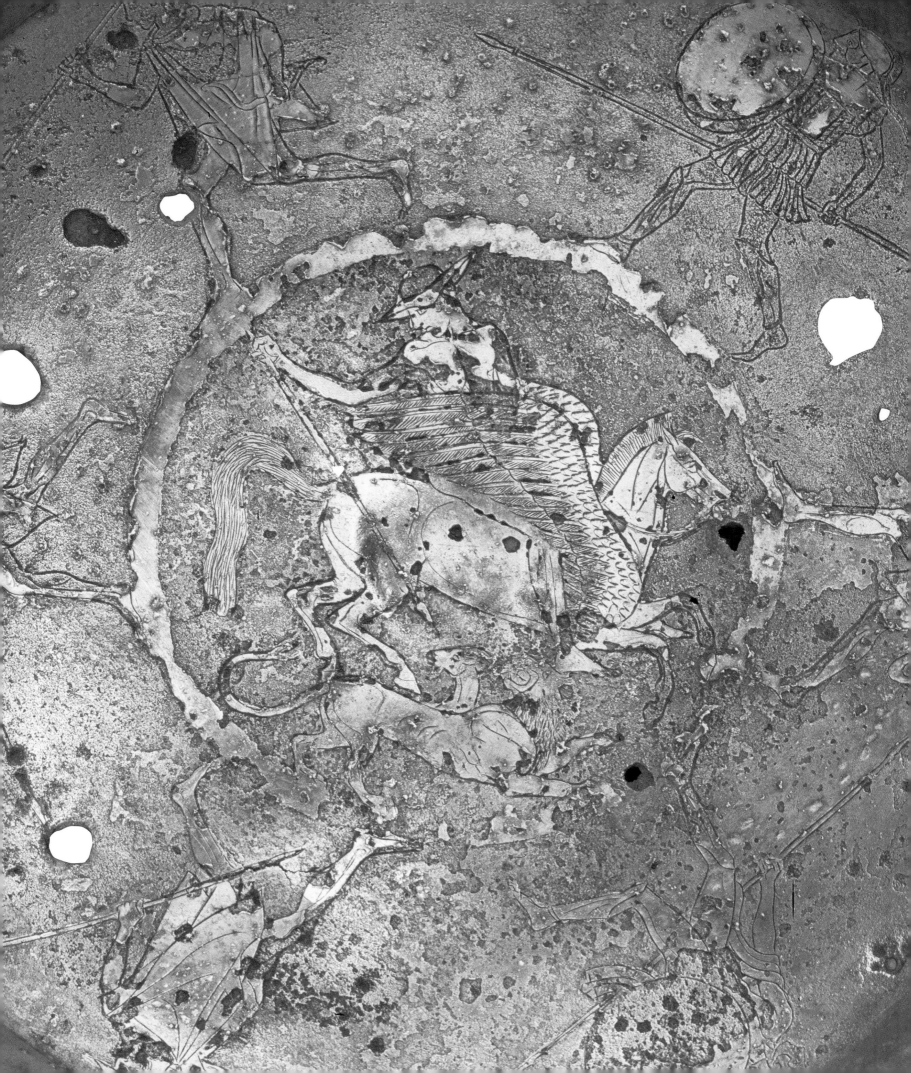

LEFT
Scaraboid with a Running Medusa
Eastern Mediterranean, 5th century BC
cat. 12

RIGHT (DETAIL)
Jug with a Mask of Medusa
Eastern Mediterranean,
first quarter of 3rd century BC
cat. 26

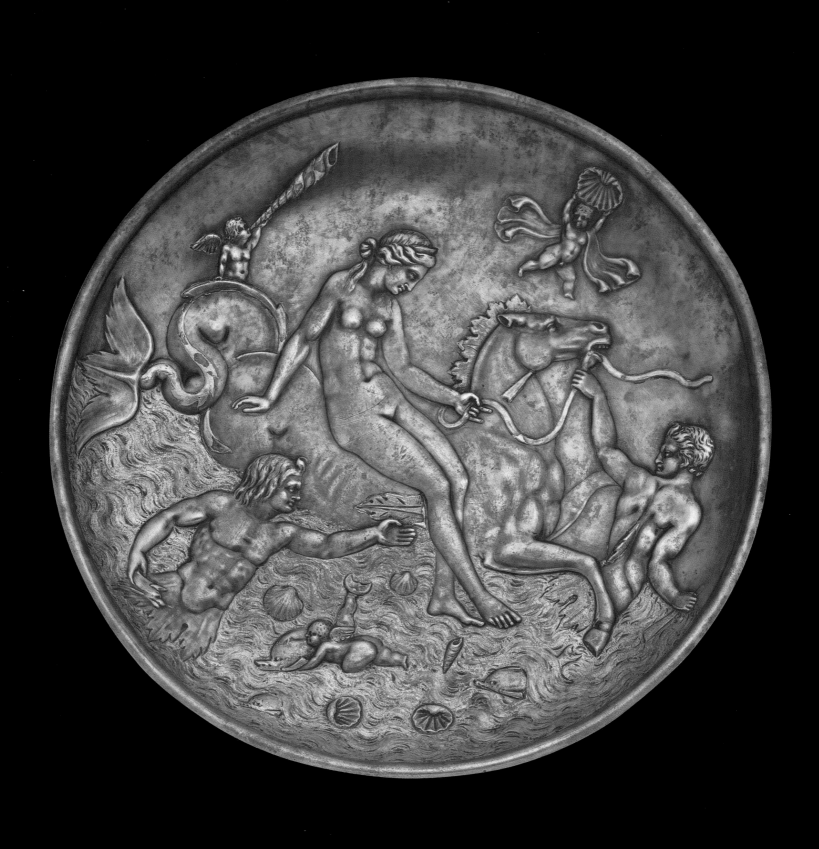

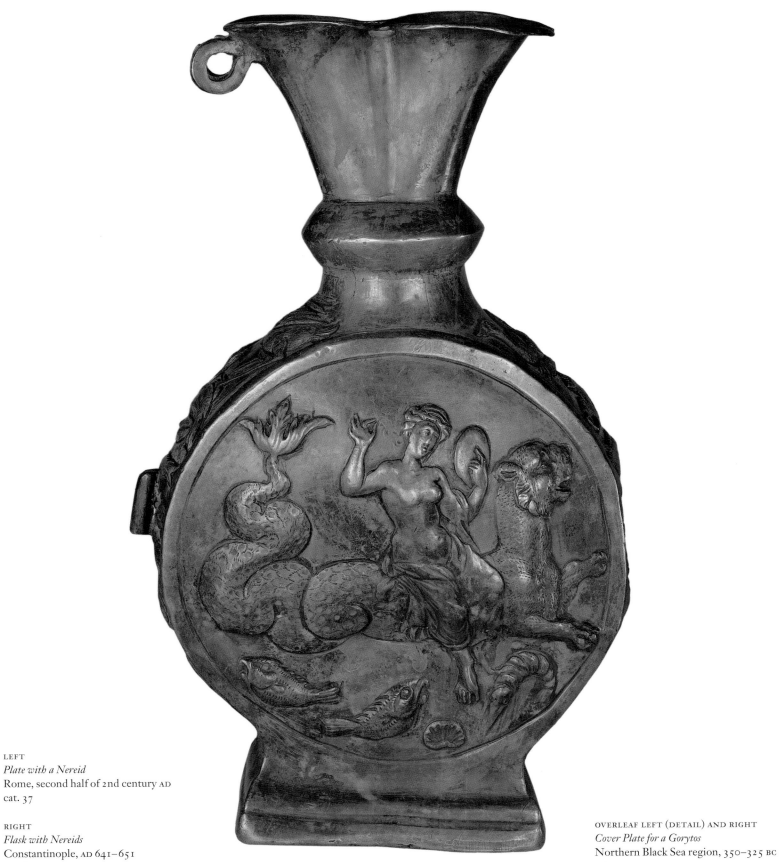

LEFT
Plate with a Nereid
Rome, second half of 2nd century AD
cat. 37

RIGHT
Flask with Nereids
Constantinople, AD 641–651
cat. 82

OVERLEAF LEFT (DETAIL) AND RIGHT
Cover Plate for a Gorytos
Northern Black Sea region, 350–325 BC
cat. 9

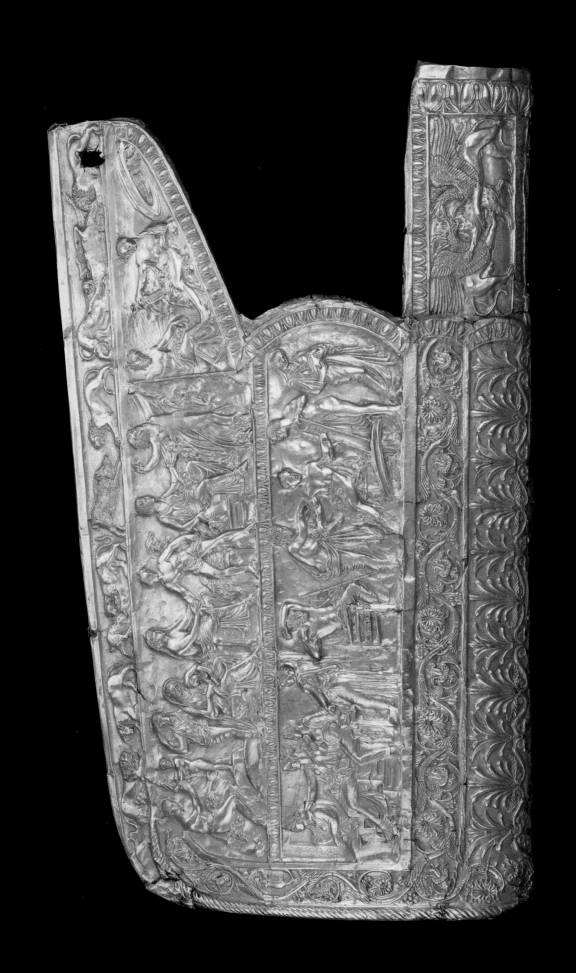

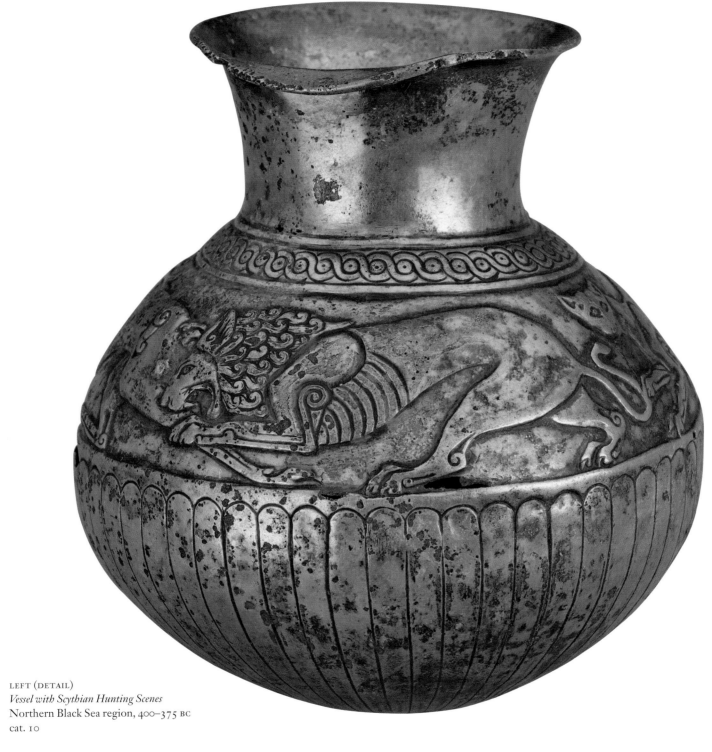

LEFT (DETAIL)
Vessel with Scythian Hunting Scenes
Northern Black Sea region, 400–375 BC
cat. 10

RIGHT
Vessel with Lions Tearing apart a Deer
Bosporan Kingdom, 4th century BC
cat. 30

LEFT
Seal of Basilios: Pigmy Fighting a Crane
Byzantium, second half of 6th to 7th century AD
cat. 159

RIGHT
Dish with Scene Derived from the Triumph of Dionysos
Sasanian, 3rd century AD (?)
British Museum
cat. 92

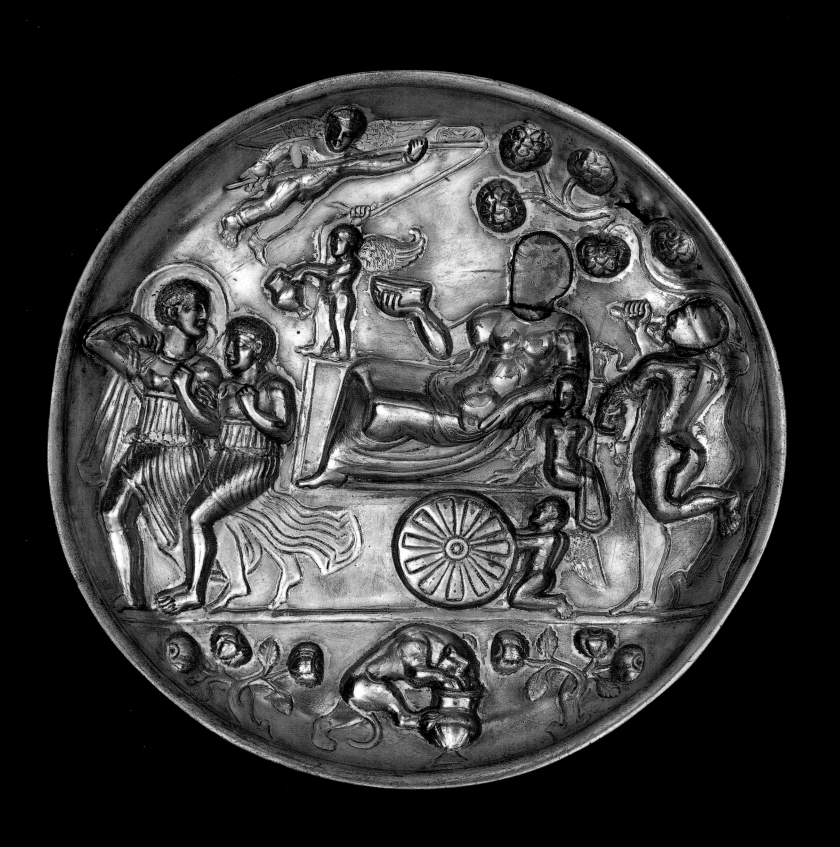

LEFT AND RIGHT (DETAIL)
Lamp with figures of Marsyas
Egypt, 4th–5th century AD
cat. 143

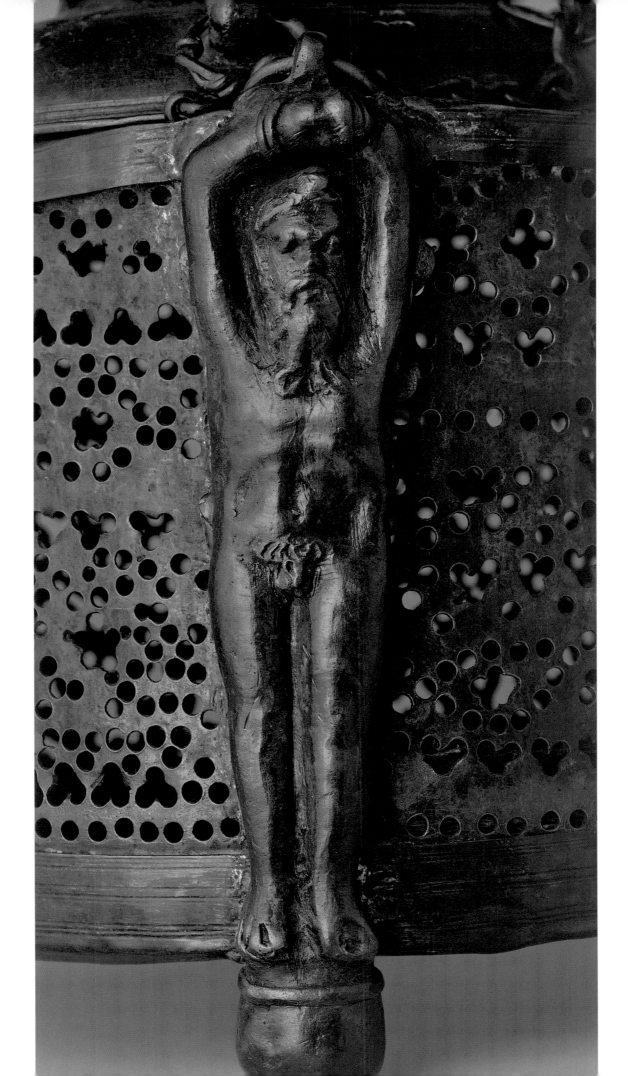

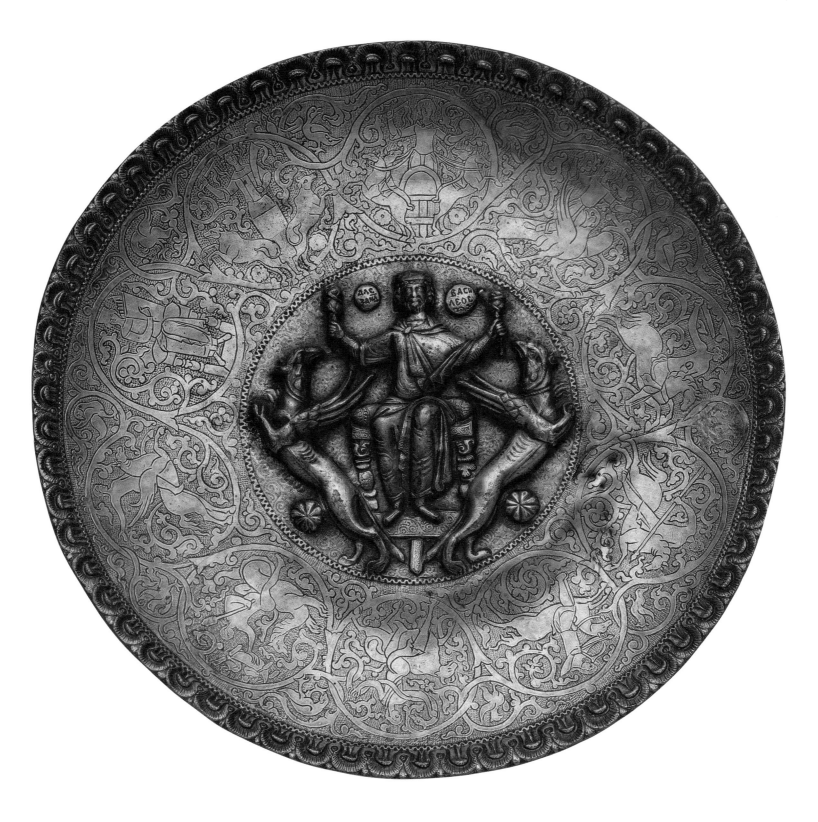

*Dish with the Flight of Alexander the Great
on Griffins*
Byzantium, 12th century AD
cat. 133

Textile with a Horseman
Egypt, 8th century AD
cat. 76

OVERLEAF LEFT (DETAIL)
Red-figure Hydria-Kalpis
with Polyxena and Achilles
Attica, Berlin Painter, *c.* 500 BC
cat. 2

OVERLEAF RIGHT (DETAIL)
Patera with Ajax
Bearing the Body of Achilles
First half of 1st century AD
cat. 36

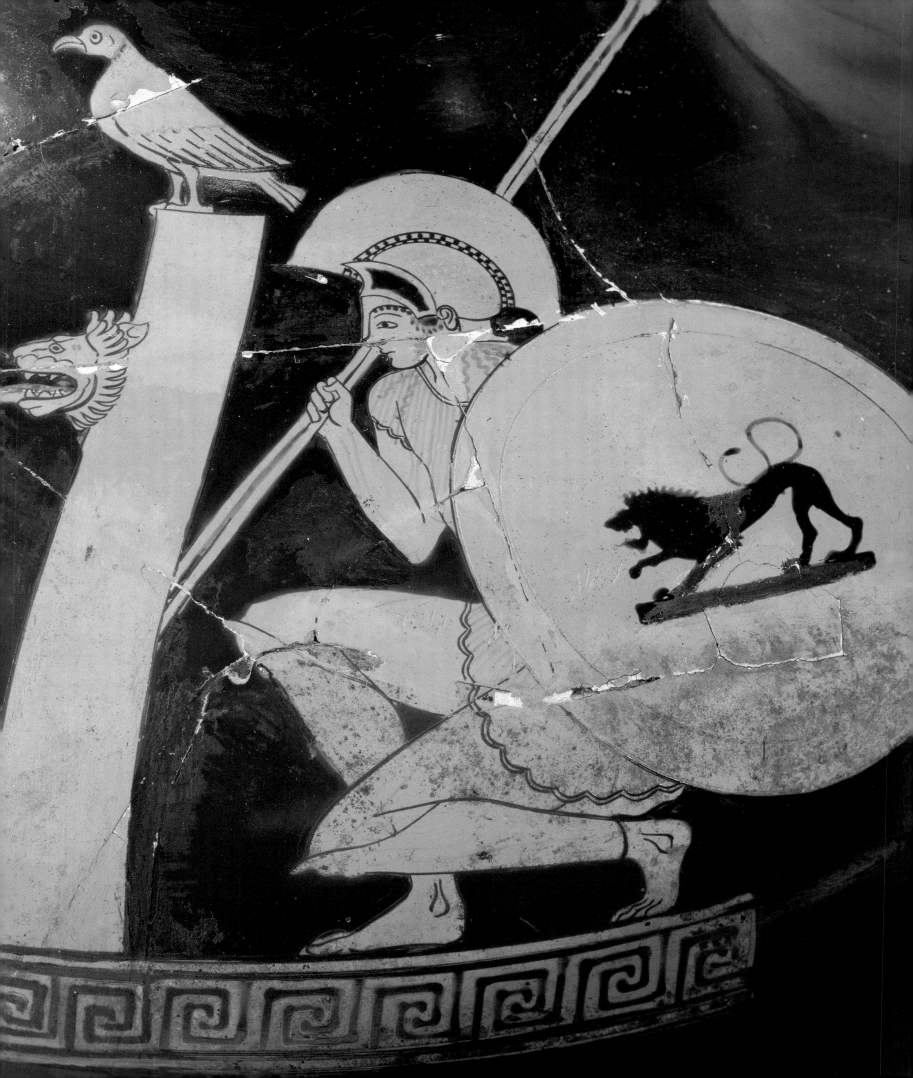

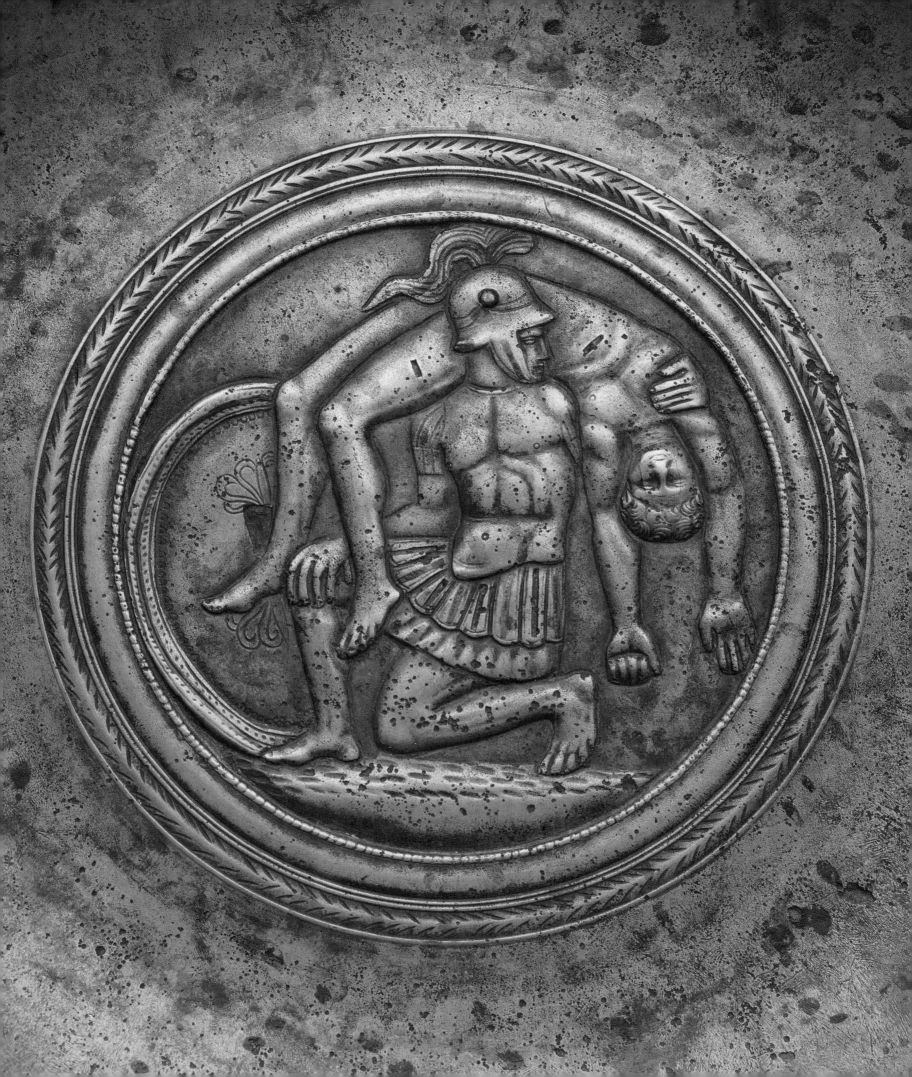

LEFT
Cross with the Archangel Michael
Syro-Palestinian Region, 10th century AD
cat. 142

RIGHT
Intaglio with Victory
Rome, 2nd century AD
cat. 47

Greek Vases of the Classical Period

First introduced in Athens in the last third of the sixth century BC, the red-figure technique of vase-painting became, in the fifth century BC, a brilliant articulation of the ideas of the Classical period. At that time significant changes occurred to both the form and content of vase-painting. As well as mythological subjects, vase-painters began to depict genre scenes reflecting various aspects of Greek life. The new red-figure technique also allowed for more complex poses and perspectives, different facial expressions and elements designating place of action. From the second quarter of the fifth century BC, vase-painters began to be influenced by monumental painting, drawing on subject-matter, compositional devices and figures from well-known pictures. By the third quarter of the fifth century BC, the influence of the Parthenon's sculptural friezes is also clearly evident.

Red-figure vase-painting provides an important source of information about the classical era; like sculpture of the same period, its development went through certain chronological phases: the early vase paintings are rigidly drawn, the figures rather constrained; vase-painting in the Classical period is characterised by complex poses and perspectives, and richly delineated details; and late vase-painting by a fluency of drawing and a certain carelessness.

All these stages of development are represented in the Hermitage's superb collection of ancient Greek vases, from early works in the red-figure style of the late Archaic/early Classical period to late vases of the fourth century BC. The highlight of the collection, a red-figure pelike with a swallow (cat. 1), although dating to the Archaic period, has a number of features characteristic of the Classical period, while still retaining (in the nature of the drawing) some earlier traditions of the black-figure style. The two hydriae (by the Berlin Painter and the Syleus Painter; cat. 2–3) demonstrate all the diversity and animation of red-figure vase-painting of the late Archaic period. The early Classical period, when artists were fully mastering the specifics and potential of the new technique, is represented by works from the

Providence Painter (cat. 4) and the Achilles Painter (cat. 6). The stamnos by the Kleophon Painter (cat. 7), which recalls the sculptural friezes of the Parthenon, is a superb example of the heights attained by vase-painting in the High Classical period. The exhibition also includes some wonderful examples of red-figure Attic vase-painting from the fourth century BC (cat. 16–19), which originate from the burial mounds of the northern Black Sea region and are rarely found in other museums; these vases served as objects for export over many centuries. AP

Treasures of the Barrows: Scythian and Greek

Throughout Scythian history (specifically from the seventh to fourth century BC) its art was dominated by the so-called Scythian Animal style – a unique system of signs that expressed religious, mythological or aesthetic concepts exclusively through the use of zoomorphic forms. The Animal style first appeared in Central Asia no later than the ninth century BC and never lost its original laconic language, which consisted of three main elements: a feline predator, a hoofed and horned animal, and a bird of prey. Over the centuries the style spawned a great number of local variations, attaining in the process a highly developed degree of expressivity.

The Scythians' use of anthropomorphic depiction, often regarded by modern scholars as borrowed from other cultures, was not completely alien to original Scythian art or religion. Scythian stone sculpture, for example, was always exclusively anthropomorphic, as was the conception of deities in the Scythian pantheon (to the extent that Herodotus even identified them with Greek gods). Nonetheless it is true that all anthropomorphic depiction in Scythian applied art, whether in the decoration of ceremonial arms, everyday items or ornaments, stemmed from the penetration into Scythia of imported wares or those created by non-Scythian craftsmen (made either to Scythian order or on Scythian themes).

THE ROAD TO BYZANTIUM:
HISTORICAL TIMELINE

PERIODS	ARCHAIC GREECE: 700–480 BC	
HISTORICAL EVENTS	508 BC	Kleisthenes' reforms in Athens – the 'invention' of democracy
	490 BC	First Persian invasion of Greece – Persians defeated at Battle of Marathon
ART	7th–6th cent. BC	Emergence of monumental stone sculpture and architecture in Greece
	c. 530 BC	Red-figure pottery invented
	c. 510 BC	'First Swallow' Pelike (cat. 1)

This penetration of foreign wares occurred twice in Scythian history. First during the famous nomadic migrations into the Near East in the seventh century BC, when ceremonial items made by eastern or Greek craftsmen from Asia Minor started to appear in 'royal' Scythian tombs (for example the gold swords, ceremonial axe, silver mirror and rhyton from the Kelermes and Melgunov Barrows). Often these items are decorated with both non-Scythian and Scythian elements – a clear indication that they were made according to the tastes and requirements of their nomadic clients. By the next generation, however, Scythian art had resumed its original zoomorphic appearance.

The second penetration of anthropomorphic elements into Scythian art occurred at the end of the fifth century BC, becoming widespread in the fourth century BC. Excavations of tombs of the Scythian nobility from this period have revealed numerous gold and silver items made and decorated by Greek craftsmen in a style sometimes called 'ethnographic realism'. This second wave was more like an explosion, coming as it did after two hundred years of Scythian and Greek co-existence in the northern Black Sea region, during which time the influence of Greek on Scythian art had been limited to just a number of individual decorative elements. (However, ordinary Greek items, such as earthenware, mirrors and ornaments, did enter everyday Scythian life and were regarded as prestigious, ceremonial objects.)

The anthropomorphic subject-matter on most of the well-known items (for example, the silver bowl from the Solokha Barrow (cat. 10), and the silver amphora from Chertomlyk) derives either from Scythian mythology, legend or religious ceremonies. More rare are Scythian items depicting purely Greek subjects or characters, which usually appear as details on certain Scythian items – for example the gold cover plate for a *gorytos* (cat. 9) and sword scabbard from the Chertomlyk Barrow. This has led to the supposition that the Greek myths could have been assimilated by the Scythians through the prism of their own mythology, thanks to clear similarities in both subject and types. AA

The Roman Sculptural Portrait

The Roman sculptural portrait was first evident as an independent artistic phenomenon around the beginning of the first century BC, by which time Rome had grown into the most powerful state in the ancient world. The era of Augustus became known as the 'Golden Age of Roman literature' (the time of Virgil, Horace, Propertius and Ovid), but architecture and artistic craftsmanship also flourished – as, in particular, did the Roman sculptural portrait.

Unlike the elevated idealism of Greek statues, Roman portraiture of the Republic is notable for its striking naturalism, verging, at times, on the unattractive. In the first century BC it was primarily the middle-aged and often the very old who were depicted. It has been suggested that the appearance of the veristic portrait (from the Latin for 'truth') came into being under the direct influence of wax death-masks, which the Romans are believed to have used in their cult of the ancestors. However, this highly individualised treatment of forms is also linked to the harsh political and economic struggles between different social groups during the time of the Republic. Unlike the Greeks, who saw man as the embodiment of a type (athlete, philosopher, military leader), the Romans emphasised their attachment to a particular family or clan, and thus both social rank and personal potential are demonstrated in these portraits.

From the first century BC, portraits, and particularly honorific statues, became a powerful tool of political propaganda. They were set up in public areas – the Roman Forum, the curia, the imperial market, temples – as well as on private property. Statues were commissioned by the senate and the Roman people and, later, by the Roman emperor. A decree by the senate would dictate the size, material and character of the portrait: thus, for example, an armour-clad or equestrian statue would be erected after a military triumph.

The ambitions and aspirations of the Republic's social and political groups in many ways defined the nature of the sculptural portrait. One tendency, which looked to the ideals of ancient Rome, was

closely linked to the leading aristocratic families, and found expression mostly in tombstones and statues with busts of the deceased, which were placed in niches in the family vaults of these well-to-do Roman families. Another – Hellenising – tendency was strongly influenced by Hellenistic Greek sculpture, represented by such powerful figures as Sulla, Caesar and Pompey.

The brilliant age of Augustus, which followed the transition from Republic to Empire, looked for inspiration to the art of classical Greece – and classicism became the officially established style in art. Statues of the ruling emperor adorned the squares and public buildings of Roman cities, and these were copied by thousands of sculptors in the provinces who toiled over endless series of works. The fact that about 250 bronze and marble portraits of Augustus still survive is an indication of the scale of this 'monumental propaganda', which covered a vast area. Portraits of Augustus have been found in Spain, France, North Africa, Egypt, Turkey and Greece; they were a powerful factor in the spread of state ideology.

The main principles of Roman rule, and the essential structure of the Empire, began to take shape during the Principate (the early imperial period), and survived until ancient Rome's demise. The relationship between society and art, in which the sculptural portrait played an important role, started to develop at much the same time. The portrait of the ruler was a depiction of the 'universal hero'; his personal characteristics thus became generalised, serving as an expression of abstract political and religious ideas. As these ideas developed, with the strengthening of the state and the broadening of the power structure in military, political and social terms, the image of the ruler became ever more impersonal; by late antiquity it had lost almost all relationship with the individual's features.

This dissolving of the personal into the idealised and universal defines the development of the official Roman portrait over the four centuries of its history: in the baroque art of the Flavian dynasty (AD 69–96), in the pseudo-Republican portraits of Trajan

CLASSICAL GREECE: 479–323 BC
(INCLUDES 'HIGH CLASSICAL' PERIOD, 450–400 BC)

480–479 BC	Second Persian invasion of Greece	431–404 BC Peloponnesian War between Athens and Sparta
480 BC	Defeat of Persians at Battle of Salamis	
479 BC	Defeat of Persians at Battle of Plataia	

447–432 BC	Building of the Parthenon	*c.* 380 BC *Xenophantos Lekythos (cat. 8)*
4th cent. BC	Bolshaya Bliznitsa, Chertomlyk and Yuz-Oba Barrows	mid-4th cent. BC Sculptor Praxiteles active
		c. 350–325 BC *Gorytos Cover from Chertomlyk (cat. 9)*
		c. 330 BC Painter Apelles active

(AD 98–117), in the period of classicism under Hadrian (AD 117–38), in the era of the Soldier Emperors (AD 193–293), and in the reign of Constantine (AD 306–37).

This religious and aesthetic apotheosis of the figure of the emperor, with the emphasis on monarchical power in general rather than that of the individual, strongly influenced the art of Byzantium. It found its most perfect embodiment in the artistic images of classical art, which brought together Greek sensuality and Roman spirit, and at the heart of which lay the idea of universal dominion and the empire as supreme power. AT

Antique and Early Byzantine Bronze

The technique of casting and artistically working bronze was fully developed in the Hellenistic states and the Roman Empire. Italy, Egypt, Asia Minor and Pannonia were particularly famous for bronze statues, small carvings for secular or religious use, as well as everyday items, from furniture and lamps to dishes, toiletry articles and jewellery. Byzantine craftsmen then adopted the Roman technique of bronze casting, and the statues of Byzantine emperors which adorned the cities of the Eastern Roman Empire, as well as furniture and doors for temples and palaces, were all made using traditional techniques. With the adoption of Christianity, numerous bronze articles were made for liturgical use, as well as items for personal devotion that were kept in people's houses. From the fourth to sixth century AD articles from earlier centuries were often re-smelted to make *lampadophores* (lamp-holders), censers, crosses or small icons. At the same time, however, the antique inheritance of the Byzantines underwent a process of Christianization, which ultimately led to representations of pagan gods being re-interpreted and, in this new capacity, being revered as Christian (for example, the statuette of Dionysos with the text of a psalm, cat. 139). This process was the subject of an epigram by Palladios entitled 'To the statues of the gods transferred to the

house of a certain Marina for Christian worship':
Turned into Christians, the gods, owners of the mansions of Olympus,
Now reside here unharmed, for henceforth
They will not be cast into the flames of the foundry and the furnace bellows. vz

Antique, Early Byzantine and Sasanian Silver

The exhibition includes silverware from the Classical, Hellenistic, Roman and early Byzantine periods, decorated with subjects that would be reproduced on such luxury items for centuries to come.

In the early Byzantine period items of silver were made primarily in the empire's largest cities – Alexandria, Antioch, Constantinople – as well as in the coastal towns of the Aegean Sea and Sea of Marmara. From the time of the economic reforms of the emperor Anastasius I (491–518), silver from the workshops in Constantinople bore control stamps testifying to the purity of the metal. These (usually five) stamps included the monogram of the ruling emperor, as well as that of the *comes sacrarum largitionum* (official responsible for state munificence). This system was used in the capital until the end of the seventh century AD, and all articles with so-called 'imperial' stamps show the exact date of manufacture. Antioch, Nicomedia, Naissus and Carthage had their own control stamps. According to written sources, the workshops of the *barbaricarii* (craftsmen who had mastered the artistic working of metal) were attached to arms *fabricae*, or workshops, set up by the emperor Diocletian (239–313) at Antioch, Edessa and Damascus. The dedications and weight inscriptions on the vessels indicate that there were toreutics workshops at Thessalonica, Sebastia in Palestine, and Caropolis in Syria. Byzantine craftsmen commonly used die-casting, beating out images in silhouette from the reverse side, then applying details to the front, sometimes with additional engraving, gilding and niello. Gold and silver items often served as

diplomatic gifts. Each year the leaders of barbarian forces whose help and support were of interest to Byzantium were sent luxurious gifts, which undoubtedly included vessels made of precious metals. It was customary to fill these with gold coins.

Craftsmen from various regions came to work in Constantinople from the time of its foundation, which explains why items made in the empire's capital show the influence of the art of different provinces: Syria, Palestine, Egypt and Roman Italy, as well as motifs and techniques brought to the empire from the Eurasian steppe. The plate with a scene from *The Odyssey* (in Quintus Smyrnaeus's version) is an example of silverware from Asia Minor (cat. 86), while the dish with a herdsman among his flock reflects features of Roman art (cat. 84). Related to Alexandria are such scenes as 'Hippolytos and Phaedra', and a deer and eagle fighting with snakes – a motif that can be dated from illustrations in the *Physiologos*, the Greek original of which was created in Alexandria. Although the largest Mediterranean cities were thoroughly Hellenised, Christianity came up against local – sometimes very ancient – cults, many of which, in spirit and outward manifestation, were not dissimilar to Christian ideas. The image of the goddess Isis feeding Horus, for example, which originated as an iconic type in Egypt, was 'revised' as the Virgin and Child and subsequently gained empire-wide recognition. Only by the seventh century AD, during the rule of the emperor Heraclius, can one speak of a fully developed school of toreutics in Constantinople, without the pronounced variety of style and eclecticism of the previous two centuries. vz

Antique and Early Byzantine Gold

The exhibition includes articles made of gold which date from the fifth century BC to the third century AD. As well as the more usual types of jewellery, including earrings (cat. 11), a necklace (cat. 55) and bracelet (cat. 57), there is also a temple-pendant that was part of the ceremonial dress of a priestess of the cult of Demeter, who was buried in the Bolshaya Bliznitsa burial

HELLENISTIC GREECE: 323–31 BC

146 BC Greece comes under Roman rule

31 BC Battle of Actium

c. 180–160 BC The Great Altar at Pergamon

ROMAN IMPERIAL PERIOD: 31 BC–FOURTH CENTURY AD

31 BC–AD 14 Reign of the emperor Augustus (Octavian)

c. 4 BC Birth of Christ

AD 54–68 Reign of the emperor Nero

1st cent. BC/AD Frescoes at Pompeii

c. 40s BC *Bronze Portrait Bust of a Roman (cat. 31)*

13–9 BC Ara Pacis in Rome

mound (cat. 20). The priestess's clothing was richly decorated with gold plaques sewn on to the fabric (cat. 21–25). A plaque with a relief depiction of the emperor Nero as the god Helios made up the central part of a priest's diadem (cat. 35), while a similar burial diadem from the necropolis of Pantikapaion is decorated with three stones (cat. 56). Some gold items, such as the ring seals with engraved bezels, were essentially utilitarian: on one, the image of Aphrodite and Eros is badly worn from prolonged use (cat. 14). These items often saw long service, with more than one owner. The scaraboid with a running Medusa (cat. 12), and a mirror with vegetable ornamentation (cat. 13), both made in the fifth century BC, easily outlived their first owner and were found in a tomb together with the fourth-century BC earrings.

Although they cannot fully reflect the huge variety of forms of antique jewellery, nor indeed the wealth of the Hermitage collection, these exhibits provide an excellent opportunity to trace some of the changes that took place in the use and design of jewellery. Thus the pendant earrings (cat. 11) are a fine example of the miniature sculptures that adorned earrings from the middle of the fourth century BC. Each mirroring the other's movements, the small figures of the maenads vividly convey the atmosphere of the frenzied dance of Dionysos's companions. The temple-pendant depicting a nereid on a hippocamp (cat. 20) is one of the most perfect examples of the jeweller's art from the classical era, illustrating the full range of the craftsman's techniques: the disk with its repoussé relief, carefully finished using a die and engraving, and the delicate pattern of filigree and granulation around the edge of the disk and on the pendants, achieve a remarkable artistic effect in gold, with only the pendants more modestly coloured with subdued shades of enamel.

The necklace (cat. 55) shows the way in which jewellers used coloured stones. The proclivity for bright colours which the Greeks learnt from the craftsmen of the Orient, particularly after Alexander the Great's campaigns, is even more evident in jewellery from the first centuries AD. The influence of Asia is clearly shown in a bracelet from the third century AD (cat. 57), although its predominantly openwork design is typical of Roman times. Both these elements – the openwork design and polychrome decoration – were further developed in the jewellery of the Middle Ages, in Byzantium and in the work of craftsmen of the northern Black Sea region. YuPK

Antique and Early Byzantine Glyptics

Many famous antique gems have come down to us, their survival owing much to the fact that they were given a later, Christian, interpretation (in the Byzantine Empire and Medieval Europe) and were used to decorate Christian relics. The collection in the Paris National Library is particularly rich in these gems from Christian treasuries, which would have once adorned relics in the cathedrals of St Denis, Chartres, Nancy, and Sainte-Chapelle in Paris. Just adding a cross or a new Christian name was enough for the gem to take on a new life. Thus, an amethyst with a portrait of the Roman emperor Caracalla bears the name of the apostle Peter (Paris); a cameo-bust of Constantine the Great has a cross on the cuirass (Paris); Antonia the Younger becomes St Helena (Prague); Antonia the Elder becomes the Madonna (Hermitage); the name of the Virgin is given next to a portrait of Cleopatra I on an icon from Svanetia (Tbilisi) and above a portrait of Julia on a Byzantine sapphire, the work of the engraver Euodos (Paris); and a portrait of Augustus bears a Greek inscription testifying that it adorned a reliquary with the remains of the Forty Martyrs (Paris). A famous cameo from the Rothschild collection (Paris) which dates from the fourth century AD has a gold Byzantine mount from the sixth century AD, at which time the young couple depicted were evidently given a new iconographic interpretation: although the cameo clearly depicts the young emperor Honorius and his wife Maria, inscribed next to each is the name of a saint – Bacchos and Sergios – both of them male.

Antique glyptics played a highly significant part in the art of Byzantine craftsmen. Long before 1204, when Constantinople was taken by the Crusaders, Byzantine dynasties were sending their embassies westwards with precious gifts, including ancient gems. Many of these entered the treasuries of monasteries and cathedrals in Europe in the form of pious offerings. Their Christian reinterpretation followed naturally: Jupiter with the eagle, for example, becoming John the Evangelist. Charlemagne presented Chartres Cathedral with a magnificent gem of this type, with the first lines of the Gospel according to Saint John inscribed around the edge. Bellerophon, and the figure of the horseman in general, became St George; Herakles fighting the lion became Samson or David; cupids and victories became angels (cat. 47); Isis with Horus or Venus with Cupid were easily transformed into the Virgin with the infant Christ (cat. 48); and the signs of the zodiac became Christian symbols: for example, the fish for the name of Christ (cat. 52, 53), or the eagle as the symbol of John (cat. 51, 54). ON

Early Byzantine Medallions

Among the coins of imperial Rome and early Byzantium are pieces which are larger in size – medallions, the precursors of modern-day medals. They have a dual character. On the one hand they have all the attributes of coins: the portrait and titles of the emperor on the obverse; depictions of mythological subjects, historical events or different aspects of the emperor's life and deeds on the reverse, as well as imperial slogans and the identity of the mint. On the other hand it is hard to see the correlation between such large coins and the usual denominations, and to determine their place in the monetary system. Also, more importantly, these items were only produced in small numbers and are therefore very rare, which suggests that they were made as commemorative issues to mark significant events – although in Rome there was in principle no need to mint special commemorative medals as ordinary coins were used for this purpose.

Latin did not even have a special term for these medallions. *Historia Augusta* tells of how the emperor Lucius Verus (AD 161–9) would amuse himself during nighttime escapades in taverns by throwing the largest coins into goblets in order to smash them. The historiographer uses the term *nummos maximos*, from which it may be assumed that he was referring to coins that were larger than the bronze *sestertius* – the largest bronze coin in imperial Rome's monetary system.

The largest quantity of bronze medallions dates from the second century AD, particularly the reign of the emperor Commodus (AD 177–92).

Silver medallions are essentially the successors to *cistophori* – light *tetradrachmae* (silver coins) minted in Rhodes and other centres of Asia Minor, which were in circulation in these provinces of the empire in the Roman period. Over time the Greek inscriptions gave way to Latin, and local sacred images were supplanted by objects of worship from across the empire, so that by the end of the first century AD *cistophori* only differed from *denarii* in size and weight. The inconsistency in the size and weight of silver medallions is explained by the fact that they were not part of the coinage system. During Hadrian's reign (AD 117–38) the *cistophori* that were minted were particularly large and can indeed be termed medallions.

It is much easier to form an opinion on gold medallions, since a fairly large amount of historical evidence has survived. *Historia Augusta*, in its account of the life of Alexander Severus (222–35), tells us that the emperor gave orders for various denominations worth up to 100 aurei, struck on the orders of his predecessor Elagabalus (218–22), to be removed from circulation and melted down. If these heavy coins had survived until the present day, they would have been listed in catalogues as medallions. It is unlikely that such heavy coins were in circulation. More likely they would have served as awards for distinguished warriors and citizens and, in the early Byzantine Empire, as diplomatic gifts to the rulers of barbarian states.

The Hermitage holds several dozen medallions made at different times and from different metals.

Among the gold medallions, pieces that are multiples of 1.5–2 *aurei* and *solidi* predominate. There are, however, larger medallions: 4-*aurei* pieces from the time of the emperor Numerian (283–4) (cat. 58), and two medallions each of 8 *solidi* from the time of the emperors Constantine I (307–37) (cat. 59) and Constantius II (337–61) (cat. 63). VG

Early Byzantine Textiles

The symbolic or allegorical interpretation of ancient myths was an integral part of ancient Egyptian culture, and the tradition was subsequently continued by the famous Alexandrian theologians Philo, Clement and Origen. In Egyptian Coptic art, the ancient culture of the classical world also became an important component. The influence was seen both in terms of style and form, and in the adoption of individual images and entire compositions. Coptic art turned to three main methods for interpreting ancient images: allegory, symbol and pre-figuration.

Coptic textiles mostly depict those images of the gods of antiquity that convey ideas of rebirth and salvation. For example, the Hermitage textile showing the Triumph of Dionysos (cat. 74), despite its purely pagan subject and attributes, became imbued with Christian symbolism and was interpreted as a prototype of Christ's Glory, His redemptive sacrifice and resurrection. In another example, a textile medallion with Dionysos amongst vines shows the god as part of a composition with the tree of life (cat. 77). However, the cult of Dionysos, which was closely connected with paganism, still did not allow him to become the prototype of Christ. The phenomenon of pre-figuration is alluded to in the Coptic Apocrypha, in which Dionysos with a maenad is interpreted as a depiction of Adam and Eve.

Such scenes with Dionysos, his followers and attributes are commonly found on Coptic fabrics from the fourth to sixth century AD. Gradually, however, the image of the god himself begins to disappear, coinciding with the destruction of the last remnants of the Dionysian Mysteries in Egypt in 543.

All that remain are Dionysos's symbols and attributes, which take on an independent meaning, becoming central rather than subsidiary to the composition. Thus textiles appear with numerous images of bacchants and maenads, grape-pickers, vines, ivy, kantharoi and goblets, and small figures of panthers. Christian theologians settled on images of Orpheus and Herakles as more appropriately neutral prototypes for Christ. Thus the composition of Orpheus playing his lyre (cat. 75) became a favourite theme for Coptic weavers. As well as images of the gods, a significant place was given to heroes, despite the fact that their cult was also alien to ancient Egyptian culture. These are mainly heroes granted immortality by the gods. The image of Herakles with the followers of Dionysos, and the depiction of his labours, was another popular theme in Coptic art (cat. 69). His labours, his ascetic way of life so valued by the Egyptian anchorites, and his death, transformed Herakles' status from hero to redeemer and saviour of mankind.

The Resurrection became a central theme in Coptic textiles. The image of Aphrodite and Eros on part of a tunic (cat. 70) illustrates the transitory nature of human life, ideas of death and resurrection. Heroic hunting scenes become symbols of the victory of life over death, as seen in a rare fifth-century curtain made using the reservage technique (cat. 68), as do triumphal images of horsemen and centaurs (cat. 76, 78). The subject of the Three Graces, personifying eternal youth and beauty, the rotation of the seasons, life and death, also belongs to this symbolism (cat. 72). The Coptic preoccupation with death is again represented by the image of the horseman and, more rarely, the eagle (which is mainly found on stelae) as the psychopomp guiding Christian souls to the underworld. The Hermitage collection contains several textile medallions with an eagle holding a cross or *ankh* in its beak (cat. 79).

The style of these textile images gradually changes over time, in the general schematisation of composition, the depth of the field and proportions, the simplification of design, the way movement is conveyed, and in the increasingly conventional use

EARLY BYZANTINE PERIOD
AD 330–843

AD 324–337 Reign of Constantine the Great as sole emperor	AD 337 Constantine baptised on death-bed	c. AD 570–632 Life of the prophet Muhammad
AD 324 City of Byzantium refounded as Constantinople	AD 476 Last western Roman emperor, Romulus Augustulus, is deposed	AD 726/30–787 First period of Byzantine iconoclasm
	AD 527–565 Reign of the emperor Justinian the Great	AD 815–842 Second period of Byzantine iconoclasm

4th–8th cent. AD *Coptic Textiles (cat. 66–80)*	6th–7th cent. AD *Pereshchepina Treasure (cat. 105–132)*
mid-4th cent. AD *Constantius II Bowls (cat. 61, 62)*	AD 613–629/30 *Silenus and Maenad Plate (cat. 85); Meleager and Atalanta Plate (cat. 87)*
c. 530s AD *Plate with a Herdsman (cat. 84)*	

of colours. These changes are clearly seen in comparisons of textiles from different eras, for example those with images of horsemen, and Orpheus taming the animals with his lyre.

Ancient and pagan images survived so long in Coptic art because of the profound, all-embracing symbolism they represented, which was so vital for the creation of Christian works of art. Most of them encompassed the idea of salvation and resurrection, forging a natural link with the Egyptians' own beliefs about the afterlife. oo

Art of the Middle Byzantine Period

The Byzantines' relationship to the classical legacy underwent certain changes around the tenth to twelfth century. As before, the choice of subjects remained traditional, symbolic and, in a number of cases, unorthodox. Roman emblems were preserved and mythological images continued to be used in a Christian context and in occultism. The symbolism of the images became so complex, however, that they were only understood by such intellectuals as those in the circles of Patriarch Photius (858–67 and 877–86), and Constantine VII Porphyrogennetos (913–59). Scenes from antique mythology often acquired such an unusual form that, as the twelfth-century writer Eustathios Makrembolites put it, one would have had to have been Oedipus to solve these riddles of the Sphinx. Followers of heretical teachings no longer resorted to expressing certain tenets of their doctrine through ancient images, as they had done in the fourth to seventh century; instead, these images were adapted for occult practices.

Examples of this 'complex antiquity' are a cameo depicting Diana and Apollo as Pothos (cat. 101), and a silver dish with the apotheosis of Alexander the Great (cat. 133). In the former, a medieval craftsman copying a cameo from the first century BC has turned a lyre on a column into a building of fantastical shape, and placed in the segment the name of the person represented: 'Pothos'. This name, when inscribed beneath the scene of Diana and Apollo, came to

signify 'prosperity', and such compositions were often known by this title. As Diana and Apollo symbolised the main heavenly bodies of the Sun and Moon, the allegory of prosperity was interpreted as being universal in scale. In Hermetic cosmogony Pothos was a planetary spirit who decided the fate of men, and in the hymns of Gregory of Nazianzus he appears as the protector of the plant world, assisting in the rebirth and renewal of nature. In Byzantine times some names of ancient deities came to be used as generalised concepts, expressing the main functions of the various gods.

On the dish with the apotheosis of Alexander are images or symbols within a 'populated vine' that had never previously been used: a griffin-psychopomp, guiding the soul to heaven and, on the right above a medallion with David the Psalm-Singer, a pelican tearing its own breast. This could be interpreted either as a symbol of Christ's suffering for the sins of mankind or, more likely, as an allegory of sacrifice. Many of the images on the dish are notable for the particularly allegorical nature of the artistic language – a typical phenomenon in an era when symbolism became a widespread way of thinking and not merely a game for refined intellects. vz

Byzantine Seals

Lead seals (molybdobulls) were used in Byzantium over many centuries to seal private and official documents. Small in diameter (on average 2–2.5 cm), the seals were two-sided. They were made by pressing blanks with special pincers called *boullotiria*, containing a die carved with a mirror-image of the design and inscription. A thread would first be inserted through an opening in the blank to attach the seal to the document. The majority of these documents have not survived.

These seals contain a wide variety of images, monograms and legends. The monograms usually include the name of the owner and sometimes his position or title(s). The legend, too, sometimes mentions his place of service. One side of the seals

is often taken up with images: of the Virgin, the saints, Christ, or occasionally scenes from the Scriptures.

Prototypes of the common, two-sided molybdobulls which gained popularity in the sixth century AD were single-sided, so-called conical seals, typical of the early centuries AD (cat. 147–8). Most often, as on intaglios from the same period, they depicted ancient subjects or characters, those who commissioned the seals or their monograms. With the spread of Christianity in the sixth and seventh centuries, these figures were replaced by depictions of the saints. Nonetheless, in a number of cases the characters from antiquity continued to be used, although, as in early Christian art in general, they were carefully selected and given a different, Christian interpretation. Seals from the sixth and seventh centuries with ancient subjects are uncommon, apart from some large groups of molybdobulls depicting an eagle (cat. 152–4), as well as imperial seals with the image of the goddess Nike (cat. 150–1). Compared with works of applied art, the range of ancient images on sphragistic works is very limited. Among others in the Hermitage's vast collection of Byzantine seals are some noteworthy examples depicting a fertility goddess (cat. 158), a lion (cat. 156), a horse (cat. 160), and a tessera with a gryllos (cat. 155). As Christianity took hold, these images disappeared from the seals. For a short time in the tenth century, during the Middle Byzantine period, there was renewed interest in ancient subjects on seals, for example the seals depicting a lion (cat. 161), and a peacock (cat. 162–3). One final group, including seals depicting a saint on horseback (cat. 157) and the ascent of the Prophet Elijah (cat. 164), shows the total transformation of ancient subjects into Christian. es

MIDDLE BYZANTINE PERIOD
AD 843–1204

AD 1054 Schism declared between the Orthodox
church and the Roman church

AD 1096–1099 The First Crusade

AD 1204 Constantinople captured by armies
of the Fourth Crusade

mid–10th century AD *Veroli Casket (cat. 103)*

12th century AD *Dish with Flight of Alexander*
(cat. 133)

LATE BYZANTINE EMPIRE
AD 1204–1453

AD 1453 Fall of Constantinople to the
Ottoman Turks – the end of Byzantium

Catalogue entries are written by the following contributors. Initials are given at the end of each entry.

AA Andrei Alekseyev
AE Antony Eastmond
NG Nadezhda Gulyaeva
VG Vera Guruleva
AAI Anna Ierusalimskaya
AI Anatoly Ivanov
NJ Nadejda Jijina
YuK Yulia Kagan
YuPK Yuri Kalashnik
EKh Elena Khodza
NK Nina Kunina
ZL Zlata Lvova
BM Boris Marshak
LN Lyudmila Nekrasova
ON Oleg Neverov
OO Olga Osharina
AP Anna Petrakova
ES Elena Stepanova
PS Peter Stewart
AT Anna Trofimova
LU Lyubov Utkina
EV Elena Vlasova
VZ Vera Zalesskaya
IZ Irina Zasetskaya

I

Red-figure Pelike
The Approach of Spring
('The First Swallow'); Wrestlers

Attica; Pioneer Group
c. 510 BC
Height 37.5 cm, diameter of mouth 17 cm,
diameter of base 19 cm
Clay
Inv. no. Б.2352
Found in Etruscan tomb in Vulci, 1835; acquired by Count
N.D. Guryev, Russian ambassador in The Hague, Rome
and Naples, who took it back to Moscow; lost by Guryev's
descendant to Minister of Finance A.A. Abaza during game
of cards; to Hermitage from Abaza's collection, 1901

The pelike is a two-handled vessel for liquids or other
substances. Each side depicts a Greek genre scene.
On one a man, youth and boy are conducting a lively
conversation, their attention drawn to the swallow
flying overhead: Ἰδοὺ χελιδών ('Look, a swallow!')
says the youth, to which the man responds, Νὴ τὸν
Ἡρακλέα ('Yes, by Herakles!') The boy cries: Αὑτηί
('There she is!'), and the whole scene is drawn
together by the words overhead: Ἔαρ ἤδη ('It is
already spring!').

The swallow was a sign of long-awaited spring,
and in many places in Greece its arrival was marked
with celebrations and processions of children singing
joyfully – as in the words of this song from Rhodes
which has survived to the present day: 'O come,
O come to us swallow, bring beautiful spring, bring
bright weather'.

The other side of the vase shows two young men
wrestling, each seeking the best possible hold on his
opponent. Such scenes were often found in Greek
gymnasia, or sports arenas, where young men met to
relax and compete. The inscription in the background
reads: Ὁ πα[ί]ς καλός Λέαγρος ('The beautiful boy
Leagros'), a reference to a noble youth who was one
of the favourites of the Athenian public at the end
of the sixth century BC.

For a long time this unique vase was believed to be
an early work of Euphronios. However, the discovery
of new vases painted by this great artist leaves little
doubt that the Hermitage pelike, while it may have
come from his workshop, was actually the work of
another vase-painter of the Pioneer Group. LU

BIBLIOGRAPHY: Peredol'skaia, 1967, no. 16 (gives all previous
literature), pl. I, XVII, 1, CLXV, 4–7, CLXVI, 1; ARV, p. 1594,
no. 48; Arte y Olimpismo, 1999, no. 63.

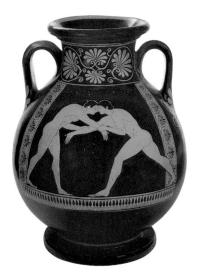

2
Red-figure Hydria-Kalpis with Polyxena and Achilles

Attica; Berlin Painter
c. 500 BC
Height 37.5 cm, diameter of mouth 17 cm,
diameter of base 13.5 cm
Clay
Inv. no. Б.200 (St 1588, B 628)
Found in Canino, Italy; to Hermitage from collection
of the surgeon Pizzati, 1834

The touching meeting between the Greek hero Achilles and the Trojan princess Polyxena at a spring beneath the walls of Troy comes early in the Trojan saga and was described in one of the books of the lost epic *Kypria*. In vase-painting the scene also appears in the black-figure style and usually includes a third character, Troilus, who accompanies his sister on horseback as she goes out to collect water. On this vase the artist has placed the fountain at the centre of the composition; the water comes out of a lion's mask shown in profile on a wall (similar to a column) with a small step. A young girl in a tunic and cloak stands before the spring; her long hair tied up in a knot is adorned with a diadem, and she has bracelets on her arms. On the other side of the fountain a warrior in full battle-dress squats down. He has a plumed helmet on his head, wears a short tunic and armour with *knemides* (greaves), while in his hands he holds two spears and a shield decorated with a lion emblem. On the step leading to the fountain stands a hydria, similar in form to the vessel on which the scene is painted. A raven sits above the fountain. This prophetic bird of Apollo, a harbinger of unhappiness, is a reference to the tragic events that will follow in the lives of the characters: Achilles' unrequited love for Polyxena; the tragedy of the long war; and the eventual death of the hero beneath the walls of Troy, struck down by chance by an arrow from Paris, followed by the death of Polyxena, sacrificed to the gods by Achilles' son Neoptolemos. With great brevity and expressiveness the artist captures the touching simplicity of this young girl, her arms slightly angled, raised in alarm – either because the water in the vessel is overflowing, or because she has caught sight of the warrior hidden behind the wall of the fountain.

The red-figure vase-painting of the Berlin Painter (so named by Sir John Beazley after a vase in the Berlin Museum) is on a par with the work of Kleophrades, and represents the culmination of late Archaic Athenian vase-painting. The painter shows complete mastery of line-drawing with his one- or two-figured compositions covering the main surface of these large vases. Usually they are placed on a black ground, even without the traditional frame of ornamentation. Here the composition is positioned around the smooth surface of the shoulders of the hydria-kalpis, while the elegant line of the meander runs beneath the figures at the widest part of the vase; in this way the illustration helps to lighten the somewhat heavy form of the vessel. Hydriae of this shape appeared from the time of the invention of red-figure painting. LU

BIBLIOGRAPHY: Peredol'skaia, 1967, no. 38 (gives all previous literature), pl. XXVIII; ARV, pp. 210, 174, 616, no. 5; Add., pp. 196, 174; LIMC, 1981, no. 266 (Achilleus); Pfisterer-Haas, 2002, p. 20, fig. 21.

3
Red-figure Hydria-Kalpis with Dionysos, a Satyr and a Maenad

Attica; Syleus Painter
490–480 BC
Height 36 cm, diameter of mouth 14.5 cm,
diameter of base 13.9 cm
Clay
Inv. no. Б.1579 (St 1624, B 629)
From collection of Marquis Campana, 1862

This vessel would have been associated with one of the Dionysian festivals (for example, Dionysia, Leneia and Anthesteria) that were held throughout the ancient Greek year. Dionysos, the god of wine, occupies the centre of the scene, which is placed on the shoulders of the vase. He sits on a tabouret covered with a panther's skin and with legs in the form of lion's paws. Dionysos is shown as a young man with a bushy beard, his head crowned with an ivy wreath, and dressed in a long tunic with a cloak thrown over his left shoulder. In his right hand the god holds a kantharos (a wine goblet on a base with high handles) – a common attribute of Dionysos – while in his left he grips an ivy branch. A naked satyr stands before him with a wine-skin in one hand and an oinochoe (one-handled jug) in the other. This loyal disciple is pouring the god of wine a drink, the ladle held high above his head. Another ever-present character in Dionysian festivals stands behind the god: a maenad, or bacchant. The girl holds a large *thyrsos* (staff) in her right hand and a branch of ivy in her left; her head is also wreathed in ivy.

Unusually for Dionysian scenes, the picture has a calm, even restful quality. The Syleus Painter (the name derives from a portrait of the struggle between Herakles and Syleus on a stamnos in Copenhagen) sets off the scene with a beautiful ornamental band; the slanting voluted palmettes break up the stiffness of the figures and imbue the whole scene with a sense of movement. LU

BIBLIOGRAPHY: Peredol'skaia, 1967, no. 46, pl. XXXII, 1, XXXIV, 1; ARV, p. 240, no. 41; Add., pp. 196, 174; LIMC, 1981, no. 266 (Dionysos).

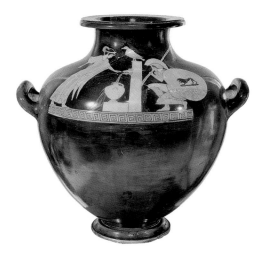

4
Red-figure Amphora
Athena; Running Girl

Attica; Providence Painter
470–465 BC
Height 34.5 cm, diameter of mouth 14.5 cm,
diameter of base 9.2 cm
Clay
Inv. no. Б.196 (St 1690, B 698)
From collection of the surgeon Pizzati, 1834

On one side of this small amphora of the Nolan type
the artist has portrayed Athena moving swiftly to the
left with her right arm outstretched (in the direction
of the girl running away from her on the other side
of the vase); her lowered left hand holds a spear.
An inscription above the spear to the left reads
'the beautiful Nikon'. The goddess is clothed in a
long semi-transparent tunic with luxuriant sleeves
trimmed with a dark border. On her breast she wears
the aegis with writhing snakes around the edge, while
her beautiful head, shown in profile, is crowned with
a plumed helmet; she has round earrings in her ears,
and bracelets on her arms. The young girl running
away on the other side of the vase has turned her head
back, and her arms are spread apart in a gesture of
surprise or confusion. She is also dressed in a long
tunic with a border. Both figures are placed on a kind
of pedestal, decorated with a meander. They stand
out expressively against the black background, and
are wonderfully integrated into the form of the vase,
emphasising its equilibrium and bringing out its
delicate outline.

 In terms of style and composition, the Providence
Painter (so named after an amphora in the Museum
of Art, Providence, Rhode Island), who was active
in the second quarter of the fifth century BC, was
strongly influenced by one of the greatest craftsmen
of the late Archaic period: the Berlin Painter (*see* cat. 2).
The Berlin Painter, famed today for his delicacy and
refinement, liked to decorate small-scale vases similar
to this amphora, as well as lekythoi. The motif of
a running or walking Athena, usually holding her
helmet in her hand, is typical of the artist. LU

BIBLIOGRAPHY: Peredol'skaia, 1967, no. 120, pl. LXXXIX,
CLXXVI, 3, 4; ARV, p. 466, no. 5; Add., p. 635, no. 23; LIMC,
1981, no. 266 (Athena).

5
Kylix with Bellerophon Killing the
Chimaera

Attica
470–460 BC
Diameter 14.7 cm
Silver; gilding
Inv. no. СБр.II.32 (АБс 369)
From excavations of Seven Brothers Barrow No. 2, Kuban
area, by V.G. Tiesenhausen, 1875; to Hermitage from
Imperial Archeological Commission, same year

This is the bowl of a kylix, with the edge bent slightly
outwards. The medallion in the centre shows a naked
Bellerophon in profile flying on Pegasus, his head
facing backwards, striking the monstrous Chimaera
with a spear. The medallion is bordered by a narrow
band, above which are depicted six single figures
of warriors in left profile, all gilded. EV

BIBLIOGRAPHY: OAK, 1881, pl. I, ill. 3; Strong, 1966, pl.15–a;
Gorbunova, 1971, pp. 23–6, 33, 36, ill. 5–7; Greek Treasures,
2004, p. 141.

6
Red-figure Krater
Poseidon and Amymone; Girl and Old Man

Attica; Achilles Painter
c. 460 BC
Height 25.7 cm, diameter of mouth 26 cm
Clay
Inv. no. Б.191 (St 1535, B 767)
From collection of the surgeon Pizzati, 1834

The front of the vase shows a half-naked Poseidon
(with a trident in his hand) following a girl who is
running away, dressed in a long tunic and robe, with
a diadem on her head. She is carrying a water pitcher
or hydria in her left hand. The scene brings to mind
characters from one of the dramas of Aeschylus
based on the story of Amymone, daughter of Danaos,
king of Argos. While fleeing from a chasing satyr,
Amymone prayed for help to Poseidon. The ruler
of the seas not only drove her pursuer away, but also
made the beautiful girl his beloved. This may explain
the two other characters on the other side of the vase:
the bearded man in a cloak with a staff in his hand
may be King Danaos himself, while the frightened
girl running towards him could be one of Amymone's
sisters. The subject of a female character being
chased by a god or hero was very popular in Greek
vase-painting of the fifth century BC. This small
calyx-krater is also elegantly decorated around the
mouth with an undulating ribbon, while a meander
runs beneath the scene.

 This form of krater is thought to have been
invented in Attica in the workshop of the great potter
and vase-painter Exekias in about 530 BC; this, at
least, is the date of the earliest known black-figure
example of this type of vessel by Exekias. The form
became particularly popular with red-figure artists
throughout the remaining period of vase-painting –
the fifth and fourth centuries BC.

 The Achilles Painter, to whom the painting
on this vase is attributed, was a typical exponent
of early classical vase-painting in Athens; his skill
is particularly evident in the depiction of Achilles
on an amphora in the Vatican Museum. LU

BIBLIOGRAPHY: Peredol'skaia, 1967, no. 189 (gives all
previous literature), pl. CXXX, 1, 3; ARV, p. 991, no. 57; Add.,
p. 986, no. 57; Kaempf-Dimitriadou, 1979, B. 8, no. 289;
LIMC, 1981, no. 266 (Amymone).

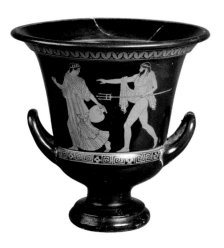

7
Red-figure Stamnos with a Komos

Attica; Kleophon Painter
440–435 BC
Height 39.8 cm, diameter of mouth 24.2 cm,
diameter of base 14 cm
Clay
Inv. no. Б.2353 (B 810)
Originally in Depoletti Collection, Rome; to Hermitage
from collection of A.A. Abaza, 1901 (possibly same history
as cat. 1)

Both sides of this stamnos colourfully portray
revellers walking through the city streets during
a night-time symposium. On one side of the vase four
half-naked revellers have completed their feast: a
flautist accompanies two youths dancing, while a man
sings to his own accompaniment on the *barbitos* (lyre).
An inscription alongside a youth with a cane reads:
'The Beautiful Megakles'. The procession continues
on the other side of the vase, where a man, his head
half-turned, is followed by two youths, one with a
staff in his hands and the other with a kylix filled with
wine. The Kleophon Painter is so called because of
this stamnos, on one side of which, above the figures,
is written the name of this Athenian favourite. The
Kleophon Painter's work comes as close as is possible
in vase-painting to the monumental style of Pheidian
sculpture. This *komos*, or revel, is notable for the
calm, rhythmic gestures of the figures as they dance
to the music of the flute and *barbitos*; the canonical
profiles of their idealised, somewhat impassive, faces
clearly bring to mind the Parthenon frieze.

The stamnos was used to mix and keep wine;
for this reason it has a large circular body that tapers
to the base, and a short wide neck. The mouth of
the vessel is decorated with an egg-and-dart design;
its shoulders have a tongue-band ornament, and a
stopped meander with cross squares runs beneath the
figures. A rich design of voluted palmettes, imitating
metalwork ornamentation, decorates the body
around the handles. LU

BIBLIOGRAPHY: Peredol'skaia, 1967, no. 209 (gives all
previous literature), pl. CXL, CXLI, CLXXIX, 1, 2; ARV, p. 1143,
no. 7; Gualandi, 1962, pp. 227–60, no. 19; Philippaki, 1967,
p. 144, no. 3, p. 145.

8
Red-figure Lekythos with a Relief Hunting Scene (the Smaller Xenophantos Lekythos)

Attica; Xenophantos
c. 380 BC
Height 23.4 cm
Clay
Inv. no. 3м.3
From excavations at Yuz-Oba (Second Serpent Barrow,
between stones, away from other finds) by N.P. Kondakov,
1883; to Hermitage, same year

This red-figure Attic lekythos is decorated with a
hunting scene with painted figures in relief. The
vessel has a large funnel-shaped mouth, a narrow
neck, an ovoid body and an indented base with stripes
of red paint. The central part of the scene is occupied
by the figure of a barbarian horseman, facing left with
a spear in his right hand. A fallen hind lies beneath
his horse's hooves. To the left of the horseman is the
figure of another barbarian holding a dog by the
collar, while to the right is a bearded barbarian with
a pole-axe in his raised hands and a fallen hind before
him. Trees executed in the red-figure style stand
between the figures, and the painting is augmented
by relief dots. The lower part of the neck is decorated
with petals, while on the shoulders of the vessel are
palmettes and, below, an egg-and-dart ornament and
a 'necklace' of relief dots. Beneath these on the left
side is the inscription: 'Xenophantos the Athenian
made it'. NJ

BIBLIOGRAPHY: Peredol'skaia, 1945, p. 47; Zervoudaki,
1968, p. 26, no. 36, pl. 1 (1–3); Neverov, 1981, p. 113
(no reproduction); Tiverios, 1997; Skrzhinskaia, 1999,
pp. 121–30, ill. 3 (p. 125).

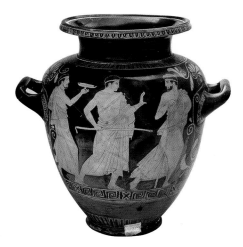

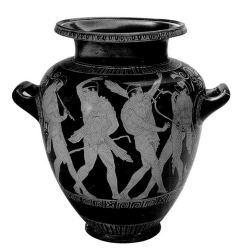

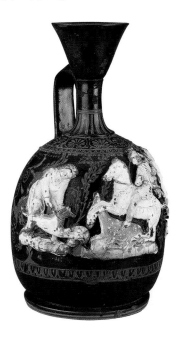

9

Cover Plate for a Gorytos with Scenes from the Life of Achilles

Northern Black Sea region, Lower Dniepr
350–325 BC
Length 46.8 cm, width 27.3 cm, weight 178.9 g
Gold; decoration impressed from metal mould or moulds
Inv. no. Дн 1863.1/435
From excavation of Chertomlyk Barrow by I.E. Zabelin,
1863; to Hermitage from Imperial Archaeological
Commission, 1865

The gold cover plate for a ceremonial *gorytos*, or
bow-and-arrow case, was discovered in one of the
niches of the main burial chamber of the Chertomlyk
Barrow, together with a sword and scabbard. It
comprises the casing for the front and bottom parts
of the *gorytos*, both made from a thin sheet of gold
and attached to the *gorytos* with small gold nails.
Three cover plates taken from the same mould are
known to exist, identical apart from some small
additional decoration to the illustrations. They all
come from Scythian burial sites of the second half
of the fourth century BC: the Ilinitsy Barrow in the
forest-steppe area around the Dniepr river; the
eighth Five Brothers Barrow in the Lower Don
region; and the Melitopol Barrow on the northern
shore of the Azov Sea.

The front plate has several decorative friezes,
partly decorated with plant motifs and scenes of
animals fighting. Of greatest interest, however,
are the two broad central friezes featuring people
in various scenes linked by a single theme. In 1889
C. Robert offered an interpretation of these scenes
based upon the description of a painting by
Polygnotos entitled *Achilles on the Island of Skyros*,
which shows the discovery by Odysseus and
Diomedes of Achilles, dressed in women's clothing
and hidden by his mother, the goddess Thetis, on
the island of Skyros with the daughters of King
Lykomedes. This interpretation was supported and
further developed by B.V. Farmakovsky and others,
and it remains the best known – but it is by no means
the only one. Other scenes from the same Greek epic
have been put forward as possible interpretations.
Another hypothesis links the scenes not to Greek,
but to Iranian, mythology.

According to the most widely accepted
interpretation, the story should be read starting
from the left-hand scene of the upper frieze.

Upper frieze: 1. The boy Achilles learns to use
a bow and arrow. 2. Odysseus identifies Achilles
among the daughters of Lykomedes (Odysseus
came to the island in the guise of a merchant and
laid out various wares, including weapons; Diomedes
then sounded the call to arms, and Achilles' hand
involuntarily took up a sword. This scene also
shows Achilles' lover, Deidameia, daughter of King
Lykomedes, and possibly their son Neoptolemos).
3. Achilles bids farewell to King Lykomedes.

Lower frieze: 4. The Queen, wife of Lykomedes
and mother of Deidameia, with her daughters as
Achilles bids farewell. 5. Achilles beneath the walls of
Troy (there are several interpretations of this scene:
one, that it shows Odysseus and Diomedes with a
seated Agamemnon; another, more widely accepted,
that it shows Priam, King of the Trojans, coming
to Achilles with the ransom for the body of his son
Hector). 6. The final scene shows Thetis, mother of
Achilles, bearing away the urn with her son's ashes,
after his death from an arrow-wound inflicted in his
heel by Priam's son Paris; in Thetis's arms is a baby in
swaddling clothes, possibly also Achilles.

Close analogies to the Chertomlyk *gorytos* cover
include the silver cover plate for a *gorytos* from
Karagodeuashkh Barrow in Kuban, and an identical
gold one from the so-called 'tomb of Philip II of
Macedon' in Northern Greece (the tomb is either
that of Philip II or of his son Philip III Arrhidaeus).
The scenes depicted are different to those on the
Chertomlyk *gorytos* cover but similar in style, and
it is likely that they too show epic scenes of the Trojan
War (possibly the capture of Troy). All these tombs
date from between 350 and 320 BC.

It is widely accepted that all these *gorytos*
decorations were made by a Greek craftsman in
one of the workshops of the Bosporan kingdom.
The region in which these objects from the so-called
'Trojan series' (the two types of *gorytos* cover and the
sword scabbard) were discovered forms an arc, with
Pantikapaion, the capital of the Bosporan kingdom,
in the centre, and the Black Sea to the west, north and
east. This suggests that such ceremonial and luxury
items, intended as diplomatic gifts for the leaders and
kings of various tribes and peoples, formed part of
the expansive diplomatic activity undertaken by the
Bosporan ruler Perisades in around 330–320 BC. AA

BIBLIOGRAPHY: Rolle et al., 1998, cat. 189; Alekseev, 2003,
pp. 240–8; Raevskii, 1980, pp. 105–7; Stähler and
Nieswandt, 1991–2.

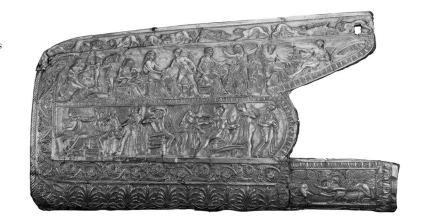

10

Vessel with Scythian Hunting Scenes

Northern Black Sea region, Lower Dniepr
400–375 BC
Height 12.1 cm, diameter 18.7
Silver, gilt; stamping, chasing, incising
Inv. no. Дн 1913.1/40
From excavations of Solokha Barrow by N.I. Veselovsky,
1913; to Hermitage from Imperial Archaeological
Commission, 1914

This two-handled vessel with a rounded body on
a low base is covered with several gilt relief friezes.
A garland of two ivy branches winds around the upper
rim; beneath are two almost symmetrical hunting
scenes. One side shows two young horsemen in
typical Scythian dress armed with bows and spears;
they are hunting a lion with dogs. On the other side
the huntsmen attack a horned lioness. This fantastical
creature seems to confirm the mythological or epic
nature of the scene. Its meaning, however, remains
elusive, despite several possible interpretations:
that this is one of the labours of a Scythian 'Herakles';
a ritual victory over a wild beast, invoking the aid
of a great goddess; or a struggle between the living
and creatures from the world of the dead. The
youthfulness of the heroes is worthy of note, just as
it is on a silver *gorytos* cover, also found in the Solokha
Barrow, which shows scenes of a battle between
young and old (and unattractive) Scythians. It is quite
possible that at this time in Scythian history – the
second half of the fifth century BC, during the reign
of King Oktamasad – the subject of a conflict between
young and old had political and ideological relevance.

Below the hunting frieze is a guilloche border and,
beneath that, fluting. Two lions are shown beneath
one handle, and two dogs beneath the other. On the
upper part the handles are decorated with two rams'
heads, a motif frequently found in Greco-Scythian
art, and linked to the ancient Iranian idea of *hvarnah*,
which was symbolised by the ram and signified good,
radiance, royal glory and so on. An eight-leafed
rosette is incised on the floor of the vessel.

The form of the vessel, and the two horizontal
handles that are its most remarkable feature, are
typical of Scythian ceremonial and cult vessels,
although it is true that in the Scythian world such
objects were more often made of wood and were
decorated with gold plates with images of deer,
fish, wild beasts and birds of prey. AA

BIBLIOGRAPHY: Artamonov, 1966, no. 152; Mantsevich,
1987, no. 61; Piotrovsky et al., 1986, nos. 157–60;
Korol'kova, 2003; Rusiaeva, 2004.

11

Earrings with Pendants in the form of Maenads

4th century BC
Height 4.4 cm
Gold
Inv. no. ЮО.4 (АБз 865)
From excavations of Yuz-Oba Barrows, Pantikapaion
Necropolis, by A.E. Lyutsenko, 1859

Each earring comprises two parts: a rosette and
a pendant. The three-layered rosette is made up
of petals edged with beaded wire, with a grain in
the centre. The two dancing maenads, which are
attached to the rosettes by small rings, seem to greet
each other. Each of them holds a *thyrsos*, or staff,
in one hand; in the other hand one maenad holds
the paw of a panther, while the other holds the hoof
of a fallow deer. The animals themselves are behind
the shoulders of the dancers, whose legs are revealed
in the energetic movement of the dance.

While these figures of dancing maenads are
examples of miniature sculpture made by a goldsmith,
the animals and other minor details of the pendants
may have been cast separately and soldered on. The
folds of the clothing, the maenads' hair, the fur of the
animals and other details are all chased.

Cast figures of deities, fantastic creatures and
dancers from the Bosporus barrows of the fourth
century BC, which frequently appear as details on
various pieces of jewellery, constitute in their own
right a gallery of miniature sculpture of the period.
LN

BIBLIOGRAPHY: CR, 1859, p. x; Muzy i maski, 2005, no. 141.

12

Scaraboid with a Running Medusa

Eastern Mediterranean; (Craftsman
of the Leningrad Gorgon)
5th century BC
2.9 × 2.3 cm
Chalcedony, gold
Inv. no. ЮО.6
From excavations of Yuz-Oba Barrows, Pantikapaion
Necropolis, 1860

This engraved stone was used as a protective amulet:
it would have been worn on the breast to ward off
evil. The monster is portrayed with six wings, and
serpents in her hands. ON

BIBLIOGRAPHY: OAK, 1860, p. 88, pl. VI, no, 7; Maksimova,
1926, p. 40, pl. II; Furtwängler, 1900, pl. VIII, no. 52;
Boardman, 1968, no. 36; Boardman, 1970, no. 378; Neverov,
1967, no. 36.

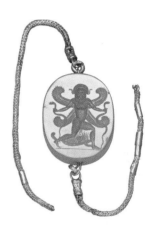

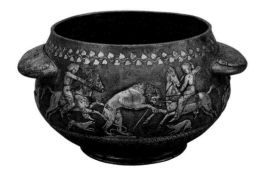

13
Mirror

Attica
c. 450 BC
Diameter 18.8 cm, length 24.3 cm, width 0.3 cm
Bronze, silver gilt
Inv no. ЮО.8
From excavations at Yuz-Oba (Stone burial no. 50)
by A.E. Lyutsenko, 1859; to Hermitage, 1862

This cast, double-sided mirror has a short pin
securing the handle and flashed volute and palmette
ornamentation. A decorative hasp made of gilded
silver leaf is secured to a disk at the base of the pin.
The hasp is decorated with an embossed image of
an eleven-leafed palmette in an oval frame, resting
on two large volutes with an ornamented crosspiece.
To each side of the larger volutes are smaller ones,
in the scrolls of which is a trefoil on one side, and a
lotus flower on the other. The plate would have been
attached to the mirror by eleven copper rivets, seven
of which have been preserved on the disk, and four
on the hasp itself.

The mirror belongs to a group of flat, disk-shaped
items with relief decoration of volutes and palmettes
which were produced in Attic bronze workshops
from the end of the sixth century BC. The finds from
the northern Black Sea area are the latest in the
group, and should be considered as dating from
the first half to mid fifth century BC. NJ

BIBLIOGRAPHY: Antichnaia bronza, 1973, no. 62
(not reproduced); Bilimovich, 1973, p. 43, no. 2, p. 44, ill. 2;
Bilimovich, 1976, cat. 36, p. 43, ill. 10, pp. 45, 62; Shefton,
1969–70, no. 9, pp. 57, 58.

14
Ring Seal with Aphrodite and Eros

Greece
4th century BC
Diameter 2.3 cm
Gold
Inv. no. ЮО.22
From excavations of Yuz-Oba Barrows, Pantikapaion
Necropolis, 1862

The ring depicts Aphrodite leaning on a column,
while Eros, kneeling before her, is adjusting the
goddess's sandals. ON

BIBLIOGRAPHY: Neverov, 1978, no. 20.

15
Ring Seal with Nike on a Chariot

Eastern Mediterranean
4th century BC
2.2 × 1.6 cm
Gold
Inv. no. ЮО.30
From excavations of Yuz-Oba Barrows, Pantikapaion
Necropolis, 1862

The ring depicts Nike's chariot pulled by two horses.
ON

BIBLIOGRAPHY: OAK, 1861, pl. VI, no. 7; Furtwängler, 1900,
pl. X, no. 47; Neverov, 1978, no. 19.

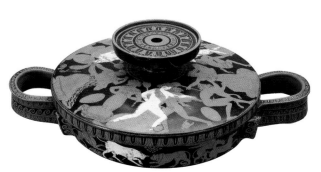

16
Red-figure Lekanis with the Infant Dionysos

Attica
370–360 BC
Height 31.3 cm, diameter 44.5 cm
Clay
Inv. no. ЮО.18
From excavations at Yuz-Oba (Barrow V, tomb no. 48,
chamber 1) by A.E. Lyutsenko, 1860; to Hermitage, 1862

The lekanis has wide horizontal handles, a circular
base and a lid crowned with a disk-shaped handle,
the upper surface of which is unpainted.

The sides of the lekanis are painted with a frieze
showing griffins and vultures attacking hoofed
animals. On one side, the central group, facing right,
comprises a leopard with its claws sunk into the back
of a dappled deer, which has fallen onto its front legs.
They are flanked by winged griffins standing on hind
legs with chests turned inwards, while on the extreme
right a leopard, its front leg raised, faces left. On the
other side, the central part of the composition is
occupied by animals in contrasting poses of attack
and defence: a bull to the left and a dappled leopard
to the right; above their heads hangs the V-shaped
branch of a tree with fruits or leaves represented
by small circles.

The scene on the lid depicts the infant Dionysos
being nursed amidst bacchanalia. The central group
consists of the figures of a bearded silenus facing
right, holding a baby out to a maenad; the latter sits
on a rock, her left elbow leaning on a timbrel and her
left hand holding a *thyrsos*, while her right hand holds
up the edge of her tunic at her shoulder. Between the
two figures is a short vine with two bunches of grapes.
Diametrically opposite the first group is a second
group of two figures facing each other: a satyr bent
slightly down to the right with a *nebris*, or fawn's skin,
over his shoulder, and a dancing maenad in a long
swirling tunic with a timbrel in her left hand and a
thyrsos in her right. There are three other pairs of
figures: two dancing maenads in tunics and patterned
cloaks, one playing on a *diaulos*, or double-flute, and
with a timbrel shown between them; two satyrs
cloaked in panther skins, embracing and taking wide
dancing steps, with an overturned kantharos at their
feet; and a third pair with a leaping Pan to the right,
his right arm grasping a naked dancing maenad with
a timbrel in her left hand and a cloak with ribbons
thrown over her shoulder and across her arm. On
her right is the delicately proportioned figure of a
panther jumping to the right, its head turned back.

According to one interpretation, the many-figured
composition on the lid portrays a satyric drama about
the young Dionysos. The painting is executed in the
style of Attic red-figure vase-painters of the second
quarter of the fourth century BC.

During excavation nuts were found inside the
lekanis. NJ

BIBLIOGRAPHY: OAK, 1861, pl. II; Schefold, 1934, p. 8, no. 18,
pl. 2 (top), 3; Skrzhinskaia, 2002, p. 33, ill. 8; Sankt-
Peterburg i antichnost', 1993, p. 96, no. 3.

17
Red-figure Hydria with Paris and Helen

Attica
375–370 BC
Height 33 cm, diameter 20.3 cm
Clay
Inv. no. IOO.26
From excavations at Yuz-Oba (Barrow V, mound above tomb
no. 48) by A.E. Lyutsenko, 1860; to Hermitage, 1862

This red-figure hydria depicting Paris and Helen has
a wide, smooth mouth, a narrow neck, an oval body
and almost horizontal shoulders. The side handles
are slightly turned upwards.

 The central part of the composition shows a
seated, half-naked Helen, with Paris standing in
front of her to the left, dressed in eastern apparel.
Two erotes hover above. A woman in a tunic with
a phiale and oinochoe in her hands stands behind
Paris. Behind the woman are a standing half-naked
youth and a seated woman. To the right of Helen are
the figures of a woman in a tunic standing with a fan,
a naked youth leaning on his right knee and a woman
facing left wrapped up in a cloak. NJ

BIBLIOGRAPHY: Bohač, 1958, fig. 7; Skrzhinskaia, 2002, p. 28,
ill. 3; Liefde, 2003, cat. 134.

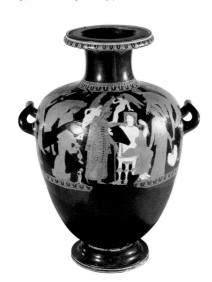

18
Red-figure Lekanis with Female Figures

Attica; Marsyas Painter
370–360 BC
Height 21 cm, diameter 36.4 cm
Clay
Inv. no. IOO.32
From excavations at Yuz-Oba (Barrow VI, stone vault no. 47)
by A.E. Lyutsenko, 1860; to Hermitage, 1862

The red-figure lekanis is decorated with gilt and
blue and white paint; it has a circular base, wide
horizontal handles with rectangular protuberances,
and a lid crowned by a disk-shaped handle decorated
with a circle of calyces and a band of lotus flowers.
The sides of this deep vessel are decorated with
a band of palmettes and lotuses framed with egg-
and-dart ornament.

 A large egg-and-dart ribbon runs round the edge
of the lid, which shows fourteen female figures at
their toilet. In the centre of the composition is a
group of three: a woman squatting down washing her
hair, a woman standing next to her, holding a vessel,
and an eros hovering above. A second group shows
a woman sitting on a chair while another standing to
her right combs her hair. A third has two more female
figures: one of them is brushing her hair while the
figure of an eros is placed between them. The next
two female figures stand on either side of a chair. The
next pair shows a woman standing holding a mirror
while a girl turns her face towards her. The final pair
comprises a woman standing with her right hand
placed on the head of a second woman who is
kneeling before her. The composition is completed
by a naked woman sitting on a cloak; to her right
is an eros and to her left a boy. The bodies of all the
figures are painted in white; the erotes, the women's
jewellery, the furniture and other details are all
executed in superposed diluted clay and gilt. The
style of the painting suggests that this vessel is the
work of the Marsyas Painter. NJ

BIBLIOGRAPHY: OAK, 1861, pl. 1; ARV, 1475, 7 (Marsyas
Painter); Schefold, 1930, pl. 15b (details); Schefold, 1934,
fig. 60, no. 19.

19
Red-figure Pelike with Nereids and Youths

Attica
340–330 BC
Height 29.2 cm
Clay
Inv. no. IOO.42
From excavations at Yuz-Oba (Medium-sized Barrow,
stone vault no. 9) by A.E. Lyutsenko, 1863; to Hermitage,
same year

This Attic red-figure pelike is in the so-called Kerch
style. It is covered in a black lustrous galena slip;
white and yellow paint is also used. Around the
mouth and neck of the vessel is an egg-and-dart
ornament (with a row of dots also around the neck),
and a similar egg-and-dart band around the lower
part of the body. Beneath the handles are double
palmettes with volutes and petals.

 Depicted on one side are two half-naked nereids
riding hippocamps, one of them with her head turned
back. Between them is an eros in a cloak with wings
spread and a cup in his left hand; his body is executed
in white and yellow paint. Beneath the eros are two
fish. The other side of the pelike shows three mantled
figures of youths. NJ

BIBLIOGRAPHY: Schefold, 1934, p. 45, no. 402, Gr. III, p. 142;
for information on the mantled figures *see*: Isler-Kerényi,
1971, p. 30; eadem Num Ant Clas 8 (1979), p. 34.

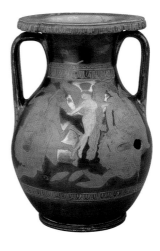

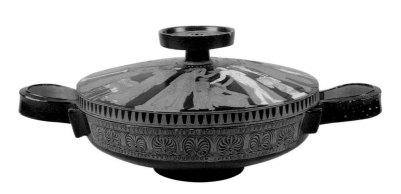

Disk Pendant with a Nereid on a Hippocamp

4th century BC
Height 15.5 cm, diameter of disk 7.3 cm
Gold, enamel
Inv. no. ББ.31 (АБз 749)
From excavations of Bolshaya Bliznitsa Barrow, Taman
Peninsula, by I.E. Zabelin and A.E. Lyutsenko, 1864

This is one of a pair of pendants with a disk containing an image in relief. Five rows of pendants of varying form, size and decoration are attached to the disk. The points where the interwoven chains join and are attached to the disk are masked by miniature two-layered filigree rosettes, each with a chased sphere in the centre, while the points where the corn- and amphora-shaped pendants join the chains are masked by shield bosses and ivy leaves. On the upper edge of the back of the disk is a suspension ring.

The filigree petals on the pendants and ivy leaves are filled with green and blue enamel. Around the rim of the disk is a border of filigree palmettes framed by beaded and plain wires. Some of the pendants, chains and decorative details have not survived, and in places the enamel is missing.

The large convex disk is decorated with an image in relief of a nereid riding a hippocamp, with dolphins swimming alongside. The small details of the relief have been finished with stippling. The image is connected to the story of Achilles, hero of the Trojan War, to whom a nereid, possibly his mother Thetis, brought armour forged by Hephaistos. In this pendant the nereid holds a breastplate in her right hand, while in its pair she holds a *knemis*, or greave, in her left. The cult of Achilles, who was believed after his death at Troy to have attained immortality, and to have settled on the island of Leuke in the north-west Black Sea (or Pontos Euxinos as the Greeks called it), was widespread among the people of the northern Black Sea region, and is reflected in works of Greek art of the period, including jewellery. LN

BIBLIOGRAPHY: CR, 1865, pl. II, no. 1; Greek Gold, 1994, no. 120; Greek Gold, 2004, p. 104.

Plaque with Herakles

4th century BC
6 × 6 cm
Gold
Inv. no. ББ.44 (АБз 1433)
From excavations of Bolshaya Bliznitsa Barrow, Taman
Peninsula, by I.E. Zabelin and A.E. Lyutsenko, 1864

This is one of fourteen square gold plaques with a portrait in relief of the head of Herakles. The hero is shown wearing a wreath, while his club rests against his right shoulder. These plaques probably belong to a series of appliqués similar in form and decoration, including those showing Demeter (cat. 23) and Persephone (cat. 22), all depicting figures connected with the Eleusinian Mysteries. It is known that Herakles was initiated into these mysteries that venerated Demeter, the goddess of agriculture and fertility, and his image played a significant role in spreading her cult beyond Greece.

This plaque – like those showing Demeter and Persephone – has a relief egg-and-dart border with eight small round holes for fastening to fabric. LN

BIBLIOGRAPHY: CR, 1865, pl. II, no. 9; Greek Gold, 1994, no. 129; Saverkina, 1997, no. 95; Greek Gold, 2004, pp. 105–6.

Plaque with Persephone

4th century BC
5.8 × 5.8 cm
Gold
Inv. no. ББ.45 (АБз 1434)
From excavations of Bolshaya Bliznitsa Barrow, Taman
Peninsula, by I.E. Zabelin and A.E. Lyutsenko, 1864

One of thirteen square gold plaques with a relief frontal head of Persephone, this object comes from a wealthy woman's burial chamber. Like the plaque with the head of Demeter (cat. 23), this is part of an original group of plaques from the Bolshaya Bliznitsa Barrow, all dedicated to a single subject: the veneration of Demeter, the goddess of agriculture and protectress of the animal and plant kingdom, which was extremely popular amongst inhabitants of the northern Black Sea region.

Persephone, Demeter's daughter, was carried away by Hades, ruler of the underworld. Here she is shown wearing identical jewellery to Demeter – a bead necklace and earrings with a disk and pyramidal pendant – while her face is framed with a veil. The decoration of Persephone's hair with ears of corn represents the regenerative life-force of nature (with Zeus's permission, Persephone was allowed to leave the underworld to spend part of each year on earth with her mother Demeter).

The relief egg-and-dart ornament around the edge of the plaque is studded with eight small round holes for fastening to fabric. LN

BIBLIOGRAPHY: CR, 1865, pl. II, no. 7; Greek Gold, 1994, no. 128; Saverkina, 1997, no. 94; Greek Gold, 2004, pp. 105–6.

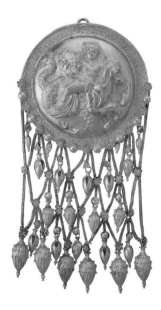

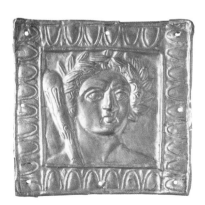

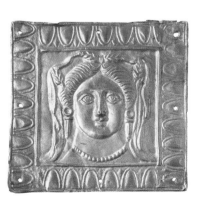

23
Plaque with Demeter

4th century BC
6 × 6 cm
Gold
Inv. no. ББ.46 (АБз 1435)
From excavations of Bolshaya Bliznitsa Barrow, Taman Peninsula, by I.E. Zabelin and A.E. Lyutsenko, 1864

The square gold plaque with an image of Demeter is one of fifteen found in the burial chamber of a priestess who led the cult of the Greek goddess on the Taman Peninsula. Along with others from the same burial chamber (cat. 21, 22, 24 and 25), it forms part of a series of ornaments connected to the Eleusinian Mysteries and the cult of Demeter, the goddess of agriculture and fertility. Interest in these mysteries around the northern coast of the Black Sea is confirmed by archaeological finds in other burial sites. However, the fact that the plaques found at Bolshaya Bliznitsa pertain to a single subject makes them unique amongst similar plaques (both square and cut out) found in the area.

The relief depiction of the head of Demeter is shown in three-quarter view. The flaming torch, a common attribute of the goddess, lights her path as she searches for her daughter Persephone (cat. 22). Demeter's jewellery can be clearly made out: a wreath, a bead necklace, and an earring with a disk and pyramidal pendant.

The relief egg-and-dart ornament around the edge of the plaque is studded with eight small round holes for fastening to fabric. LN

BIBLIOGRAPHY: CR, 1865, pl. II, no. 8; Greek Gold, 1994, no. 127; Saverkina, 1997, no. 93; Greek Gold, 2004, pp. 105–6.

24
Plaque with a Dancing Girl

4th century BC
Height 4.8 cm
Gold
Inv. no. ББ.50 (АБз 1439)
From excavations of Bolshaya Bliznitsa Barrow, Taman Peninsula, by I.E. Zabelin and A.E. Lyutsenko, 1864

This is one of twelve plaques, stamped and cut out in contour, showing a dancing girl with hands clasped above her head.

The curve of the body, the wide step (almost a jump), the flowing contours of the *chiton* (short belted tunic) and the ribbons of the hair-band all combine to capture the expressive nature of the *oklasma* (an oriental, perhaps Persian, dance). This plaque, along with another showing a dancing girl in a *kalathos* (cat. 25), would suggest that both dances were part of a ceremony connected with the cult of Demeter, the goddess of fertility. This is confirmed by the image of the goddess alongside characters from the Eleusinian Mysteries on the red-figure pelike from the Pavlovsky Barrow, and the related series of square plaques from the Bolshaya Bliznitsa Barrow (cat. 21–23).

The four small circular holes around the edge of the plaque would have been used to sew it onto fabric. LN

BIBLIOGRAPHY: CR, 1865, pl. III, no. 1; Saverkina, 1997, no. 98; Greek Gold, 2004, p. 106.

25
Plaque with a Dancing Girl in a Kalathos

4th century BC
Height 5.2 cm
Gold
Inv. no. ББ.51 (АБз 1440)
From excavations of Bolshaya Bliznitsa Barrow, Taman Peninsula, by I.E. Zabelin and A.E. Lyutsenko, 1864

This is one of twelve plaques of a dancing girl, cut out in contour. The girl is holding the skirts of her *chiton*, which is belted under her breast, while she dances on tip-toes. She is wearing a *kalathos* – a form of headwear similar to that worn by the woman buried in this barrow. In Greece, a *kalathos* is a woven basket broadening out from bottom to top, which was used for domestic purposes such as picking fruit. A hat similar in form, symbolising plenty, crowns the head of the goddess Demeter on a red-figure pelike from a female burial chamber in the Pavlovsky Barrow (Pantikapaion Necropolis), where she is shown surrounded by other characters from the Eleusinian Mysteries. A glass ring was discovered in the same barrow with figures of dancers made from gold foil; these are directly analogous to this dancer and the one on the other plaque (cat. 24) from the tomb of a priestess of Demeter in Bolshaya Bliznitsa. A similar dance of girls with baskets (*kalathiskos*) at ceremonies in honour of Demeter and Artemis is described in the works of ancient authors.

The five round holes on the plaque would have attached it to the veil of the buried woman. LN

BIBLIOGRAPHY: CR, 1865, pl. III, no. 2; Saverkina, 1997, no. 97; Greek Gold, 2004, p. 106.

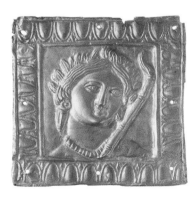

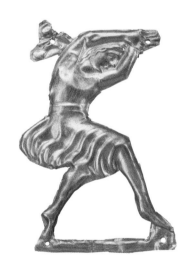

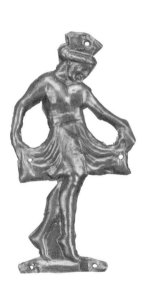

26
Jug with a Mask of Medusa

Eastern Mediterranean
First quarter of 3rd century BC
Height (with handle) 28 cm
Silver; chasing, incising
Inv. no. P.34
From excavations of a royal tomb in a barrow, Kerch,
Crimea, by A.B. Ashik, 1837; to Hermitage, 1838

This jug has an ovoid body on a foot; a raised band
around the neck is framed at top and bottom by two
narrow relief strips. The neck widens towards the
top and is crowned by an additional vertical rim.
An ornamental plate runs around the outside of the
rim and is soldered to the neck; it stretches around
half the circumference of the neck and adjoins the
handle. This plate is carved along its edge to form
symmetrically positioned smooth protuberances,
scrolls and two circles; it is decorated with incised
designs of two branches with leaves and cross-
hatching on the circles and scrolls. The flat, smoothly
curved handle of the jug is decorated at both ends.
A leaf with incised veins is soldered to the top of the
handle; at one end it is crowned by a small sphere, at
the other by a small square with an engraved pattern.
At its lower end the handle is decorated with a mask
of Medusa in relief, soldered to the side of the jug. NK

BIBLIOGRAPHY: ABC, pl. 37, no. 2; Antichnoe serebro, 1985,
p. 42, no. 56 (no illustration).

27
Jug with a Decorative Vine Frieze

Attica
First quarter of 3rd century BC
Height 12.9 cm
Silver; casting, chasing, incising, gilding
Inv. no. П.1838.28
From excavations of a flagstone tomb in a barrow,
Pantikapaion Necropolis, Kerch by A.B. Ashik, 1837;
to Hermitage, 1838

This jug has a high neck, steep shoulders and a body
narrowing towards the base on a low foot. A twisted
handle is decorated at its lower end with the head of
a beardless satyr. Where the neck of the pitcher joins
the body is a ledge decorated with incised bands: a
row of dots, a wave ornament and vertical lines. The
neck and body of the vessel are decorated with areas
of incised design on a gilded background. A branch
of acanthus leaves intertwined with ribbons decorates
the neck. On the body is a wide ornamental frieze,
filled with vines and framed above and below with
bands of a wave ornament between two rows of dots.
NK

BIBLIOGRAPHY: Zhurnal MVD, 1839, no. 1, pl. II, no. 3;
Prushevskaia, 1979, p. 247, ill. 31; Maksimova, 1979, p. 75,
ill. 23, no. Б-5; Kul'tura i iskusstvo Prichernomor'ia, 1983,
no. 303; Antichnoe serebro, 1985, p. 30, no. 31 (ill. on p. 33).

28
Kylix with the Chariot of Helios

Eastern Mediterranean
First quarter of 3rd century BC
Height 3.8 cm, diameter 12.5 cm,
length with handles 21.5 cm
Silver; casting, chasing, incising
Inv. no. П.1838.25
From excavations of a flagstone tomb in a barrow,
Pantikapaion Necropolis, Kerch by A.B. Ashik, 1838;
to Hermitage, same year

The tondo of this shallow cup with loop-shaped
handles is decorated with a medallion in relief, which
would have been made separately. Framed by an
ornamental band with an incised guilloche, or braid
pattern, the medallion depicts the sun god Helios
in a fast moving quadriga (a chariot harnessed with
four horses). The god's head is encircled by a halo
of radiating rays, and in his raised right hand he
holds a staff. The quadriga is foreshortened in three-
quarters: the front legs of the horses are raised high,
the heads of the middle pair are turned towards each
other, while the outer horses' heads are turned to
the side. Beneath their hooves the line of the ground
is shown in relief. NK

BIBLIOGRAPHY: Zhurnal MVD, St Petersburg, 1839, no. 1,
pl. II, nos. 1–2; ABC, pl. 38, nos. 5–6; Strong, 1966, p. 95,
pl. 30-a; Maksimova, 1979, p. 74, ill. 23, no. Б-1; Antichnoe
serebro, 1985, p. 29, no. 26 (ill. on p. 27); Sokolov, 1999,
p. 281, ill. 201.

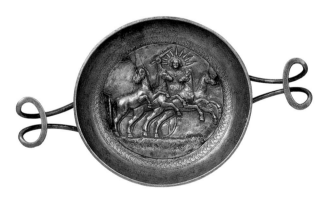

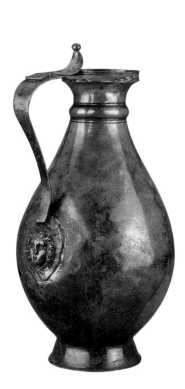

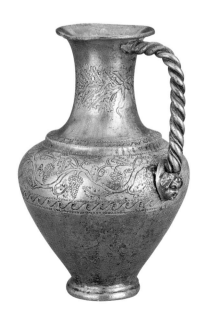

29
Vessel with Ducks and Fish

Bosporan Kingdom (probably Pantikapaion)
4th century BC
Height 12.5 cm
Silver; chasing, engraving, gilding
Inv. no. K-O.96
From excavations of a stone vault, Kul-Oba Barrow, Kerch, 1830; to Hermitage, 1831

This Scythian ritual vessel is spherical in form, with a short cylindrical neck and mouth bent slightly outwards. The vessel's surface is decorated all over with engraving. The central part of the body comprises a relief frieze with gilded depictions of swimming ducks and fish, typical of the realistic manner of Greek art of the late classical era. Five of the eight birds have caught, and are swallowing, fish.

The ornamentation decorating the vessel is also typically Greek. Above and below the figured frieze are wide bands of vertical petals in relief. Above the upper and beneath the lower band of petals are narrower bands with a guilloche, or braid ornament. The lowest of these forms a circle around the bottom, inside which (on the base of the vessel) is an eight-petal rosette in relief with trefoils between the petals.
NK

BIBLIOGRAPHY: ABC, pl. 35, nos. 5–6; Gaidukevich, 1949, p. 273, ill. 48; Artamonov, 1966, pl. 241–6; Onaiko, 1970, p. 37, ill. 6; Gajdukevič, 1971, ill. 78; Grach, 1984, p. 103, pl. I, 2; Antichnoe serebro, 1985, p. 21, no. 11 (ill. on p. 15); Aus den Schatzkammern Eurasiens, 1993, p. 93, no. 42.

30
Vessel with Lions Tearing apart a Deer

Bosporan Kingdom (probably Pantikapaion)
4th century BC
Height 14.2 cm
Silver; chasing, incising
Inv. no. K-O.98
From excavations of a stone vault, Kul-Oba Barrow, Kerch, 1830; to Hermitage, 1831

The upper part of the body of this Scythian ritual vessel is decorated with a wide relief frieze depicting the figure of a panther and a scene of a lion and lioness tearing a deer to pieces. Below the figured frieze is a rosette of vertical petals turned upwards, while at the neck is a narrow band with a guilloche, or braid ornament. The floor of the vessel is smooth.
NK

BIBLIOGRAPHY: ABC, pl. 34, 1–2; Artamonov, 1966, pl. 241, 243, 246; Grach, 1984, p. 106, pl. III; Antichnoe serebro, 1985, p. 21, no. 13 (ill. on p. 20).

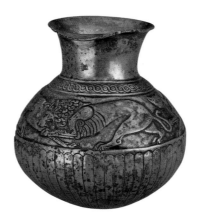

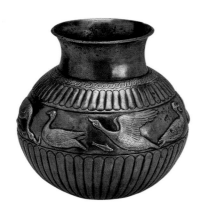

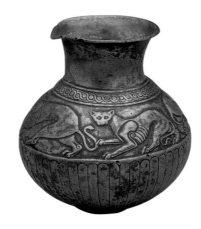

31
Portrait of a Roman

Rome
50–40 BC
Bronze
Overall height 39 cm, height of head 23.7 cm
Inv. no. B.2067 (ГР 11234)
Origin unknown; to Hermitage from State Museum Fund,
1928

This statue is one of the finest Roman portraits
not just in the Hermitage collection, but in any of
the great museum collections of the world. Its
extraordinary emotional power makes it one of the
masterpieces of antique portraiture. It is also
something of a rarity, since very few antique bronze
portraits have survived to the present day: bronze
is easily corroded and so such objects are often in a
poor state of preservation. The wonderful condition
of this portrait fully reveals the technical mastery
of the sculptor and adds to our understanding of
sculptural art at that somewhat contradictory period
of the end of the Republic and the early Empire.

The man's head is thrown slightly back and
to his right, which echoes early Hellenistic portrait
statues. The muscles of the neck and collarbone are
worked in relief, underlining the solid construction
of the bust and, at the same time, conveying a sense
of movement, of impulsiveness. The wide-open eyes

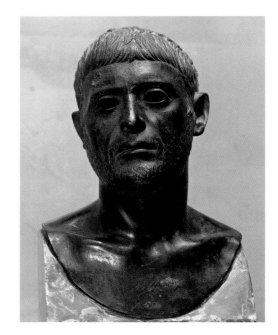

are empty: the eyeballs would have been affixed
separately and have not survived. The deep lines
in the face create strong shadows, while the sorrow
lines along the lips and the somewhat gloomy sheen
of the bronze lend the whole portrait a suffering,
tragic character.

In all probability this is a portrait of a man in
mourning. He is shown with a beard, and it is known
that Romans went unshaven as a sign of grief over
the death of relatives or to mark tragic events of state.

Schweitzer suggested that the bust was the
work of a Roman artist of the early Augustan period.
Vostchinina agrees with this view and dates it to the
last quarter of the first century BC. In the light of
recent discoveries, however, it seems likely that the
Hermitage bust is closer to a group of objects of
a slightly earlier date – between 50 and 40 BC. The
closest stylistic analogies are a portrait of Marcus
Porcius Cato, found in North Africa (Simon, 1986,
p. 59, no. 65), and a portrait of Octavian from Arles
(the 'bearded man') (Simon, 1986, p. 57, no. 62),
which are considered to be works of late Republican
classicism. AT

BIBLIOGRAPHY: Schweitzer, 1948, pp. 120–7, ill. 190–1;
Vostchinina, 1977, p. 13, no. 4.

32
Portrait of Livia,
Wife of the Emperor Augustus

Rome
Second quarter of 1st century BC
Fine-grained marble
Overall height 34 cm, height of head (to wreath) 19.5 cm
Inv. no. A.116 (ГР 3017)
Acquired by Catherine the Great, probably from Lyde
Browne Collection, London, 1787; kept in the Grotto,
Tsarskoe Selo; to New Hermitage, 1850

This head of the empress Livia would originally have
been made separately and appended to an idealised
statue of Ceres.

Livia is portrayed as Ceres, goddess of fertility,
and as head priestess of the cult of Augustus, her
deified husband, in which role she took the name
Julia Augusta. Her head is crowned with a wreath of
ears of corn and fruits, attributes of Ceres, and
a sacred band of woollen threads tied in knots, the
mark of a priestess. Her hair is shown in wavy
strands tied in a small knot at the nape of the neck –
a hairstyle typical of portraits of Livia of the late
period, and often combined, as here, with the
attributes of a priestess.

Numerous portraits of Livia were found in Rome
and many other provinces. In sculptural portraits
she is shown as Ceres, Juno and Julia Augusta; her
image was also often included in relief compositions

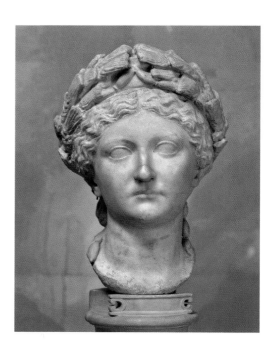

on official monuments (for example, she is shown
on the Ara Pacis in Rome). The majority of the
portraits that have survived date from the period after
the death of Augustus, during the reign of her son
Tiberius, who succeeded Augustus to the throne.

Like Augustus himself, Livia is shown young
and beautiful, and her features are idealised. The
hairstyle, in particular, echoes those of idealised
figures of the fourth century BC. The sculptural work
is remarkable for its simplicity, limited to broad
strokes with little modelling. Despite the idealisation,
the features of the face are nonetheless remarkable
for their expressive individuality: the narrow pursed
lips, the aquiline nose and the eyes set too far apart.
According to Tacitus, 'an imperious mother and
an amiable wife, she was a match for the diplomacy
of her husband and the dissimulation of her son'
(Tacitus, *Annals*, V, 1).

Portraits similar to this one are to be found in
many of the world's museums. Augustus and his
descendants paid great attention to the development
of a dynastic cult, and a particular role was played
by the women of Augustus's family – Livia, Antonia
and Agrippina. AT

BIBLIOGRAPHY: Catalogus veteris, 1768, no. 67; Opis, 1788,
no. 57; Koehler, 1853, p. 6; Poulsen, 1962, p. 72;
Vostchinina, 1977, p. 141, no. 9; Bartman, 1999, pp. 164–5,
no. 43, fig. 82.

33
Portrait of a Man Wearing a Laurel Wreath

Western Syria
Mid-3rd century AD (?)
Coarse-grained grey marble
Overall height 24 cm
Inv. no. A.571 (ГР 7410)
Found near Jerusalem, 30 metres from ancient city walls,
1873; acquired by Archimandrite Antonin who bequeathed
it to Hermitage; kept in Russian Orthodox Monastery
in Jerusalem until 1885, then transferred to RAIK;
from there to Hermitage, 1889

The portrait represents a man with a short beard;
rich curls cover his forehead and ears. He wears
a wide laurel wreath with a circular cameo showing
a standing eagle with wings spread (an image used
on Roman military standards). The brows and eyelids
are executed in relief, the pupils are deeply incised.

The subject of the portrait, based on its
iconography, has been disputed from the moment
it was first published by Clairmont-Ganneau, who
identified it as Herod, King of Judea. Waldhauer,
Watzinger and Wegner proposed that it portrayed
an unknown priest of Jupiter. Vostchinina argued
that it should be identified as the emperor Hadrian,
but Evers later excluded it from the list of portraits of
Hadrian. Trofimova has proposed that it may date
from the Gallienic period.

Although features of the face and hairstyle do
not correspond to the conventional iconography of
Hadrian, in character and style it is reminiscent of
portraits created in the eastern provinces. It is well

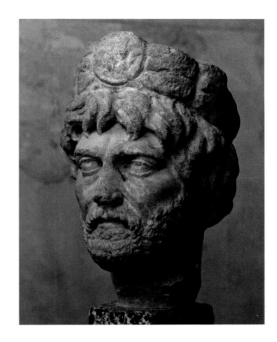

known that Hadrian was a great traveller, and statues
were often erected in the numerous cities he visited,
which explains the large number of portraits of
Hadrian that have survived to this day.

This portrait comes from a statue erected in Aelia
Capitolina, a Roman colony built by Hadrian on the
territory of Jerusalem, which had been destroyed
under the Flavians. In AD 132 a Jewish revolt erupted,
and after it was suppressed Hadrian built a Roman
city on the site of Jerusalem, complete with numerous
public buildings, temples and, of course, sculptural
portraits. To judge from the workings on the back
of the head, it appears this statue would have stood in
a niche, which would no doubt have decorated one
of the municipal buildings in the city.

The portrait from Aelia Capitolina differs
markedly from more benevolent Roman and Italian
statues. Its gloomy, elderly features are influenced by
eastern traditions which at this time were still evident
in portraits from Syria and Palmyra.

A later development of the type can be seen in the
heads of priests of eastern Roman origin, dating from
the reign of Gallienus (Inan and Alfoldi-Rosenbaum,
1979, no. 264, pl. 188, no. 75, no. 319, pl. 225, 322).
This line of development continued into early
Byzantine portraits, and thus brought together the
hieratic nature of eastern art and the more plastic
clarity of the classical idiom. AT

BIBLIOGRAPHY: Clairmont-Ganneau, 1889, p. 259; Evers,
1994, p. 292; Watzinger, 1935, p. 86, ill. 73; Wegner, 1955,
p. 99; Waldhauer, 1924, p. 106, no. 226; Voschinina, 1972,
pp. 124–35, ill. 1–3; Vostchinina, 1977, p. 159, no. 32;
Trofimova, 1994, p. 54, no. 51.

34
Portrait of Antinous as Dionysos

Rome
Second quarter of 2nd century AD
White fine-grained marble
Height 39.5 cm
Inv. no. A.27 (ГР 1705)
Reportedly found at Hadrian's Villa, Tivoli, and purchased
by I.I. Shuvalov in Rome, 1777; acquired by Catherine the
Great as part of Shuvalov collection, 1784; kept in the Grotto,
Tsarskoe Selo; to New Hermitage, 1850

This head portrait shows Antinous, the favourite of
Hadrian, in the form of Dionysos. A branch of Italian
pine – an attribute of Dionysos – adorns the curly hair,
while luxuriant ringlets hang down over the forehead.
The young man has thick, brooding brows, small
deep-set eyes and swollen, childish lips; his profile is
classically 'Greek'.

After the death of Antinous, Hadrian founded the
city of Antinoopolis on the site of his death in Egypt;
at the same time he founded an official cult, with
its own divine offices, temples, priests and numerous
statues to its idol. Although inscriptions in praise of
Antinous are known throughout the empire, including
Rome and Italy, his cult was particularly widespread
in Egypt and Greece. The youth was worshipped as
Osiris, Apollo, Dionysos, Adonis and Hermes.

The Hermitage portrait of Antinous as Dionysos
is the work of a superlative sculptor. A delicate
combination of techniques can be seen in the smooth

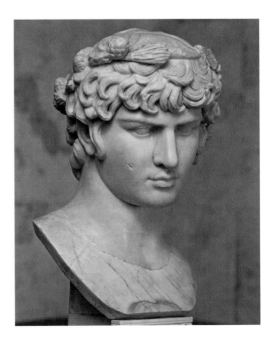

surface of the skin which contrasts with the richly
worked head of hair, made using a drill, while the
graphic execution of the brows is achieved by means
of deeply incised lines. The precise silhouette of the
head combines beautifully with the soft plastic nature
of the surface modelling.

According to Clairmont's classification this portrait
is of a type known as Replica B. This type makes up the
most common group of portraits of Antinous; they
are notable for certain distinctive qualities in the
treatment of the hair. The earliest example is the
Farnese Antinous. This major work of Hadrianic
classicism brought out Antinous's specifically Italian
features, making the youth close to the ideal statues
of the Roman deities. Many of the portraits of this
group also show Antinous deified, usually as Dionysos.

The popularity of the Dionysian image of Antinous
is in part explained by the fundamental similarities
between Hadrian's favourite and the beautiful young
Greek god. However, the cult of Antinous-Dionysos
also reveals the influence of the cult of the emperor
Hadrian himself, who was worshipped as Neos
Dionysos. Like a number of other portraits of
Antinous, this sculpture was apparently found at
Hadrian's Villa in Tivoli. AT

BIBLIOGRAPHY: Dallaway, 1800, p. 369; Koehler, 1853;
Vostchinina, 1977, p. 161, no. 35; Clairmont, 1966, p. 50,
no. 34, pl. 26; Trofimova, 2004, p. 129, no. 129.

35
Prometopidion from a Priest's Crown with Nero on the Chariot of Helios

Northern Black Sea region
AD 60–70
6.6 × 6.5 cm
Gold
Inv. no. Д.1164
Found in Anapa (Gorgippia), 1906

The *prometopidion*, or plaque, from a priest's crown shows Nero-Helios on a quadriga; above him are the symbols of Mithra – a sun and crescent moon. Historians relate that when the Armenian king Tiridates I was received at the Theatre of Pompey in Rome, a purple curtain was spread over the theatre with a similar image: Nero driving a chariot, embroidered in gold and surrounded by gold stars. The Hermitage plaque evidently relates to this curtain, which went up in flames after being struck by lightning in the gardens of Nero beyond the Tiber. ON

BIBLIOGRAPHY: Neverov, 1982, p. 108, ill. 5.

36
Patera with Ajax Bearing the Body of Achilles

First half of 1st century AD
Diameter 26 cm
Bronze, inlaid silver
Inv. no. B.407 (ГР 3870)
From collection of A.G. Laval, 1852

The patera – a fine example of Roman toreutics of the Augustan era – is in the form of a deep bowl on a low circular base with concentric interior circles in relief, and egg-and-dart and pearling decoration on the outer rim. In the centre of the bowl is a medallion in relief with an image of Ajax kneeling on his left knee and bearing Achilles' naked body on his shoulders. Ajax's right arm is resting on his right knee, while with his left he grasps the body of Achilles. Ajax is dressed in a *chiton*, over which he is wearing an anatomical breastplate with *pteryges* (strips of material suspended from the armour). On his head is a helmet with a horsehair crest, and a large oval shield lies by his feet. The inner surface of the shield bears finely engraved decoration in the form of half-palmettes. The earth beneath the hero's feet is marked with small hachures. The helmet, the edge of the shield and Ajax's clothing are all inlaid with silver.

A fluted cylindrical handle is attached to the bowl by a plate bearing plant decoration in relief. At the end of the handle is a realistically sculpted ram's head. The muzzle of the ram has been carefully worked, and its pupils are inlaid with silver.

Waldhauer concluded – from the statuesque nature of the figures and from comparison with similar images on Etruscan mirrors and red-figure vases – that the scene on the medallion is based on Greek sculpture of the early fifth century BC. Subjects on themes from Homer's *Iliad* and *Odyssey* subsequently became popular in the artistic works of craftsmen of the Byzantine Empire. Both in antiquity and, later, in Byzantine art, the ram was a symbol of eternal sacrifice. NG

BIBLIOGRAPHY: Waldhauer, 1927, p. 298 ff., ill. 1; Goulyaeva, 2000, p. 169, fig. 12.

37
Plate with a Nereid

Rome
Second half of 2nd century AD
Diameter 24 cm
Silver; chasing, incising, gilding
Inv. no. Кз 5308
Discovered by chance at end of 19th century near village of Yengikend, Geokchai District, Bakin Oblast (Azerbaijan)

The plate is made from two sheets riveted together. The image is embossed from the reverse of the upper sheet, while the lower sheet is left smooth with a ring-shaped stand soldered in the centre. Skilfully executed in high relief, the image is partially gilded and lightly incised in places. It is distinguished by the unusual fineness of the modelling and compositional structure, which have long placed it among the masterpieces of Roman toreutics.

The nereid, half-reclining on a hippocamp, carelessly holds one end of a rein, while a young triton pulls the animal forward with the other. A second triton in the foreground emphasises the direction of movement with his outstretched hand. An eros plays with dolphins in the waves amongst floating shells; another eros blows into a long shell by the hippocamp's tail, while a third eros with a large shell soars above the head of the horse.

Scholars have interpreted this subject as the scene described by Ovid in his *Metamorphoses*, when Galatea, the most beautiful of Nereus's 40 daughters, frolics in the sea (admired from the shore by her rejected lover Polyphemos) – a subject which was popular from antiquity to the Renaissance.

The dish was found (together with a gold coin which disappeared almost immediately) on the site of an ancient transit route which lead from the south to Kabalaka, the capital of Caucasian Albania, situated in modern-day Azerbaijan. AAI

BIBLIOGRAPHY: OAK, 1896, p. 114, ill. 410; Trever, 1959, pp. 176–7, pl. 3; Trever, 1969, no. 25; Matzulewitsch, 1929, pp. 43–4, pl. 5; Khudozhestvennoe remeslo, 1980, pp. 46–7, no. 127.

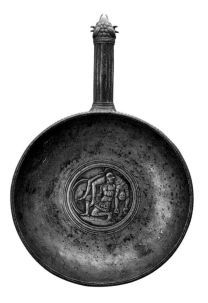

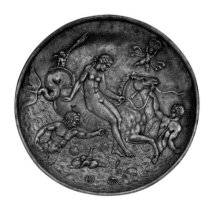

38
Intaglio with Nero (?) in the form of Helios

Rome
Mid-1st century AD
6.6 × 6.5 cm
Topaz, gold
Inv. no. Ж.1432
From excavations in village of Usakhelo (Georgia), 1911

This portrait of Nero (?) in the form of Helios may be based on a 32-metre-high statue (known as the Colossus Neronis) by the sculptor Zenodorus which stood in the centre of Rome near the Golden House of Nero. The intaglio was used as a fibula, or clasp. The portrait is visible through the convex transparent stone on the reverse. ON

BIBLIOGRAPHY: MAR, 1914, vol. 34, p. 110, pl. I; Lordkipanidze, 1969, no. 109; Neverov, 1976, no. 136.

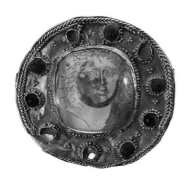

39
Votive Hand (Hand of Sabazios)

3rd–4th century AD
Height 17 cm
Bronze
Inv. no. B.972 (ГР 8018)
From Yekaterinoslav province, 1900

The hollow votive hand has two raised and two bent fingers; a pine cone is attached to the raised thumb. On the inside of the wrist in a semi-circular mount is a relief portrait of a woman lying down, feeding a child. There is an eagle in profile above the woman's knees. Just above this scene in the lower part of the palm is another group in relief showing a table with three items on it (possibly cups). On the side of the wrist beneath the thumb are the following: an amphora with an object reminiscent of a bunch of grapes above; a tree with a serpent wound round its trunk and a lizard above; and a frog. In the centre of the back of the hand is a *caduceus* (staff with two snakes wrapped around it), with scales above, and to the right a serpent in relief, its body stretched along the length of the hand and its head lying on the bent little finger. A little below the head of the serpent, on the lower phalanx of the little finger, is a tortoise. On the side of the wrist below the little finger are two pivot-shaped objects (possibly flutes), beneath which is an object reminiscent of a wine-skin, and lower still, three vessels (possibly pyxides). A fish is portrayed perpendicular to the flutes, and beneath it is an ill-defined object bent in half, similar to a lash.

The positioning of the fingers in the liturgical blessing (the *Benedictio Latina*) is typical of cult relief figurines which were associated through inscriptions with the Phrygian god Sabazios. Sabazios's cult was widespread in Thrace, and in the Roman Empire he came to be identified with the cults of Bacchus and Jupiter. All the votive hands relating to the cult of Sabazios are rich in symbols and hidden meaning: the pine cone is probably a symbol of fertility; the serpent was Sabazios's sacred animal, a constant feature on statues of the god, representing life; the eagle, another of the god's attributes, probably represents the immortality of the soul. The chthonic animals – the tortoise, frog and lizard – are a reminder of Sabazios's demonic origins, while the *caduceus* is a symbol of the god Mercury, but also of the link between the worlds of the living and the dead. Such hands are more often found in Europe than in the East. Their significance is unclear, although they may symbolize the power of the god's help. NG

BIBLIOGRAPHY: Kobylina, 1976, p. 27, no. 31, pl. xx.

40
Pyxis with Erotes and a Garland

Eastern Mediterranean
3rd century AD
Height (with lid) 16.1 cm, diameter 14.1 cm
Silver; chasing, incising
Inv. no. P.33
From excavations of a royal tomb in a barrow, Kerch, by A.B. Ashik, 1837; to Hermitage, 1838

This spherical vessel on a low foot with a lid and hinged handle bears a relief frieze depicting four erotes. A garland of leaves tied with ribbons runs across their shoulders, and they hold torches, a bee and wreaths in their hands. Above the garland are four masks of Medusa. Beneath the feet of the erotes the earth is shown as a ridge with rows of indented dots. Above, the frieze is framed by a relief band with alternating sections of leaves and sections of rows of dots. Ribbons separate the sections in six places. There is a similar wreath on the lid. NK

BIBLIOGRAPHY: ABC, pl. 37, no. 1; Khudozhestvennoe remeslo, 1980, p. 47, no. 128 (ill. on p. 46, colour ill. on p. 9); Antichnoe serebro, 1985, p. 41, no. 54 (ill. on p. 43).

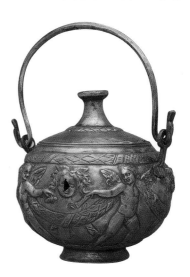

41
Chariot Decoration in the form of a Half-figure of Triton

Thrace
Late 2nd–early 3rd century AD
Height 12 cm
Bronze
Inv. no. B.866 (ГР 7043)
Found in Bulgaria, 1878; to Hermitage from Museum
of Classical Archaeology of Academy of Sciences, 1894

The half-figure of Triton, cut off below the thighs, is shown as a full-faced youth with curls falling onto his neck. He appears to be emerging from a tangle of acanthus leaves, simultaneously parting the leaves and holding them in his hands. The whites of his eyes are lined with silver. On his back is a smooth, vertical ring. The features of Triton's face resemble portraits of Antinous, the emperor Hadrian's favourite. NG

BIBLIOGRAPHY: Goulyaeva, 2000, p. 167, fig. 9; Guliaeva, 2002, p. 77, note 2.

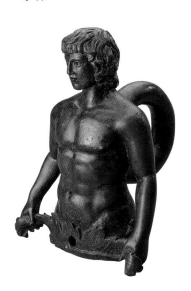

42
Cameo with a Bust of Achilles (?)

Northern Black Sea region
3rd century AD
2.8 × 1.6 cm
Cast mass
Inv. no. X.1906.21
From excavations of Chersonesos Necropolis, 1906

This cameo would most probably have been used on a *phalera* (a piece of decoration for armour). The portrait is not of Athena (the nudity excludes this) but more likely of Achilles or a heroized Alexander. ON

BIBLIOGRAPHY: IAK, 1909, vol. 33, p. 58, ill. 7 (Athena); Neverov, 1988, no. 289.

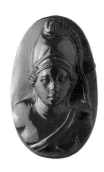

43
Cameo with Alexander the Great Hunting a Wild Boar

Rome
1st century AD
2.0 × 2.2 cm
Sardonyx
Inv. no. Ж.18
From collection of N.F. Khitrovo, St Petersburg, 1805

This subject also appears in a roundel on the Arch of Constantine in Rome, which was originally made in the second century AD, and which represented a Roman emperor. On this cameo the identification of the hunter as Alexander is based partly on his diadem – the mark of a Greek king. ON; PS

BIBLIOGRAPHY: Khudozhestvennoe remeslo, 1980, no. 189; Neverov, 1988, no. 161.

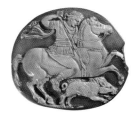

44
Cameo with the Head of a Beardless Herakles

Rome
2nd century AD
6.2 × 4.9 cm
Sardonyx
Inv. no. Ж.307
To Hermitage, end of 18th century

It is possible that this is a portrait of Antinous, the emperor Hadrian's favourite, in the form of Herakles. ON

BIBLIOGRAPHY: Maksimova, 1926, p. 96; Neverov, 1988, no. 95.

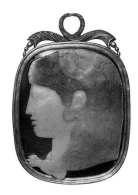

45
Cameo with Victory in Flight

Alexandria; workshop of Protarchos
1st century BC
3.0 × 2.0 cm
Sardonyx
Inv. no. Ж.303
To Hermitage, late 18th century

This is most probably a fragment of a larger composition: in her right hand the goddess of victory holds the reins of a horse, but the horses themselves have not survived. Victory is shown in flight, holding a palm branch in her other hand. ON

BIBLIOGRAPHY: Maksimova, 1926, p. 96; Neverov, 1971, no. 29; Neverov, 1988, no. 64.

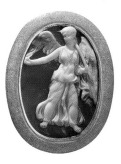

46
Cameo Bust of Annius Verus in the form of a Bacchic Genius

Rome
2nd century AD
Height 9.6 cm
Chalcedony
Inv. no. Ж.364
From Stroganov Collection, Leningrad, 1928

It is likely that, as with similar busts in Paris, this portrait of the son of Marcus Aurelius, who died young, was intended to decorate one of the *signa militaria* (legionary standards). Six such busts have been preserved, with Annius Verus portrayed on one. ON

BIBLIOGRAPHY: Neverov, 1988, no. 467.

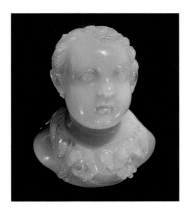

47
Intaglio with Victory

Rome
2nd century AD
2.0 × 1.7 cm
Cornelian
Inv. no. Ж.4395
To Hermitage, 19th century

This intaglio shows a semi-naked figure of Victory with large wings. She stands in three-quarter view, facing right. In her left hand she holds a sword; in her right a wreath. Such images were easily converted into Christian iconography in the form of angels, as is shown by the inscription on one ring-seal: 'I send you my angel'. ON

Previously unpublished

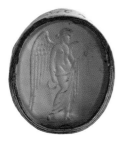

48
Intaglio with Isis and Horus

Alexandria
c. 50 BC
3.4 × 2.5 cm
Chalcedony
Inv. no. Ж.1244
To Hermitage, 19th century

The goddess Isis is shown breast-feeding her infant son, Horus. This scene, a traditional one in ancient Egypt, was used by Cleopatra VII as political propaganda: she proclaimed herself queen in direct succession to Egypt's rulers, and as a person close to Caesar, with all the might of Rome behind her. The goddess-*kourotrophos* (Isis and Horus, Aphrodite and Eros) was the origin for the iconography of the Christian Virgin and Child. ON

BIBLIOGRAPHY: Maksimova, 1926, p. 74; Arsinoia ili Kleopatra, 2002, no. 8.

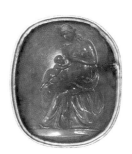

49
Cameo with Diana and Apollo

Alexandria; workshop of Protarchos
1st century BC
2.3 × 2.2 cm
Sardonyx
Inv. no. Ж.297
From collection of D. Byres, Rome, 1782
ON

BIBLIOGRAPHY: Maksimova, 1926, p. 96; Neverov, 1971, no. 25; Neverov, 1988, no. 50; Zalesskaya, 2000/2, pp. 56–9.

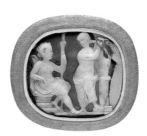

50
Intaglio with a Gryllos

Rome
2nd century AD
1.5 × 1.3 cm
Cornelian
Inv. no. Ж.6505
To Hermitage, 19th century

Such images of a gryllos (a combination of the heads of a youth, a man and a horse) probably served an apotropaic function as protective amulets. ON

Previously unpublished

51
Cameo with an Eagle

Rome
2nd–3rd century AD
1.1 × 1.3 cm
Sardonyx
Inv. no. Ж.126
To Hermitage, end of 18th century

The cameo has an unusual rectangular form with curved corners. ON

BIBLIOGRAPHY: Neverov, 1988, no. 386.

52
Cameo with an Anchor and Two Fish

Rome
3rd century AD
1.4 × 1.1 cm
Sardonyx
Inv. no. Ж.206
To Hermitage, end of 18th century

This is apparently a Christian symbol of salvation.
A carved stone from Bulgaria with a similar image
bears the Christian legend ἰχθύς (fish), the letters of
which are an acronym for the Greek phrase, 'Jesus
Christ son of God and Saviour'. ON

BIBLIOGRAPHY: Neverov, 1988, no. 288.

54
Cameo with an Eagle

Rome
2nd century AD
3.2 × 2.7 cm
Sardonyx
Inv. no. Ж.114
From collection of N.F. Khitrovo, St Petersburg, 1905

This cameo formed part of a medallion which would
probably have adorned the wreath of an emperor,
as is shown in marble portraits that have survived
to this day (*see* cat. 33). In Christian art such images
were transformed into the symbol of St John the
Evangelist. ON

BIBLIOGRAPHY: Neverov, 1988, no. 385.

55
Necklace

Cimmerian Bosporus (?)
1st century AD
Length 33.3 cm
Gold, almandine, amethyst, glass
Inv. no. П.1852.24
From excavations of Pantikapaion Necropolis, Kerch
(Mount Mithridates, Tomb no. 113, sunken into clay
sub-soil), 1853

The necklace consists of a gold chain in two sections,
and five oval mounts – one containing almandine
and two each of amethyst and green glass. The gold
mounts are joined to each other by hinges, and where
each end adjoins the chain, the fixture is concealed
by a miniature Ionic capital. Each end of the necklace
has a ring through which the chain could be threaded
to allow the wearer to adjust the position of the
necklace on the breast. As was the prevalent fashion
from the Hellenistic period, the principal effect is
created by the multi-coloured stones in the middle
of the necklace; the gold plays only a subsidiary
role as the setting for the bright stones and glass.
The earliest example of a necklace with polychrome
elements joined by hinges was found in the
Artyukhovsky Barrow, and dates from the second
half of the second century BC. YuPK

BIBLIOGRAPHY: Shilov, 1968, p. 314; Treister, 2004,
nos. 3–4, p. 200, no. 7; Kalashnik, 2004, p. 103, ill. 7.

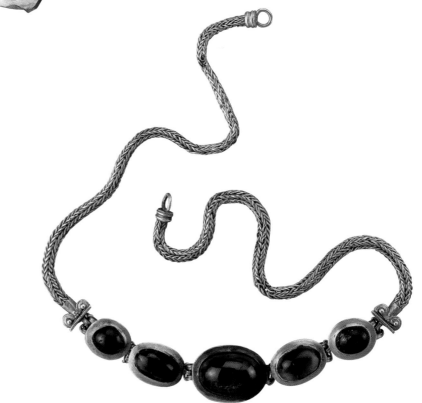

53
Cameo with Two Fish

Rome
3rd century AD
0.7 × 1.4 cm
Sardonyx
Inv. no. Ж.119
To Hermitage, end of 18th century

As with the cameo of an anchor and two fish (cat. 52),
the symbolism here is Christian. ON

BIBLIOGRAPHY: Neverov, 1988, no. 389.

56
Burial Diadem

Cimmerian Bosporus
3rd century AD
Diameter 16 cm
Gold, cacholong, onyx
Inv. no. П.1841.31
From excavations of Pantikapaion Necropolis,
Kerch (barrow on road to quarry; stone vault no. 2
with wooden coffin), 1841

The diadem consists of a band with incised
geometrical ornament; there would originally have
been three celery leaves attached to each end of the
band (five in total survive). The central plaque is
decorated with a stamped geometrical ornament and
imitation convex medallions, three of which contain
cameos: two are cut from cacholong and show the
head of Medusa, from ancient times one of the most
popular apotropaic symbols; the third, cut from
onyx, shows a winged figure. This is most likely Nike,
although the publishers of *Antiquités du Bosphore
Cimmérien* (ABC, 1892), and later Stephani and
Rostowzew, identified this third figure as Eros with
a lowered torch, presumably because such a subject
would be appropriate for a burial wreath.

The diadem was found on the skull of a woman
buried in a stone vault that had been constructed long
before her burial. A red-figure vessel from an earlier
burial stood at the feet of the skeleton.

Celery-leaf wreaths were often used in burials
in late antiquity, rather than, for example, wreaths
imitating laurel, olive or oak leaves. A wreath
underlined the heroic – that is, divine – essence of the
departed, who had lived a glorious life and expected
in death to be in the company of demigods like him
or herself. This is referred to directly in several
Bosporan epitaphs: 'Now let not the dark house
(Hades) take you, but the dwellings of heroes…'
(CIRB, p. 119); 'Having died, may you now take your
place among the heroes' (CIRB, p. 1057). The
Bosporan wreaths of the early centuries AD contain
only celery leaves, which was considered the plant
of the deceased (Plutarch, *Timoleon*, 26). The central
part of such wreaths would contain an impression
of a coin, a medallion, a relief plaque (*see* cat. 35) or
a carved stone as here.

Identification is made difficult by the poor
quality of the carving, but if it is accepted that the
figure in the centre of the diadem is indeed Nike, this
would correspond to the general heroic context of
the object: in the Roman era images of Nike were so
prevalent that they seemed to lose their specific
mythological meaning. YuPK

BIBLIOGRAPHY: Ashik, 1848, no. 39, p. 48, ill. 146; ABC,
pl. III, no. 5; CR, 1875, p. 19 ff.; Rostowzew, 1931, p. 222.

57
Bracelet

Cimmerian Bosporus
3rd century AD
6 × 6.7 cm
Gold, garnets
Inv. no. P.5
From excavations of Pantikapaion Necropolis,
Kerch (burial with gold mask) by A.B. Ashik

This openwork bracelet with a rectangular shield
is one of a pair of such objects. The body of the
rectangle is a gold plate with a repoussé vegetable
ornament, onto which various decorative elements
have been soldered: four stamped rosettes (only three
remain), reminiscent of the aracia flower, and nine
circular, oval, drop-shaped and rectangular mounts
with insets of smooth garnets. The raised edges of
the mounts are decorated with beaded wire. (Similar
mounts frame the stones in the necklace from
Pantikapaion, cat. 55). The openwork part of the
bracelet consists of three rows of narrow strips of cut
gold leaf, similar to the links in necklaces of the
Roman era. A strip with scrolls also joins the details
of the ornament on the shield of the bracelet. Smaller
mounts inset with four conical stones run down the
edge of the openwork part of the bracelet, which is
joined to the shield by means of a hinge and joint-pin.
All of the coloured insets are fixed to their mounts
with smooth gold plates. This third-century
Bosporan bracelet was created using a range of
techniques and stylistic elements from earlier
periods; at the same time its original form and rich
colours reflect the tastes of the coming era, which
explains why such works were so widespread in the
early Middle Ages. LN

BIBLIOGRAPHY: ABC, p. 55, pl. XIV, no. 4; Lepage, 1971,
p. 7, fig. 13; for necklaces *see*: Ruxer and Kubczak, 1972,
p. 153, pl. XXXV, XXXVII.

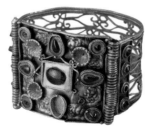

58
Medallion of Numerian

Rome
AD 284
Diameter 3.4 cm, weight 26.97 g
Gold
Inv. no. OH А3-65/Д no. 2090
To Hermitage before 1917

The obverse shows the emperor Numerian (283–4) in a diadem, cuirass and cloak; he is portrayed from the waist up and faces left. In his left hand he holds a spear thrown across his shoulder, and in his right he holds the reins of a horse standing behind him (only the head of the horse is visible). The circular inscription reads: IMP NVMERIANVS AVG ('Emperor Numerian Augustus').

The reverse shows a battle scene: two horsemen on prancing horses facing each other attack six prostrate enemies with spears. Two figures of flying victories are depicted above, crowning the horsemen with wreaths. The circular inscription reads: VIRTVS AVGVSTORVM ('the valour of the Augusti').

The younger son of the emperor Carus (282–3), Numerian was proclaimed Caesar in 282 along with his brother Carinus (emperor from 283 to 285). In 283 Carus and Numerian travelled to the east, where they fought a war against the Persians, while Carinus stayed in Rome to control the situation in the west of the empire. In the summer of 283 Carinus was elevated to the rank of Augustus, followed by Numerian in the autumn of the same year. After the death of Carus in December 283, Numerian became emperor.

It is likely that the medallion was issued soon after this event and is dedicated to the victories of Numerian and Carinus. From 283 both brothers took the titles *Germanicus maximus*, *Britannicus maximus* and *Persicus maximus*.

The British Museum has a gilded bronze medallion of Numerian with the emperor shown on the reverse alongside his brother Carinus (both are standing on a dais addressing soldiers). VG

Previously unpublished

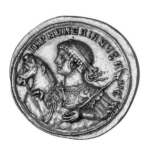

59
Medallion of Constantine I (the Great)

Thessalonica
AD 324
Diameter 4.8 cm, weight 43.86 g
Gold
Inv. no. OH А3 65/Д no. 2125
Found on south-western front during digging of trenches, 1916 (exact location unknown); acquired by Hermitage from I.Ya. Tsirel for 750 roubles, 1928

The obverse shows a bust portrait of the emperor Constantius I (306–37), facing right in a diadem, with a cuirass and cloak attached to his right shoulder by a fibula. The circular inscription reads: CONSTANTI NVS MAX AVG ('Constantine Greatest Augustus').

The reverse shows Constantine sitting frontally on a throne set on a two-stepped dais. A nimbus surrounds his head, and he is dressed in a long tunic with a belt and a cloak attached at his right shoulder. He holds a *mappa* (cloth) in his left hand and in his right hand a spear. Four of his sons stand beside the throne: Crispus and Constantius on the left, Constantine and Constans on the right. The three elder sons are in military dress, holding spears and shields, while the youngest, Constans, is in a short tunic. The circular inscription reads: SALVS ETSPESREIPVB LICAE ('safety and hope of the republic'). At the bottom are the letters TSЄ: the first two are an abbreviation of the name of the mint in Thessalonica, while the last signifies the fifth minting workshop. VG

BIBLIOGRAPHY: Pridik, 1930, pp. 11–17; Guruleva, 1991, p. 99; Brabich, 1994, p. 563, no. 541.

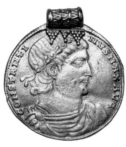

60
Cameo with Constantine the Great and the Tyche of Constantinople

Rome
4th century AD
18.5 × 12.2 cm
Sardonyx
Inv. no. Ж.146
From collection of N.F. Khitrovo, St Petersburg, 1805

This unusually large cameo shows the emperor standing, dressed in armour and holding a spear. He is being crowned by a Tyche or 'Fortune' – the protective deity of the city – who is identifiable by her *corona muralis* (crown in the form of city walls). The engraver Benedetto Pistrucci retouched this ancient stone at the beginning of the nineteenth century. At that time it was known as the Cameo of Trajan. It was evidently made to celebrate an important historical event – the founding of Constantinople, the new eastern capital of the empire. In place of a sword the emperor held a *palladion*, the statuette of Athena that was a symbol of the Trojan origins of Rome and its empire. ON; PS

BIBLIOGRAPHY: Neverov, 1988, no. 354.

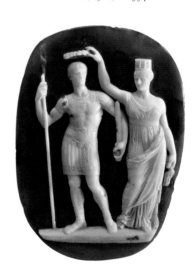

61

Decorative Bowl with a Portrait of Constantius II

Antioch
AD 343
Diameter 23.2 cm, height 3.5 cm
Silver; gilding, niello, raising, incising, chasing
Inv. no. ГЭ 1820/158
From excavations of Bosporan Necropolis, Kerch (Gostpitalnaya St, recess in Vault 145) by V.V. Shkorpil, 1904; to Hermitage, 1907

This shallow bowl was made using the technique of raising and then finished on a lathe. A relief band one centimetre in width runs around the inside edge. The floor has a central decoration of a medallion with the bust of Constantius II. The depiction is in profile, as was traditional on Roman coins. The emperor wears a diadem (circlet) with ribbons flowing free at the back of the head. The *chlamys*, or cloak, worn by the emperor is fastened at the right shoulder by a fibula. The medallion is enclosed by a 'golden frame' in the form of a gilded band of incised concentric lines.

Around the medallion is a four-tier composition of ornamental borders and inscriptions. The border closest to the medallion reproduces a creeping vine, then the Latin inscription: D[omini] N[ostri] CONSTANTI AUGUSTI VOTIS XX, indicating that the bowl was to celebrate the twentieth anniversary of the rule of Constantius II, who was proclaimed Caesar in 323. There is then a border of strigils and a frieze of arches. The vine branches and arches are incised, having first been marked out by a stippled line. The inscription is inlaid with niello, and the border of strigils in the form of indentations has been made with a special chisel-like instrument. The portrait of the emperor has also been engraved following an initial design. The emperor's hair is depicted with inlaid niello, his face, neck, garments and wreath are gilded, the gilt applied using fire gilding. On the border of strigils, gilt alternates with niello. The silver background has been shaded.

On the back is a loop for hanging and a Greek inscription in pointillé. The inscription includes the name of the city of Antioch, conveyed by its first three letters, ANT. The two following letters remain undeciphered, while the remainder give the weight of the bowl. Detailed scratched or pointillé Greek and Latin inscriptions are often found on Roman and Byzantine silverware made to honour the official dates of members of the ruling dynasty. They are usually found on the reverse side of the article.

The study of these inscriptions by different scholars has shown that most contain in abbreviated form the name of the craftsman or owner, the name of the town where the item was made, and information about the amount of material used. The name of the town, as here, was designated by the first few letters. Nicomedia, for example, was designated by the four letters NIKO, and Naissus by the two letters NA.

It is likely that another silver bowl, said to have been discovered by treasure hunters amongst items from two burial vaults on 24 June 1904, was also made in Antioch. This second bowl, also with a bust of Constantius II and a Latin inscription marking the twentieth anniversary of his rule, is in form, technique and to some extent decoration similar to this bowl from burial vault 145. Both are part of a series of anniversary pieces and came to be in the Bosporan Kingdom as gifts from Byzantium to Bosporan rulers or others of exalted birth with high social status. IZ

BIBLIOGRAPHY: Matsulevich, 1926, pp. 9–16, pl. II, no. 3; Matzulewitsch, 1929, p. 107, note 1, pl. 24; Zasetskaia, 1993, pp. 45–6, pl. 14, 38 (gives all previous literature); Zaseckaja 1995, pp. 89–100; Leader-Newby, 2004, pp. 20–1, pl. 1.7.

62

Decorative Bowl with the Triumph of Constantius II

Antioch
Mid-4th century AD
Diameter 25 cm, height 3.5 cm
Silver; gilding, niello, raising, incising
Inv. no. ГЭ 1820/79
Chance discovery at Mount Mithridates, Kerch (recess in Gordikov vault), 1891; explored further by A.A. Bobrinsky; to Hermitage, same year

This shallow bowl was made using the technique of raising and then finished on a lathe. A relief band one centimetre in width runs around the inside edge. The reverse has a loop for hanging. The tondo depicts a triumphal scene with the emperor on a horse accompanied by an arms-bearer and the goddess Nike. The emperor is wearing full military dress typical of the early Byzantine era; he is armed with a sword and spear. The arms-bearer following behind is dressed like the emperor but less richly. In his right hand he holds a spear, in his left a shield with a monogram of Christ. The goddess Nike, with a crown in one hand and palm branch in the other, is ahead of the horseman. In the foreground beneath the horse's hooves is a circular shield, symbol of the vanquished foe.

The subject and composition are based on the traditional Roman coin style, showing the emperor, mounted on a horse and accompanied by warriors and the goddess Nike, smiting his fallen enemy with a spear. However, unlike the ancient prototype, which depicts the final moment of battle, this bowl shows the scene of the triumph of victory. The entire image is subordinated to a single idea: the desire to extol the emperor as a person and emphasise his godlike power, evident from the golden halo around his head. Normal conceptions of space and proportion are thus ignored. The human figures, and particularly the horseman, are greatly enlarged and spatiality is conveyed in the way the figures are positioned. The figure of Constantius is to the fore, overlapping the other two figures. The artist thus achieves maximum emotional impact, by bringing the figure of the emperor closer to the viewer. These artistic devices are typical of Byzantine art of the transitional period of the fourth to fifth century, in which traditional subjects of antiquity take on a new meaning and are interpreted using new decorative methods. This is why this bowl is unanimously considered by experts to be among the finest examples of early Byzantine art.

Less unanimous are opinions on the iconography of the image and where the bowl was made. According to Matsulevich, the Kerch bowl depicts the emperor Constantius II; if so, the scene depicted can be linked with specific historical events, namely his triumphant arrival in Rome in the year 357, when Constantius became absolute ruler of the entire Roman Empire, having eliminated his rivals.

Comparison with two other silver bowls from the Bosporan necropolis (of which cat. 61 is one) suggests that this dish could also have been made in Antioch, as is confirmed by the similarity in form, manufacturing technique, the use of identical stylistic devices and artistic methods – and the fact, of course, that all three pieces depict the same person, Constantius II. Antioch was one of the largest trading, artistic and cultural centres of the Byzantine Empire, and its luxurious villas served as residences to the Byzantine emperors and Antioch nobility. Constantius also had his palace here, which in 353 he presented to Constantius Gallus, his sister's husband. IZ

BIBLIOGRAPHY: Matsulevich, 1926; Zasetskaia, 1994, pp. 225–7; Zaseckaja, 1995, pp. 89–100; Leader-Newby, 2004, pp. 22–3, pl. 1.8.

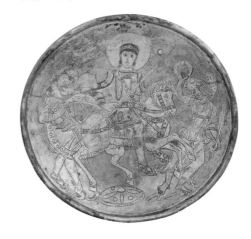

63
Medallion of Constantius II

Antioch
Undated
Diameter 4.9 cm, weight 41.89 g
Inv. no. OH A3-65/Д, No. 2142
Bought on 18 December 1899 from Kiev-Pechersk
Monastery, among 16,079 examples of coins from treasure
found in monastery's Church of the Assumption

The obverse shows a bust portrait of the emperor
Constantius II (324–61) facing right, in a diadem,
cuirass and cloak attached to his right shoulder by a
fibula. His left hand holds an orb surmounted by
a figure of Victory who is crowning the emperor with
a wreath, while his right hand is shown palm open
in front of his breast. The circular inscription reads:
DNCONSTANTIVS MAXAVGVSTVS ('Our
Lord Constantius Greatest Augustus').

 The reverse shows two emperors, Constantius
and Constans, a nimbus circling the head of each,
and both with raised right hands. They stand in a
triumphal chariot pulled by six horses moving
towards the viewer. Figures of Victory are shown
on either side of the emperors, crowning each with
wreaths. Beneath the horses are various gifts to the
army: armour, wreaths, a *modius* (measuring vessel)
with coins. The circular inscription reads DDNN
CONSTANTIVS ET CONSTANS AVGG
('Our Lords Constantius and Constans Augusti').
To the right and left of the images of gifts are
the letters *A* and *N*, signifying the Antioch mint. VG

BIBLIOGRAPHY: Gnecchi, 1912, pl. 10, no. 2; Brabich, 1987,
pp. 24–6; Guruleva, 1991, p. 92; Brabich, 1994, p. 563,
no. 542.

64
Bust of Julian the Apostate

Eastern Mediterranean
4th century AD
Height 9.2 cm
Chalcedony
Inv. no. ω 80
From collection of Catherine the Great

The emperor is portrayed in a cloak clasped by
a fibula and decorated with a diamond ornament;
there is a bracelet on his right hand. A groove runs
through his hair which would have been used to
mount a metal diadem. Similarities to portraits of the
emperor Julian (361–3) on coins indicate that this
is the same man, while the structure of the bust shows
that it would once have formed part of a consul's
staff, similar to those carved from ivory portraying
emperor-consuls of the fourth and fifth centuries,
now in private collections in Germany and the USA
(Spätantike und frühes Christentum, 1984,
pp. 605–7, no. 199). VZ

BIBLIOGRAPHY: Likhacheva, 1962, pp. 18–21; Bank, 1985,
pp. 271–2, pl. 6–7.

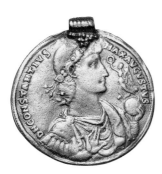

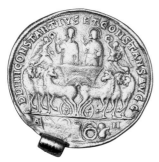

65

Intaglio with the Investiture of Valentinian III

Rome or Ravenna
c. AD 423
Engraver Flavius Romulus
8.2 × 11.8 cm (without mount), 9.6 × 12.4 cm (with mount)
Three-layered sardonyx; gold mount with hinged handle;
traces of fastenings along side; gold rivet on left
Inv. no. И 11367
To Hermitage as part of collection of carved stones
bequeathed to Alexander I by Jean-Baptiste Mallia, 1813

A Christogram with the Greek letters *a* and *ω* on
each side can be seen in the top centre of the intaglio;
at the bottom is the inscription FL. ROMUL. VEST
[iarius]. FECIT ('Flavius Romulus, *vestiarius*,
made this'). On the reverse along the left edge is the
monogram FLR, while scratched on the right are
the letters *a* (twice) and *ω* with an illegible hatched
inscription in between.

Even the earliest iconographic interpretations
of this masterpiece of late antique/early Christian
glyptics linked it to the imperial Valentinian family.
One of the first known accounts of the intaglio,
which described it as belonging to 'Chevalier Mallia'
(who worked at the Russian Embassy in Vienna and
who apparently acquired the piece 'for the enormous
sum of ten or twelve thousand ducats'), was by
Franz de Paula Neumann. He identified the main
subject as Valentinian I (born 321), who was emperor
of the Western Roman Empire from 364 to 375
(he made his brother Valens, previously his co-
regent, Augustus of the Eastern Empire in 364, and
proclaimed his eight-year-old son Gratian co-regent
in 367). Köhler, who included the gem in his personal
catalogue when Mallia's collection was acquired by
the Hermitage, indicated only that the gem portrayed
the coronation of Valentinian, without stating which
of the three Valentinians it was. Later, according to
Stephani and Drexel, Köhler came to the conclusion,
as did Stephani and Bernoulli, that in fact the intaglio
shows Valens and Gratian crowning Valentinian II,
the four-year-old youngest son of the dynasty's
founder, in 375. Furtwängler and Drexel thought
both interpretations possible. Today, however,
Delbrück's assertion that the principal figure is in
fact Valentinian III (born 419; reigned 423/5–455)
is most commonly accepted: Delbrück identified
features in the child which were characteristic
of adult portraits of Valentinian III in sculpture and
other carved stones; he also attributed certain stylistic
qualities of the intaglio's carving to that period.

The young emperor Valentinian III stands on
a three-stepped podium, while his uncle Honorius
(born 384; reigned 395–423), the first ruler of
the west after the division of the Roman Empire,
reaches out with both hands towards his shoulder as
if fastening his imperial vestments. On the other
side, Valentinian's father, the military commander
Constantius, who for a few months in 421 was
Honorius's co-regent as Constantius III, places a
palm wreath on his head. Neither Constantius nor
Honorius were actually alive for the event portrayed,
so winged figures are shown on either side holding
a staff in one hand and suspending similar wreaths

over the heads of the deceased emperors in the other.
The composition of the intaglio thus demonstrates
the continuity of power and expresses the idea –
so important at a time of crisis – of the *Concordia
Augustorum* ('concord between Augusti').

The lack of depth in the carving of the authorial
inscriptions, which are not given in mirror-image,
as well as the intaglio's unusually large size, show that
it would not have been used as a seal. Intaglios of
this size are characteristic of the late Empire, and in
a dynastic cult they could have been used as the fibula
on the ceremonial dress of a person of high rank
(Delbrück, 1933, p. 124); they might also have been
used to decorate wreaths (Neverov, 1976, p. 20),
which would seem to be confirmed by the traces of
fastenings on the Hermitage intaglio.

The carving is notable for its hieratic stateliness
and severe asceticism: the two-dimensional figures
are treated with extreme simplicity; the drawing
is conventional, and the composition and use of two
colours is strictly symmetrical. At the same time, the
carving is reduced to two basic techniques: line and
V-shaped grooves which only partly reveal a layer
of white stone enclosed between two layers of brown.
The upper brown layer – thin and therefore lighter –
serves as a background while the whole composition
is brought to life by the angular protuberances of
the folds on the *chlamydes* and tunics, the rectilinear
incisions on the steps of the podium, and the lines on
the wings of the flying figures. The relative thickness
of the lower layer, not visible on the surface except
around the edge (which forms a natural three-
coloured frame to the composition), makes it almost
black. It is no coincidence that, notwithstanding
the stone's unusually large size and structure, the
artistic composition of the intaglio brings to mind
the miniature contrast carving on sardonyx and
nicolo (blue-black variety of onyx), so beloved by
the Romans (Bruns, 1948, p. 34). Some modern
scholars, familiar with the gem only through printed
reproductions, have mistaken it for a cameo
(Bruns, 1953; Vollenweider, 1966).

This carved stone is often compared with early
Byzantine intaglios, especially those with images
of Jesus Christ (or his symbols) and the Apostles
(Zazoff, 1983, p. 377, pl. 124, 5, 6–7), as well as with
thirteenth-century Venetian or southern Italian
stones showing Christ on his throne being crowned
by two Victories. Nau refers to the flying figures
flanking the main characters here as Victories;
however, a number of external and symbolic features
transforms them into genii (or angels, as Stephani
called them using Christian iconography), which
thus serve as a continuation of the classical motif.
Late antiquity, with its striving towards symmetry,
particularly during the last artistic flourish of the era
of Constantine and his successors, did indeed often
duplicate such figures.

Although Prozorovskii suggests that the *vestiarius*
(keeper of the imperial clothing) Flavius Romulus
was not the creator but the commissioner and first
owner of the stone, the addition of the words FECIT
('made') presents unequivocal evidence to the
contrary. It is important to note that this intaglio is

the only surviving example of the work of this carver,
who worked in Rome and Ravenna, where Honorius
moved his residence.

Finally it should be noted that Zazoff's assertion
that the intaglio was found during excavations in
Kerch is not accurate. This erroneous provenance is
perhaps explained by the fact that Reinach included
the craftsman Romulus in an index of names based
on the Accounts of the Archaeological Commission
for Bosporan-Cimmerian Excavations (Reinach,
1892, p. 190). Stephani described this intaglio
alongside other objects from these excavations,
and no doubt Reinach and, consequently, Zazoff
mistakenly concluded that it was one of them. YuK

MANUSCRIPT SOURCES: Neumann MS [v. 1811], f. [9]
(an engraving with chisel and aquatint above a linear
rendering of the size of the stone with an explanatory text
beneath); Köhler MS [1813], f. 14.

BIBLIOGRAPHY: Stephani, 1883, pp. 125–7, pl. v, nos. 23–4;
Prozorovskii, 1894, pp. 166, 171 ('Caligula, Praying to an
Idol'); Bernoulli, 1894, p. 253; Furtwängler, 1900, p. 365;
Drexel, 1930, pp. 38–9; Delbrück, 1933, pp. 211–14, ill. 73,
pl. III, 1 (reproduced in mirror-image); Bruns, 1948,
p. 34; Deér, 1952, pl. XXIV, no. 7; Bruns, 1953, p. 97
('Romulus-Kameo'); Nau, 1966, pp. 160–1, ill. 40, note 60;
Vollenweider, 1966, p. 80, note 84 ('Sardonyxcameo');
Engemann, 1978, p. 295, pl. 12; Zazoff, 1983, pp. 323, 377,
pl. 96, no. 7.

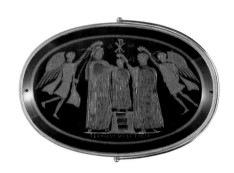

66
Textile with the Earth Goddess Gaia

Akhmim
4th century AD
Diameter 25.5 cm
Flax, wool; tapestry weave
Inv. no. 11440
Brought from Egypt by Vladimir Bock, 1898

The medallion depicts a three-quarter profile bust
of a young woman framed by flowers and leaves. On
the left, in the medallion's background, is the name
of the earth goddess woven in Greek letters *ΓH* ('Ge').
She is holding a cup, an ancient eastern fertility
symbol. Her black hair, which is parted, falls onto her
shoulders in long tresses, and her head is decorated
with a band crowned by a golden disk bearing an
image of the sacred serpent *uraeus*, and with ears of
corn beneath. The goddess's ears are adorned with
golden earrings characteristic of the Syro-Palestinian
region during the Roman period. Over a pinkish-
lilac *chiton* (tunic), a dark yellow *himation* (mantle) is
thrown across her right shoulder and secured at her
breast by a so-called Isis knot.

The details of the costume and head decoration
and other attributes indicate the link between the
Greek earth goddess and the ancient Egyptian Isis –
a characteristic example of the religious syncretism
of late antiquity. The image on the Hermitage textile
closely resembles the Hellenistic images of Isis,
Demetrios and Euthenius, and in Egypt the cult of
the earth goddess often merges with veneration
of the ancient Egyptian Isis. This medallion is one
of a pair; the other one, in the Pushkin Museum
in Moscow, depicts the river deity Nilus (the Nile)
and was used to decorate the upper part of a tunic.
Interest in the pair of Nile deities was still
fairly strong despite the spread of Christianity. The earth
goddess personified the soil fertilised by the Nile.
Thus images of Gaia and Nilus woven into
medallions personified abundance, fertility and
the discovery of eternal life.

In its style and use of bright colours, which gives
the image an unusual sense of plasticity, the textile
still shows the influence of Hellenistic art. The
working is exceptionally fine, with 14 to 15 threads
per ten centimetres of cloth. oo

BIBLIOGRAPHY: Bock, 1897, pp. 229–30; Mat'e and
Liapunova, 1951, p. 94, no. 15; Kakovkin, 1978, p. 14, no. 2;
Rutchowscaya, 1990, pp. 66, 79–80; Osharina, 1997, p. 45;
L'Art copte, 2000, p. 38, fig. 2; Kakovkin, 2004, p. 47, no. 27.

67
Textile with Eros

Egypt
4th century AD
18 × 17.5 cm
Flax, wool; tapestry weave
Inv. no. 13216
From collection of A. Bobrinsky

The textile shows Eros flying to the left. In his
extended left hand he holds a bowl; the folds of his
cloak billow behind his back, and his head is encircled
by a nimbus. The frame consists of four bands,
one of which contains plain circles against a green
background. Winged genii and erotes (cupids) were
borrowed by Christian art from the rich heritage
of antiquity. Images of numerous small erotes were
characteristic of Hellenistic art, in particular of
the Alexandrian school; they were shown with
an extremely diverse range of attributes, sometimes
amusing themselves with pranks. The bowl in the
hands of Eros, who is a symbol of fertility, became
transformed in the Christian era into a symbol
of the Eucharist. Three similar medallions are in
the Pushkin Museum in Moscow. oo

BIBLIOGRAPHY: Mat'e and Liapunova, 1951, p. 154, no. 270,
pl. II, no. 1; Kakovkin, 1978, pp. 14–15, no. 4; Kakovkin,
2004, p. 49, no. 31.

68
Textile with a Hunting Scene

Egypt
5th century AD
82 × 104 cm
Flax, wool; reservage technique
Inv. no. 11658
Brought from Egypt by Vladimir Bock, 1898

The scene portrays four hunters with nimbuses
around their heads, battling with various animals.
The groups are separated from each other by
trees, and the space in between is filled by individual
figures of animals. The composition and poses
of the hunters and animals are similar to examples
of Roman art. Thus, a hunter hurling himself towards
a lion with a spear in his hands (bottom right) is
a typical figure which appears in almost all hunting
scenes. Figures of fleeing animals and those turning
on the run are found in murals and mosaics at
Pompeii. However, a significant departure from
Greco-Roman examples is evident in the somewhat
conventional and ornamental nature of the images
and in the changes of proportion. Heroic hunting as
a symbol of immortality, common in the funerary
symbolism of the Romans, was taken up by Byzantine
art. Hunting scenes became an allegorical expression
of the victory of good over evil and the triumph of
life over death. Such scenes identified the dead with
the valour, strength and virtue of the hunters, thus
associating them with immortality. oo

BIBLIOGRAPHY: Matzulewitsch, 1929, p. 17; Mat'e and
Liapunova, 1951, pp. 66–7, 91, no. 6, pl. III; Baratte, 1985,
pp. 62–70, fig. 27–8; Kakovkin, 2004, p. 50, no. 33.

69
Textile with Dionysos and Ariadne and the Twelve Labours of Herakles

Egypt
5th century AD
22.5 × 21.5 cm
Flax, wool; tapestry weave, 'flying needle' technique
Inv. no. 11337
Brought from Egypt by Vladimir Bock, 1889

In the centre of the medallion, framed by a square, is an image of Dionysos and Ariadne in a chariot, to which three panthers are harnessed. A coachman sits at the front, and Herakles is to the left of the chariot with a staff on his shoulder. Depictions of the triumph of Dionysos are one of the favourite themes of the art of late antiquity. With its promise of rebirth in a new life, this composition is a graphic glorification of Dionysos's cult, and is found on sarcophagi, mosaics and fired ceramics.

The twelve labours of Herakles are shown around the square, read clockwise from the top left corner. Images of Herakles were very common as early as the Ptolemaic period. The Hermitage textile includes not the most common scenes, but those which are compositionally suited to adjacent images. Six of the twelve labours are consistently identified by every scholar: wrestling with the Nemean Lion, duelling with Hippolyte, queen of the Amazons, capturing the Keryneian Hind, fighting the Lernaian Hydra, the capture of Cerberus, and seizing the apples of the Hesperides. Scholars differ in their interpretation of the remaining six labours. In Byzantine Egypt the ascetic image of the life of Herakles was particularly valued. The hero's labours, his search for a moral path, his agonising end – all of this transformed him into a saviour and redeemer of mankind. The twelve labours thus represent a metaphor for the earthly path travelled by Herakles, as a result of which the hero attains immortality and reaches Olympus. oo

BIBLIOGRAPHY: Bock, 1897, p. 230; Mat'e and Liapunova, 1951, pp. 53–4, 98–9, no. 35, pl. XVIII; Kakovkin, 1978, p. 16, no. 11; Rutchowscaya, 1990, p. 92; Kakovkin, 1994, pp. 41–54; Osharina, 1997, p. 45; L'Art copte, 2000, p. 157, fig. 149; Kakovkin, 2004, p. 63, no. 77.

70
Upper Part of a Tunic with Aphrodite and Eros

Egypt
4th century AD
Tunic 96.8 × 125 cm, inset 11.7 × 10.4 cm
Flax, wool, gold thread; tapestry weave, 'flying needle' technique
Inv. no. 11620
Brought from Egypt by Vladimir Bock, 1889

The upper part of the tunic has two shoulder medallions and a collar with two vertical strips in front and behind and a rectangle on the chest. The medallions are filled with braiding, and an image of Aphrodite turned to the right is woven into the rectangle; her head is adorned with a garland, and her right arm, raised upwards, is leaning on a staff. She holds a shawl, which billows above her head. To the right is an image of Eros, holding out a garland to the goddess. The accuracy of the drawing and the closeness of the figure to ancient traditions date this textile to the fourth century AD. In the Hellenistic era Aphrodite was venerated by the Greeks not only as the goddess of love, but also as patroness of the underworld. In Egypt the Greeks identified her with the goddess Hathor, the guardian of the graveyards, and with Isis, the 'giver of the breath of life'. Late Roman art already associated the image of Eros with funeral cult objects, and in particular with sarcophagi. In the Middle Ages this tradition is known to have continued, identifying the image of Eros with the image of death. The wreath which is held by Eros is a sign of all that is ephemeral, a symbol of the transience of human life. However, the presence here of the goddess Aphrodite inspires hope of salvation. oo

BIBLIOGRAPHY: Mat'e and Liapunova, 1951, p. 52, no. 8, pl. IX, nos. 1–2; Kybalova, 1967, p. 70, nos. 17–18; Renner-Volbach, 1981, p. 89, ill. 7–8; Kakovkin, 2004, pp. 48–9, no. 29.

71
Textile with Dionysos and a Dancing Maenad

Egypt
4th century AD
32.5 × 38.5cm
Flax, wool; tapestry weave
Inv. no. 11334
Brought from Egypt by Vladimir Bock, 1898

In the centre of the medallion, set inside a rectangular frame, is the figure of Dionysos, his left arm leaning on a column, and his right arm raised upwards, replicating a famous composition by Praxiteles. Dionysos is portrayed naked with a sling across his shoulder; the end of his cloak, thrown across his right arm, hangs down to his right. To the right of the column is a dancing bacchant, or maenad, in a long garment; a long shawl held in her raised hand swirls above her head. The square outer frame comprises a series of diamond shapes containing images of flowers and fruit against an orange background; vine leaves and bunches of grapes fill the spaces between them. Apocryphal Coptic texts interpreted this subject as depicting Adam and Eve. oo

BIBLIOGRAPHY: Liapunova, 1940, p. 155, pl. IV; Mat'e and Liapunova, 1951, pp. 101–2, no. 46, pl. IV, no. 1; Koptische Kunst, 1963, p. 320, no. 34; Kakovkin, 1978, p. 14, no. 5; Kakovkin, 2004, p. 48, no. 28.

72
Textile with the Three Graces

Egypt
5th–6th century AD
18 × 17.5 cm
Flax, wool; tapestry weave
Inv. no. 11390
Brought from Egypt by Vladimir Bock, 1889

The central square contains an image of the Three Graces. The figure furthest left is turned towards the left, and correspondingly the figure furthest right is turned towards the right; the central Grace is shown from the back, clasping her companions by the waist. The background is filled with stylised plants. The frame contains a series of diamond medallions with two vine leaves between each. A pendant ornament runs along the very edge of the textile.

The Graces of antiquity personified eternal youth and beauty. In Orphic hymns they were venerated for bringing the joy of life. They whirled about in a round dance, recreating the rotation of the seasons, and were symbols of life and death in early Christian art. oo

BIBLIOGRAPHY: Mat'e and Liapunova, 1951, p. 100, no. 40, pl. XIX, no. 2; Kakovkin, 1978, p. 21, no. 22; Kakovkin, 2004, pp. 73–4, no. 118.

73
Fragment of a Tunic with scenes from Euripides' Tragedy 'Hippolytos'

Egypt
4th century AD
30 × 61 cm
Flax, wool; tapestry weave
Inv. no. 13139
Brought from Egypt by Vladimir Bock, 1889

Coptic textiles include a specific group which portray ancient Greek dramatic heroes. The subjects most commonly come from Euripides. More than ten textiles from the third to eighth century are known to exist, with images of heroes from his tragedies – Hippolytos, Phaedra and Iphigenia. The most popular subject for ancient weavers was the episode described by Euripides in which Phaedra's lust for Hippolytos is revealed to him by her nurse. Phaedra was usually also portrayed, standing a little to one side. This is the episode shown here, on part of a linen tunic with woven inserts in the form of a strip and a rectangle.

On the left of the central square is Phaedra, standing frontally; her right arm is across her chest, and her left would evidently have been raised upwards. The nurse is in the middle, lowered onto one knee, and we see the gesture of her hands as she tries to persuade Hippolytos, who is standing to the right. Naked, he is leaning his left arm on a spear, and there is a sling over his right shoulder. The border contains images of two standing and two flying erotes holding hares, and in the corners of the medallion are images of birds and vine leaves. A textile with a similar subject, dating to the same period, is in the Textilmuseum in St Gallen; only the border differs. This subject is found in other works of applied art and may also have been shown on textiles from Cairo. Hippolytos is regarded as one of the most famous ancient mythological figures in Coptic art. A passionate disciple of Artemis, he was primarily revered as a hunter. Prizing virtue above all else, he anticipated the Christian ascetics, and was seen by Christians as one of the traditional symbols of resolute virginity. Quite specific soteriological hopes were also associated with Hippolytos: according to one of the myths, the hero's death proved merely temporary, as he was resurrected by Asklepios. oo

BIBLIOGRAPHY: Mat'e and Liapunova, 1951, p. 98, no. 34, pl. XVI; Koptische Kunst, 1963, p. 315, no. 289; Kakovkin, 2001, pp. 128–32; Kakovkin, 2004, p. 50, no. 32.

74
Fragment of a Textile with the Triumph of Dionysos

Egypt
4th century AD
23 × 33 cm
Flax, wool; tapestry weave
Inv. no. 11335
Brought from Egypt by Vladimir Bock, 1889

In the centre of the textile is an image of Dionysos standing in a chariot drawn by two panthers rearing up; to the left of the chariot are a dancing satyr and maenad, and to its right the partially preserved figure of a dancing maenad and a bound Indian captive. Almost all scholars consider that this fragment of fabric shows the Triumph of Dionysos. One exception is Friedländer, who saw in the central figure an image of Cybele, explaining his interpretation by the excessively feminine contours of the figure. Lenzen, however, in his research into a fabric with a similar subject in the Metropolitan Museum, New York, based both on figurative material and on written sources, has demonstrated that the modelling of Dionysos's body is distinguished by its femininity and fluidity of contour.

The somewhat unusual iconography of the Hermitage textile is notable. As a rule, the scene of the Triumph of Dionysos is depicted in profile or at a three-quarter angle, but here it is shown frontally. The subject itself is closely associated with the victorious return of Alexander from the Indian campaign. Drawing on this real-life event, the poet Nonnos of Panopolis created a new cycle: the Indian campaign of Dionysos. Nonnos saw the principal attributes of Dionysos as being ivy and grapes. He also described the head of Dionysos as being crowned with a *corona muralis* (crown in the form of city walls), an eastern symbol of protection and salvation.

The Neoplatonic tradition as represented by Proklos refers to Dionysos as the king of all the gods of the world through six generations. Macrobius glorifies Dionysos as a god who combines other deities such as Apollo and Helios. In the first half of the second century, meanwhile, in myths relating to Dionysos, Herakles and Asklepios, Justin Martyr saw distorted biblical prophecies concerning Christ. Justin found Dionysos and Christ to have an unusual amount in common. In this fragment the wheel of Dionysos's vehicle is at the same time a strong grapevine shoot, which in the Hellenistic period served as a symbol of the tree of life, and in the Christian era was associated primarily with the famous words of Christ: 'I am the true vine' (John 15:1).

The edges of both the Hermitage textile and the one in the Metropolitan Museum are decorated with images of dolphins, whose plasticity and circular forms strongly support a date of the fourth century AD. In the Christian tradition the dolphin is widely known as a symbol of salvation. There is little doubt that the poses of Dionysos's retinue owe much to well-known compositions on neo-Attic reliefs, as well as the less renowned but wonderfully executed reliefs on Dionysian sarcophagi which originated in Syria around AD 180.

Despite its use of a purely pagan subject and attributes, by the time the Hermitage textile was created these had acquired entirely new significance. Filled with Christian symbolism and associated with New Testament images, the Triumph of Dionysos soon came be perceived as a prototype of the Glory of Christ, and of His redemptive sacrifice and resurrection. oo

BIBLIOGRAPHY: Liapunova, 1940, pp. 150–2, pl. 1; Mat'e and Liapunova, 1951, p. 102, no. 47, pl. XXI, no. 2; Lenzen, 1960, pl. 1a; Kakovkin, 1978, p. 14, no. 6; Kakovkin, 2004, p. 47, no. 26; Osharina, 2004, pp. 237–48.

75
Textile with Orpheus Playing the Lyre

Egypt
6th century AD
Diameter 10 cm
Flax, wool; tapestry weave
Inv. no. 13217
Brought from Egypt by Vladimir Bock, 1889

The figure of Orpheus appears in the centre in long vestments, his head adorned with a Phrygian cap. Birds sit above him on either side, while lower down on one side is a centaur or satyr, and on the other side Pan; a griffin sits beneath him. All the figures surrounding Orpheus are turned towards the centre. Two different compositions involving this subject exist. The earlier one shows Orpheus half naked with a cloak thrown over his shoulder and an uncovered head. The animals around Orpheus are portrayed in lively motion, running and pursuing each other. The later composition, of which this textile is an example, is designed in a more symbolic way. Proportions are not observed: the figure of Orpheus is a great deal larger than the animal figures, and both large and small species are represented as being the same size. The image of Orpheus was well known to Gnostics and became part of Christian symbolism at an early stage, in particular in the Good Shepherd composition. The subject of Orpheus taming wild animals by playing the lyre became particularly popular in Christian art; in it Orpheus was regarded as a prototype of Christ. oo

BIBLIOGRAPHY: Bock, 1897, no. 8, pl. III; Mat'e and Liapunova, 1951, pp. 61–2, 100, no. 39, pl. XX, no. 5; Kakovkin, 2004, p. 78, no. 136.

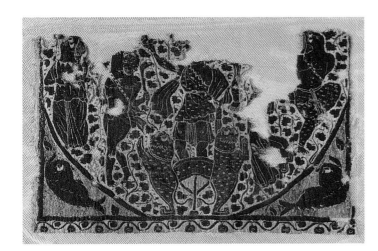

76
Textile with a Horseman

Egypt
8th century AD
15 × 11 cm
Flax, wool; tapestry weave
Inv. no. 11524
Brought from Egypt by Vladimir Bock, 1889

The textile is part of a medallion containing an image of a horseman wearing a diadem, his head encircled by a nimbus. To the right of his galloping horse is a figure with the body of a serpent and the head of a woman. Part of the ornamental edging of the medallion is also preserved at the top.

This iconographic composition is the product of a number of influences: a Palestinian composition with an image of King Solomon pursuing a demon in the form of a woman; a Greco-Roman subject with a captive barbarian being trampled on by the emperor or by a symbolic figure; and late Egyptian images of a horseman from Alexandrian necropolises, whose task it is to tame a serpent in order to pass into the underworld. On coins dating from the first half of the third century AD the emperor can be seen trampling a serpent with a human head underfoot. According to Eusebius, a picture with a similar composition decorated the palace of Constantine the Great. The image of the horseman was particularly popular in Coptic art of the sixth and seventh centuries, and this was connected with the appearance in Egypt of a Byzantine horse detachment. Here the artist depicts not the scene of battle, but its victorious conclusion – the victor engaging in a symbolic ceremony. OO

BIBLIOGRAPHY: Mat'e and Liapunova, 1951, p. 127, no. 145, pl. XXXII, no. 7; Kakovkin, 2004, pp. 102–3, no. 224, pl. 6.

77
Textile with Dionysos among Vine Branches

Egypt
4th century AD
Diameter 10 cm
Flax, wool; tapestry weave
Inv. no. 11153
Brought from Egypt by Vladimir Bock, 1889

The medallion depicts a vase from which vines with bunches of grapes spread out across the composition. In the centre among the branches stands Dionysos; a panther sits at his feet. Birds are visible in the branches, and deer stand on either side of the vase. The importance attached to the depiction of the grapevine reveals its symbolism as the tree of life.

The subject has its origins in the ancient East. In Egyptian art portrayals of Osiris are known, which show him against the background of a grapevine rising out of a vessel. The closeness of these deities' cults led to the replacement of the Egyptian Osiris with the Greek Dionysos; the followers of the Dionysian cult believed their god would resurrect them to a new life. Christian art appropriated several elements from this composition. The figure of Dionysos himself was replaced by images of erotes collecting grapes, symbolising the Eucharist. Over time, other previously more marginal attributes and images from the composition came to dominate. OO

BIBLIOGRAPHY: Mat'e and Liapunova, 1951, pp. 61–2, 100, no. 39, pl. XX, no. 5.

78
Textile with a Centaur

Egypt
4th century AD
33 × 23 cm
Flax, wool; tapestry weave
Inv. no. 11307
Brought from Egypt by Vladimir Bock, 1889

The five medallions in this rectangular textile have frames formed from a woven grapevine ornament. The central medallion shows a centaur looking back over his shoulder with one arm extended. The corner medallions contain two centaurs and two fantastic beasts with fish tails. The background within each medallion is filled with dots, while between the medallions are four baskets with a half-rosette in each. The border is formed from a narrow purple strip.

The image of the centaur is associated with the cult of Dionysos and is often included in his retinue together with satyrs and bacchants. Followers of the cult believed the god promised them resurrection to a new life. The bright primary colours of the tapestry are perfectly matched to the exuberant, cheerful nature of the half-horse, half-man. In an essay by an anonymous early Christian author, entitled *Physiologos*, the centaur is interpreted as a symbol of duality, a heretic who knows the truth but intentionally conceals it. OO

BIBLIOGRAPHY: Mat'e and Liapunova, 1951, p. 116, no. 106, pl. XXIV, no. 8.

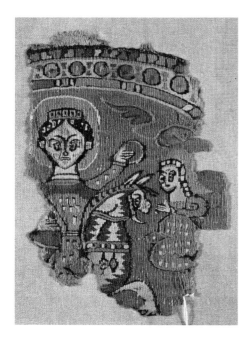

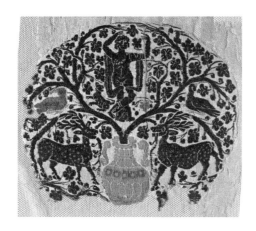

79
Textile with an Eagle

Egypt
4th century AD
Diameter 14.5 cm
Flax, wool; tapestry weave
Inv. no. 11603
Brought from Egypt by Vladimir Bock, 1889

The woven medallion contains a central image of a bird in a circle with wings spread, holding a cross in its beak. Four round medallions with images of human heads are woven into the border, connected to each other by diamonds containing ornamental figures. The eagle does not have a single specific meaning in Christian literature. Here its symbolism is multifaceted, representing the souls of the righteous; the psychopomp, that is, the guide of Christian souls to the afterlife; the Resurrection and the Eucharist; and finally it serves as a protector. Only two authors, St Maximus of Turin and St Ambrose of Milan, identified the image of an eagle directly with Christ. The multiple meanings of the image can also be seen in Christian works of art, where its symbolism varies depending on the overall context of the work.

The eagle was particularly common during the Christian era in Byzantine Egypt. In the opinion of Palli, it was borrowed by the Egyptians from Syria in the mid-fifth century AD, where it was depicted on funeral stelae. Cumont came to the conclusion that the depiction of an eagle on a funeral stela was used either as a symbol of resurrection or as an image of the human soul.

The Copts perceived the eagle only as a propitious beginning, and in Gnostic texts it appears as a protector and defender against evil forces. In the *Revelation of Paul the Apostle* it is stated that the paradise glimpsed by the apostle was crowned by eagles. This idea of the protection of Heavenly Jerusalem by an eagle may be observed in a whole range of early Christian works of art. Again, in the *Revelation of Paul*, the eagle replaces the figures of the angels that John the Baptist saw – they too, like the eagle, guides of human souls. In this light it is interesting to note the replacement of the eagle in the iconographic formula by an angel carrying a wreath with a cross: as the angel in glory raises the portrait of the deceased or a wreath with a cross to heaven, so the eagle raises a wreath with a cross, as if symbolically raising the soul of the deceased. In certain cases the image of the eagle proves to be inseparable from the mystery of the Eucharist. The gathering of souls around the dead body of the saviour is especially common in early Christian sources, which interpret the text from the Gospel of St Luke (17:37) as a gathering of believers around the body of Christ to accept the bread of the Eucharist, resulting in the believer becoming an eagle and soaring up to paradise.

St Ambrose identified eagles as the souls of the righteous, and the body as the church where we become spiritually reborn through the grace of baptism. St Anastasios of Sinai also saw in the representation of eagles the righteous being summoned to paradise. In his hymn, St Ephrem the Syrian identified the body of the Gospel text with the bread of the gathering, through the eating of which each believer becomes an eagle and soars to paradise. In his commentary on the same text, St Cyril of Alexandria called eagles the righteous, who will fly to their father. The idea of an ascending eagle may originate from the idea of the return of Christ to His Father. This is consistent with St Ambrose's remark that the eagle is Christ, who by His resurrection delivered man from the clutches of the devil and then flew back to His Father. oo

BIBLIOGRAPHY: Mat'e and Liapunova, 1951, pp. 171–2, no. 381, pl. XLVII, no. 11; Khristiane na Vostoke, 1998, p. 141, no. 178; Osharina, 2003, pp. 139–50; Kakovkin, 2004, p. 61, no. 72.

80
Textile with a Horseman

Egypt
4th century AD
30 × 29 cm
Flax, wool; tapestry weave
Inv. no. 11300
Brought from Egypt by Vladimir Bock, 1889

The square fabric contains five medallions, their frames formed from a woven vine ornament. The central medallion shows a horseman in a flowing cloak, galloping to the right; his raised right hand holds a circular object, and under the legs of the horse lies a shield. In the corner medallions are warriors in flowing cloaks, their legs bent at the knees. Each one holds a shield in his arms, and a circular object in his raised right hand (in the bottom right medallion the image has not been preserved). Between the medallions are baskets containing rosettes, with vine shoots to either side. The framed spaces between the medallions contain different-coloured spots.

The iconography of the horseman, new to Coptic Egypt, appeared at the beginning of the fifth century AD. The majority of textiles with this subject originated from Akhmim. The horseman is moving almost at a gallop, an image that embodies energy and creates the impression of battle. The front legs are raised high above the shield lying on the ground. North African mosaics were a particularly strong influence on the creation of these compositions, reflecting the Hellenistic concept of the travels of the soul as a horseman and its triumph over the enemy. oo

BIBLIOGRAPHY: Mat'e and Liapunova, 1951, pp. 171–2, no. 381, pl. XLVII, no. 11.

81
Amphora

Byzantium
4th century AD
Height 42.5 cm, diameter of body 29 cm
Silver; gilding, raising, forging, chasing, soldering
Inv. no. ГЭ 2160/1
Chance discovery in tomb by village of Conceşti on right
bank of River Prut, Romania (formerly Moldavia), 1812;
to Hermitage, 1814

This vessel is in the form of an amphora on a circular foot; it has a narrow neck leading to a rounded ridge; the neck then narrows further towards the top. Its handles are in the form of centaurs. The vessel is ornamented with three decorative friezes depicting hunting scenes and subjects from Greek mythology. The central frieze shows three battle scenes of Greek warriors with Amazons. The representation of the Amazons is traditional for ancient art: warlike women dressed in Greek tunics with high boots and helmets, armed with axes and shields. The Greek warriors are also depicted in traditional fashion: two of them are clad in metal armour, helmets and coats of mail, and armed with shields and spears. Cloaks fastened with fibulas at the right shoulder billow out behind them. Two other warriors are naked and armed with short swords. All the figures are distinguished by the dynamism of their pose, conveying swift and impassioned movement.

The upper frieze, around the shoulders of the amphora, depicts two hunting scenes. In one, hunters with dogs have surrounded a wild boar, while in the other, hunters with spears and a dog are pursuing two deer, which are running straight into nets spread out by the hunters' helper. The hunters are dressed in short tunics decorated with medallions and a border – typical ornamentation for Byzantine clothing. The hunter with the nets is dressed differently: his tunic is wider with long sleeves, and he wears tight breeches and high boots. His headwear in the form of a hood with a round cape, typical of Celtic clothing, is worthy of note.

The last frieze on the lower part of the vase represents three figures of nereids, floating on the sea on fantastical animals in the form of a horse, a lion and a goat with fish tails. The sea is depicted with pointillé wavy lines.

All the friezes are remarkable for their technical and artistic mastery. While continuing the tradition of ancient art, the craftsman has used new illustrative techniques which reflect the cultural influences of his era. This is expressed in the stylistic features of the decoration and certain details in the form of the vessel: the conventional use of perspective in the depiction of landscape; the scaly pattern on the neck of the vessel; the way in which the designs on the clothes and horse harnesses are conveyed; the border granulation on the foot; and finally the distinctive form of the neck. Such features are typical of early Byzantine art of the fourth century AD. A similar amphora, known only from preliminary publication, is kept at JP Morgan Bank in New York.

There are reasons to suppose that the vase did not originally have handles. This is suggested by the crude way in which they have been attached directly onto the relief of the upper frieze, as well as by the find of a similar vessel without handles. IZ

BIBLIOGRAPHY: Matzulewitsch, 1929, pl. 36–43; Frühbyzantinische Silbergefässe, 1979, pp. 87–93, ill. 6–9; Mundell Mango and Bennett, 1994, pp. 194–239, figs. 5–53.

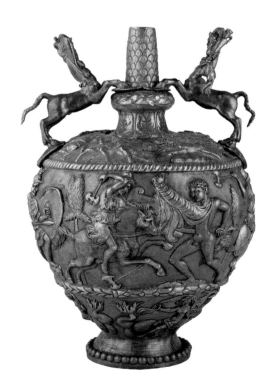

82
Flask with Nereids

Constantinople
AD 641–651
Height 25.2 cm, diameter of circular sides 13.5 cm
Silver; chasing, incising
Inv. no. ω 256
To Hermitage, 1925 (exact site of discovery unknown;
possibly outskirts of Perm, where it was bought)

The flask has two circular flat sides and a widening
neck, onto which two loops have been soldered for a
lid; the foot is pyramidal. There is a conical knop on
the lower part of the neck, and a loop for a handle on
one of the narrow sides of the vessel. The two main
flat sides of the body are decorated with embossed
images in circular medallions showing nereids riding
fantastical sea creatures; on the narrow sides are fish,
birds and shells. The base has five stamps from the
time of Emperor Constans II (641–51). vz

BIBLIOGRAPHY: Matzulewitsch, 1929, pp. 589–91, pl. 19–21;
Dodd, 1961, pp. 212–13, pl. 15; Kent and Painter, 1977,
p. 97, no. 161; Iskusstvo Vizantii, 1977, vol. I, no. 138; Bank,
1985, p. 286, pl. 88–90; Mundell Mango, 1986, p. 212,
fig. 48, no. 1; Kitzinger, 1995, pp. 20–1; Zalesskaia, 2002,
pp. 306–7, no. 333; Zalesskaya, 2004, p. 285; Leader-Newby,
2004, pp. 174–8, fig. 4.4.

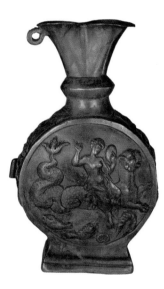

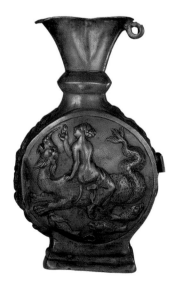

83
Lyre

Byzantium
First half of 4th century AD
Length 26 cm, width 21.5 cm, depth 9.5 cm, length of side
panels 23 cm, width between panels 5–5.5 cm
Bronze, silver; forging, stamping, raising, incising
Inv. no. ГЭ 1820 / 1005
Chance discovery on estate of F. Colongello, Kerch
(earth tomb in clay quarry), 1910; to Hermitage, 1915

The lyre consists of a bronze oval resonator with
segmental side panels and ivory pegs. The convex
surface of the resonator is in the form of a tortoise
shell, and the scales in the centre are inlaid with fine
silver plates. The edges of the resonator are bent
in to a width of one centimetre. The side panels are
joined to the resonator with bronze hinges at one
edge, while the other edges are bent inwards. Small
holes run along the edge; these would have been used
to fix a flexible membrane (tympanum) to increase
resonance. The side panels are richly ornamented: an
incised design of stylised feathers runs along the top;
beneath it are female heads in profile, possibly masks;
and beneath them are the figures of Nike on the left
and a young warrior on the right, framed top and
bottom with bands of relief egg-and-dart ornament.

The winged goddess of victory is shown in profile
with a wreath in her hand; she seems to hover above
the earth. She wears a long, wide tunic hanging from
her shoulders. The luxuriant braids that frame the
goddess's head are tied at the back in a top-knot.

The youth is a naked warrior shown frontally,
with his head turned in profile. He stands leaning
with his right hand on a shield and his left on a spear;
his head is helmeted, and a light cloak billows behind
his shoulders. Mars, the god of war, like the Greek
god Ares, was often portrayed as a lightly armed
naked youth; he is also often shown accompanied
by Nike.

Both motifs belong to ancient Greco-Roman
traditions, although stylistic elements in these
portraits suggest the object is an example of early
fourth-century Byzantine art, which developed from
such traditions.

Sixteen ivory pegs were found along with the
resonator; these would have been used to stretch the
same number of strings. Multi-stringed lyres were
typical of the Roman period, as is shown by works
of art of the time, particularly the wall-paintings of
Pompeii. Although known since ancient Egyptian
times, lyres were also common in Aegean countries
during the Mycenaean era. From that time they
retained their basic form and structure right up until
the fifth century AD, when they were superseded by
the harp, an instrument with strings of different
lengths (unlike the lyre and the *kithara*) and thus with
a wider range of tones. IZ

BIBLIOGRAPHY: Alekseevskaia, 1915, pp. 140–51, plate IX;
Zasetskaia, 1993, p. 90, pl. 59, 60, no. 350.

84
Plate with a Herdsman

Constantinople
AD 530s (?)
Diameter 23.8 cm, diameter of stand 9 cm
Silver; chasing, incising
Inv. no. ω 277
Found in village of Klimovo, Solikamsk Uezd,
Perm Gubernia, 1907

The circular tondo of the plate shows a herdsman
and his flock. The reverse is decorated with incised
tendrils of acanthus flowing from four vases and
culminating in rosettes. On the base are five stamps
from the time of Justinian I.

The herdsman is shown on the left side of the
plate, sitting on a stone bench, a dog lying at his feet.
On the right two goats are depicted on different
planes: one is chewing leaves by a tree, another is
lying among bushes. The composition is bordered
by a relief pattern in the form of acanthus leaves.

The bucolic theme appears on many works of
'Byzantine antiquity'. This plate has all the typical
components of the genre: the herdsman deep in
contemplation of nature, and the inspired and
heroized Hellenistic landscape. Prototypes of the
scene depicted on the Hermitage plate are found
in Hellenistic examples from the time of the emperor
Hadrian, such as the fresco in the National Museum
of Naples, showing Paris among the flock on Mount
Ida, or a mosaic in Hadrian's villa which is similar in
composition. Although the subject matter does not
mark this plate out from other examples of 'Byzantine
antiquity', the Roman character of the portrayal does
distinguish it from other items with similar subjects.
Indeed, the sculptural modelling of the images, their
marked statuesque quality, and the individualisation
of the image of the herdsman make this plate similar
to purely Roman examples, such as the Roman
consular diptychs of Probus and Boethius.

To judge from the monogram in the sigma-
shaped stamp, the *comes sacrarum largitionum* (official
responsible for state silver production) at the time
the mark was applied was a certain Peter. The only
comes with this name known at this stage of Justinian's
rule was Peter Barsymes, who held the post from
547–50 (possibly also from 539–42). Cruickshank
Dodd, however, believes that the Peter on this plate
must refer to a different *comes* of the same name
(Dodd, 1961, p. 28). According to written sources,
the *comes* in the 520s was called Elias. However,
from 530–2 the *comes* was unknown; it would
therefore seem very likely that this was the time when
the unidentified Peter held the post. The end of
the 520s and beginning of the 530s saw the closest
contacts between Constantinople and Ostrogoth
Italy. Theodoric's daughter Amalasuntha, who
came to power in 526, gained support from the pro-
Constantinople nobility and conducted a policy
favourable to Byzantium, which only came to an end
with her death in 534. Equally significant, however,
is the fact that from the beginning of the 530s
Justinian's policy was aimed at rapprochement with
Rome and the Ostrogoth kingdom. Therefore it
is possible that the plate with a herdsman, with
its overtly Roman style, could have been a special
reflection of the policy of the Constantinople
court towards Italy. vz

BIBLIOGRAPHY: Matzulewitsch, 1929, pp. 112–13, pl. 31–2;
Dodd, 1961, pp. 70–1, no. 9; Kent and Painter, 1977, p. 142,
no. 303; Iskusstvo Vizantii, 1977, vol. I, no. 129; Zalesskaia,
1982, pp. 128–30; Zalesskaya, 1982, pp. 102–6, ill. 5; Bank,
1985, pp. 279–80, pl. 55–6; Aus den Schatzkammern
Eurasiens, 1993, pp. 300–1, no. 157; Kitzinger, 1995, p. 109,
fig. 193; Zalesskaia, 1997/3, pp. 10–11, ill. 10; Zalesskaia,
2000, pp. 48–9, no. B-3; Zalesskaia, 2002, pp. 310–12,
no. 337; Leader-Newby, 2004, pp. 174–6, fig. 4.3.

85
Plate with a Silenus and a Maenad

Constantinople
AD 613–629/30
Diameter 25.7 cm
Silver; gilding, chasing, incising
Inv. no. ω 282
Found in village of Kalganovka, near Solikamsk,
Perm Gubernia, 1879; to Hermitage from Stroganov
Collection, 1925

The plate has a relief image of the dancing
companions of Dionysos, a silenus and a maenad.
The silenus, dressed in a short tunic, is holding
a wineskin on his shoulders. The maenad holds
percussive musical instruments in her hands. Below
the line of the ground, in the segment, are a bunch
of grapes and a wineskin, thrown under the silenus's
feet by the maenad to hinder his pursuit of her.
On the base are five stamps of the time of the
emperor Heraclius. vz

BIBLIOGRAPHY: Matzulewitsch, 1929, pp. 3, 18–24, ill. 3,
pl. 2; Dodd, 1961, pp. 202–3, pl. 70; Iskusstvo Vizantii, 1977,
vol. I, no. 135; Bank, 1985, p. 284, pl. 84; Kitzinger, 1995,
p. 107, pl. 190; Zalesskaya, 2004, pp. 291–3.

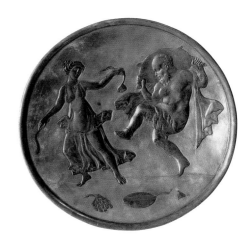

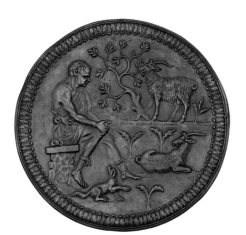

86

Plate with the Quarrel between Ajax and Odysseus over Achilles' Armour

Asia Minor (?)
6th century AD
Diameter 26.6 cm, diameter of base 10.8 cm
Silver; chasing, incising
Inv. no. ω 279
Found near village of Sludka, Perm Gubernia, 1780 (?);
to Hermitage from Stroganov Collection

The plate shows the scene of the quarrel between Ajax and Odysseus over Achilles' armour, which is shown in the segment. The plate has no mark. The reverse is decorated with vines, birds and fruit. The centre of the composition is occupied by Athena, goddess of wisdom, seated on a throne. She is helping to solve the dispute between the Achaean heroes. The right hand of the goddess is raised in blessing towards Ajax, who stands beside her. Odysseus stands to the right of Athena. In the top right corner against a background of conventionally portrayed hillocks is a figure with a shepherd's crook. With its thematic link to Homer's epic poems, this piece is a typical example of 'Byzantine antiquity'. According to Weitzmann, the scene shown on the Hermitage plate differs in a number of ways from the ancient model. Athena is in the centre, taking the place of Nestor or Agamemnon; Ajax, with his unusual pose and gestures, is more like Ares, while Odysseus is shown in the pose in which he is normally depicted in conventional representations of Odysseus and Dolon. This object is a typical example of *pasticcio*, or pastiche (Weitzmann, 1960, pp. 46–9).

The figure of the shepherd in the top right-hand corner is quite unrelated to the scene of the quarrel over Achilles' armour. There is no such character either in Homer's text or in the works of the cyclic poets, even Lesches of Mytilene, whose poem comes closest to the subject depicted. The presence of this shepherd can only be explained by Quintus Smyrnaeus's work *Posthomerica* (fourth to fifth century AD). First, in this work a prominent place is taken up by the episode of the quarrel over Achilles' armour, and, secondly, the poem is narrated by a shepherd, who tells of the Trojan events while tending his animals not far from Smyrna (Quintus Smyrnaeus, XII, 310). Quintus Smyrnaeus's poem was popular in Byzantium and was used for educational purposes, replacing the forgotten works of Homer and the cyclic poets. Evidently an episode from this famous poem was reproduced on this plate. The shepherd's gesture can be seen as an invitation to view the quarrel between the heroes. A similar shepherd, placed apart from the main composition, is to be found in the upper left-hand corner of a plate depicting Bellerophon and Pegasus in the Museum of History and Art in Geneva. As Quintus Smyrnaeus's poem includes an episode with Bellerophon (Quintus Smyrnaeus, X, 162), the appearance of the shepherd in the Geneva plate is also clearly connected with this work. Both plates date from the sixth century AD and neither is from a major centre of production. It would seem entirely probable that these items, made at the same time and based on the same literary work, were produced in the same place. The pieces that are closest to metropolitan works are those from Asia Minor. Therefore it is possible that both plates illustrating episodes from the poem written in Smyrna could have been made in a coastal town in Asia Minor. vz

BIBLIOGRAPHY: Matzulewitsch, 1929, pp. 54–8, pl. 35, no. 6; Tusculum-Lexicon, 1963, p. 129; Kent and Painter, 1977, p. 187, no. 866; Iskusstvo Vizantii, 1977, vol. I, no. 134; Zalesskaia, 1982, pp. 130–2; Zalesskaya, 1982, pp. 106–9, ill. 8–9; Bank, 1985, p. 280, pl. 60–1; Antichnoe serebro, 1985, p. 49, no. 63; Zalesskaya, 1988, pp. 227–31, pl. I, no. 3; Zalesskaia, 1997/3, p. 18, ill. 19; Zalesskaya, 2004, pp. 289–94.

87

Plate with Meleager and Atalanta

Constantinople
AD 613–629
Diameter 27.8 cm
Silver; chasing, incising
Inv. no. ω 1
To Hermitage, 1840

In the centre of the plate against a background of a Pompeian landscape are the hunters Meleager and Atalanta, who slew the Calydonian Boar; in the segment below are hunting dogs and an article whose purpose is unclear – possibly a sack. The scene is not of the hunt itself, but of the preparations for it. The allegorical meaning of such scenes was revealed in the compositions of Dio Chrysostom, who saw hunting as a school of courage and valour (*Oratio*, LXX, 2). In official iconography of the victorious hunt, dating from the rule of Marcus Aurelius, there were four constant components, each conveyed by its own composition: *virtus* (valour), *clementia* (clemency), *pietas* (piety, deference to the gods) and *concordia* (harmony) (*La chasse au Moyen Age*, 1980). These qualities were among the traditional Roman virtues and were widely accepted as the basis of Roman morality. Thus *pietas* signified voluntary submission to religious, state and family duty, respect for society and its foundations; *concordia* was interpreted both in the political sense – the unity of the empire – and with regards to the family.

If we compare the actions of the characters on this plate with similar compositions on Roman sarcophagi, three of the virtues mentioned are present: *virtus* – the valour of those taking part in the hunt; *pietas* – piety personified in the figure of the huntsman on the left, preparing to sacrifice a lamb; and *concordia* – the union of the main heroes, Meleager and Atalanta.

In Roman funerary symbolism the heroic hunt represented the victory of good over evil, and thus immortality; in Byzantine art it was interpreted as part of a triumphal cycle, and as one means of preparing a monarch to be strong, courageous and magnanimous. A well-known example of the latter quality is the *megalopsychia* which Aristotle instilled in Alexander the Great. The same quality of magnanimity is embodied by a female figure who occupies the centre of a famous Antioch mosaic, surrounded by symmetrically placed groups of hunters, one of whom is Meleager (*Byzantinische Mosaiken*, 1986, p. 23, ill. 12).

The plate with Meleager and Atalanta is a late example (from the first quarter of the seventh century) of 'Byzantine antiquity', in which a mythological image is used to express non-mythological ideas and concepts. vz

BIBLIOGRAPHY: Matzulewitsch, 1929, pp. 9–17, ill. 1,2, pl. 1; Dodd, 1961, pp. 146–77, pl. 57; Kent and Painter, 1977, pp. 96–7, no. 160; Iskusstvo Vizantii, 1977, vol. I, no. 136; Bank, 1985, p. 284, pl. 83; Zalesskaia, 1986, p. 136, ill. 1; Zalesskaia, 1988, pp. 20–36; Zalesskaya, 1994/2, p. 32, no. 7; Kitzinger, 1995, p. 107, pl. 191; Zalesskaia, 1997/3, pp. 13–14, ill.13; Zalesskaya, 2004, pp. 290–3; Leader-Newby, 2004, pp. 139–40, fig. 3.9.

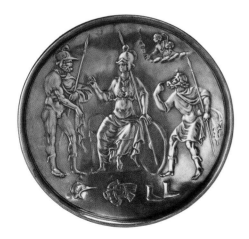

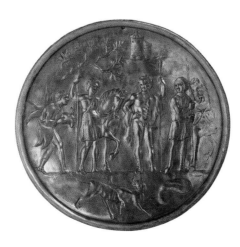

88
Wash Basin with Fishing Scenes

Constantinople
AD 641–651
Height 6.3 cm, diameter 13.5 cm
Silver; gilding, chasing, incising
Inv. no. ω 292
In collection of M.A. Obolensky, 1870s (Matsulevich suggests part of treasure found in village of Peshnigort, Solikamsk Uezd, Perm Gubernia, 1853); to Hermitage from *Antikvariat*, Moscow, 1927

The basin is round with convex sides, a smooth floor and a straight handle which is figured where it joins the body. A ridge runs along the edge of the basin. The outside shows a frieze with fishing scenes: fishermen with tridents, harpoons and nets surrounded by fish, shells and water fowl. The handle bears an image of Neptune with a trident, spearing a fish. (For information on similar objects, *see Byzance*, 1992, pp. 108–9, no. 56.) The base has five stamps from the time of the emperor Constans II. vz

BIBLIOGRAPHY: Matzulewitsch, 1929, pp. 65–71, 75, pl. 12–15; Dodd, 1961, pp. 218–19, pl. 77; Iskusstvo Vizantii, 1977, vol. I, no. 138; Bank, 1985, p. 285, pl. 85–7.

89
Plate with Animal Medallions

Iran
Second half of 3rd century AD
Diameter 23 cm
Silver; chasing
Inv. no. S-74
Found as part of treasure by village of Nizhnyaya Shakharova, Perm Gubernia, 1886; to Hermitage, 1891

At first glance this Sasanian plate with the heads of animals in medallions would appear to be late Roman. Although the decorative motif with figures of gladiators fighting wild animals is indeed borrowed from the art of the Roman Empire, the plate is in fact Iranian, from the time of the first kings of the Sasanian Dynasty (third century AD). The Roman motif has been reworked: the hunters have no interaction with the animals, who are conveyed with the solemnity of an official portrait. The central medallion shows two bacchants, one riding a lion, the other blowing a horn. It has been suggested that the figure on the lion is the Iranian goddess Anahita, and that the animals are incarnations of Zoroastrian gods. However, the small size of the rider compared with the lion, the fact that she is compositionally no more important than the second woman, as well as the lack of a crown or other attributes, would indicate that the composition is allegorical rather than strictly iconic.

From ancient times images of powerful animals had a kind of magical significance in the art of Iranian peoples; this included the Scythians and their famous 'Animal style'. The craftsman or, more likely, the donor, wished for the owner to be as strong, brave and swift as the animals depicted in the medallions: a lion, lioness, zebu, bear and boar.

In the 270s a series of crowns belonging to the Shahanshah, his wife and the crown prince were decorated with the heads of an eagle, boar, horse and griffin. For Sasanian Iran, iconic images of gods are not at all typical, whereas symbolic compositions are.

On the reverse of the plate is a Sogdian inscription from a later period (sixth to eighth century AD). The plate was found as part of a treasure in northern Russia, where many Central Asian, Sogdian and Khoresmian merchants traded Iranian, Bactrian, Sogdian and even Byzantine silver vessels for fur. BM

BIBLIOGRAPHY: Marshak, 1971, ill. 30, pp. 79–80; Trever and Lukonin, 1987, pp. 49–51, 107, 121, no. 1, pl. 1–5.

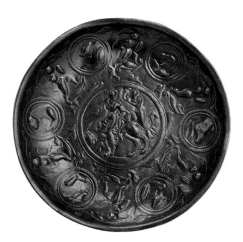

90
Bowl with Herakles

Northern Tokharistan (Central Asia)
6th to 7th century AD
Diameter 14.5 cm, height 4.6 cm
Silver; gilding, chasing
Inv. no. S-75
To Hermitage from Stroganov Collection

Rounded bowls of this shape are typical of Bactrian silver of the third to fourth century AD; this one, however, has a Sogdian inscription: 'This is the bowl of Yamak son of Khun'. These vessels recall late Hellenistic, or Megarian, bowls – evidence of the reverence of the Bactrian people towards Greco-Bactrian art of the third to second century BC. The bowl shows a typical seated Herakles alongside other characters in Greek costume. Herakles also appears in a second scene brandishing a mace, either at a boar or at a man with a dagger preparing to stab the beast. In the second century AD the name and image of Herakles were still engraved on Bactrian coins. In Iran, however, statues of Herakles were believed to be depictions of the god of victory, Verethragna. The scene with the boar perhaps reflects the dispute over the means used to sacrifice animals: the Zoroastrians killed them with sticks, not knives.

Another part of the bowl portrays a couple on a single throne. A winged camel with a peacock's tail – probably a symbol of Verethragna – flies down. The clothes and pose have analogies in wall-paintings from the late sixth or early seventh century AD (particularly in Balalyk-Tepe in Uzbekistan). However, it would be wrong to see this simply as a portrait of a Central Asian aristocratic couple as, apart from the Central Asian servants, the feast is served by monkey musicians. It is quite possible that the bowl was given as a wedding present, likening the owner and his wife to Rama and Sita, heroes of the Indian epic, *Ramayana*. Later, in the tenth century AD, the translation of this work into Arabic – evidently from an earlier Persian translation – became famous.

In the *Ramayana*, monkeys with human features fight alongside Rama to free his wife, who has been captured by a demon. The bottom of the bowl has an Indian apotropaic image: the monster Kirtimukha.

The combination of local, Greek and Indian motifs is a clear illustration of the syncretism of Central Asian culture. BM

BIBLIOGRAPHY: Trever, 1940, pl. 18–21, pp. 81–7, no. 16; Marschak, 1986, p. 35, ill. 15–16.

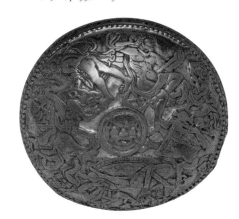

91
Lanx

Syria (?)
8th–9th century AD
Diameter 68.5 cm
Bronze (or brass); chasing, incising
Inv. no. ИР-2320
To Hermitage from former Baron A.L. Stieglitz Central
School of Technical Drawing (P.V. Charkovsky collection),
1924

This lanx, or tray, is one of a group of nine (the
fragments of a tenth also survive); seven of them are
in the Hermitage. In the mid-1930s they were
designated works of art from Dagestan, because this
is where they were acquired. Further investigation,
however, has shown that only three lances were of
Dagestani origin; and, indeed, there is documentary
evidence relating to only one of these, which shows
that it was in existence in the village of Kubachi in
Dagestan in the second half of the nineteenth century.

This lanx's place in the history of art of the Middle
East (along with the others in the group) was
established in a major article published in 1978 by
B.I. Marshak. With its central image of a goddess in a
corona muralis – the patroness of some particular town
– this lanx essentially follows Byzantine iconography:
it reflects the development of early Islamic culture,
which absorbed the cultural and artistic achievements
of subjugated countries of the Arab and Muslim
world. In early Islamic art under the first Umayyad
Dynasty (661–750), with its centre in Syria, the
Byzantine-Hellenistic traditions of Egypt and, in
particular, Syria, predominated, while in the art of the
subsequent Abbasid Dynasty (749–1258), Iranian
traditions began to dominate.

Of those objects that retained classical Byzantine
traditions, this tray is the most stylised and,
consequently, the latest. It may be dated to the eighth
or ninth century. AA

BIBLIOGRAPHY: Orbeli and Trever, 1935, pl. 67; Marshak,
1978, pp. 29–30, 41–2, 46–8; Marschak, 1986, pp. 294–5,
ill. 200, 205; Islamic Masterpieces, 1990, no. 4; Islamic Art,
1995, no. 8; Earthly Beauty, 1999, no. 110; Zemnoe
iskusstvo, 2000, no. 107; Piotrovskii, 2001, p. 62.

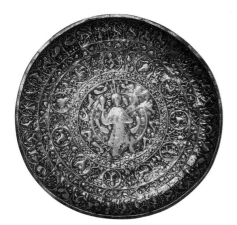

92
Dish with a Scene Derived from the Triumph of Dionysos

Sasanian
3rd century AD (?)
Diameter 22.5 cm, weight 906.2 g
Silver; chasing, appliqué, gilding
Inv. no. ANE 124086
British Museum, London
Owned by Mirs of Afghanistan until 1829; acquired by
Dr Lord, 1838, who later presented it to India Museum,
from where transferred to British Museum, 1900

This gilded silver dish of Sasanian (Persian) origin
bears a scene clearly derived from classical models,
and particularly from the common motif of the
triumph of Dionysos. Aspects of the composition
correspond almost exactly to Greco-Roman
representations in other media, notably a late
Hellenistic cameo now in Naples. The original scene
showed Dionysos reclining on a chariot pulled by
psychai (butterfly-winged girls) and accompanied by
erotes. Here, however, the subject has lost its
coherence: the female figures, now wingless, are
no longer harnessed to the chariot; the vehicle has
become a carpet-like platform above a single
disembodied wheel; the actions of the 'erotes' are
obscure, while 'Dionysos', who reclines with a wine-
cup like a diner at a symposium, is accompanied
by an oddly diminutive female, perhaps his consort
Ariadne, but quite different from her conventional
classical appearance. Finally, the figure behind the
vehicle, who resembles a Greco-Roman satyr (an
appropriate follower for Dionysos), has been given
the attributes of the Greek hero-god Herakles,
a lionskin and club. In the exergue a panther drinks
from a vase surrounded by pomegranates or peonies.

The reasons for the iconographical
transformations are difficult to determine. It is
unclear to what extent the Greco-Roman models had
been copied without being understood, or whether

the new version of the scene made particular sense in
the context of Persian culture. The importance of the
dish lies in the evidence it offers for the spread of
classical ideas into the Persian east at the time of the
rise of the Sasanian dynasty. The proximity of the
western frontier of the Sasanian Empire to Antioch,
one of the most important cities of the Greco-Roman
world and a major metal-working centre, provides a
possible arena for the transfer of such ideas. Equally,
Antioch provides evidence of Sasanian artistic
ideas being adopted by Romans. The dish shows
the porosity of the frontier, and the existence of a
common visual language of luxury and feasting in the
Near East in this period.

The dating of the dish is controversial, but it is
usually placed in the third century AD. The loss of the
head of Dionysos reveals the way in which the dish
was made: the figures were all hammered into shape
from separate sheets of silver, gilded and then
soldered onto the dish. Recently faint inscriptions
have been discovered on the reverse of the dish.
These may be in Parthian, written in Aramaic script,
and perhaps record the early ownership of the dish.
AE; PS

BIBLIOGRAPHY: Dalton, 1964, pp. 49–51, pl. 27, no. 196;
Ward, 1993, p. 44, fig. 29; Boardman, 1993/1, pp. 96–7,
fig. 4.27; Boardman, 1993/3, pp. 16–27, fig. 17.

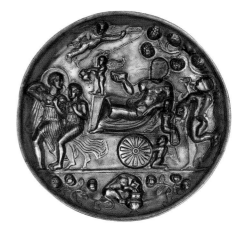

93
Gold-glass Medallion with a Family Portrait, from Floor of a Vessel

Rome
4th century AD
Diameter 8.1 cm
Glass, gold leaf
Inv. no. E.2039 (16079)
To Hermitage from collection of Alexander P. Bazilevsky, Paris, 1885 (found in catacombs in Rome)

This floor of a vessel is made of transparent colourless glass; a thin sheet of gold foil between two layers of the glass is used to create the portrait of a man, woman and girl. The facial features, hairstyles, jewellery, and folds and patterns of the clothing are all conveyed through incising. A mirrored Latin inscription runs around the portrait between two concentric gold bands: BALERI. BALENTINO PERGAMIA ZESES ('Valeria, Valentina, Pergamia, Hail'). The whole composition is framed by three narrow gold rings.

To judge from the inscription, which is a salutation, this is probably the floor of a vessel that would have been used to drink in commemoration of the depicted family. Such objects with portraits and salutations were found in burial sites, particularly in the Roman catacombs; it seems likely, therefore, that they were connected with burial rituals.

There is a certain stiffness and solemnity about the image, arising in particular from the marked frontality of the portraits, while the two-dimensionality and delicate linearity of the execution of this late-Roman object is strongly reminiscent of some Byzantine works of art. EKh

BIBLIOGRAPHY: Kunina, 1997, no. 434, pp. 338–9, pl. 219.

94
Small Plate with Nike

Egypt
4th century AD
Diameter 7 cm
Jade
Inv. no. ω 1296
From collection of Nikolai P. Likhachev

A bust of Nike in a Corinthian helmet is carved on the inside of the plate; a tendril motif runs along the border. On the back is a rosette with multiple arrow-shaped leaves. More than a dozen small plates of similar form and structure are known; all were found in Egypt (Parlasca, 1983, pp. 147–52) and were originally used in offices of the cult of Serapis. By the fourth century AD they were used as vessels for the preparation of medicine, although they retained images borrowed from the Greco-Roman pantheon and treated in a mystical style. Similar small plates from the former Kaiser Friedrich Museum in Berlin date from the turn of the fourth century AD (*Spätantike und frühes Christentum*, 1984, pp. 476–7, no. 79; pp. 504–5, no. 125). VZ

BIBLIOGRAPHY: Zalesskaia, 1991, pp. 42–4; Zalesskaia, 1993, pp. 517–18, no. 125.

95
Fragment of a Plate with Nereids on Hippocamps

Asia Minor
Late 4th century AD
12 × 24.5 cm
Clay
Inv. no. ω 823
From collection of Nikolai P. Likhachev; on the reverse is a sticker with the inscription: *Aleksandriia (Arkhiv BAN, No. 991, opis 1, delo)* [Alexandria (Archive of the Library of the Academy of Sciences, list 1, file)]

The fragment shows the stamped depiction of two nereids in the water: one is sitting on a hippocamp and blowing a horn; next to her is a male figure with a wineskin on his back – evidently a satyr. Visible at the bottom edge of the break is a pattern of grains in relief, which would once have framed the dish's central medallion. The entire composition can be reconstructed from analogies (*see Age of Spirituality*, 1979, pp. 151–2, no. 130) as follows: in the centre would have been the head of an old man personifying the earthly ocean, or Cosmos, surrounded by fantastic sea creatures and characters from Dionysian mysteries. The Greek inscription along the edge is from the Christmas homily of Father Gregory of Nyssa (PG, vol. XLVI, col. 1141D): 'Lord, Help us, in contemplating the cave in which You were born, to see Your star in the darkness of our caves.' This type of composition was a symbolic reflection of Christmas. Just as in the days of the January Calendars in Ancient Rome it was the custom to offer gifts as a way of wishing others well, so in fourth- and fifth-century AD Byzantium, during the Christmas festivities people gave each other items in some way connected with the event. This clay dish would have been one such gift, with its wish to see the true Light. VZ

BIBLIOGRAPHY: Iskusstvo Vizantii, 1977, vol. I, no. 1999; Zalesskaia, 1987, pp. 38–40; Zalesskaia, 1993, p. 67, no. 153.

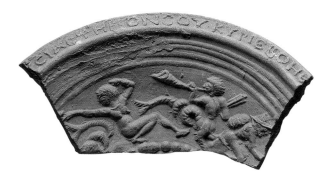

96
Intaglio with Three Portraits

Eastern Mediterranean
4th century AD
Height 3.9 cm, width 5.15 cm
Cornelian, garnets, glass paste, gold
Inv. no. ω 1170
Acquired from V.M. Shervashidze in 1888

This oval intaglio shows three busts: two males, on the left and in the centre, and a female on the right. Greek letters along the edge give the names of those portrayed. The youth on the left was called Vis, the man in the centre Anis and the woman Ninas; Ulrivis would have been the surname of all three. The same surname in abbreviated form appears in the weight inscription on a fourth-century AD silver ladle with a Dionysian scene in the Armoury Museum of the Moscow Kremlin (*Memorial'nost'*, 2005, pp. 6, 31, no. 1). The ladle's handle bears the name of the craftsman or official responsible for the quality of the object, followed by the name of a town, in this case Sebastia in Palestine. This is similar to a weight inscription on a dish with scenes from the life of Achilles found in the ancient Roman military *castrum* of Kaiseraugst in Switzerland.

Both the ladle and the intaglio were discovered on the Caucasian coast of the Black Sea: the ladle was found in Sochi, while the intaglio, according to V.M. Shervashidze who sold it to the Hermitage in 1888, was found in Sukhumi. It seems likely that the Ulrivis family was connected to both objects, one of which was made in Sebastia in Palestine. vz

BIBLIOGRAPHY: Iskusstvo Vizantii, 1977, vol. 1, no. 78; Zalesskaia, 2003/2, pp. 27–9; Zalesskaia, 2004/2, ill. 5.

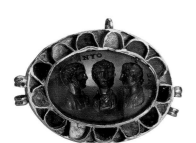

97
Fragment of a Dish with a Circus Hunting Scene

Eastern Mediterranean, 'African' type
4th–5th century AD
15 × 32.5 cm
Clay, red slip
Inv. no. X 339
Found in Chersonesos; to Hermitage, 1915

This is a fragment of a rectangular dish with a raised rim. The floor shows a circus hunting scene in which a horseman with a spear is about to strike a bear; beneath him (part of a related scene) is a fight with another bear. The figure of a man lies on the part of the rim that has been preserved; alongside him is a servant with a fan. vz

BIBLIOGRAPHY: Iskusstvo Vizantii, 1977, vol. 1, p. 72, no. 83; Bank, 1985, p. 274, pl. 20.

98
Necklace with a Cross and Pendants

Constantinople
6th century AD
Length of chain 33 cm; cross 4.9 × 3.8 cm
Gold, chalcedony, paste; stamping, granulation
Inv. no. ω 104
Found Mersina, ancient Zephyrion (Asia Minor), 1889; to Hermitage, 1893

The necklace is wrought from interlaced rings and has five pendants of which one is pyriform and decorated with inset chalcedony, a second is oval and bears a stamped image of the Archangel with a spear and orb, and the other three are small rings filled with paste. The clasp, which consists of two coin-shaped disks, each bearing an image of the Archangel with a cross and the Latin letters CONOB (imitating the mark of the mint at Constantinople), has a hook on one disk and a loop on the other. Necklaces and crosses of this type can generally be dated to the sixth century AD (*see* Rusu, 1983–84, p. 74, fig. 6; Brouskari, 1985, p. 144, no. 116; *Byzantium at Princeton*, 1986, p. 91, nos. 87–8; *Byzantium*, 1988, p. 36, no. 46). The pyriform pendant with chalcedony dates from the Roman era. vz

BIBLIOGRAPHY: Iskusstvo Vizantii, 1977, vol. 1, no. 161g; Bank, 1985, p. 287, pl. 98; Zalesskaia, 1997/3, p. 9, ill. 9; Zalesskaia, 2000, p. 56, no. B-13 e.

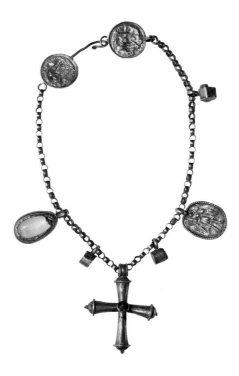

99
Earrings

Eastern Mediterranean
Late 6th century AD
Height 3.1 cm, length 3.9 cm
Gold; openwork, incising
Inv. no. ω 96 a, б
To Hermitage from Mersina, 1893

This pair of earrings is in the form of flat half-moons with five grains around the edge. The openwork half-moons contain an image of two peacocks with a vase in the centre. They show particular technical expertise, and may have been made in Constantinople or another major artistic centre. Similar earrings were widespread in various parts of the Byzantine Empire (*see Age of Spirituality*, 1979, pp. 315–16, no. 290; *L'arte albanese*, 1985, no. 395, p. 103, pl. VI; *Byzantium at Princeton*, 1986, p. 35, no. 47, p. 38, no. 55; Postnikova-Loseva et al., 1985, no. 10; Winkelmann and Gomolka-Fuchs, 1987, p. 150, ill. 105; Yeroulanou, 1988, fig. 6; *Byzance*, 1992, p. 129, nos. 80–1; Buckton, 1994, p. 97, nos. 101–2; *Art of Late Rome*, 1994, pp. 86–7, no. 24; Kalavrezou, 2003, p. 246, no. 138). VZ

BIBLIOGRAPHY: Iskusstvo Vizantii, 1977, vol. I, p. 118, no. 161 v; Bank, 1985, p. 287, pl. 97; Zalesskaia, 2000, p. 55, no. B-33 a.

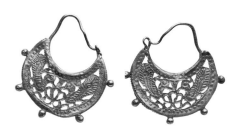

100
Cameo with Christ Emmanuel

Byzantium (?)
6th century AD (?); mount 18th century
4.3 × 3.2 cm (without mount), 5.1 × 4.1 cm (with mount)
Sardonyx, gold
Inv. no. ω 373
To Hermitage, second half of 18th century

The bust of the young Christ Emmanuel is executed in bas-relief. Certain features of the technical execution of the image suggest that the artist was reworking an ancient stone which may have portrayed one of the Roman emperors. Only the *lorum* (central strip of the tunic), decorated with a diamond, and the hair are left of the original portrait, which was executed in higher relief. The halo is shown only by the three terminals of the cross, which widen at their ends; the letters IC XC are carved into the surface of the stone. VZ

BIBLIOGRAPHY: Bank, 1966, p. 295, pl. 108.

101
Cameo with Diana and Apollo as Pothos

Byzantium
12th century AD (?); gold mount 18th century
3.2 × 2.6 cm
Three-layered sardonyx
Inv. no. ω 372
From collection of Catherine the Great

Two human figures are carved out in light layers of sardonyx on a dark brown oval background; between them is a bird (a goose or duck). Five Greek letters beneath the composition form the word ΠΟΘΟΣ ('Pothos'). The principal iconographic features of the characters are quite clearly expressed. The effeminate youth on the right is Apollo as Pothos, whose symbol was a goose, which, like the bird of Apollo, represented the sun. The female warrior in a short tunic facing him is Artemis. In a cameo of the first century BC which shows the same pair of Olympian gods (cat. 49), Artemis sits on the left holding a spear while Apollo stands on the right, leaning with his bent right arm on a pedestal crowned with a lyre. In this twelfth-century cameo the Byzantine artist has copied an ancient model similar to the one described. The artist has correctly conveyed the outline of the pedestal but has not understood the significance of the lyre, which here has been turned into a trapezoid object whose surface is covered with wavy lines, which in the original signified the strings. The epithet 'Pothos' should not be understood by its literal meaning of 'yearning' or 'desire'. In the Byzantine era some epithets of the deities began to be used in a generalised sense to express the principal function or attribute of a particular god or goddess. In this inscription, for example, 'Pothos' signifies 'prosperity', and it should be applied in this sense to the composition as a whole.

The mythological subject makes this object unique among Byzantine glyptics; the suggested dating to the mid-Byzantine period is thus based less on particular iconographic and stylistic analogies than on general tendencies in Byzantine art of the tenth to twelfth century. The treatment by the artist of a mythological subject, where the ancient symbolic subtext clearly comes through, is typical of neo-classicism of the mid-Byzantine period. Similar subjects are quite common in the work of Byzantine miniaturists who illustrated the homilies of St Gregory of Nazianzus: they preferred to use bucolic scenes, which in spirit were connected with Gregory's 'Word for the New Week' with its accent on portrayals of nature awakening in spring. VZ

BIBLIOGRAPHY: Zalesskaya, 2000/2, pp. 56–9; Zalesskaia, 2002, pp. 113–19.

102

Cameo with the Ascension of Christ and the Adoration of the Cross

Byzantium
12th century AD (?); mount 18th century
5.5 × 4.6 cm
Sardonyx, gold
Inv. no. ω 373
From collection of Catherine the Great

The upper part of the stone has a half-figure of Christ Pantocrator with two angels bowing before him. Their arched wings, which are surmounted by small heads of angels, curve to form a kind of mandorla around Christ's head. The images are accompanied by Greek inscriptions: above the head of Christ is the word 'Lord' and the thrice repeated 'Holy' – twice running along the edge of the cameo and a third time with its letters in the form of a cross, positioned between the bowing angels. This is evidently part of the supplication common on amulets of the mid-Byzantine period: 'Holy, Holy, Holy, Lord God of Sabaoth, Heaven and earth are full of Thy glory'. This formula appeared on small religious images of the twelfth century, evidence not only of the influence of phylacteries of the same period, but also of the apocryphal tradition of Pseudo-Matthew of Patara and the twelfth-century mystics, in particular the teachings of Joachim of Floris.

In stylistic terms the cameo belongs to a group of Italo-Byzantine glyptics of the turn of the thirteenth century. vz

BIBLIOGRAPHY: Zalesskaia, 1997/3, pp. 41–2, ill. 40.

103

The Veroli Casket

Byzantine (probably Constantinople)
Mid-10th century AD
Length 40.5 cm, width 16 cm, height 11.2 cm
The figural ivory panels and bone rosette strips are fixed onto a wooden core, with a metal hinge and handle
Inv. no. 216–1885, Victoria & Albert Museum, London
Purchased from Cathedral of Veroli by John Webb, 1861; sold by Webb to Victoria & Albert Museum for £420, 1865

This, the finest surviving Byzantine ivory and bone casket, is decorated with numerous scenes from classical mythology. It is carved in a technically audacious way, with the limbs of many of the figures completely undercut to make them stand proud of the surface. The casket demonstrates the longevity of the classical tradition in the Byzantine world, and is linked to a number of manuscripts and other objects from the mid-tenth century AD, which show a similar renewed interest in the styles and iconographies of antiquity.

The figures depicted come from a diverse range of mythological sources, including the rape of Europa on the lid, the sacrifice of Iphigenia on the front, and Dionysiac revelry on the sides and back. In addition, other figures are interspersed among these, including Asklepios and Hygeia, Herakles, Bellerophon and the winged horse Pegasus, as well as numerous erotes who cavort, suckle and dive naked into baskets. The meaning behind this array of figures and juxtapositions, notably the placing of Europa alongside a crowd of stone-throwing youths,

has long been a mystery. Some scholars have sought to unify the images in a coherent 'programme' based on, for example, the *Dionysiaca* of Nonnos of Panopolis, written in the fifth century AD. Others have explained it away as an eclectic or confused selection, in which the replication of ancient forms, rather than iconographic meanings, was the prime goal. The overt eroticism of the erotes and almost satirical echoing of poses, as in the way an eros on a panel on the back rides a bull in a parody of Europa on the lid, suggests that a more playful interpretation may be called for: perhaps a witty and erudite mythological puzzle for its wealthy owner to untangle.

The mythological iconography gives no clue as to the object's function. It is assumed to have had a secular purpose, perhaps as a marriage gift or holder of perfume bottles, but other ivory caskets with almost identical rosette border decorations have religious iconography, relating to the Fall of Adam and Eve and to the wars of Joshua.

Despite the extraordinary quality of the figural carving, the rosette strips (which are carved from bone, not ivory) were clearly mass-produced. They were certainly not designed for the dimensions of this casket, and strips are cut without regard to the decoration to fit the lengths required. AE

BIBLIOGRAPHY: Goldschmidt and Weitzmann, 1930, no. 21; Weitzmann, 1951, pp. 169–77; Masterpieces of Byzantine Art, 1958, no. 122; Beckwith, 1962; Simon, 1964; Cutler, 1984–5, pp. 32–47; Cutler, 1994, pp. 56–63, 117, 150–1, 224, 240–3, figs. 61, 128; Glory of Byzantium, 1997, no. 153; Hanson, 1999.

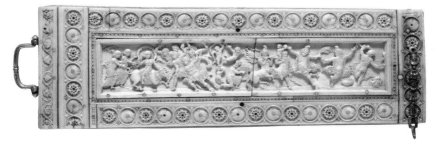

104
Amphora

Constantinople
6th century AD
Height 48.5 cm, diameter of rim 12.1 cm, diameter of body
28.5 cm, diameter of floor 12.7 cm
Silver; gilding, engraving, forging, casting
Inv. no. ω 828
Found near to settlement of Malaya Pereshchepina, Poltava
province (Ukraine), 1912; part of group of Byzantine,
Sasanian and Barbarian artefacts included in burial of
Kuvrat, khan of Great Bulgaria

The body of the amphora is made up of several parts
soldered together. The amphora's neck, rim and
handles are cast; the two semi-conical parts of the
amphora and the second decorative band show traces
of having been roughly worked with a scraping
instrument along the body: in other words, they were
not cast, but made by hand. The assay marks and
weight inscription on the bottom are only just visible
through the thick layer of gilding. In the centre only
one cruciform hallmark can be made out, with an
open monogram which could equally be dated to the
reign of the emperor Anastasius I (491–518) or that
of Justinian (527–65). Distinguishable in the weight
inscription are marks rendered in pointillé, which
refer to the amount of silver used for the amphora:
20 litres and 20 ounces – either 7,003.2 or 6,955
grams, depending on whether the amphora dates
from the reign of Anastasius or Justinian (under the
former a litre equalled 326.16 grams, and under the
latter, 323.75 grams).

The difference in weight of 1.5 kilograms between
that given in the inscription and the amphora's
present weight cannot be explained by wear, which is
insignificant. It is clear that the craftsman, when

mounting the vessel, must have used the stand of a
different silver amphora, made, according to the
hallmarks, in Constantinople in the first half of the
sixth century. Since the Pereshchepina treasure
mostly belonged to Kuvrat, khan of Great Bulgaria
(*see* Werner, 1984, p. 10), a Byzantine patrician and
ally of the emperor Heraclius, it seems likely that the
upper part of the amphora and handles were made
at Kuvrat's headquarters in Phanagoria, a town by
the Azov Sea.

The body of the vessel is decorated with three
embossed friezes. The first, below the rim, comprises
a *kymation*-style ornament, the nearest analogy to
which is the decoration of the medallion on a sixth-
century dish found at Sutton Hoo in England. The
middle part of the body is decorated with acanthus
tendrils, within which are masks, vases with fruit,
and rosettes. The structure and composition of the
various elements of this central frieze are reminiscent
of the mosaic in the Great Palace in Constantinople.
The third frieze is on the stand of the amphora and
comprises a border of vertically arranged acanthus
leaves.

The depiction of dolphins on amphorae – in this
case in the form of the dolphin handles – relates to
Hellenistic and Roman traditions: the dolphin, which
came to symbolise salvation in the Byzantine period,
was often used on vessels meant for grain, oil and
wine. vz

BIBLIOGRAPHY: Matzulewitsch, 1929, pp. 7, 107–9, pl. 28,
ill. 23–4; Dodd, 1961, p. 225, pl. 79 a, b; Iskusstvo Vizantii,
1977, vol. I, no. 139; Werner, 1984, p. 10, pl. 8, ill. 17 a, b;
Bank, 1985, p. 282, pl. 70; Zalesskaya, 1996/1, p. 218;
Zalesskaia, 1997/1, pp. 113–14; Zalesskaia, 1997/3, p. 8,
ill. 5; Zalesskaia, 2000, pp. 50–1, no. B-5 a; Zalesskaya, 2002,
pp. 305–7.

105
Wash Basin

Constantinople
AD 582–602
Height 7.25 cm, diameter 25.2 cm, length (with handle)
38.5 cm
Silver; gilding, chasing, engraving
Inv. no. ω 825
Part of Pereshchepina complex

This wash basin has a flat rim bent outwards and a
short, flat handle that widens slightly towards the
end. The floor is decorated with an eight-petal
rosette surrounded by a garland of ivy. Around the
edge of the central rosette are ten scoops with
engraved shells. An egg-and-dart ornament runs
along the rim. In places there are faint traces of
gilding. The base is circular. On the reverse are five
marks from the time of the emperors Maurice and
Tiberius (582–602): four on the bottom and one
on the handle, together with a pointillé Greek
inscription which reads: 'this is a hand-washing set
having 8 litres, 1 ounce and 20 grams'. In other
words, the weight of silver is given as 2,634 grams,
which accords with the combined weight of the wash
basin (1,265.2 grams) and the ewer found with it
(1,364 grams, cat. 106). The difference of 4.8 grams
is explained by slight wear on both objects.
The term used in the inscription, χερνιβόξεστον
('cherniboxeston'), signifies a hand-washing set,
comprising a χερνιβόν ('chernibon' or wash basin),
and a ξεστος ('xestos' or ewer). A similar weight
inscription, including not just the weight of the
article itself but the weight of the whole set, is to be
found on a silver pyxis – a gift from the deaconess
of Tiberina to St Stephen (Museum of St Louis,
USA; *see* Mundell Mango, 1986, p. 254) and a silver
ladle with a Dionysian scene kept in the Moscow
Kremlin museums (Zalesskaia, 2003/2, pp. 27–9).
The weight given on the pyxis would suggest that
there is a second case in which the pyxis was placed
with a dedication, while the weight on the handle
of the Kremlin wash basin includes both its weight
and the weight of a silver spoon found with it.

The use in Byzantium of hand-washing vessels of
this type, both in everyday life and at cult ceremonies,
goes back to the traditions of antiquity. A small
number of preserved washing-sets relate to Roman
times. The shells in the scoop-like indentations
of the basin and the ivy around the central rosette
(*see* Cumont, 1942/1, pp. 21–38) are symbols of
immortality, which fully accords with its secular
function for use at banquets. vz

BIBLIOGRAPHY: Matzulewitsch, 1929, pp. 7, 80–3, pl. 17,
ill. 13–14; Dodd, 1961, pp. 118–19, pl. 30; Nuber, 1972,
pp. 7–232; Iskusstvo Vizantii, 1977, vol. I, no. 140; Werner,
1984, p. 11, pl. 2 a, b; Bank, 1985, p. 281, pl. 64–5; Mundell
Mango, 1986, pp. 254–5; Zalesskaya, 1996/1, pp. 218–20,
ill. 5, 20; Zalesskaia, 1997/1, pp. 114–15, no. 3; Zalesskaia,
1997/2, pp. 81–2, no. 28; Zalesskaia, 1997/3, p. 8, ill. 3;
Zalesskaia, 2000, pp. 50–1, no. B-5 c.

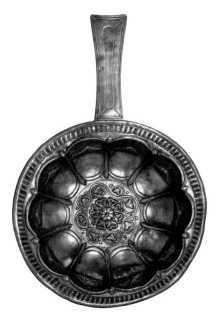

106
Ewer

Constantinople
AD 582–602
Height 28 cm, diameter of foot 9.6 cm
Silver; gilding, chasing, engraving
Inv. no. ω 826
Part of Pereshchepina complex

This faceted ewer has a separately cast handle
soldered to the rim and body. The handle is
decorated with the image of a panther's head, the
rim with two dolphins. The ewer is part of a hand-
washing set (*see* cat. 105). Dolphins, masks and
panthers are traditional ancient images connected to
the Dionysian mysteries. Designs of this type are
usual for ceremonial hand-washing articles intended
as diplomatic gifts, in this case a gift to the Bulgarian
ruler and ally of Byzantium. This may have been
Organa, khan of Bulgaria during the First Turkic
khanate, and uncle and regent (before his nephew
came of age) of Kuvrat. In 619 Organa visited
Constantinople, where he had conferred upon him
the Byzantine office of *patrikios* and received a
wealth of gifts. vz

BIBLIOGRAPHY: Matzulewitsch, 1929, pp. 6, 82–5, ill. 15–17,
pl. 18; Dodd, 1961, pp. 120–1, pl. 31; Ettinghausen, 1972,
pp. 3–10, pl. VIII–X, nos. 27–37; Iskusstvo Vizantii, 1977,
vol. I, no. 141; Werner, 1984, p. 11, pl. 4 a, b; Bank, 1985,
p. 281, pl. 62–3; Zalesskaya, 1996/1, pp. 218–20, ill. 5, 21;
Zalesskaia, 1997/1, pp. 115–16, no. 4; Zalesskaia, 1997/2, pp.
82–3, no. 29; Zalesskaia, 1997/3, p. 8, ill. 2; Zalesskaia, 2000,
pp. 50–1, no. B-5 c.

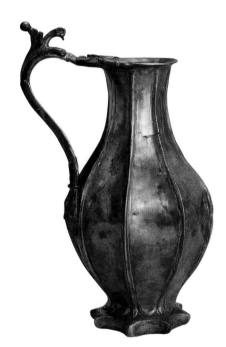

107
Ring with a Monogram

Constantinople
c. AD 619
Diameter of hoop 2.7 cm, diameter of disk 1.6 cm
Gold
Inv. no. 1930/187
Part of Pereshchepina complex

This ring consists of a round disk with an engraved
cruciform monogram soldered to a thick hoop. Rings
of similar construction are typical of the seventh
century AD (*Age of Spirituality*, 1979, pp. 328–9,
no. 308; *East Christian Art*, 1987, p. 23, no. 8). The
monogram may be interpreted as BATOPXA[I]OY
ΠΑΤΡΙΚΙΟΥ, referring to Organa, who was ruler of
Bulgaria and appanage Turkic khan during the First
Turkic khanate and regent for his young nephew
Kuvrat. In 619, according to the testimony of the
patriarch Nikephoros, Constantinople was visited by
a certain sovereign with his *arkhontes* (high-ranking
officials) and *doryphoroi* (bodyguards) from the tribe
of the Huns, presumably Organa. The visitors
were baptised and honoured with imperial gifts; the
emperor Heraclius conferred on their leader the
office of *patrikios* and gave him generous gifts, of
which this gold ring may have been one. ZL

BIBLIOGRAPHY: Zalesskaya, 1996/1, p. 216; Zalesskaia,
1997/1, pp. 41–4, no. 14; Zalesskaia, 1997/2, pp. 72–7,
no. 33.

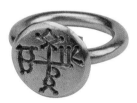

108
Ring with a Monogram

Constantinople
Early 7th century AD
Diameter of hoop 2.7 cm; diameter of disk 1.2 cm
Gold
Inv. no. ω 1052
Part of Pereshchepina complex

The ring's round disk is formed of two cones cut
in cross-section and joined at the base with a large
hoop. The cruciform monogram on the disk may be
interpreted as XOBPATOY, or Kuvrat, khan of
Great Bulgaria, who at a young age was brought by
his regent Organa to Constantinople, where he was
raised at the Byzantine court. The ring may relate to
the time that Kuvrat was in Constantinople. vz

BIBLIOGRAPHY: *see* cat. 107

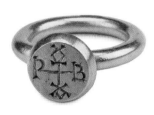

109
Ring with a Monogram

Constantinople
c. AD 635
Diameter of hoop 2.6 cm; diameter of disk 1.6 cm
Inv. no. ω 1053
Part of Pereshchepina complex

The ring has a structure similar to the previous entry
(cat. 108). The cruciform monogram on the round
disk can be interpreted as XOBPATOY ΠΑΤΡΙΚΙΟΥ
('Kuvrat patrikios'). The ring relates to the time
of the defeat of the Avars by the Bulgarians in about
635, for which the Byzantine emperor Heraclius
sent Kuvrat gifts and conferred on him the position
of *patrikios*. The ring originates from this wealth
of gifts. vz

BIBLIOGRAPHY: *see* cat. 107

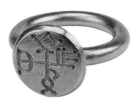

Belt-buckle and Belt-end

Byzantium
Mid-7th century AD
Buckle 17.8 × 5.7 cm, belt-end 13.6 × 5.5 cm
Gold, glass
Inv. no. 1930/91, 92
Part of Pereshchepina complex

The buckle and belt-end are from the same belt
set. The decoration on the buckle is typical of the
period of the migration of peoples. However, in the
structure of the design both pieces are similar to
adornments from Constantinople. This buckle and
belt-end decorated the patrician belt which was
presented to Kuvrat by the emperor Heraclius when
Kuvrat was awarded the rank of *patrikios*. This
occurred between 634 and 640, when peace was
concluded between Byzantium and Great (Azov)
Bulgaria. Taking into account the tastes of the
intended recipient of the belt, the Constantinople
craftsman has filled the inserts in the design with
coloured glass, as was fashionable among the
Huns. ZL

BIBLIOGRAPHY: Werner, 1984, pp. 38–45; Zalesskaia, 1997/1,
pp. 41–4, nos. 8–9.

Parts of a Belt Set

Byzantium
Mid-7th century AD
Gold, glass
Inv. nos. 1930/34–47, 59–61, 87–90
Part of Pereshchepina complex

The belt with pseudo-buckles from Pereshchepina
is part of a set of arms and armour belonging to a
noble warrior. Apart from the belt, the set consists
of a sword with a ring-shaped finial and gold facing,
two gold ends of the belt on which it hung, and
a gold rhyton. Sets very similar to these were found
in rich Avar burial sites in Hungary, which some
scholars believe to be the graves of the Avar khans.
The general style and technical similarity of the sets
suggest that they were created at the same centre,
as gifts and contributions for nomadic nobles, taking
their tastes into account.

Werner has suggested that this belt set, along
with the entire complex of items from Pereshchepina,
belonged to Kuvrat, khan of Great Bulgaria. The set
of arms and armour, which included the decoration
with pseudo-buckles, was presented to Kuvrat by the
emperor Heraclius when peace was concluded
between them in the years 634–40. ZL

BIBLIOGRAPHY: Werner, 1984, pp. 38–45; Zalesskaia, 1997/1,
pp. 144–54, nos. 30–7; Zalesskaia, 1997/2, pp. 88–93, 105–8,
nos. 38–51; L'vova, 1998, pp. 110–22, ill. 2, nos. 1–8, ill. 3,
nos. 1–8.

133
Dish with the Flight of Alexander the Great on Griffins

Byzantium
12th century AD
Diameter 28 cm, height 5.3–6 cm
Silver; gilding, chasing, incising
Inv. no. ω 1501
Found among collection of silver objects in village of
Lopkhari, Shuryshkarsky district, Yamalo-Nenets
Autonomous Region, 1982; presented as gift to Hermitage
by government of Yamalo-Nenets Autonomous Region,
2003

This dish is one of the finest examples of Byzantine toreutic art of the era of the Crusades, both in terms of its technical mastery and unique composition. It was made in Constantinople by a craftsman trained in the capital. The depiction of the flight of Alexander on griffins, which occupies the central medallion and is executed in high relief, is surrounded by a whole series of additional images and scenes. They include Bellerophon and Pegasus, representing the elements of the earth and sea; a heavenly charioteer; King David on his throne; a horseman at the moment of attack; a spear-carrying horseman; a bowman; a youth who has saddled an eagle; and a youth in a chariot. The decoration of this secular vessel is thus made up of diverse subjects all symbolising strength, victory and celebration; they represent, therefore, a wish for all good things to come to the owner of the dish.

The object is a perfect illustration of the recommendations in *On Diverse Arts*, written by Theophilus at the beginning of the twelfth century, that gold and silver objects should be decorated with figures of 'horsemen fighting dragons, lions and griffins, or images of Samson and David tearing apart lions' jaws, as well as single lions and griffins'. The images on this dish follow the traditions of both classical and early Byzantine antiquity. The light,

almost unfinished, figures around the side are executed in the Hellenistic *non-finito* technique, while the high relief of the figure of Alexander the Great in the central medallion anticipates the classicizing statues of the Palaiologan Renaissance of the fourteenth century. Alexander is presented as a forerunner of the Byzantine emperors Basil I and II: his flight represents both leadership and a striving to attain heavenly beauty. The iconography of the heavenly bodies is also traditional: in the Greek tradition the sun, moon and stars shown together turned the decorative field into a symbolic representation of the cosmos. Bellerophon flying on the back of Pegasus signified the ascension of the soul and the triumph of ideas, while the battle scenes (whether fighting warriors, hunters or athletes) represented not simply the triumph over the enemy or wild beasts, but also the victory of good over evil. The depiction of the figure in a crown sitting on a bird of prey with the disk of the sun in his hand is also full of hidden meaning: this is the apotheosis of the deified Roman emperor, or, in this context, of Alexander the Great. The so-called populated vine that delineates the side medallions is an ancient Dionysian motif which became particularly popular in the twelfth and thirteenth centuries; it was identified by contemporaries with the tree of Jesse, and later with the tree of life.

On the reverse of the dish is a cryptogram consisting of twelve symbols in which it is supposedly possible to read the name of Alexander. The apotropaic nature of this inscription is entirely in keeping with the image on the front. vz

BIBLIOGRAPHY: Marshak, 1997, pp. 399–401; Marshak, 2003, pp. 1–41; Zalesskaia, 2003/1, pp. 45–8; Sokrovishcha Priob'ia, 2003; Zalesskaia, 2004/3, pp. 109–12.

134
Bowl with an Empress's Banquet

Byzantium
12th century AD
Diameter 18.5 cm, height 11.7 cm
Silver; gilding, chasing, engraving
Inv. no. ω 3
Acquired in Berezov, Tobolsk Gubernia, 1967
(from a man whose family had moved there from Nizhny
Novgorod)

Around the outside of the bowl are seven rows of convex scales with chased images. The upper row shows a Byzantine empress, two standing servants, seated musicians, dancers and acrobats. The second row shows a pair of sphinxes beneath the empress, while beneath the other first-row figures are pairs of sirens with peacock tails and pairs of sphinxes. These may echo animal supports on thrones of this period.

The third row shows hares, dogs and bears, the fourth birds, the fifth lion masks and heads of youths as well as the foreparts of griffins and dogs, while the sixth and seventh rows comprise palmettes. Relief arches on the foot contain lions, sirens, dogs, hares and birds in pairs. The whole composition is executed against a pointillé ground and reveals the predominantly decorative interests of the craftsman, who shows less interest in the subject matter of the images, making the central figure of the empress herself barely noticeable. The interior floor of the cup shows a mounted St George, his name inscribed in Greek above his head. An inscription in Russian is scratched on the exterior of the base, which refers to monetary or weight units: В ПОЛѢ ЧЕТВѢРЬТА ДЕСАТЕ ГРИВЬНѢ, which may mean that the value of the cup in Ancient Rus was 35 silver *grivna* (*see* Darkevich, 1975, p. 81). In palaeographic terms the Russian inscription is close to the birch-bark writings made in Novgorod in the twelfth century, and may date from the same period. The cup is traditionally considered to be an example of twelfth-century Byzantine toreutics (*see* Bank, 1985, p. 312), although there is also an unsubstantiated theory that it originated in Ancient Rus (*see* Svirin, 1972, pp. 74–7). vz

BIBLIOGRAPHY: Darkevich, 1975, pp. 78–99, 127–31, 144, 147, 159–64, 167–9, 171–3, 175–7, 179–85, 187–90, 193–8, 200–1, 204, 207–17, 225–9, 232–3, 240, 252, 267, 274; Bank, 1978, pp. 52–63, ill. 33; Bank, 1985, p. 312, pl. 213–15; Marshak, 1996, pp. 28, 142, ill. 67; Zalesskaia, 2000, no. B-82; Piatnitskii, 2004, pp. 128–39.

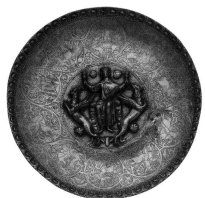

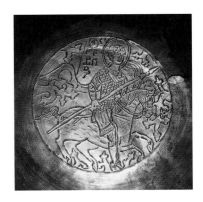

135
Bowl with the Ascension of the Prophet Elijah

Boboshevo, Bulgaria
AD 1593
Diameter 18 cm, height 4.5 cm
Silver; gilding
Inv. no. ω 34
From collection of Alexander Bazilevsky

The medallion in the centre of the bowl shows the prophet Elijah being carried up to heaven by four horses. He is framed by two rows of figured arches containing twelve half-figure portraits of the prophets with unfurled scrolls, and twelve full-length portraits of the Apostles holding codices. A Slavonic inscription runs along the outer rim of the bowl, which proclaims 'This cup was forged in the year 7 thousand 101 [1593] in the month of April day 3 in the village of Boboshevo. Craftsman Petr-dyak, son of Valuzhernich'. The treatment of the images, the composition of the surface and the palaeography of the inscriptions pertaining to the saints and the authorial inscription, suggest that this cup is an example of the work of the craftsmen of Ciprovac in Bulgarian Macedonia. From the sixteenth century, artists who worked here were predominantly southern Slavs, either Bulgarians or Serbs. The works of the Ciprovac artisans were remarkable for the synthesis of late Byzantine and eastern (Turkish) artistic techniques; they are devoid of any clearly expressed style and may be said to be part of the cultural heritage of both Bulgars and Serbs. The development of silverwork in Ciprovac continued until 1688, when the town was completely destroyed by the Turks, and those craftsmen who survived fled to Serbia, Romania and Hungary. Of the sixteen cups from Ciprovac which have survived to this day, no others show the scene of the Ascension of Elijah. In Byzantium, where the depiction of this prophet was not especially common, he was shown either in the desert with a raven or during his ascension to heaven on a chariot of fire, which became a symbolic precursor of Christ's Ascension. As the 'Christian Helios', Elijah in his fiery chariot was also linked with the cult of the sun. vz

BIBLIOGRAPHY: Zalesskaya and Piatnitsky, 1993, pp. 250–65, fig. 383; Zalesskaia, 1996, pp. 145–54.

136
Steatite Icon with St George

Byzantium
13th century AD
Height 6.6 cm, width 7.4 cm
Steatite
Inv. no. ω 347
From collection of Nikolai Romanchenko, 1924

The tondo shows St George in typical military dress. A patterned nimbus encircles the saint's head, while a shield with ornamental edge is visible above his left shoulder; his right hand holds a spear with which he is piercing a dragon writhing beneath the hooves of his horse. The height of the relief and the modelling of the face and body are comparable to small-scale examples of the plastic arts of the early Palaiologan era, and suggest that this icon should be dated to the thirteenth century.

Steatite icons are described in the *ekphraseis* (verses dedicated to works of art) of the Byzantine poet Manuel Philes (*c.* 1275–*c.* 1345) who lived under the Palaiologan dynasty. He even mentions a steatite icon with an image of St George, in which 'the martyr stands armed on a clear stone' (*Poems*, 1:133). In court circles the warrior St George was considered a patron of the Byzantine emperor and his victorious campaigns. The image of the saint armed with a shield, sword or spear was stamped on coins and placed on seals, while his statue adorned the stern of the imperial ship. According to the historian Nikephoros Gregoras (1295–*c.* 1360) the famous artist Paul painted St George on horseback on the wall of the Blachernae Palace in front of the Church of the Theotokos Nikopeia in Constantinople. vz

BIBLIOGRAPHY: Zalesskaia, 2004/1, pp. 38–42, ill. 1.

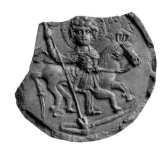

137
Bronze Icon with St Demetrios

Thessalonica
AD 1204–1224
8.6 × 7.9 × 0.65 cm
Bronze
Inv. no. ω 1131
Bought in Constantinople; to Hermitage from collection of Richard Martin

St Demetrios is shown in chainmail with a tunic on top and a billowing cloak thrown over his left shoulder. He holds a spear in his right hand and a round shield is visible behind his left hand, with which he grasps hold of his horse's reins. A Greek inscription engraved in the lower left-hand corner of the icon names him, and his shield bears the Latin letters HIS. These may be an abbreviation of the name 'Ihesus' (Jesus) or of the city 'Iherusalem' (Jerusalem). The horse of St Demetrios is shown against a patterned background covered in foliate flourishes. The saint is not shown threatening the enemy with his spear; rather, he is portrayed during a ceremonial procession, perhaps during *Adventus*. Similar images of saints on horseback on a relief background of palmettes were widespread at the time of the Crusades. This Hermitage icon is the only known example which shows St Demetrios, the patron saint of Thessalonica, with the attributes of a Crusader, which would suggest that it dates to the period of Crusader rule in the city – between 1204 and 1224. It was during this twenty-year period that the Crusader symbol on the shield could have appeared alongside more traditional iconography.

Portable icons of this type with portraits of saints on horseback were often carried by pilgrims. vz

BIBLIOGRAPHY: Zalesskaia, 2001/1, pp. 78–82.

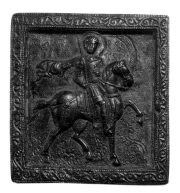

138
Mirror Frame

Eastern Mediterranean
4th century AD
Diameter 7.9 cm, diameter of mirror 3 cm
Lead
Inv. no. ω 746
From RAIK museum, 1931

The central medallion shows the frontal head of a woman; she wears large earrings with radial pendants and two rows of beads around her neck. Six animals are positioned around the medallion: a panther, two griffins and three goats running after each other. This animal frieze is framed by beading, with a smooth wide border between the frieze and the edge of the plate. In the centre of the smooth surface on the opposite side is a circle. This corresponds in size and position to the medallion on the side shown, which analogies from Roman times suggest is the back of a mirror (*see* Kalashnik, 1979, pp. 116–23; Garbsch, 1980, pp. 225–6). Its front (not preserved in the Hermitage example) would have contained a convex glass in the centre with a reflective coating, a round frame and a hole in the middle. This kind of mirror, with its small reflective area (diameter 2–3.5 cm), was used not so much as part of a toilet set as in the practice of the occult and magic (*see* Kisa, 1908, p. 361). In size and decoration the closest analogy to the Hermitage mirror is a fourth- to fifth-century frame from Trebizond, now in the Louvre. VZ

BIBLIOGRAPHY: Zalesskaia, 1986, pp. 137–8, ill. 3; Zalesskaia, 1994/2, pp. 122–3, no. 133.

139
Statuette of Dionysos inscribed with Text from Psalm 28:3

Rome, 2nd–3rd century AD (statuette)
Byzantium, 8th–9th century AD (inscription)
Bronze
Inv. no. До 1864 2/2
Found by chance by River Don, 1867

The bronze statuette of Dionysos is a typical example of small-scale Roman plastic arts of the second to third century. At one time Dionysos's head would have been decorated with a wreath, and his shoulders covered by a cloak, as is indicated by the surviving holes for fastenings on his head and torso. The text of Psalm 28:3 (Psalm 29:3 in the Revised Standard Version), which is engraved on his waist, starting with a small cross, and the stamps containing cross-shaped monograms – two on the chest and one on each thigh – were evidently added at a time when the depiction of this pagan god was adapted for Christian religious purposes. Words from verse three of Psalm 28 form part of the liturgical reading of Kosmas the Melode, bishop of Maiuma, uttered during the consecration of water during the feast of the Epiphany: 'I have heard Your voice, Lord, crying in the wilderness; when You thundered over the mighty waters, bearing witness to Your Son'. Liturgical ewers bearing this text are known, which were used to hold holy water. Ewers originating from excavations in Corinth and Vrap, in Albania, are usually dated to the period of iconoclasm, around the eighth and ninth centuries. The letters visible at the end of the crosses within the two stamps on Dionysos's chest combine to form the traditional entreaty: 'Lord help me'. The name of the person asking for God's help is also given in a monogram, in circles on the thighs of the youth. The letters are hard to distinguish, but the name 'Bartholomew, son of Timothy' may be surmised.

Such inscriptions are also found on votive items that would have been kept in Christian homes or used for personal devotions. The sculpture would not have been used in church because of its typically pagan appearance, and was therefore more likely to have been kept in the house of a believer. It is possible that the statue of Dionysos, reworked in the early Middle Ages, began to serve as a distinctive receptacle for consecrated oil or water: this is suggested by the opening in Dionysos's head, similar to the neck of a jug, and also by the form and average dimensions of glass pilgrim vessels for unction oil and water. If this hypothesis is correct, a glass capsule would have been placed inside the figure through the opening in the head, and the opening would then have been sealed with wax. The image of this ancient god and, in particular, his vine occupied a significant position in early Christian symbolism. VZ

BIBLIOGRAPHY: OAK for 1867 (St Petersburg, 1868), pp. 41–5, pl. 1, 4; Zalesskaia, 1994/1, pp. 142–5, ill. 2.

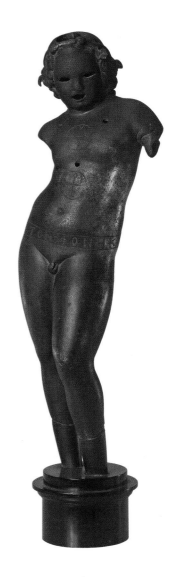

140
Bird and Nestling Figurine

Italy
4th–5th century AD
Height 7.2 cm, length 13.5 cm, width 5.6 cm
Bronze
Inv. no. ω 38
From collection of Alexander Bazilevsky, 1885

This cast figurine shows a bird with a nestling on its back and a pellet in its mouth. The plumage is incised and the eyes are stamped. The significance of such figurines is shown in reliefs in the Roman catacombs, where inscriptions reveal that the image of an adult bird and nestling would accompany the joint grave of a mother and child (*see* Boube-Piecot, 1966, pp. 332–4). Evidently this figurine, a symbol of two souls, was part of a burial inventory. vz

BIBLIOGRAPHY: Bank, 1985, p. 274, pl. 19.

141
Votive Hand with a Cross

Syria
6th century AD
Height 22.8 cm
Bronze
Inv. no. ω 191
From collection of A.P. Kapnist, 1906, who received it from K.N. Lishin, Russian General Consul in Beirut, where he purchased the object

This extended right hand holds a sphere crowned with a cross; the terminals have 'tear-drops' at the corners. The wrist broadens out to form a base with a small pivot at the bottom centre. The hollow sphere is supported between the thumb, index finger and middle finger. At the centre of the cross and at the end of each terminal are incised concentric circles. The cross has a Greek inscription: ὑπὲρ σωτηρ(ίας) (down the vertical) and Γεωργίου (along the horizontal); together they read 'For the salvation of George'. The letter 'ρ' in the words ὑπὲρ and σωτήρ has been engraved over the small incised circles, indicating that the inscription was added by the artist after the object had been completed. The form and proportions of the cross date it to the sixth century, while the structural features of the base make it clear that it is a votive object. This kind of ex-voto object had its prototypes in an earlier age: from the first to third century AD bronze items were made in the form of hands dedicated to various Syrian gods, including Baal of Heliopolis, Jupiter Dolichenus, Sabazios (*see* cat. 39) and the goddess Atargatis (*Age of Spirituality*, 1979, pp. 621–2, no. 557; L. Kötzsche, 'Hand (ikonographisch)', RAC, vol. XIII, col. 402–83; *Byzance*, 1992, p. 120, no. 67; *Byzanz*, 2002, pp. 156–60, nos. 1.55, 1.56). vz

BIBLIOGRAPHY: Zalesskaia, 1967, pp. 84–9; Iskusstvo Vizantii, 1977, vol. 1, no. 70.

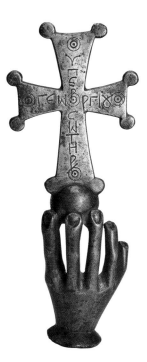

142
Cross with the Archangel Michael and the Apostle Philip

Syro-Palestinian Region
10th century AD
13 × 6.7 cm
Bronze
Inv. no. ω 316
From collection of Nikolai Romanchenko, 1924

The engraved and heavily stylised depictions of the Archangel Michael and Apostle Philip are accompanied by Greek inscriptions of their names. The cross is an example of a widespread kind of reliquary called an *enkolpion* (*see Khristiane na Vostoke*, 1998, nos. 31–46; Zalesskaya, 2005, pp. 72–87, nos. 69–99); they were made from the tenth to twelfth century for pilgrims to the Holy Land, which came back under the control of the Byzantine Empire after the victorious campaigns in the Middle East. vz

BIBLIOGRAPHY: Zalesskaia, 1998, p. 35, ill. 31.

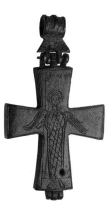

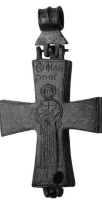

143
Lamp with figures of Marsyas

Egypt
4th–5th century AD
Length 19 cm
Bronze; casting
Inv. no. 13220
Brought by Vladimir Bock from Egypt, 1889

The lamp is in the form of a cylindrical lantern; attached to its openwork sides in three places are figures of Marsyas bound to a tree. The round lid is suspended from three chains, while at the base of the lantern is a candle-holder. According to the myth, Marsyas attained great mastery in the flute and dared to challenge Apollo himself to a musical contest. Apollo not only defeated Marsyas in the competition, but also flayed him alive. Portrayals of Apollo and Marsyas were common in Roman funerary art. The triumph of Apollo over Marsyas demonstrated the victory of the Olympian gods over the old chthonic deities, the titans. Here Coptic artists have chosen the subject to represent the victory of the new over the old, of the cult of the sun and the light of Christianity over old pagan ideas.

The form of the lamp, like a Roman lantern, and the remarkable modelling in relief of Marsyas's body, date this object to the fourth to fifth century AD. oo

BIBLIOGRAPHY: Koptische Kunst, 1963, p. 442, no. 601.

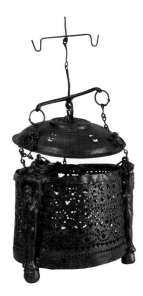

144
Vessel in the form of an Amphora

Egypt
5th century AD
Height 23.5 cm
Bronze; casting, engraving
Inv. no. 10647
Brought by Vladimir Bock from Egypt, 1889

This vessel is an elongated amphora of a traditional Egyptian form. Its handles are in the form of lions, whose claws are attached to the edge of the vessel on both sides. The lid is in the form of an eagle crowned with a cross; there is an animal between its claws, possibly a dolphin. The source of this motif is the ancient Egyptian story of the struggle between Horus and Seth. In their treatment of the subject, however, the Coptic masters have turned to Greco-Roman traditions: unlike the ancient Egyptian compositions, here the image of the eagle dominates. The inclusion of the eagle in a Coptic vessel, as well as the vessel's typically Egyptian form, may partly be explained by its possible place of manufacture: Luxor, a city rich in ancient Egyptian traditions. In ancient Egypt the falcon was the symbolic equivalent of the imperial eagle in Roman apotheoses. By the time of late Egyptian texts in the first centuries AD, however, the falcon came to be replaced by an eagle, and it was the eagle that symbolised the worship of Horus. There is another analogous bronze stopper in the Hermitage collection, which shows an eagle with a creature in its claws, possibly a fish. The head of the bird wears the crown of Upper and Lower Egypt. Some experts see in this subject a symbol of the Eucharist or baptism; for others it symbolises the victory of good over evil. A comparison with early Byzantine motifs and, in particular, the images on capitals and mosaics, suggests that here the subject is a symbol of salvation, where the eagle is fulfilling a protective role, saving the Christian soul from the powers of darkness. This protective image is in keeping with the function of the vessel, which would originally have been used to preserve unction. The use of the amphora as a container for cosmetics was only secondary. oo

BIBLIOGRAPHY: Osharina, 1998, pp. 265–9; Khristiane na Vostoke, 1998, p. 168, no. 231; L'Art copte, 2000, p. 215, fig. 368.

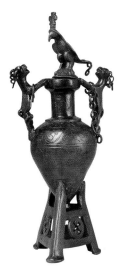

145
Vessel in the form of a Dove

Egypt
5th century AD
Length 18.5 cm
Bronze; casting
Inv. no. 10713
Brought by Vladimir Bock from Egypt, 1889

This vessel in the form of a dove was probably used as a lamp. A storeroom of models for various bronze and clay objects found in Memphis shows that Greek and distinctively Egyptian forms were made in the same workshop. Discoveries of similar lamps in such far-apart places as Italy and Egypt indicate that the process of exporting models was still continuing in the fourth and fifth centuries AD. By the end of the fifth century, however, each region was beginning to produce its own specific type of lamp: in Italy in the form of a bird; in Egypt with decorations in the form of crosses; in Syria with floral motifs. In the fifth and sixth centuries, however, lamps in the form of birds, and particularly the dove, gained a special popularity. Many such lamps are known from antiquity, their widespread popularity due also, in part, to the cult of the goddess Isis and the many sculptured representations of doves connected with her.

The theme of the dove with an olive branch in its beak was taken by Christian art from the Book of Genesis (7:2). A dove was released from Noah's Ark and returned with an olive branch, thus proclaiming peace to the world. Justin Martyr ascribed to the Ark the symbolic significance of the day of Christ's resurrection. Initially the image of the dove and olive branch was closely linked to the theme of the Ark. It was only in the last quarter of the third century that it became an independent subject, representing the symbol of life in Christ; as such the symbolism seems altogether in keeping with the object's function as a lamp, illuminating the way for believers with God's light. The majority of such objects were discovered in Upper Egypt or Nubia, and date from the fourth and fifth centuries; this has led Ross to conclude that they were made in Upper Egypt. Beckwith, however, disagrees: he correctly points out that the various lamps differ significantly in terms of style, size and stand, which in turn suggests that they were made in several different places. oo

BIBLIOGRAPHY: Greko-rimskii i vizantiiskii Egipet, 1939, p. 6, no. 13; Iskusstvo Vizantii, 1977, vol. 1, p. 187, no. 391; Kakovkin, 2004, p. 60, no. 67.

146
Stamp for Communion Bread

Eastern Mediterranean
6th century AD
Diameter 7 cm
Clay
Inv. no. X 368
Found in Chersonesos (circumstances surrounding discovery unknown); to Hermitage, 1914

This stamp has an image of a peacock and a bunch of grapes. It is an example of a common type of object used specially to make an imprint on communion bread (*see* Galavaris, 1970). vz

Previously unpublished

147
One-sided Conical Seal of Hegemonios

Byzantium
4th century AD
Maximum diameter 1.6 cm
Lead
Inv. no. M-5869
From collection of Nikolai P. Likhachev

The seal shows a bust portrait of a man – its owner – in profile. A short beard and moustache are clearly visible; there may be a band on his head. The inscription along the sides reads: HΓEMII ONIOV ('of Hegemonios').

One-sided conical seals were evidently used by a fairly wide circle of people, including emperors. The first known lead seals of emperors whose names were not indicated are thought to date from the first centuries AD (*see* Dembski, 1995).

It is not entirely clear how these conical seals were made. According to Seibt, a small piece of lead was probably heated in a vessel like a small ladle. A thread would then be dropped into the soft metal, and shortly before cooling a stamp, ring or carved stone would be pressed into the blank upper surface of the seal creating an imprint (Seibt, 1978, p. 33). ES

BIBLIOGRAPHY: Likhachev, 1936, pl. LXXXIV, no. 2.

148
One-sided Conical Seal

Byzantium
4th century AD
1.9 × 1.1 cm
Lead
Inv. no. M-11514
From collection of Nikolai P. Likhachev

The seal shows a frontal bust portrait of a man with a long moustache and a short beard: the seal's owner. The circular inscription which runs along either side has only been partially preserved: K.NT.IINIOV. ES

Previously unpublished

149
Imperial Seal

Byzantium
AD 474–491
Overall diameter 2.2 cm, field 1.7 cm
Lead
Inv. no. M-11149
From collection of Nikolai P. Likhachev

The seal, which is covered with a patina, has a frontal bust portrait of the emperor Zenon on the obverse; he is wearing a cloak and a diadem with a plume. An inscription beneath the image reads: D(ominus) N(oster) ZEN(on) ('Our Master Zenon'). The seal's broad rim has a foliate ornament.

The image of the goddess Nike, shown on the reverse holding a wreath interwoven with ribbons in each hand, was treated in a great variety of ways in the first centuries AD, but on the coins and seals of the Byzantine emperors it had a specific meaning: victory. Even in ancient times winged Nike appeared in triumphal scenes of the emperor, crowning the victor with a wreath (*see Age of Spirituality*, 1979, pp. 43–6; nos. 42, 44).

Images of the goddess similar to the one on this seal of Zenon were included on imperial seals from a much earlier time. This is shown by a whole group of molybdobulls (lead seals) which have been dated differently (Laurent, for example, dates them broadly from the fourth to sixth century AD: Laurent, 1962, pp. 3–5, nos. 1–4). In all probability, however, Likhachev is closer to the truth when he dates them to the reigns of Arcadius and Honorius (398–408), a view supported by Sokolova (Likhachev, 1911/1, vol. 1, pp. 501, 502, no. 7; Sokolova, 1991, no. 1).

The Hermitage collection of Byzantine molybdobulls contains three other seals of Zenon, one from the RAIK collection (M-5156, copy (?); published in Likhachev, 1911/1, p. 503. ill. 12) and two from the collection of Nikolai P. Likhachev (inv. nos. M-11150, M-11734). ES

BIBLIOGRAPHY: Likhachev, 1911/1, p. 503, ill. 13; Sokolova, 1991, no. 5.

150
Imperial Seal

Byzantium
AD 491–518
Overall diameter 2.0 cm, field 1.5 cm
Lead
Inv. no. M-12409
Found in Chersonesos; to Hermitage from collection of N.N. Grandmezon

On the obverse is a frontal bust portrait of the emperor Anastasius wearing a cloak with a fibula on his right shoulder and a diadem with pendants; the circular inscription reads: D(ominus) N(oster) AN[asta]SIVS P(er)P(etuus) AVG(ustus) ('Our Master Anastasius Perpetual Augustus').

On the reverse is Nike, the goddess of victory, standing on a sphere, with her head facing to the left and a wreath in each hand. ES

BIBLIOGRAPHY: Zacos and Veglery, 1972, p. 5, no. 1; Sokolova, 1991, p. 204, nos. 1, 6.

151
Imperial Seal

Byzantium
AD 527–565
Diameter 1.7 cm
Lead
Inv. no. M-4830
From RAIK collection

The obverse shows a frontal bust portrait of the emperor Justinian I wearing a helmet and diadem; around his head is a nimbus. To the left of the portrait is part of a circular inscription: [D(ominus) N(oster) IVSTINI] ANUS P(er) P(etuus) [AUG(ustus)].

On the reverse is a full length frontal portrait of Nike, goddess of victory; she stands with a wreath interwoven with ribbons in each hand; on either side are large-scale Latinate crosses.

These crosses represent an important innovation. As well as the goddess of victory, the seals of Justinian I were the first to include the image of the Virgin and Child flanked by similar crosses. It is likely that this transformation – so significant for the whole Christian world – had not yet been finally confirmed. While there are seals of Justinian II (565–78) which still show Nike, later the image of the goddess of victory was dropped altogether from imperial molybdobulls. ES

BIBLIOGRAPHY: Zacos and Veglery, 1972, nos. 3, 5; Sokolova, 1991, no. 11; Likhachev, 1991, plate LXXV, no. 12.

152
Seal: Eagle and Bust of Christ

Byzantium
Second half of 6th to 7th century AD
Diameter 2.1 cm
Lead
Inv. no. M-8161
From collection of Nikolai P. Likhachev (who wrote: 'the molybdobull came via Constantinople, and did not originate in Italy')

On the obverse of the seal, with its foliate rim, is an eagle with raised wings, and between the wings a bust of Christ with a nimbus. On the reverse are the Latin letters D, E, M, and R arranged at the terminals of a small cross, similar to a cruciform monogram (possibly signifying the name Demetrios).

Likhachev was in no doubt that the bust above the eagle represented Christ, despite the absence of a cross nimbus. The image of Christ between the wings of an eagle is extremely rare in Byzantine sphragistics; in fact there is only one other known example with a similar composition (*see* Zacos and Veglery, 1972, no. 2839: seal dated to 550–650, with a Greek cruciform monogram of the name of Abraham on the reverse).

Seals with an eagle are a specifically early Byzantine phenomenon, generally dated to no later than the eighth century (*see* Zacos and Veglery, 1972, nos. 585–730). In this period of Byzantine art the eagle was interpreted in several different ways: it represented both the Resurrection and the Eucharist, it could be seen as a guide for Christian souls, or as an envoy from God, and was frequently associated with Christ himself or with his followers (*see* Maguire, 1991–92, p. 290). The symbolic reading depended on the specific context of each work. In the case of seals, the appearance of the eagle is probably connected with the image of Christ, an interpretation usually underlined by additional elements positioned between the bird's wings: a cross, a star, a monogram (often cruciform, with the name of the owner or the invocator), or in rare instances, as here, a bust of Christ. It was not just the figure of the eagle itself that was symbolically significant, but its wings, which are shown as a semicircle, forming a wreath. In Christian art the wreath symbolised immortality or the triumph over death: it would frame an image of Christ, the Lamb, a cross or a christogram.

An examination of sphragistic material reveals an interesting pattern in the use of the eagle: it appears predominantly either on personal seals, without any indication of the position of the owner, or else on the seals of state functionaries, but not on seals of those connected with the church. This may be explained by the eagle's continuing identification at this time with imperial iconography (*see Age of Spirituality*, 1979, p. 71, no. 61).

By the eighth century, seals with an image of an eagle had practically disappeared. Breckenridge and, later, Zacos and Veglery suggest that the eagle's religious associations began to diminish after the Council of Trullo in Constantinople (692) forbade the use of any symbolic images of Christ. The almost total disappearance of the image of the eagle, however, is usually linked with the beginning of the iconoclastic movement (*see* Zacos and Veglery, 1972, p. 489). ES

BIBLIOGRAPHY: Likhachev, 1991, pl. LXXI, no. 3; Stepanova, 2006, no. 119.

153
Seal of Gennadios: Eagle and Star

Byzantium
Second half of 6th to 7th century AD
Diameter 2.0 cm
Lead
Inv. no. M-7708
From collection of Nikolai P. Likhachev

The obverse shows an eagle with raised wings, between which is a star, while on the reverse is a cruciform Greek monogram representing Γεννα(δ)ίου ('of Gennadios'). ES

BIBLIOGRAPHY: Likhachev, 1936, pl. XC, no. 4.

154
Seal of Georgios: Eagle and Monogram

Byzantium
Second half of 7th century AD
Diameter 2.3 cm
Lead
Inv. no. M-7765
From collection of Nikolai P. Likhachev

Between the raised wings of the eagle on the obverse is a cruciform invocatory monogram indicating the Greek: Θεοτόκε βοήθει ('Mother of God, Help'). The reverse bears a complex Greek monogram.

Likhachev suggested that the monogram should be interpreted as 'to Georgios, apohypatos', but to the right of the principal letter of the monogram (ω) is a partially preserved letter K. For this reason the monogram should be read as: Γεωργίω ἀπὸ ὑπάτων πατρικίω ('to Georgios, apohypatos patrikios'). The inscription enclosed in the monogram on the reverse is a continuation of the invocation on the obverse. ES

BIBLIOGRAPHY: Likhachev, 1936, pl. XC, pl. 12.

155
Tessera: Gryllos

Byzantium
6th century AD (?)
Diameter 2.1 cm
Lead
Inv. no. M-7859
From collection of Nikolai P. Likhachev (acquired in Italy from G. Sambon)

On the obverse of this tessera (or possibly test imprint for a seal) is a gryllos – an eagle whose wings have been replaced by bearded heads in profile. Above the head of the eagle is a blocked monogram in Latin. A blocked monogram on the reverse probably represents the Latin name ANCELMVS (Anselm).

This tessera is the only one in the Hermitage collection with a representation of a gryllos. The tradition of creating composite monsters from parts of wild animals, birds and humans has its roots in ancient times (*see* cat. 50). By the early Byzantine period, however, such images were practically unknown. In fact there is only one known example of a gryllos on a seal, which consists of the heads of a horse, a bearded man and a lion, and the legs of a cockerel (dated to the beginning of the sixth century in Zacos and Veglery, 1972, no. 1374). It is likely that this tessera also dates to no later than the sixth century, although the type of monogram on the reverse is found on Italian coins of the Roman Popes, the Lombardians and the Franks as late as the ninth century. ES

BIBLIOGRAPHY: Likhachev, 1936, pl. LXXXVI, no. 13; Stepanova, 2006, no. 128.

156
Seal of Sabba: Lion

Byzantium
Second half of 6th to 7th century AD
Diameter 1.5 cm
Lead
Inv. no. M-3734
From RAIK collection

On the obverse of this seal with a foliate border is a lion with a crooked raised tail, moving to the right; along the sides of the lion's muzzle are images of the sun and moon. The cruciform Greek monogram on the reverse gives the name Σάββα ('Sabba').

The depiction of a lion strongly reflects the influence of Sasanian art, in which the lion as sun god is often accompanied by solar signs, as symbols of eternity (*see* Borisov and Lukonin, 1963, nos. 306–7, 309, 315, 323, 326–30). ES

Previously unpublished

157
Seal: Saint on Horseback

Byzantium
Second half of 6th to 7th century AD
Diameter 1.5 cm
Lead
Inv. no. M-6780
From collection of Nikolai P. Likhachev (previously in collection of Gustave Schlumberger)

On the obverse a saint on horseback smites a snake with a spear crowned with a cross; to the right of the field is a small cross. On the reverse is the cruciform monogram of a name.

There were two main prototypes for images of warrior saints on horseback in Christian art: the equine portraits of conquering emperors of the Roman era, and images of Solomon – whose cult was widespread in Syria, Palestine and Egypt – striking down sickness in the form of a woman (*see* Grabar, 2000, pp. 62–72; Bank, 1956, pp. 331–8). ES

BIBLIOGRAPHY: Schlumberger, 1884, p. 86, no. 6; Iskusstvo Vizantii, 1977, vol. 1, no. 242.

158
Seal of John: Goddess holding a Cornucopia

Byzantium
Second half of 6th to 7th century AD
Diameter 2.7 cm
Lead
Inv. no. M-8263
From collection of Nikolai P. Likhachev

On the obverse is the bust of a goddess with a cornucopia (horn of plenty), while the reverse bears a cruciform monogram for the name John.

The poor condition of the top part of the obverse makes it hard to discern the precise form of hairstyle and headwear of the goddess, but one hypothesis is that it shows the Tyche of Constantinople. Similar representations of the horn of plenty are found on other items dedicated to this goddess (*see Age of Spirituality*, 1979, nos. 153–5). ES

BIBLIOGRAPHY: Likhachev, 1911/2, pl. v, p. 11, ill. 6; Bank, 1966, no. 117; Iskusstvo Vizantii, 1977, vol. 1, no. 245.

159
Seal of Basilios: Pigmy Fighting a Crane

Byzantium
Second half of 6th to 7th century AD
Diameter 2.3 cm
Lead
Inv. no. M-12079
Acquired in Istanbul from antiquary Osman Nuri Bey

On the obverse a pigmy dressed in a short tunic is threatening a crane with his spear; between them is a small stylised tree. The reverse bears the cruciform monogram representing Βασιλίου χαρτουλαρίου, indicating the seal belonged to a *chartoularios*, or official.

The legend of pigmies fighting against the cranes which have ravaged their fields is well known from the time of Herodotus, and is a scene found on numerous works of ancient art. Christian authors, such as Hieronymus, St Augustine and Isidore of Seville, also made various references to pigmies. By the Middle Ages, however, this scene was rarely depicted in works of art. The seal in the Hermitage collection is one of the earliest of its type. ES

BIBLIOGRAPHY: Kakovkin, 1971, pp. 53–7; Iskusstvo Vizantii, 1977, vol. 1, no. 249.

160
Seal: Riderless Horse and Monogram

Byzantium
Second half of 6th to 7th century AD
Diameter 2.5 cm
Lead
Inv. no. M-3696
From RAIK collection

The obverse shows a horse moving to the left; above is a cruciform monogram of the name Constantine. On the reverse is a bust portrait of the Virgin and Child, with small crosses on each side.

The depiction of a riderless horse is extremely rare in Byzantine art; indeed, it is not even described in the Byzantine *Physiologos*. It is thus extremely difficult to identify any particular symbolism that might have been attached to the image at that time, although generally the horse represented strength, vitality and steadfastness.

This molybdobull is one of a number of seals from the sixth and seventh centuries with horses depicted in this way. They belonged either to private individuals (as is the case here) or to *chartoularioi* (officials). It is possible that the image of a horse on these seals had a purely secular character, simply denoting the place of service of such officials. Guilland suggests that χαρτουλάριοι τού στάβλου ('chartoularioi of the stables') were court officials who served as the means of communication between the emperor and the administration of the imperial stables. They retained this function in later times: from the thirteenth century, the grand *chartoularios* was an official of the highest rank, who led the emperor's horse during ceremonies (*see* Guilland, 1976, pp. 406–7).

It is unclear when the position of the *chartoularios* of the stables first appeared, but the earliest historical references to the office come in sphragistic works. A whole series of eighth- and ninth-century seals give the title of the position in full, and it is possible that sixth- and seventh-century seals such as this one show that the position had already been created by this period. ES

Previously unpublished

161
Seal of Theodore: Lion

Byzantium
10th century AD
Diameter 2.6 cm
Lead
Inv. no. M-7472
From collection of Nikolai P. Likhachev

The obverse shows a Patriarchal cross on three steps, with rosettes on either side of the cross, and part of a circular inscription: + K...ΔΩΡΩVΠΑΤ/ (Κ [ύριε βοήθει Θεό]δωρῳ 'υπάτ(ῳ)) ('Lord, help hypatos Theodore').

On the reverse is a lion with a crooked raised tail, its head turned back; between its fore and rear paws is a stylised plant. There is a partially preserved circular inscription: ΙΩΘΕCCΑΛ/ΝΙΚ/ (ιῳ Θεσσαλ(ο)νικ(ῆς)) ('... of Thessalonica').

The seal belonged to the *hypatos* Theodore, who carried out his responsibilities in Thessalonica. The position of the official has not been preserved, but he may have been a *commerciarius*, or customs officer.

In the tenth century, the image of the lion retained its earlier symbolic meaning – most probably as guardian of the writings of the person who commissioned the seal. ES

Previously unpublished

162
Seal of John: Peacock

Byzantium
10th century AD
Diameter 2.3 cm
Lead
Inv. no. M-5161
From RAIK collection

The obverse has a frontal image of a peacock with tail spread; the bird's head is surrounded by a nimbus and turned to the left. A circular inscription reads: +ΚΕΡΟΗΘΕΙΤΩϹΩΔΥΛ' (Κ(ύρι)ε βοήθει τῷ σῷ δ(ού)λ(ῳ)) ('Lord help Thy servant'). The five-line inscription on the reverse reads:

ΙΩΑΝ
Ν.ΠΑΤΡΙΚ'
Ρ'Α'ϹΠΑΘ/Ϲ
ϹΤΡΑΤΙΓ/ϹΙ
ΚΕΛΙΑϹ

('Ιωάνν(η) πατρικ(ίῳ) β(ασιλικῷ) (πρωτο)σπαθ(αρίῳ) (καὶ) στρατίγ(ῳ) Σικελίας) ('John patrikios imperial protospatharios and strategos of Sicily').

The image of the peacock, a symbol of paradise and resurrection, is not found in early Byzantine sphragistics. By the tenth century, however, it was much in demand, and a whole group of seals with images of this bird of paradise appeared at this time. One possible explanation for this was the increased interest in the peacock that emerged in the second half of the ninth century, during the reign of Basil I, which has even led some scholars to refer to the 'peacock style' (see Reimbold, 1983, pp. 42–3).

This seal may have belonged to John Mouzalon, strategos of Sicily. In order to ensure the payment of tribute to the Arabs, Mouzalon increased taxes and illegal levies, much to the dismay of the people. He was murdered soon after the accession to the throne of Roman I (probably in 920, and no later than 921–2). ES

BIBLIOGRAPHY: Stepanova, 1998, pp. 296, 336; see also Catalogue of Byzantine Seals, 1991, p. 28, no. 5.17

163
Seal of Basilios: Peacock

Byzantium
10th century AD
Diameter 2.5 cm
Lead
Inv. no. M-5713
From collection of Nikolai P. Likhachev

The obverse has a frontal image of a peacock with tail spread; the bird's head is surrounded by a nimbus and turned to the left. A circular inscription reads: + ΚΕΡΟΗΘΕΙ..ϹΩΔΟΥΛ' (Κ(ύρι)ε βοήθει [τῷ] σῷ δού(λ(ῳ))) ('Lord help Thy servant'). The five-line inscription on the reverse reads:

+RACH
ΛΗ'Ρ'ϹΠΑΘ.
Ρ,Κ'Δ'ΣΤΥΡ
ΜΑΡΧ'RΙΚ
ΤΟΡΟΝ

(Βασ(ι)λ(ίῳ) β(ασιλικῳ) σπαθ[α]ρ(ο)κ(αν)δ(ιδάτῳ) (καὶ) τουρμάρχ(η) Βικτορων) ('Basilios imperial spatharokandidatos and tourmarches of the victors').

The two holes show that the seal would have been attached to a document on more than one occasion. The seal is broken in half.

The position of tourmarches (military commander of a tourma, one of the divisions of the army) is mentioned only in the work of Constantine VII Porphyrogennetos (Constantini Porphyrogeniti, 1829, p. 663). Kühn suggests that the title 'tourmarches of the victors' is a traditional one (Kühn, 1991, p. 87, ill. 64). Seals belonging to such commanders are very rare (SBS 8, p. 235, no. 795: second half of 10th century). ES

Previously unpublished

164
Seal: Ascension of the Prophet Elijah

Byzantium
11th century AD
Diameter 1.5 cm
Lead
Inv. no. M-10381
From collection of Nikolai P. Likhachev

The obverse shows the ascension of the Prophet Elijah; in the upper part of the field is a bust portrait of the saint with raised arms, and, below, two rearing horses facing outwards. The inscription on the reverse has not been preserved.

Despite the seal's poorly preserved state, the subject matter and the inscription on the reverse can be re-established with certainty thanks to a seal in the Numismatic Museum of Athens (Konstantopoulos, 1917, no. 604a; Stavrakos, 2000, pp. 74–5, no. 20: dated by the author to the 1060s–70s). The seal belonged to patrikios Simeon Antiokhit. ES

Previously unpublished

BIBLIOGRAPHY

AAA: Acta ad archaeologiam et artium historiam pertinentia

ABC: S. Reinach, *Antiquités du Bosphore Cimmérien*, Paris, 1892

Add.: L. Burn, R. Glynn, *Beazley Addenda, Additional References to ABV, ARV² and Paralipomena*, Oxford, 1982

ARV: J.D. Beazley, *Attic Red-Figure Vase-Painters* (2nd ed.), Oxford, 1963

CIRB: *Corpus inscriptionum regni Bosporani*, Leningrad, 1965

CR, 1859: Compte-rendu de la Commission Impériale archéologique pour l'année 1859

CR, 1865: Compte-rendu de la Commission Impériale archéologique pour l'année 1865

CR, 1875: Compte-rendu de la Commission Impériale archéologique pour l'année 1875

IAK: *Izvestiia imperatorskoi arkheologicheskoi komissii, SPb* (Proceedings of the Imperial Archaeological Commission, St Petersburg)

LIMC: Lexicon Iconographicum Mythologiae Classicae, Zurich–Munich

MAR: *Materialy po arkheologii Rossii* (Materials on the archaeology of Russia)

OAK: *Otchet imperatorskoi arkheologicheskoi komissii, SPb* (Report of the Imperial Archaeological Commission, St Petersburg)

RAC: *Reallexikon für Antike und Christentum*, Stuttgart

RAIK: Russkii arkheologicheskii institut v Konstantinopole, Sofiia (Russian Archaeological Institute in Constantinople, Sofia)

SBS: *Studies in Byzantine Sigillography*, Munich–Leipzig, 2003, vol. 8

AGE OF SPIRITUALITY, 1979: K. Weitzmann (ed.), *Age of Spirituality: Late Antique and Early Christian Art, Third to Seventh Century*, New York, 1979

ALEKSEEV, 2003: A.Iu. Alekseev, *Khronografiia Evropeiskoi Skifii VII–IV vv. do n.e.* [Chronology of European Scythia 7th–4th century BC], State Hermitage Publishing House, St Petersburg, 2003

ALEKSEEVSKAIA, 1915: L.M. Alekseevskaia, 'Lira iz Kerchi' [The lyre from Kerch], *Izvestiia imperatorskoi arkheologicheskoi komissii* [News of the Imperial Archaeological Commission], Petrograd, 1915, issue 58, pp. 140–52

ANATOLIAN CIVILISATIONS, 1983: *The Anatolian Civilisations, Greek, Roman, Byzantine*, ex. cat., Istanbul, 1983

ANTICHNAIA BRONZA, 1973: *Antichnaia khudozhestvennaia bronza* [Ancient artistic bronze], ex. cat., State Hermitage, Leningrad, 1973

ANTICHNOE SEREBRO, 1985: *Antichnoe khudozhestvennoe serebro* [Ancient artistic silver], ex. cat., State Hermitage, Leningrad, 1985

ARNHEIM, 1982: R. Arnheim, *The Power of the Center*, Berkeley, 1982

ARSINOIA ILI KLEOPATRA, 2002: A.O. Bol'shakov, O.Ia. Neverov, Iu.L. Diukov, *Arsinoia ili Kleopatra?* [Arsinoe or Cleopatra?], ex. cat., St Petersburg, 2002

ART OF LATE ROME, 1994: A. Gonosova and C. Kondoleon, *Art of Late Rome and Byzantium in the Virginia Museum of Fine Arts*, Richmond, 1994

ARTAMONOV, 1966: M.I. Artamonov, *Sokrovishcha skifskikh kurganov v sobranii Gosudarstvennogo Ermitazha* [Treasures of the Scythian Barrows in the collection of the State Hermitage], Prague–Leningrad, 1966

ARTAMONOV, 1969: M.I. Artamonov, *Treasures from Scythian Tombs in the Hermitage Museum, Leningrad* (introduction by T. Talbot Rice), London, 1969

ARTE Y OLIMPISMO, 1999: *Arte y Olimpismo*, ex. cat., Palma, 1999

ASHIK, 1848: A.B. Ashik, *Bosporskoe tsarstvo* [Bosporan Kingdom], vol. 2, Odessa, 1848

ATIYA, 1968: A.I. Atiya, *A History of Eastern Christianity*, London, 1968

AUS DEN SCHATZKAMMERN EURASIENS, 1993: *Aus den Schatzkammern Eurasiens. Meisterwerke antiker Kunst*, ex. cat., Kunsthaus Zürich, January–May 1993

Russian Transliteration

The Library of Congress (LC) system is used for Russian publications in the bibliography (both at the end of each catalogue entry and in the general bibliography) to facilitate access to works in the original Russian.

In the catalogue bibliographies, a shortened form is given for each publication (usually author or exhibition title, date of publication, page or picture reference), while the full entry can be found in the main bibliography – in the case of Russian publications, first transliterated, then translated.

For publications in Russian, the names of Russian authors are transliterated according to the LC system. Foreign-language publications may use a different spelling for the same author; these differences are reflected in the bibliography. Thus, for example, Zalesskaia (corresponding to the LC system) is used for publications in Russian, while Zalesskaya is used if that spelling has appeared in a foreign-language publication (similarly e.g. Marshak/Marschak; Gaidukevich/Gajdukevič).

AVERINTSEV, 1976: S.S. Averintsev, 'Sud'by evropeiskoi kul'turnoi traditsii v epokhu perekhoda ot antichnosti k srednevekov'iu' [The fate of the European cultural tradition in the period of transition from antiquity to the Middle Ages], *Iz istorii kul'tury Srednikh vekov i Vozrozhdeniia* [From the cultural history of the Middle Ages and Renaissance], Moscow, 1976

AVERINTSEV, 2004: S.S. Averintsev, *Poetika vizantiiskoi literatury* [Poetics of Byzantine literature], St Petersburg, 2004

BALLIAN AND DRANDAKI, 2003: A. Ballian and A. Drandaki, 'A Middle Byzantine Silver Treasure', Benaki Museum, Athens, 2003, no. 3, pp. 47–80

BALLINT, 1977: C. Ballint, review of V.P. Darkevich (1976), *Acta Orientalia Hungarica*, 1977, no. 31, pp. 271–7

BALTY, 1979: J. Balty and C. Junius Brutus, 'Stoïcisme et révolte dans la fin de la République', *Bulletin de la classe des Beaux-Arts* (5th series), Brussels, 1970, no. 61, p. 12

BANK, 1956: A.V. Bank, 'Gemma s izobrazheniem Solomona' [Gem with depiction of Solomon], *Vizantiiskii vremennik* [Byzantine chronicle], Moscow, 1956, no. 8, pp. 331–8

BANK, 1966: A.V. Bank, *Vizantiiskoe iskusstvo v sobraniiakh Sovetskogo Soiuza* [Byzantine art in the collections of the Soviet Union], Moscow-Leningrad, 1966

BANK, 1978: A.V. Bank, *Prikladnoe iskusstvo Vizantii IX–XII vv. Ocherki* [Applied art of Byzantium 9th–12th century: essays], Moscow, 1978

BANK, 1985: A. Bank, *Byzantine Art in the Collections of Soviet Museums*, Leningrad, 1985

BARATTE, 1985: F. Baratte 'Héros et chasseurs: la tenture d'Artemis de la Fondation Abegg à Riggisberg', *Monuments et Mémoires*, Paris, 1985, no. 67, pp. 31–76

BARTMAN, 1999: E. Bartman, *Portraits of Livia: Imaging the Imperial Woman in Augustan Rome*, Cambridge, 1999

BASSETT, 2004: S.G. Bassett, *The Urban Image of Late Antique Constantinople*, Cambridge, 2004

BEARD, 1985: Mary Beard, 'Reflections on "Reflections on the Greek Revolution"', *Archaeological Review from Cambridge*, 4:2, 1985, pp. 207–13

BECKWITH, 1962: J. Beckwith, *The Veroli Casket*, London, 1962

BERGMANN, 1999: M. Bergmann, *Chiragan, Aphrodisias, Konstantinopel: zur mythologischen Skulptur der Spätantike*, Wiesbaden, 1999

BERNOULLI, 1894: J.J. Bernoulli, *Römische Ikonographie*, Stuttgart, 1894, vol. II/3

BILIMOVICH, 1973: Z.A. Bilimovich, *Atticheskie zerkala v Severnom Prichernomor'e. Pamiatniki antichnogo prikladnogo iskusstva* [Attic mirrors in the northern Black Sea coastal region: ancient applied art], Leningrad, 1973

BILIMOVICH, 1976: Z.A. Bilimovich, 'Grecheskie bronzovye zerkala ermitazhnogo sobraniia' [Greek bronze mirrors from the Hermitage collection], *Trudy Gosudarstvennogo Ermitazha* [Materials of the State Hermitage], Leningrad, 1976, vol. 17

BOARDMAN, 1968: J. Boardman, *Archaic Greek Gems*, London, 1968

BOARDMAN, 1970: J. Boardman, *Greek Gems and Finger Rings*, London, 1970

BOARDMAN, 1993/1: John Boardman, *The Diffusion of Classical Art in Antiquity*, Princeton, 1993

BOARDMAN, 1993/2: J. Boardman (ed.), *The Oxford History of Classical Art*, Oxford, 1993

BOARDMAN, 1993/3: J. Boardman, *Classical Art in Eastern Translation: A Lecture Delivered at The Ashmolean Museum, Oxford, on 27th May, 1993*, Oxford, 1993

BOARDMAN, 1996: J. Boardman, *Greek Art*, London, 1996

BOARDMAN, 2000: J. Boardman, *Athenian Red-Figure Vases: The Classical Period*, London, 2000

BOHAČ, 1958: Jifii M. Bohač, *Kerčske vazy*, Prague, 1958

BOCK, 1897: V.G. Bock, 'O koptskom iskusstve: koptskie uzorchatye tkani' [On Coptic art: Coptic patterned textiles], *Trudy VIII Arkheologicheskogo s'ezda v Moskve v 1890* [Materials of the VIII Archaeological conference in Moscow in 1890], vol. 3, Moscow, 1897, pp. 229–30

BORBEIN, 2002: A.N. Borbein, 'Klassische Kunst', in *Die griechische Klassik Idee*, ex. cat., 2002, pp. 9–25

BORISOV AND LUKONIN, 1963: A.Ia. Borisov and V.G. Lukonin, *Sasanidskie gemmy* [Sasanian gems], Leningrad, 1963

BOUBE-PIECOT, 1966: C. Boube-Piecot, 'Bronzes coptes du Maroc', *Bulletin d'archéologie marocaine*, Rabat, 1966, no. 6, pp. 332–4

BOYD AND MUNDELL MANGO, 1992: Susan A. Boyd and Marlia Mundell Mango (eds.), *Ecclesiastical Silver Plate in Sixth-Century Byzantium*, Washington, DC, 1992

BRABICH, 1987: V.M. Brabich, 'Unikal'nyi zolotoi Konstantiia II i svidetel'stvo Ammiana Martselina' [Unique gold coin of Constantius II and testament of Ammian Martselin], *Numismatika v Ermitazhe* [Numismatics in the Hermitage], Leningrad, 1987, pp. 24–6

BRABICH, 1994: V. Brabich, entries on medallions of Constantine I and Constantius II, *The State Hermitage. Masterpieces from the Museum's Collections* (gen. ed. Vitaly Suslov), vol. 1, London, 1994, p. 563

BRANDENBURG, 1968: H. Brandenburg, 'Bellerophon christianus', *Römische Quartalschrift*, Rome, 1968, no. 63,5, pp. 49–85

BRASHINSKII, 1979: I.B. Brashinskii, *V poiskakh skifskikh sokrovishch* [In search of Scythian treasures], Leningrad, 1973

BROUSKARI, 1985: M. Brouskari, *The Paul and Alexandra Canellopoulos Museum: a Guide*, Athens, 1985

BROWN, 1991: P. Brown, *The World of Late Antiquity: AD 150–750*, London, 1991

BROWN, 1992: P. Brown, *Power and Persuasion in Late Antiquity: Towards a Christian Empire*, Madison, WI, 1992

BROWN, 1996: P.F. Brown, *Venice and Antiquity: The Venetian Sense of the Past*, New Haven, London, 1996

BRUNS, 1948: G. Bruns, 'Staatskameen des 4. Jahrhunderts nach Christi Geburt' (Winckelmannsprogramm, 104), *Der Archäologischen Gesellschaft zu Berlin*, Berlin, 1948, pp. 5–40

BRUNS, 1953: G. Bruns, 'Der grosse Kameo von Frankreich', *Mitteilungen des Deutschen Archäologischen Instituts*, 1953, vol. 6, p. 93 ff.

BUCKTON, 1994: D. Buckton (ed.), *Byzantium: Treasures of Byzantine Art and Culture from British Collections*, London, 1994

BUCKTON, 1998: D. Buckton, 'The Gold Icon of St. Demetrios', in J. Ehlers and D. Kötzsche (eds.), *Der Welfenschatz und sein Umkreis*, Mainz, 1998, pp. 277–86

BULL, 2005: Malcolm Bull, *The Mirror of the Gods: Classical Mythology in Renaissance Art*, London, 2005

BYZANCE, 1992: *Byzance: L'art byzantin dans les collections publiques françaises*, Paris, 1992

BYZANTINISCHE MOSAIKEN, 1986: *Byzantinische Mosaiken aus Jordanien*, ex. cat., Vienna, 1986

BYZANTIUM AT PRINCETON, 1986: *Byzantium at Princeton: Byzantine Art and Archaeology at Princeton University*, ex. cat., Princeton, 1986

BYZANTIUM, 1988: *Byzantium: The Light in the Age of Darkness*, ex. cat., Ariadne Galleries, New York, 2 November 1988–31 January 1989

BYZANZ, 2002: *Byzanz. Das Licht aus dem Osten. Kult und Alltag im Byzantinischen Reich vom 4. bis 15. Jahrhundert*, ex. cat., Erzbischöfliches Diözesanmuseum, Paderborn, Mainz, 2002

CAHN, 1984: H.A. Cahn, A. Kaufmann-Heinimann et al., 'Der spätrömische Silberschatz von Kaiseraugst', *Baseler Beiträge zur Ur- und Frühgeschichte*, no. 9, Derendingen, 1984

CAMERON, 1991: A. Cameron, *Christianity and the Rhetoric of Empire: the Development of Christian Discourse*, Berkeley, CA, 1991

CATALOGUE OF BYZANTINE SEALS, 1991: *Catalogue of Byzantine Seals at Dumbarton Oaks and in the Fogg Museum of Art*, vol. 1 (Italy, North of the Balkans, North of the Black Sea; eds. J. Nesbitt and N. Oikonomides), Washington, DC, 1991

CATALOGUS VETERIS, 1768: *Catalogus veteris aevi varii generis monumentorum quae Cimelarchio Lyde Browne apud Wimbeldon asservantur*, 1768, no. 50

CHATZIDAKIS, 1994: N. Chatzidakis, 'Saint George on Horseback "in Parade": a Fifteenth-Century Icon in the Benaki Museum', *Thymiama*, Athens, vol. I, 1994, pp. 61–2

CLAIRMONT, 1966: C.W. Clairmont, 'Die Bildnisse des Antinous. Ein Beitrag zur Porträtplastik unter Kaiser Hadrian', *Bibliotheka Helvetica Romana*, vol. 6, Swiss Institute, Rome, 1966

CLAIRMONT-GANNEAU, 1889: C. Clairmont-Ganneau, *Archaeological Research in Palestine during the years 1873–74*, London, 1889

CLARK, 1956: K. Clark, *The Nude: A Study in Ideal Form*, New York, 1956

COHEN, 2000: B. Cohen (ed.), *Not the Classical Ideal: Athens and the Construction of the Other in Greek Art*, Leiden, Boston, Cologne, 2000

COOKE, 1927: J.D. Cooke, 'Euhemerism: a mediaeval interpretation of classical Paganism', *Speculum*, 1927, vol. 2, pp. 396–410

CORMACK, 2000: R. Cormack, *Byzantine Art*, Oxford, 2000

CUMONT, 1942/1: F. Cumont, *La stèle du danseur d'Antibes et son décor végétal. Etude sur le symbolisme funéraire des plantes*, Paris, 1942

CUMONT, 1942/2: F. Cumont, *Recherches sur le symbolisme funéraire des Romains*, Paris, 1942

CUTLER, 1968: A. Cutler, 'The De Signis of Nicetas Choniates. A Reappraisal', *American Journal of Archaeology*, 1968, no. 72, pp. 113–18

CUTLER, 1984–85: A. Cutler, 'On Byzantine boxes', *Journal of the Walters Art Gallery*, 1984–85, nos. 42–3, pp. 32–47

CUTLER, 1994: A. Cutler, *The Hand of the Master: craftsmanship, ivory and society in Byzantium (9th–11th centuries)*, Princeton, 1994

DALLAWAY, 1800: J. Dallaway, *Anecdotes of the Arts in England*, London, 1800

DALTON, 1901: O.M. Dalton, *Catalogue of early Christian antiquities and objects from the Christian East in the Department of British and mediaeval antiquities and ethnography of the British Museum*, London, 1901

DALTON, 1964: O. M. Dalton, *The Treasure of the Oxus, With Other Examples of Early Oriental Metal-Work*, London, 1964

DANIÉLOU, 1961: J. Daniélou, *Les symboles chrétiens primitifs*, Paris, 1961

DARKEVICH, 1975: V.P. Darkevich, *Svetskoe iskusstvo Vizantii. Proizvedeniia vizantiiskogo khudozhestvennogo remesla v Vostochnoi Evrope 10–13 veka* [Secular art of Byzantium: works of Byzantine artistic craftsmanship in Eastern Europe 10th–13th century], Moscow, 1975

DARKEVICH, 1976: V.P. Darkevich, *Khudozhestvennyi Metall Vostoka VIII–XIII vv.* [Artistic metalwork of the East, 8th–13th century], Moscow, 1976

DEÉR, 1952: J. Deér, *Der Kaiserornat Friedrich II*, Bern, 1952

DELBRÜCK, 1933: R. Delbrück, *Spätantike Kaiserporträts von Constantin Magnus bis zum Ende des Westreiches*, Berlin, 1933

DEMBSKI, 1995: G. Dembski, 'Die Römischen Bleiplomben aus Österreich', *Studies in Byzantine Sigillography*, Washington, DC, 1995, no. 4, pp. 81–96

DEMUS, 1955: O. Demus, 'A Renascence of Early Christian Art in thirteenth-century Venice', in K. Weitzmann (ed.), *Late Classical and Medieval Studies in Honor of A.M. Friend*, Princeton, 1955, pp. 348–60

DEMUS, 1995: O. Demus, *Le Sculture Esterne di San Marco*, Venice, 1995

DENWOOD, 1973: P. Denwood, 'A Greek Bowl from Tibet', *Iran*, 1973, no. 11, pp. 121–7

DIE GRIECHISCHE KLASSIK, 2002: *Die griechische Klassik. Idee oder Wirklichkeit*, ex. cat., Mainz, 2002

DODD, 1961: E.C. Dodd, 'Byzantine Silver Stamps' (with an excursus on the *comes sacrarum largitionum* by J.P.C. Kent), *Dumbarton Oaks Studies*, Washington, DC, no. 7, 1961

DODD, 1973: Erika Cruickshank Dodd, *Byzantine Silver Treasures*, Bern, 1973

DREXEL, 1930: F. Drexel, 'Die Familie der Valentiniane', *Germania: Korrespondenzblatt der Romisch-Germanischen Komission*, 1930, no. 14, pp. 38–9

EARTHLY BEAUTY, 1999: *Earthly Beauty, Heavenly Art: Art of Islam*, ex. cat., Amsterdam, 1999

EAST CHRISTIAN ART, 1987: *East Christian Art: a 12th anniversary exhibition*, ex. cat. (comp. and ed. Y. Petsopoulos), London, 1987

EFFENBERGER ET AL., 1978: Arne Effenberger, Boris Marschak, Vera Zalesskaja and Irina Zaseckaja, *Spätantike und frühbyzantinische Silbergefässe aus der Staatlichen Eremitage Leningrad*, Berlin, 1978

ELSNER, 1998: J. Elsner, *Imperial Rome and Christian Triumph*, Oxford, 1998

ELSNER, 2000: J. Elsner, 'From the Culture of Spolia to the Cult of Relics: The Arch of Constantine and the Genesis of Late Antique Forms', *Papers of the British School at Rome*, 2000, no. 68, pp. 149–84

ELSNER, 2003: J. Elsner, 'Visualising Women in Late Antique Rome: the Project Casket', *Through a Glass Brightly: Festschrift for David Buckton* (ed. C. Entwistle), Oxford, 2003

ENCICLOPEDIA, 1961: *Enciclopedia dell'arte antica*, Rome, 1961

ENGEMANN, 1978: J. Engemann, in RAC, vol. 2, 1978

ETTINGHAUSEN, 1972: R. Ettinghausen, *From Byzantium to Sasanian Iran and the Islamic World*, Leiden, 1972

EVERS, 1994: C. Evers, 'Les portraits d'Hadrien: typologie et ateliers', *Collection des Mémoires de la Classe des Beaux-Arts*, Brussels, 1994, no. 7

FRÜHBYZANTINISCHE SILBERGEFÄSSE, 1979: *Spätantike und Frühbyzantinische Silbergefässe aus der Staatlichen Eremitage*, Leningrad–Berlin, 1979

FURTWÄNGLER, 1900: A. Furtwängler, *Die Antiken Gemmen. Geschichte der Steinschneidekunst im Klassischen Altertum*, Berlin, vol. 3, 1900

GAIDUKEVICH, 1949: V.F. Gaidukevich, *Bosporskoe tsarstvo* [Bosporan Kingdom], Leningrad, 1949

GAJDUKEVIČ, 1971: V.F. Gajdukevič, *Das Bosporanische Reich*, Berlin, 1971

GALAVARIS, 1970: G. Galavaris, *Bread and the Liturgy: The Symbolism of Early Christian and Byzantine Bread Stamps*, Madison, Milwaukee and London, 1970

GALAVARIS, 1989: G. Galavaris, 'Alexander the Great, Conqueror and Captive of Death: his various images in Byzantine Art', *Canadian Art Review*, Toronto, 1989, no. 16, no. 1, pp. 12–18

GARBSCH, 1980: J. Garbsch, 'Ein römischer Dosenspiegel', *Bayerische Vorgeschichtsblätter*, Munich, 1980, pp. 225–6

GNECCHI, 1912: F. Gnecchi, *I medaglioni Romani*, Milan, 1912, vol. 1

GOLDSCHMIDT AND WEITZMANN, 1930: A. Goldschmidt and K. Weitzmann, *Die byzantinischen Elfenbeinskulpturen des X–XIII Jahrhunderts*, Berlin, 1930, vol 1: *Die Kästen*

GOMBRICH, 1960: E. Gombrich, *Art and Illusion: A Study in the Psychology of Pictorial Representation*, Oxford, 1960

GOMBRICH, 1995: E. Gombrich, *The Story of Art* (16th edition), Oxford, 1995

GORBUNOVA, 1971: K.S. Gorbunova, *Serebrianye kiliki iz Semibratnikh kurganov. Kul'tura i iskusstvo antichnogo mira* [Silver kylikes from the Seven Brothers Barrows: culture and art of the ancient world], Leningrad, 1971

GOULYAEVA, 2000: N. Goulyaeva, 'The Collection of Roman Bronzes in the Hermitage Museum', *Kölner Jahrbuch*, 2000, no. 33

GRABAR, 1972: A. Grabar, 'Le tiers monde de l'Antiquité à l'école de l'art classique et son rôle dans la formation de l'art du Moyen Age', *Revue de l'art*, Paris, 1972, no. 18, pp. 1–59

GRABAR, 2000: A. Grabar, *Imperator v vizantiiskom iskusstve* [The Emperor in Byzantine art], Moscow, 2000

GRACH, 1984: N.L. Grach, 'Kruglodonnye serebrianye sosudy iz kurgana Kul'-Oba (k voprosu o masterskikh) [Round-bottomed silver vessels from Kul-Oba Barrow (concerning the workshops)], *Trudy Gosudarstvennogo Ermitazha* [Materials of the State Hermitage], Leningrad, 1984, vol. 24

GREEK GOLD, 1994: D. Williams and J. Ogden (eds.), *Greek Gold*, ex. cat., London, 1994

GREEK GOLD, 2004: *Greek Gold*, ex. cat., Amsterdam, 2004

GREEK TREASURES, 2004: *The Hermitage Museum of St. Petersburg: The Greek Treasures*, ex. cat., Athens, 2004

GREKO-RIMSKII I VIZANTIISKII EGIPET, 1939: *Gosudarstvennyi Ermitazh: greko-rimskii i vizantiiskii Egipet. Putevoditel' po vystavke* [State Hermitage: Greco-Roman and Byzantine Egypt. Exhibition guide], Leningrad, 1939

GUALANDI, 1962: G. Gualandi, 'Le ceramiche del Pittore di Kleophon rinvenute a spine', *Arte Antica e moderna*, 1962, no. 19, pp. 227–60

GUILLAND, 1976: R. Guilland, 'Chartulaire et grand chartulaire: Titres et fonctions de l'Empire Byzantin', *Variorum Reprints*, London, 1976, vol. 18

GULIAEVA, 2002: N.P. Guliaeva, 'Bronzovye ukrasheniia frakiiskikh kolesnits' [Bronze decorations from Thracian chariots], *Thrace and Aegean. Eighth International Congress of Thraceology. Sofia-Yambol, 25–29 September 2000*, Sofia, 2002

GURULEVA, 1991: V.V. Guruleva, 'Vizantiiskaia numismatika v Ermitazhe' [Byzantine numismatics in the Hermitage], *Vizantinovedenie v Ermitazhe* [Byzantine study in the Hermitage], Leningrad, 1991, pp. 92–9

HAMANN-MACLEAN, 1949/50: R. Hamann-MacLean, 'Antikenstudium in der Kunst des Mittelalters', *Marburger Jahrbuch für Kunstwissenschaft*, 1949/50, Marburg, vol. 15

HAMBYE, 1957: E. R. Hambye, *Early Christianity in India*, London, 1957

HANFMANN, 1980: George M.A. Hanfmann, 'The Continuity of Classical Art: Culture, Myth and Faith', in K. Weitzmann (ed.), *Age of Spirituality: A Symposium*, New York, 1980, pp. 75–99

HANNESTAD, 1994: N. Hannestad, *Tradition in Late Antique Sculpture: Conservation, Modernization, Production*, Aarhus, 1994

HANSON, 1999: J. Hanson, 'Erotic imagery on Byzantine ivory caskets', in L. James (ed.), *Desire and Denial in Byzantium*, Aldershot, 1999, pp. 173–84

HENIG, 1983: M. Henig (ed.), *A Handbook of Roman Art: A Survey of the Visual Arts of the Roman World*, London, 1983

HÖLSCHER, 2004: T. Hölscher, *The Language of Images in Roman Art* (trans. A. Snodgrass and A. Künzl-Snodgrass, foreword J. Elsner), Cambridge, 2004

HUNTER-STIEBEL, 2000: Penelope Hunter-Stiebel (ed.), *Stroganoff: The Palace and Collections of a Russian Noble Family*, New York, 2000

HUSKINSON, 1974: J. Huskinson, 'Some Pagan Mythological Figures and Their Significance in Early Christian Art', *Papers of the British School at Rome*, 1974, no. 42, pp. 76–91

INAN AND ALFÖLDI-ROSENBAUM, 1979: J. Inan and E. Alföldi-Rosenbaum, *Römische und frühbyzantinische Porträtplastik aus der Türkei*, Mainz am Rhein, 1979

ISKUSSTVO VIZANTII, 1977: *Iskusstvo Vizantii* [Art of Byzantium], ex. cat., Moscow, 1977, vols 1–3

ISLAMIC ART, 1995: *Islamic Art Treasures from the Collections of the Hermitage*, ex. cat., Turku, 1995

ISLAMIC MASTERPIECES, 1990: *Masterpieces of Islamic Art in the Hermitage Museum*, ex. cat., Kuwait, 1990

ISLER-KERÉNYI, 1971: C. Isler-Kerényi, 'Ein Spätwerk des Berliners', *Antike Kunst*, 1971, no. 14

JACOFF, 1993: M. Jacoff, *The Horses of San Marco and the Quadriga of the Lord*, Princeton, 1993

JOHANSEN, 1978: F. Johansen, 'Antike portaetter af Kleopatra VII og Marcus Antonius', *Meddelelser fra Ny Carlsberg Glyptotek*, Copenhagen, 1978

KAEMPF-DIMITRIADOU, 1979: S. Kaempf-Dimitriadou, 'Zeus und Ganymed auf einer Pelike des Hermonax', *Antike Kunst*, 1979, no. 22

KAHLER, 1950: H. Kahler, *Hadrien und seine Villa bei Tivoli*, Berlin, 1950

KAISER AUGUSTUS, 1988: *Kaiser Augustus und die verlorene Republik*, ex. cat., Martin-Gropius-Bau, Mainz, 1988

KAKOVKIN, 1971: A.Ia. Kakovkin, 'Vizantiiskii molivdovul s antichnym siuzhetom' [Byzantine molybdobull with an ancient subject], *Palestinskii sbornik* [Palestinian collection], Moscow–Leningrad, 1971, no. 23, pp. 53–7

KAKOVKIN, 1978: A.Ia. Kakovkin, *Koptskie tkani iz fondov Ermitazha* [Coptic textiles from the Hermitage reserves], ex. cat., Leningrad, 1978

KAKOVKIN, 1981: A.Ia. Kakovkin, 'Koptskaia tkan' s izobrazheniem Ganimeda' [Coptic textile with the image of Ganimede], *Vestnik drevnei istorii* [Bulletin of Ancient History], Moscow, 1981, no.1

KAKOVKIN, 1994: A.Ia. Kakovkin, 'O dvukh koptskikh tkaniakh s izobrazheniem dvenadtsati podvigov Gerakla' [On two Coptic textiles with the depiction of the 12 labours of Herakles], *Vizantiia i Blizhnii Vostok* [Byzantium and the Near East – collection of academic works], St Petersburg, 1994

KAKOVKIN, 2001: A.Ia. Kakovkin, 'Geroi tragedii Evripida na koptskikh tkaniakh' [Heroes of the tragedies of Euripedes on Coptic textiles], *Vestnik drevnei istorii* [Bulletin of Ancient History], Moscow, 2001, no. 3, pp. 128–32

KAKOVKIN, 2004: A.Ia. Kakovkin, *Sokrovishcha koptskoi kollektsii Gosudarstvennogo Ermitazha* [Treasures of the Coptic collection of the State Hermitage], ex. cat., St Petersburg, 2004

KALASHNIK, 1979: Iu.P. Kalashnik, 'Svintsovye ramki stekliannykh zerkal v sobranii Ermitazha' [Lead frames of glass mirrors in the collection of the Hermitage], *Iz istorii Severnogo Prichernomor'ia v antichnuiu epokhu* [From the history of the northern Black Sea coastal region in antiquity], Leningrad, 1979, pp. 116–23

KALASHNIK, 2004: Iu.P. Kalashnik, 'Dva ozherel'ia iz Khersonesa (ob ellinisticheskikh traditsiiakh v rimskom iuvelirnom iskusstve)' [Two necklaces from Chersonesos (on the Hellenistic traditions in Roman jewellery art)], *Ellinisticheskie shtudii v Ermitazhe* [Hellenistic studies in the Hermitage], St Petersburg, 2004

KALAVREZOU, 2003: I. Kalavrezou (with contributions by A. Laiou), *Byzantine Women and their World*, Cambridge, MA, New Haven and London, 2003

KALAVREZOU-MAXEINER, 1985: I. Kalavrezou-Maxeiner, 'The Cup of San Marco and the "Classical" in Byzantium', in K. Bierbrauer, P.K. Klein and W. Sauerländer (eds.), *Studien zur mittelalterlichen Kunst 800–1250*, Munich, 1985, pp. 167–74

KASCHNITZ VON WEINBERG, 1961: G. Kaschnitz von Weinberg, *Das Schöpferische in der römischen Kunst*, Munich, 1961

KASTER, 1988: R. Kaster, *Guardians of Language: The Grammarian and Society in Late Antiquity*, Berkeley, CA, 1988

KAZHDAN, 1991: A. P. Kazhdan (ed.), *The Oxford Dictionary of Byzantium*, New York, 1991

KEMP, 1984: Martin Kemp, 'Seeing and Signs: E.H. Gombrich in Retrospect', *Art History*, 1984, no. 7, pp. 228–43

KENT AND PAINTER, 1977: J.P.C. Kent and K.S. Painter (eds.), *Wealth of the Roman World: Gold and Silver AD 300–700*, London, 1977

KHRISTIANE NA VOSTOKE, 1998: *Khristiane na Vostoke. Iskusstvo mel'kitov i inoslavnykh khristian. IV–XX vv.* [Christians in the East: Art of the Melkites and non-Orthodox Christians, 4th–20th century], ex. cat., St Petersburg, 1998

KHUDOZHESTVENNOE REMESLO, 1980: *Khudozhestvennoe remeslo epokhi rimskoi imperii (I v. do n.e.–IV v.)* [Artistic craftsmanship of the period of the Roman Empire (1st century BC–4th century AD)], ex. cat., State Hermitage, Leningrad, 1980

KIILERICH, 1993: B. Kiilerich, *Late Fourth-Century Classicism in the Plastic Arts: Studies in the So-Called Theodosian Renaissance*, Odense, 1993

KISA, 1908: A. Kisa, *Das Glas im Altertum*, Leipzig, 1908

KITZINGER, 1981: E. Kitzinger, 'The Hellenistic Heritage in Byzantine Art Reconsidered', *XVI Internationaler Byzantinistenkongress, Akten 1/2*, Vienna, 1981, pp. 658–75

KITZINGER, 1995: E. Kitzinger, *Byzantine Art in the Making*, Cambrige, MA, 1995

KOBYLINA, 1976: M.M. Kobylina, *Divinités orientales sur le littoral Nord de la Mer Noire*, Leiden, 1976

KOEHLER, 1853: H. Koehler, *Gesammelte Schriften*, St Petersburg, 1853, vol. 6, p. 6

KÖHLER MS [1813]: H.K.E. Köhler, *Catalog reznym kamniam Mallia* [Catalogue of Mallia's carved stones], State Hermitage archive, f. 1, op. 6 'c', ed. khr. 18

KON, 1998: I.S. Kon, *Lunnyi svet na zare. Liki i maski odnopoloi liubvi* [Moonlight at dawn: Faces and masks of homosexual love], Moscow, 1998

KONSTANTOPOULOS, 1917: K.M. Konstantopoulos, *Byzantiaka molyvdoboulla tou en Athenais Ethnikou Nomismatikou Mouseiou*, Athens 1917

KOPTISCHE KUNST, 1963: *Koptische Kunst: Christentum am Nil*, ex. cat., Villa Hugel, Essen (3 May to 15 August 1963), Essen, 1963

KOROL'KOVA, 2003: E.F. Korol'kova, 'Ritual'nye chashi s zoomorfnym dekorom v kul'ture rannikh kochevnikov' [Ritual cups with zoomorphic decoration in the culture of early nomads], *Arkheologicheskii sbornik* [Archaeological collection], St Petersburg, 2003, issue 36

KÜHN, 1991: H.-J. Kühn, *Die byzantinische Armee im 10. und 11. Jahrhundert*, Vienna, 1991

KUL'TURA I ISKUSSTVO PRICHERNOMOR'IA, 1983: *Kul'tura i iskusstvo Prichernomor'ia v antichnuiu epokhu. Vystavka iz sobranii Bolgarii, Rumynii i Sovetskogo soiuza* [Culture and art from the northern Black Sea coastal region in antiquity: exhibition from collections in Bulgaria, Romania and the Soviet Union], ex. cat., Moscow, 1983

KUNINA, 1997: N.Z. Kunina, *Ancient Glass in the Hermitage Collection*, St Petersburg, 1997

KYBALOVA, 1967: L. Kybalova, *L'art des bords du Nil. Les tissues coptes*, Prague, 1967

L'ART COPTE, 2000: *L'Art copte en Egypte: 2000 ans de christianisme*, Paris, 2000

L'ARTE ALBANESE, 1985: *L'arte albanese nei secoli*, ex. cat., Museo Nazionale Preistorico Etnografico 'Luigi Pigorini', Rome (February–April 1985), Rome, 1985

LA CHASSE, 1980: 'La chasse au Moyen Age', *Actes du colloque de Nice (22–24 juin, 1979): Publications de la faculté des lettres et des sciences humaines de Nice*, Nice, 1980, no. 20

LAUR-BELART, 1967: R. Laur-Belart, *Der spätrömische Silberschatz von Kaiseraugust, Aargau*, ex. cat., Basel, 1967

LAURENT, 1962: V. Laurent, *Les sceaux byzantins du Médaillier Vatican*, Vatican City, 1962

LEADER-NEWBY, 2004: R. Leader-Newby, *Silver and Society in Late Antiquity: Functions and Meanings of Silver Plate in the Fourth to Seventh Centuries*, Aldershot, 2004

LEBEDEV, 1992: G.S. Lebedev, *Istoriia otechestvennoi arkheologii. 1700–1917 gg.* [History of Russian archaeology 1700–1917], St Petersburg, 1992

LEMERLE, 1971: P. Lemerle, *Le prémier humanisme byzantin*, Paris, 1971

LENZEN, 1960: V.F. Lenzen, 'The Triumph of Dionysos on Textiles of the Late Antique Egypt', *University of California Publications in Classical Archaeology*, Berkeley, CA, 1960, vol. 5, no. 1

LEPAGE, 1971: C. Lepage, 'Les braslets de luxe romains et byzantins du III-e au IV-e siecles', *Cahiers archéologiques: Fin de l'Antiquité et Moyen Age*, 1971

LESCENKO, 1976: B.I. Lescenko, 'Ispol'zovanie vostochnogo serebra na Urale' [Use of eastern silver in the Urals], in Darkevich (1976), pp. 176–88

LIAPUNOVA, 1940: K.S. Liapunova, 'Izobrazhenie Dionisa na koptskikh tkaniakh vizantiiskogo Egipta' [Depiction of Dionysos on Coptic textiles of Byzantine Egypt], *Trudy Otdela Vostoka Gosudarstvennogo Ermitazha* [Materials of the Oriental Department of the State Hermitage], Leningrad, 1940, vol. 3, pp. 149–59

LIEBESCHUETZ, 1996: W. Liebeschuetz, 'The Use of Pagan Mythology in the Christian Empire with Particular Reference to the Dionysiaca of Nonnos', in P. Allen and E.M. Jeffreys (eds.), *The Sixth Century – End or Beginning? Byzantina Australiensa*, Brisbane, 1996, no. 10, pp. 75–91

LIEFDE, 2003 *Liefde uit de Hermitage*, Amsterdam, Zwolle, 2003

LIKHACHEV, 1911/1: N.P. Likhachev, 'Nekotorye stareishie tipy pechatei vizantiiskikh imperatorov' [Some ancient types of seals of Byzantine emperors], *Numizmaticheskii sbornik* [Numismatic collection], Moscow, 1911, vol. 1, pp. 497–539

LIKHACHEV, 1911/2: N.P. Likhachev, *Istoricheskoe znachenie italo-grecheskoi ikonopisi. Izobrazhenie Bogomateri v proizvedeniiakh italo-grecheskikh ikonopistsev i ikh vliianie na kompozitsii nekotorykh proslavlennykh russkikh ikon* [Historical significance of Italo-Greek icon-painting: the depiction of the Mother of God in works of Italo-Greek icon-painters and their influence on the composition of some famous Russian icons], St Petersburg, 1911

LIKHACHEV, 1936: N.P. Likhachev, 'O vizantiiskikh pechatiakh' [On Byzantine seals (MS)], St Petersburg branch of Russian Academy of Sciences, 1936, f. 246, op. 1, d. 157–9

LIKHACHEV, 1991: N.P. Likhachev, *Molivdovuly grecheskogo Vostoka* [Molybdobulls of the Greek East, compiled with commentaries by V.S. Shandrovskaia], Moscow, 1991

LIKHACHEVA, 1962: V.D. Likhacheva, 'Khaltsedonovyi biust Iuliana Otstupnika' [Chalcedony bust of Julian the Apostate], *Soobshcheniia Gosudarstvennogo Ermitazha* [Reports of State Hermitage], Leningrad, 1962, vol. 22, pp. 18–21

LORDKIPANIDZE, 1969: M.D. Lordkipanidze, *Korpus pamiatnikov gliptiki drevnei Gruzii* [Collection of works of glyptic art from ancient Georgia], Tbilisi, 1969, vol. 1

L'VOVA, 1998: Z.A. L'vova, 'Nabor predmetov vooruzheniia i snariazheniia znatnogo voina iz Pereshchepinskogo kompleksa' [Set of items from the arms and equipment of a noble warrior from the Pereshchepina complex], *Arkheologicheskii sbornik* [Archaeological collection], St Petersburg, 1998, no. 33

MAGUIRE, 1991–92: H. Maguire, 'An Early Christian Marble Relief at Kavala', in *Deltion tes Christianikes Archaiologikes Etaireias*, 1991–92, no. 16, pp. 283–95

MAKSIMOVA, 1926: M.I. Maksimova, *Antichnye reznye kamni Ermitazha. Putevoditel' po vystavke* [Ancient carved stones of the Hermitage: Guide to the collection], Leningrad, 1926

MAKSIMOVA, 1979: M.I. Maksimova, *Artiukhovskii kurgan* [Artiukhovskii Barrow], Leningrad, 1979

MANGO, 1963: C. Mango, 'Antique Statuary and the Byzantine Beholder', *Dumbarton Oaks Papers*, Washington, DC, 1963, vol. 17, pp. 55–64

MANTSEVICH, 1987: A.P. Mantsevich, *Kurgan Solokha* [Solokha Barrow], Leningrad, 1987

MARSCHAK, 1986: B.I. Marschak, *Silberschätze des Orients: Metallkunst des 3–13 Jahrhunderts und ihre Kontinuität*, Leipzig, 1986

MARSHAK, 1971: B.I. Marshak, *Sogdiiskoe serebro. Ocherki po vostochnoi torevtike* [Sogdian silver: essays on Eastern toreutics], Moscow, 1971

MARSHAK, 1978: B.I. Marshak, 'Ranneislamskie bronzovye bliuda (siro-palestinskaia i iranskaia traditsii v iskusstve khalifata)' [Early Islamic Bronze dishes (Syro-Palestinian and Iranian traditions in the art of the khalifate)], *Trudy Gosudarstvennogo Ermitazha* [Materials of the State Hermitage], Leningrad, 1978, vol. 19, pp. 29–30, 41–2, 46–8

MARSHAK, 1996: B.I. Marshak, in B. Marshak and M. Kramorovskii (eds.), *Sokrovishcha Priob'ia* [Treasures of the Ob region], ex. cat., St Petersburg, 1996, pp. 6–44 (introductory article)

MARSHAK, 1997: B.I. Marshak, 'Plate with the Ascension of Alexander the Great', *The Glory of Byzantium: Art and Culture of the Middle Byzantine Era A.D. 843–1261*, ex. cat., The Metropolitan Museum of Art, New York, 1997, pp. 399–401

MARSHAK, 2000: Boris Marshak, 'Late-Antique Silver', in Hunter-Stiebel (2000), pp. 101–3

MARSHAK, 2003: B.I. Marshak, 'Serebrianoe bliudo so stsenoi poleta Aleksandra Makedonskogo' [Silver dish with the scene of the flight of Alexander of Macedon], *Vizantinorossika*, St Petersburg, 2003, no. 2, pp. 1–41

MASTERPIECES OF BYZANTINE ART, 1958: *Masterpieces of Byzantine Art*, ex. cat., Edinburgh and London, 1958

MAT'E AND LIAPUNOVA, 1951: M.E. Mat'e, K.S. Liapunova, *Khudozhestvennye tkani koptskogo Egipta* [Artistic textiles of Coptic Egypt], Moscow–Leningrad, 1951

MATSULEVICH, 1926: L.A. Matsulevich, *Serebrianaia chasha iz Kerchi* [Silver cup from Kerch], Leningrad, 1926

MATSULEVICH, 1929: L.A. Matsulevich, *Vizantiia i epokha velikogo pereseleniia narodov. Kratkii putevoditel'* [Byzantium and the time of the great migration of peoples: a short guide], Leningrad, 1929

MATZULEWITSCH, 1929: L.A. Matzulewitsch, *Byzantinische Antike: Studien auf Grund der Silbergefässe der Eremitage*, Berlin and Leipzig, 1929

MEMORIAL'NOST', 2005: *Memorial'nost'. Drevnost'. Iskusstvo ispolneniia: novye postupleniia v Muzei Moskovskogo Kremlia* [Memoriality, antiquity and the art of fulfilment: new acquisitions of the Museums of the Moscow Kremlin], ex. cat., Moscow, 2005

MEYERS, 1992: P. Meyers, 'Elemental Compositions of the Sion Teasure and Other Byzantine Silver Objects', in Boyd and Mundell Mango (1992), pp. 169–89

MOLTESEN, 2000: M. Moltesen, 'The Esquiline Group: Aphrodisian Statues in the Ny Carlsberg Glyptotek', *Antike Plastik*, 2000, no. 27, pp. 111–31

MOULE, 1940: A.C. Moule, *Nestorians in China*, London, 1940

MUNDELL MANGO, 1986: M. Mundell Mango, *Silver from Early Byzantium: The Kaper Koraon and Related Treasures*, Baltimore, 1986

MUNDELL MANGO, 1992: M. Mundell Mango, 'The Purpose and Places of Byzantine Silver Stamping', in Boyd and Mundell Mango (1992), pp. 203–16

MUNDELL MANGO, 1995: M. Mundell Mango, 'Silver Plate Among the Romans and Among the Barbarians', in F. Vallet and M. Kazanski (eds.), *La noblesse romaine et les chefs barbares du IIIe au VIIe siècle*, Paris, 1995

MUNDELL MANGO, 1998: M. Mundell Mango, 'The Archaeological Context of Finds of Silver in and Beyond the Eastern Empire' in N. Cambi and E. Marin, *Acta XIII Congressus internationalis archaeologiae christianae*, Vatican and Split, 1998, pp. 218–26

MUNDELL MANGO, [forthcoming]: M. Mundell Mango, 'From "Glittering Sideboard" to Table: Silver in the Well-Appointed Triclinium', in L. Brubaker (ed.), *Eat, Drink and Be Merry* (forthcoming)

MUNDELL MANGO AND BENNETT, 1994: M. Mundell Mango and A. Bennett, *The Sevso Treasure: Part I* (Art Historical Description and Inscriptions, Methods of Manufacture and Scientific Analyses), Journal of Roman Archaeology supplementary series no. 12, part 1, Ann Arbor, 1994

MUZY I MASKI, 2005: *Muzy i maski* [Muses and masks], ex. cat., State Hermitage, St Petersburg, 2005

NAKHOV, 1976: I.M. Nakhov, 'Kinizm Diona Khrisostoma' [The Cynicism of Dio Chrysostom], *Voprosy klassicheskoi filologii* [Questions of classical philology], Moscow, 1976, issue 6, pp. 61–3

NAU, 1966: E. Nau, 'Meisterwerke staufischer Glyptik: Beiträge zur staufischen Renaissance', *Schweizerische Rundschau*, 1966, vol. 45, pp. 145–69

NEUMANN MS [1811]: F. de Paula Neumann, *Remarques sur les pierres gravées*, Vienna, 1811

NEVEROV, 1971: O.Ia. Neverov, *Antichnye kamei v sobranii Gosudarstvennogo Ermitazha* [Ancient cameos in the collection of the State Hermitage], Leningrad, 1971

NEVEROV, 1976: O.Ia. Neverov, *Antichnye intalii* [Ancient intaglios], Leningrad, 1976

NEVEROV, 1978: O.Ia. Neverov, *Antichnye perstni* [Ancient rings], ex. cat., Leningrad, 1978

NEVEROV, 1981: O.Ia. Neverov, *Kul'tura i iskusstvo antichnogo mira. Ocherk-putevoditel'* [Culture and art of the ancient world: essay-guide], Leningrad, 1981

NEVEROV, 1982: O.Ia. Neverov, 'Neron-Iupiter i Neron-Gelios. Gosudarstvennyi Ermitazh' [Nero-Jupiter and Nero-Helios: the State Hermitage], *Khudozhestvennye izdeliia antichnykh masterov* [Artefacts of ancient craftsmen – collected essays], Leningrad, 1982

NEVEROV, 1988: O.Ia. Neverov, *Antichnye kamei* [Ancient cameos], ex. cat., Leningrad, 1988

NIKA, 1935: 'Nika' *Dictionnaire d'archéologie chrétienne et de liturgie*, vol.12/1, Paris, 1935, col. 1269–1272

NIKETAS CHONIATES, 1984: Niketas Choniates, *Historia* (English trans. H. Magoulias, *O City of Byzantium, the Annals of Niketas Choniates*, Detroit, 1984)

NOONAN, 1980: T.S. Noonan, 'When and How Dirhams First Reach Russia: A Numismatic Critique of the Pirenne Theory', *Cahiers du monde russe et soviétique*, 1980, no. 21, pp. 401–89

NUBER, 1972: H.U. Nuber, 'Kanne und Griffschale', *Bericht der Römisch-Germanischen Kommission 1972*, vol. 53, pp. 7–232

ONAIKO, 1970: N.A. Onaiko, 'Antichnyi import v Pridneprov'e i Pobuzh'e v IV–II vv. do n.e.' [Ancient import into the Dniepr and Bug regions from 4th to 2nd century BC], *Svod arkheologicheskikh istochnikov* [Collection of archaeological sources], D. 1–27, Moscow, 1970

OPIS, 1788: 'Opis' bronzovykh i mramornykh statui, khraniashchikhsia v Sele Tsarskom' [Inventory of bronze and marble statues kept in Tsarskoe Selo], 1788, TSGIA [Central State Historical Archive], f. 487, op. 21, d. 178, l. 10 obl.

ORBELI AND TREVER, 1935: I.A. Orbeli and K.V. Trever, *Sasanidskii metall* [Sasanian metalwork], Leningrad, 1935

OSHARINA, 1997: O. Osharina, 'Die Geschichte der Koptischen Sammlungen der Eremitage', *Kemet – das Schwarze Land*, Ägypten, vol. 6, no. 2, April 1997, p. 45

OSHARINA, 1998: O.V. Osharina, 'Motiv orla v koptskom iskusstve. Nekotorye nabliudeniia nad pamiatnikami iz sobraniia Ermitazha' [Motif of the eagle in Coptic art: some observations on works from the Hermitage collection], *Antichnaia drevnost' i Srednie veka* [Antiquity and the Middle Ages], Ekaterinburg, 1998, pp. 265–9

OSHARINA, 2003: O.V. Osharina, 'O gruppe koptskikh stel s izobrazheniem orla' [On a group of Coptic stelae with the depiction of an eagle], *Vlast', politika, pravo v antichnosti i srednevekov'e* [Power, politics and law in antiquity and the Middle Ages], Barnaul, 2003, pp. 139–51

OSHARINA, 2004: O.V. Osharina, 'Koptskaia tkan' "Triumf Dionisa" IV veka: vozmozhnaia interpretatsiia' [Coptic textile 'Triumph of Dionysos' of 4th century: possible interpretation], *Kul'turnoe nasledie Egipta i Khristianskii Vostok* [Cultural Heritage of Egypt and the Christian East], Moscow, 2004, issue 2

PAINTER, 1977: K.S. Painter, *The Mildenhall Treasure: Roman Silver from East Anglia*, London 1977

PANOFSKY, 1960: E. Panofsky, *Idea. Ein Beitrag zur Begriffsgeschichte der älteren Kunsttheorie*, Berlin, 1960

PARLASCA, 1983: K. Parlasca, 'Ein späthellenistisches Steinschälchen aus Ägypten im Paul Getty Museum', *The Paul Getty Museum Journal*, Los Angeles, 1983, no. 11, pp. 147–52

PEREDOL'SKAIA, 1945: A.A. Peredol'skaia, 'Vasy Ksenofanta' [Vases of Xenophantos], *Trudy Otdela antichnogo mira* [Materials of the department of the ancient world], State Hermitage, Leningrad, 1945, vol. 1

PEREDOL'SKAIA, 1967: A.A. Peredol'skaia, *Krasnofigurnye atticheskie vazy v Ermitazhe* [Red-figure Attic vases in the Hermitage], Leningrad, 1967

PERRY, 2005: E. Perry, *The Aesthetics of Emulation in the Visual Arts of Ancient Rome*, Cambridge, 2005

PFISTERER-HAAS, 2002: S. Pfisterer-Haas, *Jahrbuch des Archäologischen Instituts*, 2002, no. 117, p. 20, ill. 21

PHILIPPAKI, 1967: B. Philippaki, *The Attic Stamnos*, Oxford, 1967

PIATNITSKII, 2004: Iu.A. Piatnitskii, 'K istorii postupleniia v Ermitazh serebrianoi chashi XII veka' [Towards a history of the silver 12th-century cup entering the Hermitage collection], *Vizantiia v kontekste mirovoi istorii* [Byzantium in the context of world history], St Petersburg, 2004, pp. 128–39

PIOTROVSKII, 2001: M.B. Piotrovskii, *O musul'manskom iskusstve* [On Muslim art], St Petersburg, 2001

PIOTROVSKY ET AL., 1986: B. Piotrovsky, L. Galanina, N. Grach, *Scythian Art: The Legacy of the Scythian World mid-7th to 3rd century BC*, Leningrad, 1986

POLLIT, 1972: J.J. Pollit, *Art and Experience in Classical Greece*, Cambridge, 1972

POSTNIKOVA-LOSEVA ET AL., 1985: M. Postnikova-Loseva, N. Platonova, B. Ulianova, G. Smorodinova, *The Historical Museum, Moscow*, Leningrad, 1985

POULSEN, 1962: V. Poulsen, *Les portraits romains*, Copenhagen, 1962

PRIDIK, 1930: E.M. Pridik, 'Neizdannyi zolotoi medal'on Konstantina Velikogo v Gosudarstvennom Ermitazhe' [Unpublished gold medallion of Constantine the Great in the State Hermitage], *Doklady Akademii Nauk SSSR* [Reports of the USSR Academy of Sciences], 1930, pp. 11–17

PROZOROVSKII, 1894: D. Prozorovskii, 'O reznykh kamniakh' [On carved stones], *Svod svedenii, otnosiashchikhsia do tekhniki i istorii medal'ernogo iskusstva* [Collection of information relating to the technique and history of medal art], St Petersburg, 1894, app. II, pp. 154–77

PRUSHEVSKAIA, 1979: E. Prushevskaia, 'Khudozhestvennaia obrabotka metalla (torevtika)' [Artistic working of metal (toreutics)], *Antichnye goroda Severnogo Prichernomor'ia* [Ancient towns of the northern Black Sea coastal region], Moscow–Leningrad, 1979, vol. 1

RAEVSKII, 1978: D.S. Raevskii, '"Skifskoe" i "grecheskoe" v siuzhetnykh izobrazheniiakh na skifskikh drevnostiakh (k probleme antropomorfizatsii skifskogo panteona)' ['Scythian' and 'Greek' in the subject illustrations on Scythian antiquities (the problem of the anthropomorphisation of the Scythian pantheon)], *Antichnost' i antichnye traditsii v kul'ture i iskusstve* [Antiquity and ancient traditions in culture and art], Moscow, 1978

RAEVSKII, 1980: D.S. Raevskii, 'Ellinskie bogi v Skifii? (k semanticheskoi kharakteristike greko-skifskogo iskusstva)' [Hellenic gods in Scythia? (towards semantic characteristics of Greco-Scythian art)], *Vestnik drevnei istorii* [Bulletin of Ancient History], Moscow, 1980, no. 1, pp. 105–7

RAEVSKIJ, 1981: 'Antropomorphe Motive in der Kunst Skythiens', *Das Altertum*, 1981, issue 1, vol. 27, pp. 19–28

RAHNER, 1957: G. Rahner, *Griechische Mythen in christlichen Deutungen*, Zürich, 1957

REIMBOLD, 1983: E.T. Reimbold, *Der Pfau: Mythologie und Symbolik*, Munich, 1983

REINACH, 1892: S. Reinach, *Antiquités du Bosphore*, St Petersburg, 1892

RENNER-VOLBACH, 1981: D. Renner-Volbach, 'Spätantike figürliche Purpurwirkeren', *Documenta Textilia: Festschrift S. Müller-Christensen*, Munich, 1981

ROBERTSON, 1968: M. Robertson, *A History of Greek Art*, Cambridge, 1968

ROLLE ET AL., 1998: R. Rolle, V.Yu. Murzun, A.Yu. Alekseev, 'Königskurgan Čertomlyk. Ein skythischer Grabhügel des 4. Vorchristlichen Jahrhunderts', *Tielbände*, vols 1–3, Mainz, 1998

ROSTOWZEW, 1931: M. Rostowzew, *Skythien und der Bosporus*, Berlin, 1931, vol. 1

ROUECHÉ AND ERIM, 1982: C. Roueché and K. Erim, 'Sculptors from Aphrodisias: Some New Inscriptions', *Papers of the British School at Rome*, 1982, no. 50, pp. 102–15

RUSIAEVA, 2004: M.V. Rusiaeva, 'Stseny okhoty na chashe iz kurgana Solokha' [Hunting scenes on the cup from Solokha Barrow], *Bosporskie chteniia, V: Bospor Kimmeriiskii i varvarskii mir v period antichnosti i Srednevekov'ia. Etnicheskie protsessy* [Bosporan lectures, v: Cimmerian Bosporus and the barbarian world in the period of antiquity and the Middle Ages; ethnic processes], Kerch, 2004

RUSU, 1983–84: M. Rusu, 'Paleocristnismul nord-dunărean sietnogeneza Românilor', *Cluj-Napoca*, 1983–84, no. 25, pp. 35–84

RUTCHOWSCAYA, 1990: M.-H. Rutchowscaya, *Nissus coptes*, Paris, 1990

RUXER AND KUBCZAK, 1972: M.S. Ruxer and J. Kubczak, *Naszynik grecki w Okresach hellenistycznym i Rzymskim*, Warsaw–Poznan, 1972

SANKT-PETERBURG I ANTICHNOST', 1993: *Sankt-Peterburg i antichnost'* [St Petersburg and antiquity], ex. cat., Marble Palace, St Petersburg, 1993

SAVERKINA, 1997: I. Saverkina, *Zwei Gesichter der Eremitage*, Bonn, 1997

SCHEFOLD, 1930: K.V. Schefold, *Kertscher Vasen*, Berlin, 1930

SCHEFOLD, 1934: K. Schefold, 'Untersuchungen der Kertshcher Vasen', *Archäologische Mitteilungen aus Russischen Sammlungen*, Berlin–Leipzig, 1934

SCHINDLER, 1985: W. Schindler, *Römische Kaiser: Herrscherbild und Imperium*, Leipzig, 1985

SCHLUMBERGER, 1884: G. Schlumberger, *Sigillographie de l'empire byzantin*, Paris, 1884

SCHWEITZER, 1948: B. Schweitzer, *Die Bildniskunst der Römischen Republik*, Leipzig–Weimar, 1948

SEIBT, 1978: W. Seibt, *Die byzantinischen Bleisiegel in Österreich*, Vienna, 1978, part 1

SEMENOV-ZUSER, 1947: S.A. Semenov-Zuser, *Skifskaia problema v otechestvennoi nauke. 1692–1947* [Scythian question in national study, 1692–1947], Kharkov, 1947

SEZNEC, 1940: J. Seznec, *La survivance des dieux antiques*, London, 1940

SHEFTON, 1969–70: B.B. Shefton, 'The Greek Museum, University of Newcastle upon Tyne', *Archaeological Reports for 1969–70*, no. 9, pp. 57–8

SHELTON, 1981: K. Shelton, *The Esquiline Treasure*, London 1981

SHILOV, 1968: V.P. Shilov, 'Pozdnesarmatskoe pogrebenie u s. Staritsa' [Late Sarmatian burial by the village of Staritsa], *Antichnaia istoriia i kul'tura Sredizemnomor'ia i Prichernomor'ia* [Ancient history and culture of Mediterranean and Black Sea area], 1968

SIMON, 1964: E. Simon, 'Nonnos und das Elfenbeinkästchen aus Veroli', *Jahrbuch des Deutschen Archäologischen Instituts 79*, 1964, pp. 279–336

SIMON, 1986: E. Simon, *Augustus: Kunst und Leben in Rom um die Zeitwende*, Munich, 1986

SKRZHINSKAIA, 1999: M.V. Skrzhinskaia, 'Afinskii master Ksenofant' [Athenian painter Xenophantos], *Vestnik drevnei istorii* [Bulletin of Ancient History], Moscow, 1999, no. 3, pp. 121–30

SKRZHINSKAIA, 2002: M.V. Skrzhinskaia, 'Illiustratsii literaturnykh proizvedenii na atticheskikh vazakh iz raskopok Bospora' [Illustrations of literary works on Attic vases from excavations of the Bosporus], *Rossiiskaia arkheologiia* [Russian archaeology], 2002, issue 1

SMITH, 1985: R.R.R. Smith, 'Roman Portraits: Honours, Empresses, and Late Emperors', *Journal of Roman Studies*, 1985, vol. 75, pp. 208–21

SMITH, 1999: R.R.R. Smith, 'Late Antique Portraits in a Public Context: Honorific Statuary at Aphrodisias in Caria, A.D. 300–600', *Journal of Roman Studies*, 1999, vol. 89, pp. 155–89

SMITH, 2001: Jennifer Nimmo Smith, *A Christian's Guide to Greek Culture: The Pseudo-Nonnus Commentaries on Sermons 4, 5, 39 and 43 by Gregory of Nazianzus*, Liverpool, 2001

SOKOLOV, 1999: G.I. Sokolov, *Iskusstvo Bosporskogo tsarstva* [Art of the Bosporan kingdom], Moscow, 1999

SOKOLOVA, 1991: I.V. Sokolova, 'Vizantiiskie pechati vi– pervoi poloviny ix vv. iz Khersonesa' [Byzantine seals from 6th to first half of 9th century from Chersonesos], *Vizantiiskii vremennik* [Byzantine Chronicle], Moscow, 1991, no. 52, pp. 201–13

SOKROVISHCHA PRIOB'IA, 2003: *Sokrovishcha Priob'ia. Zapadnaia Sibir' na torgovykh putiakh Srednevekov'ia* [Treasures of the Ob region: Western Siberia on the trade routes of the Middle Ages], ex. cat., Salekhard– St Petersburg, 2003

SPÄTANTIKE UND FRÜHES CHRISTENTUM, 1984: *Spätantike und frühes Christentum*, ex. cat., Städtische Gallerie Liebighaus, Museum Alter Plastik, Frankfurt, 1984

STÄHLER AND NIESWANDT, 1991–92: K. Stähler, H.-H. Nieswandt, 'Der skythische Goryt aus dem Melitopol-Kurgan', *Boreas: Münstersche Beiträge zur Archäologie*, 1991–92, nos. 14–15

STANSBURY-O'DONNELL, 1999: M.D. Stansbury-O'Donnell, *Pictoral Narrative in Ancient Greek Art*, Cambridge, 1999

STAVRAKOS, 2000: C. Stavrakos, *Die byzantinischen Bleisiegel mit Familiennamen aus der Sammlung des Numismatischen Museums Athen*, Wiesbaden, 2000

STEPANOVA, 1998: E.V. Stepanova, 'Pechati Sitsilii viii–xi vv. iz sobraniia Ermitazha' [Sicilian seals of 8th to 11th century from the Hermitage collection], *Antichnaia drevnost' i Srednie veka* [Antiquity and the Middle Ages], Ekaterinburg, 1998, pp. 290–9

STEPANOVA, 2006: E.V. Stepanova, *Pechati s latinskimi i greko-latinskimi nadpisiami VI–VIII vv. iz sobraniia Ermitazha* [Seals with Latin and Greco-Latin inscriptions of 6th to 8th century from Hermitage collection] (forthcoming)

STEPHANI, 1883: L. Stephani, 'Erklärung einiger Kunstwerke der Kaiserlichen Eremitage', *Compte-rendu de la Commission Impériale Archéologique pour l'année 1881* (supplement), St Petersburg, 1883, pp. 5–138

STEWART, 2004: Andrew Stewart, *Attalos, Athens, and the Acropolis: The Pergamene 'Little Barbarians' and their Roman and Renaissance Legacy*, Cambridge, 2004

STICHEL, 1982: R.H.W. Stichel, *Die römische Kaiserstatue am Ausgang der Antike: Untersuchungen zum plastischen Kaiserporträt seit Valentinian I (364–375 v.Chr.)*, Rome, 1982

STRONG, 1966: D.E. Strong, *Greek and Roman Gold and Silver Plates: A Methuen Handbook of Archaeology*, London, 1966

SVIRIN, 1972: A.N. Svirin, *Iuvelirnoe iskusstvo Drevnei Rusi 11–17 vekov* [Jewellery art of Ancient Rus' 11th–17th century], Moscow, 1972

SWINDLER, 1929: M. Swindler, *Ancient Painting*, New Haven, 1929

THE GLORY OF BYZANTIUM, 1997: H.C. Evans and W.D. Wixom (eds.), *The Glory of Byzantium: Art and Culture of the Middle Byzantine Era, AD 843–1261*, ex. cat., New York, 1997

THOMAS, 2000: Thelma Thomas, *Late Antique Egyptian Funerary Sculpture: Images for this World and the Next*, Princeton, 2000

TIVERIOS, 1997: M. Tiverios, 'Die von Xenophantos Athenaios signierte grosse Lekythos aus Pantikapaion: Alte Funde neu betrachtet', *Athenian Potters and Painters: Conference Proceedings*, Oxford, 1997, pp. 269–84

TORP, 1969: H. Torp, 'Leda Cristiana: The Problem of the Interpretation of Coptic Sculpture with Mythological Motifs', in AAA, 1969, vol. 4, pp. 101–12

TREADGOLD, 1984: Warren Treadgold, 'The Macedonian Renaissance', in W. Treadgold (ed.), *Renaissances Before the Renaissance: Cultural Revivals of Late Antiquity and the Middle Ages*, Stanford, 1984, pp. 75–98

TREISTER, 2004: M.Yu. Treister, 'Polychrome Necklaces from the Late Hellenistic Period', *Ancient Civilizations from Scythia to Siberia*, 2004, vol. 10, pp. 199–257

TREVER, 1940: K.V. Trever, *Pamiatniki greko-baktriiskogo iskusstva* [Works of Greco-Bactrian art], Moscow–Leningrad, 1940

TREVER, 1959: K.V. Trever, *Ocherki po istorii i kul'ture Kavkazskoi Albanii* [Essays on the history and culture of Caucasian Albania], Moscow–Leningrad, 1959

TREVER, 1969: K.V. Trever, 'Bliudo s nereidoi' [Dish with nereid], *Sokrovishcha Ermitazha* [Treasures of the Hermitage], Leningrad, 1969

TREVER AND LUKONIN, 1987: K.V. Trever, V.G. Lukonin, 'Sasanidskoe serebro. Sobranie Gosudarstvennogo Ermitazha' [Sasanian silver from the collection of the State Hermitage], *Khudozhestvennaia kul'tura Irana III–VIII vekov* [Artistic culture of Iran 3rd–8th century], Moscow, 1987

TRILLING, 1987: J. Trilling, 'Late Antique and Sub-antique, or the "Decline of Form" Reconsidered', *Dumbarton Oaks Papers*, Washington, DC, 1987, vol. 41, pp. 469–76

TROFIMOVA, 1994: A.A. Trofimova, 'Portret imperatora Adriana (?) v lavrovom venke' [Portrait of Emperor Hadrian (?) in a laurel wreath], *Kollektsiia muzeia RAIK v Ermitazhe* [Collection of RAIK museum in the Hermitage], St Petersburg, 1994

TROFIMOVA, 2004: A. Trofimova, 'Portret van Antinoos-Dionysos', in *Liefde uit de Hermitage*, ex. cat., Amsterdam, 2004

TUNKINA, 2002: I.V. Tunkina, *Russkaia nauka o klassicheskikh drevnostiakh iuga Rossii (XVIII–seredina XIX v.)* [Russian study of classical antiquities in southern Russia (18th–mid-19th century)], St Petersburg, 2002

TUSCULUM-LEXIKON, 1963: *Tusculum-Lexikon. Griechischer und Lateinischer Autoren des Altertums und des Mittelalters*, Munich, 1963

VICKERS, 1986: Michael Vickers (ed.), *Pots and Pans: A Colloquium on Precious Metals and Ceramics in the Muslim, Chinese and Greco-Roman Worlds, Oxford, 1985*, Oxford, 1986

VIPPER, 1972: B.R. Vipper, *Iskusstvo Drevnei Gretsii* [Art of Ancient Greece], Moscow, 1972

VOLLENWEIDER, 1966 M.-L. Vollenweider, *Die Steinschneide-kunst und ihre Künstler in spätrepublikanischer und augustinischer Zeit*, Baden-Baden, 1966

VOSHCHININA, 1972: A.I. Voshchinina, 'Portret imperatora Adriana iz Elii Kapitoliny i nekotorye zamechaniia k portretnoi skul'pture Sirii' [Portrait of Emperor Hadrian from Aelia Capitolina and a few comments on the portrait sculpture of Syria], *Trudy Gosudarstvennogo Ermitazha* [Materials of the State Hermitage], Leningrad, 1972, issue 13, pp. 124–35

VOSTCHININA, 1977: A. Vostchinina, *Le portrait Romain: Musée de l'Ermitage*, Leningrad, 1977

WALDHAUER, 1924: O.F. Waldhauer [Val'tgauer], *Antichnaia skul'ptura* [Ancient sculpture], Petrograd, 1924

WALDHAUER, 1927: O. Waldhauer, 'Eine "Pasquinogruppe" des fünften Jahrhunderts', *Archäologischer Anzeiger*, 1927, nos. 2–3

WARD, 1993: *Islamic Metalwork*, London, 1993

WATZINGER, 1935: C. Watzinger, *Denkmäler Palestinas*, vol. 11, Leipzig, 1935

WEBSTER, 1939: T.B.L. Webster, *Tondo Composition in Archaic and Classical Greek Art* (Journal of Hellenic Studies), 1939, no. 59

WEGNER, 1955: M. Wegner, *Hadrian*, Berlin, 1955

WEITZMANN, 1943: K. Weitzmann, 'Three "Bactrian" Silver Vessels with Illustrations from Euripides', *Art Bulletin*, 1943, no. 35, pp. 289–324

WEITZMANN, 1951: K. Weitzmann, *Greek Mythology in Byzantine Art*, Princeton, 1951

WEITZMANN, 1960: K. Weitzmann, 'The Survival of Mythological Representations in Early Christian and Byzantine Art and their Impact on Christian Iconography', *Dumbarton Oaks Papers*, Washington, DC, 1960, vol. 14, pp. 45–68

WEITZMANN, 1973: K. Weitzmann, 'The Heracles Plaques of St. Peter's Cathedral', *The Art Bulletin*, New York, 1973, vol. 55, no. 1, pp. 1–37

WERNER, 1984: J. Werner, 'Der Grabfund von Malaja Pereščepina und Kuvrat Kagan der Bulgaren', *Bayerische Akademie der Wissenschaften, philosophisch-historische Klasse, Abhandlungen*, N.F., vol. 91, Munich, 1984, pp. 5–45

WINCKELMANN, 2000: J.J. Winckelmann [Vinkel'man], *Istoriia iskusstva drevnosti: Malye sochineniia* [History of the art of antiquity: Short essays], St Petersburg, 2000

WINKELMANN AND GOMOLKA-FUCHS, 1987: F. Winkelmann and G. Gomolka-Fuchs, *Frühbyzantinische Kultur*, Leipzig, 1987

YEROULANOU, 1988: A. Yeroulanou, 'The Byzantine Openwork Gold Plaque in the Walters Art Gallery', *Journal of the Walters Art Gallery*, Baltimore, 1988, no. 46, pp. 2–11

ZACOS AND VEGLERY, 1972: G. Zacos and A. Veglery, *Byzantine Lead Seals*, Basel, 1972, vol. 1, nos. 1–2

ZALESSKAIA, 1967: V.N. Zalesskaia, 'Vizantiiskii votivnyi pamiatnik v sobranii Ermitazha i ego prototipy' [The Byzantine votive artefact in the Hermitage collection and its prototypes], *Palestinskii sbornik* [Palestinian collection], Leningrad, 1967, no. 17, pp. 84–9

ZALESSKAIA, 1982: V.N. Zalesskaia, 'Vizantiiskaia torevtika 6 v. Nekotorye aspekty izucheniia' [Byzantine toreutics of the 6th century: some aspects of research], *Vizantiiskii vremennik* [Byzantine chronicle], Moscow, 1982, no. 43, pp. 124–33

ZALESSKAIA, 1986: V.N. Zalesskaia, 'Stseny okhoty na rannevizantiiskikh filakteriiakh: simvolika obrazov' [Hunting scenes on Early Byzantine phylacteries: symbolism of the images], *Antichnaia torevtika* [Ancient toreutics – collected essays], Leningrad, 1986, pp. 135–40

ZALESSKAIA, 1987: V.N. Zalesskaia, 'Gomilii Grigoriia Nisskogo i rannevizantiiskie streny' [Homilies of Gregory of Nyssa and Early Byzantine strenae], *Soobshcheniia Gosudarstvennogo Ermitazha* [Reports of State Hermitage], Leningrad, 1987, vol. 52, pp. 38–40

ZALESSKAIA, 1988: V.N. Zalesskaia, 'Simvolika antichnykh obrazov v rannevizantiiskom iskusstve' [Symbolism of ancient images in Early Byzantine art], *Vostochnoe Sredizemnomor'e i Kavkaz 4–16 vv.* [Eastern Mediterranean and Caucasus 4th–16th century – collected essays], Leningrad, 1988, pp. 20–36

ZALESSKAIA, 1991: V.N. Zalesskaia, 'Obraz Niki v rannesrednevekovoi plastike iz Aleksandrii' [Image of Nike in Early Medieval plastic arts from Alexandria], *Soobshcheniia Gosudarstvennogo Ermitazha* [Reports of State Hermitage], St Petersburg, 1991, no. 55, pp. 42–4

ZALESSKAIA, 1993: V.N. Zalesskaia, 'Pamiatniki vizantiiskoi i postvizantiiskoi epigrafiki' [Works of Byzantine and post-Byzantine Epigraphy], *Iz kollektsii N.P. Likhacheva* [From the collection of N.P. Likhachev], ex. cat., St Petersburg, pp. 66–76

ZALESSKAIA, 1994/1: V.N. Zalesskaia, 'K interpretatsii simvoliki liturgicheskikh sosudov iz sobraniia Gosudarstvennogo Ermitazha' [Towards an interpretation of the symbolism of liturgical vessels from the collection of the State Hermitage], *Vostochnokhristianskii khram. Liturgiia i iskusstvo* [Eastern Christian Church: liturgy and art], St Petersburg, 1994, pp. 142–5

ZALESSKAIA, 1994/2: V.N. Zalesskaia, *Pamiatniki vizantiiskogo i postvizantiiskogo prikladnogo iskusstva. Kollektsiia muzeia RAIK v Ermitazhe* [Works of Byzantine and post-Byzantine applied art. Collection of RAIK museum in the Hermitage], St Petersburg, 1994

ZALESSKAIA, 1996: V.N. Zalesskaia, 'Dve serebrianykh chashi masterov Chiprovatsa i Dubrovnika v sobranii Ermitazha' [Two silvers cups by craftsmen of Ciprovac and Dubrovnik in the Hermitage collection], *Vizantiia i vizantiiskie traditsii* [Byzantium and Byzantine traditions – collected essays], St Petersburg, 1996, pp. 145–54

ZALESSKAIA, 1997/1: V.N. Zalesskaia, 'Vizantiiskie veshchi Pereshchepinskogo klada' [Byzantine items from the Pereshchepina hoard], *Sokrovishcha khana Kuvrata. Pereshchepinskii klad* [Treasures of Khan Kuvrat: Pereshchepina hoard], St Petersburg, 1997, pp. 41–4, 110–22

ZALESSKAIA, 1997/2: V.N. Zalesskaia, Z.A. L'vova, B.I. Marshak, R.Kh. Teliaskhov, *Kubrat khan. Sokrovishcha khana Kubrata* [Kubrat Khan. Treasures of Khan Kubrat], ex. cat., Kazan and St Petersburg, 1997

ZALESSKAIA, 1997/3: V.N. Zalesskaia, *Prikladnoe iskusstvo Vizantii 4–12 vekov. Opyt atributsii* [Applied art of Byzantium 4th–12th century: experience of attribution], St Petersburg, 1997

ZALESSKAIA, 1998: V.N. Zalesskaia, 'Krest-enkolpion s izobrazheniem arkhangela Mikhaila i apostola Filippa' [Enkolpion-cross with a depiction of the Archangel Michael and Apostle Philip], *Khristiane na Vostoke. Iskusstvo mel'kitov i inoslavnykh khristian* [Christians in the East: Art of the Melkites and non-Orthodox Christians], St Petersburg, 1998, p. 35

ZALESSKAIA, 2000: V.N. Zalesskaia, catalogue descriptions in: *Sinai. Vizantiia. Rus'. Pravoslavnoe iskusstvo s 6 do nachala 20 veka* [Sinai, Byzantium, Rus': Orthodox art from 6th to early 20th century], ex. cat., London, 2000, nos. B-3, B-5 A-C, B-13 A, C, B-82

ZALESSKAIA, 2001/1: V.N. Zalesskaia, 'Fessalonikskie ikonki-evlogii i obrazki epokhi Latinskoi imperii' [Thessalonian eulogion-icons and small relious images from the era of the Latin empire], *Piligrimy. Istoriko-kul'turnaia rol' palomnichestva* [Pilgrims: Historico-cultural role of pilgrimage – collected essays], St Petersburg, 2001, pp. 78–82

ZALESSKAIA, 2001/2: V.N. Zalesskaia, 'Egipetskaia zhizneutverzhdaiushchaia simvolika v kul'te Sabaziia' [Eyptian life-confirming symbolism in the cult of Sabazios], *Drevnii Egipet i khristianstvo* [Ancient Egypt and Christianity – thesis papers], Moscow, 2001, pp. 43–5

ZALESSKAIA, 2002: V.N. Zalesskaia, 'Kameia s mifologicheskim siuzhetom iz sobraniia Gosudarstvennogo Ermitazha (O simvolike antichnykh obrazov v sredne-vizantiiskii period) [Cameo with a mythological subject from the collection of the State Hermitage (on the symbolism of ancient images in the mid-Byzantine period)], *Drevnerusskoe iskusstvo. Rus' i strany vizantiiskogo mira XII v.* [Ancient Russian art: Rus' and countries of the Byzantine world in the 12th century], St Petersburg, 2002, pp. 113–17

ZALESSKAIA, 2003/1: V.N. Zalesskaia 'Ob interpretatsii graffiti na chashe so stsenoi poleta Aleksandra na grifonax' [On the interpretation of the graffiti on a cup with the scene of Alexander's flight on griffins], *Vizantinorossika*, St Petersburg, 2003, no. 2, pp. 45–8

ZALESSKAIA, 2003/2: V.N. Zalesskaia, 'Sevastiia Palestinskaia – tsentr proizvodstva rannevizantiiskoi torevtiki (gipotesy i fakty)' [Palestinian Sebastia – centre of production of Early Byzantine toreutics (hypotheses and facts)], *Ermitazhnye chteniia pamiati B.B. Piotrovskogo* [Hermitage lectures in memory of B.B. Piotrovsky], St Petersburg, 2003, pp. 27–9

ZALESSKAIA, 2004/1: V.N. Zalesskaia, 'Obraz Georgiia-voina v melkoi plastike Paleologovskogo vremeni' [Image of St George the Warrior in the small plastic arts of the Palaiologan era], *Vizantiia v kontekste mirovoi istorii* [Byzantium in the context of world history], St Petersburg, 2004, pp. 38–42

ZALESSKAIA, 2004/2: V.N. Zalesskaia, 'Rannevizantiiskaia gliptika v sobranii Ermitazha' [Early Byzantine glyptics in the collection of the Hermitage], *Sfragistika i istoriia kul'tura* [Sphragistics and the history of culture], St Petersburg, 2004, pp. 13–22

ZALESSKAIA, 2004/3: V.N. Zalesskaia, 'Bliudo so stsenoi poleta Aleksandra Makedonskogo. O simvolike antichnykh obrazov v srednevizantiiskii period' [Dish with the scene of Alexander of Macedon's flight: on the symbolism of ancient images in the mid-Byzantine period], *Soobshcheniia Gosudarstvennogo Ermitazha* [Reports of State Hermitage], St Petersburg, 2004, vol. 62, pp. 109–22

ZALESSKAYA, 1982: V. Zalesskaya, 'Die byzantinische Toreutik des 6. Jahrhunderts. Einige Aspekte ihrer Erforschung', *Metallkunst von der Spätantike bis zum ausgehenden Mittelalter*, Berlin, 1982, pp. 97–111

ZALESSKAYA, 1988: V. Zalesskaya, 'La toreutique byzantine du VI siècle (Les centres locaux)', *Argenterie romaine et paléobyzantine*, Paris, 1988, pp. 227–33

ZALESSKAYA, 1994/1: V. Zalesskaya, 'Byzantine Metalwork, Ivory and Bone Carving', *The State Hermitage: Masterpieces from the Museum's Collections*, London, 1994, vol. I, pp. 378–93

ZALESSKAYA, 1994/2: V. Zalesskaya, 'Dish showing Meleager and Atalanta', *Treasures from the Hermitage*, St Petersburg (European Fine Art Fair), Maastricht, 1994

ZALESSKAYA, 1996/1: V. Zalesskaya, 'Byzantinische Gegenstände im Komplex von Mala Pereshchepina. Reitervölker aus dem Osten. Hunnen und Awaren' (Generalkonzept: Dr. F. Daim), Vienna, 1996, pp. 216–20

ZALESSKAYA, 1996/2: V. Zalesskaya, 'The Imagery of Heavenly Messengers in some Monuments of Byzantine Applied Arts', *Acts, XVIIIth International Congress of Byzantine Studies* (vol. 3: Art History, Architecture, Music), Shepherdstown, WV, 1996, pp. 383–90

ZALESSKAYA, 2000/1: V. Zalesskaya, 'Ajax Quarelling with Odysseus about Achilles' Armor', *Stroganoff: The Palace and Collections of a Russian Noble Family*, New York, 2000, pp. 235–6

ZALESSKAYA, 2000/2: V. Zalesskaya, 'On the Symbolism of Classical Images in Middle Byzantine Art: a Cameo with a Mythological Subject. Perceptions of Byzantium and its Neighbors (843–1261)', *The Metropolitan Museum of Art Symposia*, New York, 2000, pp. 56–9

ZALESSKAYA, 2002: V. Zalesskaya, Annotations to: 'Silver gilt amphora', 'Flask with Nereids and sea Monsters', 'Silver Plate with a bucolic Scene', in D. Papanikola Bakirtzi (ed.), *Byzantine Hours, Works and Days in Byzantium: Everyday Life in Byzantium*, ex. cat., Thessaloniki (October 2001–January 2002), Athens, 2002, pp. 305–7, 309–12

ZALESSKAYA, 2004: V. Zalesskaya, 'Masterpieces of Byzantine Art: Applied Art', *The Hermitage Museum of St.Petersburg: The Greek Treasures*, Athens, 2004, pp. 285–307

ZALESSKAYA, 2005: V. Zalesskaya, 'Souvenirs of the Holy Land', *Byzantium–Jerusalem: Pilgrim Treasures from the Hermitage*, Zwolle, Hermitage Amsterdam, 2005, pp. 72–87

ZALESSKAYA [forthcoming]: V. Zalesskaya, 'Entre l'Orient chrétien et Rome – A propos de quelques intalles paléochrétiennes inédites de l'Ermitage', *Weltkongress für Christliche Archäologie*, Vienna

ZALESSKAYA AND PIATNITSKY, 1993: V. Zalesskaya and Yu. Piatnitsky, 'The Sun in Byzantine and Russian Art', in Madanjeet Singh (ed.), *The Sun: Symbol of Power and Life*, New York, 1993

ZANKER, 1977: P. Zanker, *Klassizistische Statuen*, Mainz am Rhein, 1977

ZASECKAJA, 1995: I. Zaseckaja, 'A propos du lieu de fabrication des plats en argent portant la représentation de Constance II et trouvés à Kertch', in F. Vallet and M. Kazanski (eds.), *La noblesse romaine et les chefs barbares du III-e au VII siècle*, Association Française d'Archéologie Mérovingienne, Paris, 1995, vol. 9, pp. 89–100

ZASETSKAIA, 1993: I.P. Zasetskaia, 'Materialy Bosporskogo nekropolia vtoroi poloviny IV–pervoi poloviny V vv. n.e.' [Materials from the Bosporan necropolis from the second half of 4th to first half of 5th century AD], *Materialy po arkheologii, istorii i etnografii Tavrii* [Materials on the archaeology, history and ethnography of Taurus], Simferopol, 1993, vol. 3, pp. 23–105

ZASETSKAIA, 1994: I.P. Zasetskaia, 'O meste izgotovleniia serebrianykh chash s izobrazheniem Konstantsiia II iz Kerchi' [On the place of manufacture of the silver cups with the image of Constantius II from Kerch], *Materialy po arkheologii, istorii i etnografii Tavrii* [Materials on the archaeology, history and ethnography of Taurus], Simferopol, 1994, vol. 4, pp. 225–37

ZAZOFF, 1983: P. Zazoff, *Die antiken Gemmen*, Munich, 1983

ZEMNOE ISKUSSTVO, 2000: *Zemnoe iskusstvo – nebesnaia krasota. Iskusstvo islama* [Earthly art, heavenly beauty: the art of Islam], St Petersburg, 2000

ZERVOUDAKI, 1968: E. Zervoudaki, 'Attische polychrome Reliefkeramik des späten 5. und des 4. Jahrhunderts vor Chr', *Mitteilungen des Deutschen Archäologischen Instituts*, Athenische Abteilung, Berlin, 1968, vol. 83, pp. 1–88

ZHURNAL MVD, 1839: *Zhurnal ministerstva vnutrennykh del* [Journal of the Ministry of Home Affairs], St Petersburg, 1839

ZWEI GESICHTER, 1997: *Zwei Gesichter der Eremitage*, ex. cat., Bonn, 1997, vol. I (Die Skythen und ihr Gold)

INDEX

Page numbers in *italic* refer to the illustrations